HOGARTH
His Art and His World

HOGARTH

His Art and His World

Jack Lindsay

TAPLINGER PUBLISHING COMPANY / NEW YORK

First published in 1979 by
TAPLINGER PUBLISHING CO., Inc.
New York, New York

Library of Congress Cataloging in Publication Data

Lindsay, Jack, 1900—
 Hogarth : his art and his world

 Bibliography: p.
 Includes index.
 1. Hogarth, William, 1697—1764. 2. Painters—
England—Biography.
ND497.H7L77 1979 760'.092'4 [B] 78-21289
ISBN 0-8008-3916-1

Printed in the United States of America

9 8 7 6 5 4 3 2 1

To Michael Wilding

Suddenly to see the world

just as it is, obliquely near,
out there beyond the meddling mind,
exposed off guard, fixed flat and hard:
a gawky instantaneous flash.

Suddenly to see the world

just as it is, a splintering rush,
blind fragments with no sense or shape
apart from what mechanics tells,
blown out or in by wavering gusts.

And then to find a meaning there,
a rhythm of involving truths
intact, not losing or refusing
those first mad visions of death and fury.

There's something of this harrowed hell
in all true art, I know it well,
but some of us can better grasp
the opposites and tell less lies.

Hogarth was such a man who dared
to see himself in others' faces.
London his hell, and heaven too,
door after door, in luring mazes.

Suddenly to see the world.

<div align="right">Jack Lindsay</div>

Contents

Foreword

*I*n postwar years there has been a steady increase in the appreciation of Hogarth's qualities as a painter and the understanding of his place in the history of art. The Tate Gallery exhibition of 1971–2 did much to help in bringing these positions to a head. There has further been the monumental work of Ronald Paulson on his life and art, together with a long commentary on the Graphic Works: books to which anyone hereafter writing on Hogarth must make an unqualified tribute. The ground has been fully cleared for further evaluation and analysis.

I have myself long been fascinated by the *Analysis of Beauty*, surely the most interesting and original treatise on art produced by any artist, which I believe has not yet been fully understood and appreciated. One of the main aims of my book has been to bring out what I feel to be the significance of the *Analysis* in relation to Hogarth's own work, the art of his world, and art in general. A number of highly important ideas are set out in the *Analysis*, with comments which enable us to see in much detail how he sought to apply them. Central is the idea that form can never be considered apart from movement. This idea led Hogarth to reject all existing forms of art teaching and to construct his system of mnemonics, which enabled him always to see a part of a form in its connection with the living whole, and which led to his deep sense of organic form. Structure, organism, movement were felt to be all inseparable aspects of a single reality, which could further be grasped in terms of variety, intricacy, and simplification. The mnemonic system implied that the artist was in the midst of what he depicted, and thus a new concept of artistic activity was developed – activity and participation being inseparable. The search for form was a search into form, in which the relation

of the active intellect and the object became a sort of 'chace', and sensuous pleasure was an integral part of the act of grasping the form, defining, and enjoying it.

In turn the quest for the inner structure, the wholeness, of a form was linked with the quest for inner meanings, for full human comprehension of all that was involved in a character, a sense, a group of persons. Here it was the use of emblems, of symbolic overtones and undertones, coming into play, with a highly complex working out.

Finally this new active relation of life and art necessitated the rejection of all the old (aristocratic) systems of art values or patronage, the creation of a new and broad audience, the search for new ways of getting at this audience; and at the same time the creation of new methods of art teaching, with the rejection of all kinds of 'copying'. The new kind of self-consciousness produced by the stress on movement and on participation, on a new relation to the audience, was linked with a correlation of art and theatre. Here the baroque concept of a cosmic theatre was given a realistic focus, in which Hogarth was helped by his response to the *Beggar's Opera*. His social criticism was given force by the notion of everyone acting a role, pretending to be other than his real or natural self; drama consisted of the conflict between the real self and the imposed role through which men betrayed and destroyed themselves.

Many more points emerge in this many-sided struggle of Hogarth to create an art in which the old forms of mediation are dropped. His personal story is dramatic and complex. He keeps on trying to make people understand the new art that he is creating, and at the same time to engage the enemy (the art establishment of patrons, dealers, critics) on their own ground in a restless series of advances and retreats, in which he keeps returning to his own chosen ground. On that ground he is without rival, though decried or ignored by the establishment, and unable to make anyone really understand what he is doing, the decisive new direction he has given to art. The tragic element in the conflict increases after the publication of the *Analysis* and reaches its climax in the conflict with Wilkes.

These brief comments will give some pointers to the way in which my argument unfolds, and some idea of the reasons impelling me to write the book.

Jack Lindsay

1 *Early Years (1697–1707)*

*A*bout 1686 Richard Hogarth, a young schoolmaster, journeyed south from Westmorland to London. He came of farming stock in a sheep-rearing region where about half the population struggled along near or under subsistence level. Defoe, a little later, declared that the children of the purely agricultural districts, as they grew up, were apt to run away to be footmen or soldiers, thieves or beggars, or to sell themselves to the planta-tion to avoid gaol and gallows. Richard Hogarth was making no such drastic choice. He had claims to scholarship, but the lack of chances for advance-ment in Westmorland made him as keen to leave for London as any young-ster of farming stock who saw no future except that of becoming a burden on the rates. It was natural that such an uprooted man should be the father of the artist who was to depict society at a desperate moment of change, with human misery and defeat everywhere evident in street and by-way.

But Richard, travelling south, had high hopes and ambitions. Born on 14 January 1663 or 1664, he had gained a good knowledge of Latin and Greek, perhaps at the free school of Bampton or that of St Bees in Cumber-land, though, as the family was Presbyterian, he may have been educated at some dissenting academy. Perhaps he had tried to set up a school in his home area and found it too difficult; in any event he must have felt that the place in which to try out his talents was London. He seems to have kept up contacts with his family in the north; later a brother settled not far from him in London as a victualler. There was a Thomas Hogarth of Troutbeck who wrote verses, satirical and amatory, and who won some local fame. On the testimony of Adam Walker, a friend of the painter's widow, he has been taken as a brother of Richard, but at most he seems a great-uncle. For all his

rusticity he sprinkled his verses with trite classical allusions, and it is likely that he and Richard knew one another, even that they corresponded. We are told that Richard came south with Edmund Gibson, later Bishop of London, who had been educated at Bampton Grammar School, and with Thomas Noble, also of the Bampton area, both of them apparently on their way to Oxford. Later Richard got some aid from Noble, but failed with Gibson. His stories about the self-important bishop (called the Pope of the Whigs under Walpole) seem to lie behind his son's hitting out at Gibson in the *Harlot's Progress*.

He arrived in London just before the upheavals that drove out the last of the Stuarts and brought in William of Orange with the Glorious Revolution of 1688, and he must have shared in the excitements of the occasion. We can learn much about him from the textbooks he published, which show that he had given much thought to education and owned some originality of line. By May 1689 he brought out *Thesaurus Trilingue Publicum: Being an Introduction to English, Latin and Greek*. No author is named, but a prefatory poem speaks of *Victrix Hogarthica Penna*. Richard defends the use of the vernacular, attacks the spelling of words according to the 'Pronunciation that time by Corruption has given them', admits Fancy as a writer's guide after rules and memory have done their work, wants several letters banished from the alphabet, and gives a list of homonyms so that children may quiz one another as a spur to learning. His grouping of words shows he pronounced them very rustically. In November 1689 he abridged Skinner's *Etymologicon Linguae Anglicanae*. On the ratebooks and the title page of a 1711 book he termed himself schoolmaster; but he does not seem to have been licensed with the Bishop of London: no doubt to escape swearing to the Thirty-nine Articles.

In 1690 he lodged just off Smithfield Market, in Bartholomew Close, where the timber houses had survived the fire of 1666. The house was that of John and Anne Gibbons, who had had nine children, though only two girls and a son, John, aged fourteen, were still with them. The daughter Anne (baptized in November 1661) married Richard on 4 November 1690, probably in a dissenting chapel. She proved to be a strong and capable woman, a good balance for a more volatile husband who was some three years younger. When Gibbons died in 1692, his widow kept the house on, and the Hogarths seem to have had a floor of their own, with a small school installed by 1695. Four children had then been borne by Anne: John, Elizabeth, and Anne, all dying in infancy, and Richard, baptized on 11 April 1695. We see that the couple had enough worries in their early married years. William was born on 10 November 1697 and baptized on the 28th at St Bartholomew the Great.

About this time Tom Brown drew a picture of a madly devoted school-master who might well be based on our Richard. He calls the man Richard Bentlesworth (that is, Good-as-Bentley). Round 1697 the scholar Bentley was being much discussed in a controversy from which emerged Swift's *Battle of the Books*. In the small London of the time Brown, with his eye for oddities, might easily have met Richard in a coffee-house where he was setting out his ideas and complaining of his neglect as an author:

Richard Bentlesworth, superintendent of a small grammar-elaboratory, in the out-skirts of the town, was so monstrously over-run with the *Scorbuticum Pedanticum*, that he used to dumbfound his milk-woman with strange stories of *gerunds* and *particles*; would decline you *domus* in a cellar in the *Strand* before a parcel of chimney-sweepers, and confute *Schioppius* and *Alvarez* to the old wall-ey'd matron, that sold him grey-pease. Tho' this strange distemper, when once it has got full possession of a man, is as hard to be cured as an hereditary pox, yet I have absolutely recovered him; so that now he troubles the publick no more with any of his *Dutch-Latin* dissertations, but is as quiet an author as ever was neglected by all the town, or buried in *Little Britain*.

On 23 November 1693 Mary was born to the Hogarths. By April next year the family had moved a short way to a smaller house at the bottom of St John's Street, the main route from Smithfield to the north. In October 1701 there was another daughter, Anne, baptized at St Sepulchre's church. On 12 November 1703 the family moved again, a little to the north; and that day another son, Thomas, was baptized in St James's church. By the new year, and probably earlier, they were in St John's Gate, a quieter neighbourhood with a pleasant square beyond. Then early in 1704 Richard took a bold step, advertising in the *Post Man* that he was opening a coffee-house at his place, where Latin could be spoken daily, 'The Master of the House, in the absence of others, being always ready to entertain Gentlemen in the Latin Tongue'. Later 'daily' was changed to 'Every day at 4 a Clock'. Also, a Society of Trades met every Monday night 'in the Great Room over the Gateway, for the promoting their respective Trades'. The gate had once been the southern entry to the Priory of St John of Jerusalem. The Great Room over the arch was not much larger than the rooms in the side towers, but had a high ceiling. (From 1731 on it was used as the printing offices of the *Gentleman's Magazine*.) Possibly the Hogarths lived in one of the gate-rooms; we may assume that Richard had given up schoolmastering. His project was not so odd as it may seem. Coffee-houses, beginning under the Commonwealth, were often used by gentlemen who liked to display learning and for whom Latin-speaking was a useful accomplishment.

In late July 1705 a fourth son, short-lived, was born; and on 17 December the boy Richard, aged ten, died. Despite his young years and the commonness of infant mortality, William cannot but have been affected by the bereavements. By now he must have known the areas of Smithfield and Clerkenwell thoroughly. North of the churchyard was the surgeon's sign with 'the figures of Mad people' and advertisements for the cure of lunacy. Through the streets were led animals to be baited, mostly on the town's outskirts, where also, amid the brick-kilns, pigsties, and cowsheds, pugilists fought brutally. From the coffee-house William could see the sign of John the Baptist's head on a charger (which he used in *Noon*). With his father he may have wandered to St Paul's Churchyard where print and book trades were concentrated, and stared at engravings. Now and then the family must have gone south to where Edmund Hogarth now had a shop at the Surrey end of London Bridge, near the Waterhouse, a pumping-station that sent water along wooden mains, made of tree trunks, to the City. The old medieval bridge was lined with overhanging houses held up on brackets and the heads of traitors and other malefactors were stuck on the big stone gate at the southern end. Later, when William wanted to depict a typical London merchant's residence, he showed the bridge, with its mounted heads, through the window.

The area of Bartholomew Close and Smithfield, where William grew up, was still heavily medieval, untouched by the Great Fire. The church had been despoiled under Henry VII, but the eastern gate and the massive Norman choir escaped, hemmed in by houses and workshops, a shadowy warren of narrow lanes, courts, passages often connected with textiles. Through the eastern gate one reached Smithfield, a cloth-exchange in medieval days, then a horse market under Elizabeth, now turned into a big cattle market. The oxen and sheep, driven up through the night hours, converged here every Monday morning, with much noise and stench. Swift, describing a city shower (October 1710) tells how the torrents 'from Smithfield to St 'Pulchre's shape their course', carrying along dung, guts, and blood from butchers' stalls, drowned puppies, stinking sprats, dead cats, and turnip tops. Across the market square was St Bartholomew's Hospital.

The area left indelible impressions on William. He remained always very interested in hospitals; and the narrow heavy enclosed spaces must have contributed to the claustrophobic element that is seldom lacking in his indoor or street scenes. For a few weeks each year the area was the seat of a great fair, with every sort of popular entertainment: merry andrews and strolling players, puppets, acrobats, rope dancers, giants, dwarfs, drolls, mountebanks, quacks, jugglers, huxters, performers of 'Comick Dances and

Songs, with Scenes and Machines never seen before', jigs, sarabands, and country dances. Dolls called Bartholomew Babes were sold, tricked up with ribbons and knots; lotteries and raffles were held in the Great Cloister, with booths under the blackened vaulting; whores and thieves abounded. Pie Corner, at the end of Giltspur Street, was where 'cooks stood dripping at their doors, like their roasted swines'-flesh at their fires', extolling their wares, with hosts of flies waiting to attack the pig sauce. At the playbooth women were cracking nuts in the pit; a girl danced with filled glasses on the backs of her hands or whirled round in a sword dance, while the watchers applauded by hand-claps or heel-kicks. Oyster wenches went round in blue aprons and straw hats, while a jack-pudding blew his nose on the crowd. 'Monkeys in the balconies were imitating men, and men making themselves monkeys.' Outside the playbooth were 'a number of kings, queens, heroes, harlots, buffoons, comics, priests, profligates, and devils in the balcony'. There were holes for the gamblers, and the hospital gate was a 'rendezvous of jilts, harlots, and sharpers'. At a raffling shop near by, men bought silver knick-knacks for girls.

Here William came to know a strange and vivid mixture of elements from contemporary theatre with immemorial mummings and broken-down survivals of medieval drama. Leading actors came from the West End to jostle with the merry andrews and clowns. Hogarth certainly saw for instance *The Old Creation of the World* at Heathley's Booth, with a Marlborough Battle, *Jephtha's Rash Vow* at Doggett's Booth, with farcical roles for Toby and Ezekiel, and Settle's adaptation of *The Siege of Troy* at Mrs Mynn's, its highflown scenes interspersed with comic ones in which the cobbler's wife nagged to see the Great Horse. When William painted *Southwark Fair*, some twenty-five years later, he included all these shows. The link of rustic festival and town fair is brought out by the fact that Thomas Hogarth of Troutbeck composed a *Destruction of Troy*, played after his death on the Westmorland hillside. It began with a long procession. The clown or jack-pudding, says Walker, 'was the most important personage in the whole play, for his office was, to turn the most serious parts of the drama into burlesque and ridicule'. He opened the epical play with a song, and the whole thing was 'interlarded with apt songs, both serious and comic, all the production of Ald Hogart'.

The fair did not lack political satire, as when a merry andrew, to mock at the weak state of government finance, singed a pig with exchequer notes and tallies, and roasted it, for which he was whipped. From time to time efforts were made to reduce the fair to its original three days or to suppress its excesses, but with no lasting effect.

Young William was deeply affected by the spectacle of the fair. Here was everyday life suddenly raised to a new level of merriment, noise, energy. At the same time it was a game, a play-acting. People dressed up and pretended to be other than they were, and all the while the bright pretences were being mocked at. The world inexplicably became a mad glamorous absorbing play; then the wild glory subsided, leaving a mess of rubbish and broken things, and people were back at their daily toil without the laughter, mockery, violence. Which was the real world, the play or the deflated drudgery? Ned Ward points to the key aspects of the fair: the dressing-up and the exposure of people who are trying to seem other than they were – 'everyone looking notwithstanding his dress, like what he really was, and not like what he represented' – and the mocking of the heroic: the merry andrew strutting 'along before the glittering train of Imaginary Heroes, leading them to play the Fool inside'. And the mime of life taking over, lifting ordinary actions to a new level of meaning, emptying them of meaning, bringing out the hidden jest, making the spectator see them from new angles: the merry andrew beginning 'a tale of a tub which he illustrates with abundance of ugly faces, and mimical actions, for in that lay the chief of the comedy, with which the gazers seemed to be most affected'. Tom Brown comments: 'Certainly no place sets mankind more on a level than *Smithfield* does.'

William later wrote: 'I had naturally a good eye, shews of all sorts gave me uncommon pleasure when an Infant and mimickry common to all children was remarkable in me.' In his *Analysis of Beauty*, dealing with Quantity, he discusses the ways in which laughter is excited when 'improper or incompatible excesses meet'. He gives several examples, such as 'a fat grown face of a man, with an infant's cap on, and the rest of the child's dress stuff'd, and so well placed under his chin, as to seem to belong to that face. This is a contrivance I have seen at Bartholomew-fair, and always occasion'd a roar of laughter.'

Somehow he managed to escape being educated in the full rigours of his father's grammatical ideas. Perhaps the financial worries that descended on Richard made him unable to train his son as he would certainly have liked to do. But though William resisted his father's academic side, he was affected by him in various ways. We may link with his father the need he felt to systematize, to work out a unity of theory and practice; his sense of art as a kind of language with its own forms of communication; his development of mnemonic methods for recording forms without reducing them mechanically to ready-made systems. In such matters we see both his resistance to his father's outlook and his struggle to re-create that outlook on new levels,

in the sphere of art. Later he contrasted the copying of words and of forms:

What is wrote is what should be retained as it may be word for word the same with the original whereas what is copied for example at an academy is not the truth, perhaps far from it, yet the performer is apt to retain his perform'd Idea instead of the original. More reasons I form'd to myself but not necessary here why I should not continue copying objects but rather read the Language of them (and if possible find a grammar to it) and collect and retain a remembrance of what I saw by repeated observations only trying now and then upon my canvas how far I was advanc'd by that means.

In his last days, in some confused notes, he declared: 'Drawing and painting are only a much more complicated kind of writing', and repeated that mere copying of forms was opposed to creativeness. The great painter or sculptor 'can conceive the most minute and perfect part [of] a Human with all its circumstances [and] variation' when the form is not present. The artist needs to be able to record memories and be prepared to use them; otherwise he may 'know the words and their meaning and yet never be able to write, lacking the hand to perform'.

An important passage in the *Analysis* gives us a glimpse of Hogarth as an observant child fascinated by ribbon ornament and the twirling jack in the kitchen. A figure shows a worm turning in a wheel. He loved the spiralling movement, the ceaseless disappearance and reappearance, and thus laid the basis for much of his later theory and practice. In the *Analysis* he seeks to define the active relation between the eye and forms in movement, using the analogy of an imaginary ray passing over a line of letters as we read, dealing with successive letters and yet handing on to the mind a unified meaning 'at one sudden view'.

In this manner of attending to forms, they will be found whether *at rest*, or *in motion*, to give *movement* to this imaginary ray; or, more properly speaking, to the eye itself, affecting it *thereby* more or less *pleasingly*, according to their different *shapes* and *motions*. Thus, for example, in the instance of the jack, whereby the eye (with this imaginary ray) moves slowly down the line, to which the weight is fix'd, or attends to the slow motion of the weight itself, the mind is equally fatigu'd: and whether it swiftly courses round the circular rim of the flyer, when the jack stands; or nimbly follows one point in its circularity whilst it is whirling about, we are almost equally made giddy by it. But our sensation differs much from either of these unpleasant ones, when we observe the curling worm, into which the worm-wheel is fixt: for this is always pleasing, either at rest or in motion, and whether that motion is slow or quick. . . .

I never can forget my frequent strong attention to it, when I was very young, and that its beguiling movement gave me the same kind of sensation

then, which I since have felt at seeing a country-dance; tho' perhaps the latter might be somewhat more engaging; particularly when my eye eagerly pursued a favourite dancer, through all the windings of the figure, who then was bewitching to the sight, as the imaginary ray, we were speaking of, was dancing with her all the time.

This single example might be sufficient to explain what I mean by *the beauty of a composed intricacy of form*; and how it may be said, with propriety, to lead the eye a kind of chace.

The boy, fascinated by the rhythmic movement of forms, into which he felt actively drawn, resisted and defeated his father's efforts to turn him into a Latinist. He 'drew the alphabet with great ease', he tells us, and had a 'natural turn' for drawing rather than for 'learning a language'. His exercises 'were more remarkable for the ornaments which adorned them than for the Exercise itself'. In his lessons he was beaten by 'Blockheads with better memories', but in drawing he 'was particularly distinguished'. Then 'an early access to a neighbouring Painter drew my attention from play' and 'every opportunity was employed in attempts at drawing'. Whether the artist he met was a painter of pictures, a coach-painter, a sign-painter, or the like, is not made clear.

His urge to drawing and his impulse to mimicry were certainly akin; and this fact helps us to understand why as an artist he was so absorbed by character and movement. The miming activity drew his whole body into the projection of some character or action; and as he matured he felt the need to project into his images this totality of sensation and emotion, this concentration of form at a moment of typical activity, of organic movement. The miming impulse was thus in turn linked with his feeling of rhythmic movement as a fascinating maze of involving form, as something simultaneously observed and felt with every fibre of his being.

A work much used as a Greek and Latin textbook, which would certainly have been in Richard's library and known to his son, was *Tabula Cebetis:* a dialogue in which Cebes stands before a painting and deciphers it to his friends. Life is shown as a walled enclosure with various compartments on the hillside. People enter the Gates of Life, directed by a Divine Genius but met by Deceit who administers to each a draught of error and ignorance. Inside the walls they meet blind Fortune standing on a round stone and distributing honours, children, chance gains. Courtesans, Opinions, Desires, Pleasures try to lead the people astray. In the second compartment, higher up, are the courtesans Intemperance, Prodigality, Insatiableness, Flattery. These coax away Fortune's gifts and enslave the people into doing vile and pernicious things. The slaves are taken over by Torture, Grief,

Vexation, Anguish, and so on. Among the further areas of trial, ordeal, and disaster is the one of False Learning. Many artists tried to depict the *Tabula* or to use the Choice-of-Hercules pattern to express a crucial moment of moral choice. In the 1750s a Scot, James Moor, used Hogarth's prints as examples of the ways in which different times and places were represented in the *Tabula*.

An instance of the way in which he was affected by pictures from textbooks which he must have known in young days is afforded by his late designs for the 1761 catalogue of the Society of Arts. There Royal Bounty is shown successfully watering the trees of the arts, while the connoisseur monkey fails with his watering-can on dead stumps. Hogarth is recalling the design of Grammatica watering the young plants, the young minds, which was found in several iconologies and which went back to an engraving by Marc-antonio of a naked woman watering flowers.

We can then make out how many elements from childhood entered deeply into Hogarth's spirit and helped to shape his art. The darkly enclosing labyrinthine city full of turmoiling energies, with its narrow streets and lanes where one life pressed hard in on another, and then the wild burst of grotesque laughter and encircling dance, which seemed to carry men and women into a different world; the busy hopes and schemes of Richard, always chafing against the constraints and harsh necessities of his situation, defeated and yet reasserting themselves – all these elements became lasting ingredients in his art, his vision of life. The stories he would have heard of the life of the Hogarths in Westmorland would have increased his sense of being an exile in a strange and confined world, full of unpredictable events of danger and delight, and would have helped to give him his mixture of critical distance and excited participation in those events.

This topsyturvy and exciting world is well evoked by Tom Brown in his remarks on Bartholomew Fair. He speaks of the 'sublime fustian and magnificent nonsense', and ends:

But to leave off this bombast with which the booths have infected me, and deliver myself in a more familiar stile, you must know, that at this present writing your humble servant is in a musick-booth; yet, tho' he is distracted with a thousand noises and objects, as a maid whirling round with a dozen rapiers at her neck, a dance of chimney-sweepers, and a fellow standing on his head on the top of a quart-pot, he has both leisure and patience enough to write to you.

There indeed is Hogarth, absorbed and detached in his art in the midst of the equally engrossing hurly-burly.

2 Gaol and Apprenticeship (1707–18)

Some time after the summer of 1707 the coffee-house failed. Before the end of 1708 Richard was gaoled in the Fleet for debt. In January his wife advertised her gripe ointment, 'in pity to Infants that cannot tell their ails'. She offered halfcrown pots from 'next door to the Ship in Black and White Court, Old Bailey'. She was doing her best to bring in some money. A debtor who hid was liable to capital punishment; otherwise he was declared bankrupt and lost all his property unless the creditors accepted a composition. In gaol he mouldered away unless he managed somehow to pay up or arranged terms with his creditors. There were two sides, the Common and the Master, where conditions were extremely hard; but if a prisoner could meet the gaol charges, he had a much better lot. Five pounds, with security, gained him the Freedom of the Rules; he could go outside the walls in a defined area. By 1709, when the winter was bitter, Richard had gained this freedom, no doubt with the aid of his brother Edmund; he lived in the Old Bailey precinct and seems to have carried on some sort of school, despite the prohibition against a debtor earning money. He was lucky to have served his term before Huggins took over in 1713 with increased exactions and cruel treatment of debtors.

On 23 September 1710 he wrote to Robert Harley, the queen's first minister, recounting his wretched condition and begging for help. Harley, hard put to deal with the national debt, was ready to receive any suggestions, such as those Defoe set out in his *Essay upon Credit*. Richard, unable to maintain his own credit, was one of the many ready to save the nation. We do not know exactly what he advised, though he mentions having sent two proposals, 'harmful to nobody, by which the royal revenue can be raised for

the coming year'. He bursts out: 'If only I could I'd be happy to run to you through the windows.' He fears that some men have 'fished out' his ideas and are now 'showing them to some who are close to the Queen'. He warns that these 'nonentities, ignorant butchers and cobblers' are the 'most senseless foes to all Monarchy and its friends and above all to you'. He boasts of his friends who will vouch for his 'reliability, diligence, capacity, and soundness'. His special faculty 'lies in searching out difficult matters'. At the moment he is compiling 'a most excellent dictionary'.

The letter sounds desperate, with a touch of persecution mania and an effort to shed the last remnant of a dissenting past. William, now in his twelfth year, listened to his father's wild talk, and more than twenty years later in the *Rake's Progress* he showed a frantic character in the Fleet, who drops a scroll: *Being a New Scheme for paying ye Debts of ye Nation,* together with another marked *Debts.*

On 3 January the Fleet debtors presented a petition for themselves and their fellows; and we may be sure that Richard had taken a leading part in the matter. Petitions followed from other gaols. A Bill to free debtors owing up to £50 was introduced, gaining the Royal Assent on 22 May, and on 9 September 1712 Richard was named as winning his discharge.

During these years William's schooling must have been rather irregular, and perhaps he was doing odd jobs to help the family along. He observed the prisoners and their keepers, and gained the feeling that the institutions claiming to impose order and decency were themselves the cause of much disorder and destruction. The prisoners, betrayed by the struggle for money or a rise in social status, were battened on by wardens and officials; the roles of rogue and official, of exploiter and sufferer, were continuously interchangeable. Society itself began to seem like a huge prison, of which the Fleet was only a simplified version. The gaol walls were for ever coming closer to immure the individual already trapped in his follies and villainies. The betraying elements, born out of an effort of self-assertion, in their working out produced the loss of the true self, the sufferer's individuality, and thus his dressing-up, his masquing, his fabrication of a false self to which he clung with ever greater vehemence. Not that the boy would have as yet thought things out in these terms, but he was accumulating the experiences that made possible the later concepts. (It is of much interest that the two greatest Londoners, Hogarth and Dickens, both in early boyhood lived in a debtors' prison.)

In April 1713 Richard published *New School Dialogues,* which had an unusual success, being adopted at St Paul's School. Things now seem to have been easier for the Hogarths, who lived in the house in Long Lane which

Mrs Hogarth kept on after her husband's death. (At the corner of the Lane was a boisterous rag market.) According to the family tradition Richard was callously treated by the booksellers, who did well out of his books and prevented his main work, a new dictionary, from getting into print. Later William explained why he turned to art rather than to a learned profession. Apart from natural talent: 'I had before my Eyes the precarious State of authors and men of learning. I saw not only the difficulties my father went through whos dependance was cheifly on his Pen, the cruel treatment he met with from Booksellers and Printers particularly in the affairs of a lattin Dictionary the compiling had been [the] work of some years.'

He considered that his father died 'of Illness occationd by partly the usage he met with from this sort of people', and partly 'by disappointment from great mens Promises'. Apparently patrons had failed to back him with subscriptions, and booksellers thought his project too ambitious or did not want to lose their profits from dictionaries of which they held the copyright. (Richard may well have done much more hackwork than we know of.) The emotions generated in William by his father's troubles played a strong part in developing his later attitudes to patrons and connoisseurs, to the print trade and the booksellers, to the whole cultural establishment. From the outset he was determined not to become a victim as he felt his father had been; and his resistances seem to have been helped by his inheriting his mother's combative strength of mind as a counterpart to the hopeful planning of systems which his father had ineffectively carried on.

On 2 February 1714 he was apprenticed to Ellis Gamble, engraver of Blue Cross Street, Leicester Fields, with the sign of the Golden Angel, who was somehow related to the wife of Edmund Hogarth. He was enrolled in the book of the Merchant Taylors' Company at the big hall (hung with tapestry of the patron John the Baptist) in Threadneedle Street. No record of a payment exists. William merely says that he was taken early from school, his father being too poor to do more than put him in 'a way to shift for himself'. Gamble, called the son of a Plymouth gentleman, was but a dozen years older than William, and had bought his freedom only in March 1713. Apprentices lived in the master's house, and William found another lad already there, son of a Westminster waterman; in 1717 they were joined by a young Fleming. Apprentices usually worked from 5 a.m. to 7 or 8 p.m., from mid-March to mid-September, with some two and a half hours off for meals; the rest of the year they worked the whole time of daylight. They got no wages, but were kept and instructed. Nollekens mentions that in these years he often saw William saunter round the Fields, 'with his master's sickly child hanging its head over his shoulder'.

So, from the age of sixteen to twenty, he was set to work hard at small heraldic designs on metal. Men like Gamble were specialists doing jobs for goldsmiths, engraving plate, watch cases, bookplates, jewellery, and the like. William, in the *Analysis*, remarks of sphinx, siren, griffin, centaur: 'These may be said to be monsters, it's true, but then they convey such noble ideas, and have such elegance in their forms as greatly compensates for their being unnaturally join'd together.' But 'he soon found that business too limited on every respect'. Apart from the narrow range of the designs, he felt very strongly the pull of the world around him and wanted to share in its amusements. His problem was to find a balance between studies and pleasures. Coming at a relatively late age to attempt the techniques of engraving on copper, he sought short cuts. 'The common methods were much too tedious for one who loved his pleasure.' He repeats this point often.

Wanting a quicker method than 'that usually taught by artists' and hitting on 'a Method more suitable to his disposition', he strove to make study and pleasure go hand in hand 'by retaining in my mind *lineally* such objects as fitted my purpose'. Again:

He never accustomed himself to coppy but took the short way of getting objects by heart so that wereever he was caught some things and thus united his studies with his pleasures by this means he was apt [to] catch momentary actions and expressions.

His need to make up for lost time and his desire to enjoy life in the fullness of everyday experience combined to drive him to his mnemonic systems; and these systems suited the deepest impulse in his creative outlook, the need to grasp forms in terms of movement. So what he felt as a limiting factor in his equipment was in truth the expression of his need to by-pass all the accepted systems of analysing and defining form, and to find methods whereby he might learn how to grasp 'the beauty of a composed intricacy of form', which may be said 'to lead the eye a kind of chace'. The impulse he felt towards his pleasures was in the last resort indistinguishable from his whole impulse towards art. It ensured that his art would be vividly entangled with the processes of living: not an intellectual construction, but somehow derived directly from a shared spectacle and experience, from the whole impact of immediate reality. This dynamic element was what separated his work from all previous expressions, in which the artist might have entered deeply, passionately, sympathetically, into the imagery depicted, but had not done so with quite this direct participation.

How far he was hoping for a fuller development as an artist in these early years, we do not know; but with his fervid temperament he must have been nourishing plans of some sort. He does, however, tell us that engraving on

copper 'at twenty was his utmost ambition', and it is likely that all along he was looking for some more satisfying use of his powers of draughtsmanship. In his resolution to combine somehow both studies and pleasures, he could defend to himself the need to drop his set work and let himself go in the streets, taverns, coffee-houses, even brothels, by the plea that he was learning all the while to memorize forms, gestures, facial structures and expressions. Not long after this period a friend saw him 'draw something with a pencil on his nail. Enquiring what had been his employment, he was shewn the countenance (a whimsical one) of a person who was then at a small distance. He was engaged in one of the tricks he used as part of the system of mnemonics we have discussed. Nichols says, while still an apprentice he set out one hot day with two or three companions for Highgate. In a public house they witnessed a brawl; a man hit another on the head with a quart pot and cut him badly.

The blood running down the man's face, together with the agony of the wound, which had distorted his features into a most hideous grin, presented Hogarth, who shewed himself thus early 'apprised of the mode Nature had intended he should pursue,' with too laughable a subject to be overlooked. He drew out his pencil, and produced on the spot one of the most ludicrous figures that ever was seen. What rendered this piece the more valuable was, that it exhibited an exact likeness of the man, with the portrait of his antagonist, and figures in caricature of the principal persons gathered round him.

While we may see nothing so comic in the picturing of agony, we may believe that from the outset Hogarth had developed his power of catching a likeness and of defining an expressive moment. Though in fact violence was not a theme that attracted him, there was also in his art at all stages an element of realism based on a determination to flinch from nothing, a joyous conviction of being part of the complicated scene enacted all round him. No doubt, never losing a chance to look in at the print shops, he had been stimulated by Dutch works such as those of Brouwer, Ostade, and Heemskirk, though he was never absorbed by the mere grotesque, the caricature.

Caricature was defined as a way of drawing that brought out the victim's faults so that the result was more true than the actual appearance. Addison writing on Detractors in the *Spectator*, remarked: 'From all these hands we have seen such draughts of mankind as are represented on those burlesque pictures which the Italians call Caricaturas, where the art consists in preserving, amidst distorted proportions and aggravated features, some distinguishing likeness of the person, but in such a manner as to transform the most agreeable beauty into the most odious monster.' William of Orange had been chief patron of the caricaturist and emblematist Romeyne de

Hooghe; and following him had come many Dutch or Flemish draughts-men and engravers. Steele in the *Tatler* says that a burgher of Amsterdam had sent him 'several draughts of humourous and satirical pictures by the best hands of the Dutch nation. They are a trading people, and their very minds mechanics. They express their wit in manufacture as we do in manu-script.' In 1710, when the uproar round Sacheverell produced many prints, the Tories insisted that caricature had only recently been brought in from Holland and was a political weapon of the Whigs. 'The Print is originally a Dutch talisman,' says one writer, who goes on to describe 'the magic power of the mezzotint' and the tortures inflicted by various grotesque designs. Satirical and grotesque drawing was thus considered to be bound up with the world of mechanics and manufactures, with Whiggery, with popular forces that outraged the traditional aristocratic world and its attitudes. Further, it was felt to have a talismanic and magic force. The Duchess of Marlborough in Brussels said to Bubb Doddington, fresh from Italy, 'Can you find me somebody that will make me a caricature of Lady Masham, describing her covered with running sores and ulcers, that I may send it to the Queen to give her a slight idea of her favourite?'

Indeed an element of magic persisted in early works of aggressive abuse, as in the Roman practice of *vituperatio*, where the furious language was felt to reduce the enemy to a sort of allegorical blown-up image of greed, treachery, and so on. In medieval forms the public enemy might be depicted hanging on the gallows on the façade of the town hall, 'and such hangings in effigy, as Kriss has reminded us, were still closer to witchcraft than they were to art' (Gombrich). Something of this emotion carried on through Hogarth's century, culminating in the baleful glare of Gillray's phantasmagoric images. Hogarth in *The Invasion* (2) shows the popular notion of caricature as a defiant and damaging act of aggression, where the grenadier paints on the wall the large image of the French king with gallows in one hand and sword in the other.

On 11 May 1718 Richard Hogarth died intestate. 'Widow Hogarth' took over in the ratebook and stayed some ten years in Long Lane, perhaps already arranging for the millinery business she ran later with her girls. William decided that he had been long enough an apprentice and that his place was back with mother and sisters. He ended his contract, apparently with Gamble's agreement. In 1728 he did a shop-card for him. By April 1720 he was back with the family 'near the Black Bull' in the Lane, and there he set up as an independent engraver. Hs issued his own card, the name and address flanked by figures of Art and History, with cherubs at the top. The design suggests that he already had ambitious plans. He himself tells us that

from his late start he despaired 'at so late as twenty of having the full command [of] the graver for on these two virtues', Care and Patience, 'the Beauty and delicacy of the stroke of graving chiefly depends'. Still, under Gamble, he had learned something of baroque forms and the new rococo curves. The use of signs and symbols had increased his sense of emblematic meanings as well as leading him to a careful filling-in of details.

Here then he was at last, at twenty-three, launched on the wider field of art; his immediate problems were to master copper engraving and to extend his control of forms. Engravers were in effect the employees of the print-sellers, who wanted capable reproducers of designs or paintings with techniques handed on from Marcantonio and Lucas van Leyden. At the same time they wanted to keep the engravers in economic subjection, 'squeeze and screw, trick and abuse', as Vertue said, though a few engravers advertised and sold prints from their own shops. The sellers were mainly interested in versions of Italian works, which would attract travellers or *cognoscenti*. But Hogarth must have already resolved that he wanted to be more than an engraver, however original. He must have been considering how to gain the skills needed for a painter, and no doubt he was trying out his hand now and then with paints.

Looking afresh at his concept of the image and the language of art, we may surmise that through his father he had known Comenius' method of teaching by word and image together, and the thesis set out by Bishop John Wilkins in 1688 in *An Essay towards a real Character*. There stress was laid on the image for the full conveying of truth. 'Natural characters are either the pictures of things or some symbolical representation of them'. The fusion of emblem or symbol and human character was aided by the wide reach of the term *Character* at this period. It could mean, as well as a trait or essential peculiarity of a person, a cipher, a letter of the alphabet, a digit, musical notation, any kind of ideogram or pictorial sign, a magical symbol. Already used to mean someone's report of a person's qualities, towards the middle of the eighteenth century it was applied to the persons in a novel or a play.

3 Masquerades (1718–24)

At first Hogarth was ready to do any odd job from silverwork to cards; but at no time did he engrave the work of other artists. He was interested in book illustration, and probably began in this sphere with seventeen designs for Butler's *Hudibras* (sold only in 1726). In this set and in other book illustrations of this time, we see much uncertainty and a reliance on earlier book work; but when he turns to his own world, original elements break through, as in the benefit ticket for the spendthrift actor Spiller (apparently of March 1720), which shows the debtor's prison and instruments of punishment for debt. Realistic elements are mixed with symbols (Fortune and her wheel, scales, the *auto-da-fé* round Spiller's feet). The individual case is generalized and given many overtones. A funeral ticket makes the ceremony symbolic, showing death as darkly cut off from life, with the mercer waving back the crowd who represent continuing existence.

He also tried his hand at etching, stimulated by the work of Callot and his followers, with its interest in popular elements, fairs, entertainments crowd amusements; he also was affected for a while by the elongated mannerist forms. A more lasting effect came from Callot's use of contrasting patterns, undulating *repoussoirs*: figures set in corners to deflect the eye into the main area of action. Callot depicted the unheroic confusion of everyday events; his series dealing with the Thirty Years' War was realistic. He was fascinated by the cruel spectacle that he sought to set down in its dishevelled truth, while a grotesque element linked him with men like Brueghel and Bosch. In turning to Callot, Hogarth recognized where his kinship in the art tradition lay. He too had the task of raising to a high level elements that had been largely consigned to the sphere of rough popular prints.

But what then of the world in which he seeks to find his feet as an artist and which he wants to define? After the confused tensions under Charles II and James II, 1688–9 had seen the triumph of the upper bourgeoisie. We see the first secure consolidation of the bourgeois state, with much commercial and banking expansion, and with the effective working out of a state bureaucracy, especially in the Treasury. From 1714 to 1742 Walpole was prime minister, controlling what was in effect a one-party system. Even when he went, Whig ministries ran the country, under Carteret, the Pelhams, and Pitt, a descendant of East India merchants. More and more merchants entered Parliament; by 1761 there were some fifty London merchants there, with at least thirty-seven of them doing extensive business with the government. Not till the accession of George III in 1760 did things change and the conflict of Tories and Whigs take on an effective force. Hogarth belonged wholly to the period when the new state was emerging, with vast corruption, and there was no sign of conflicts that could change the situation, no sign of new forces coming up to challenge things. These points are of extreme importance for the understanding of his mind and art.

There soon came about an occasion that deeply stirred his judgement of this world. In 1720 a financial crisis was brought about by the frantic greed and credulity over investments, which the unstable expansion had induced and which in England was centred on the South Sea Company. That company even took over the national debt. The most fantastic projects found ready investors. Prints from Holland satirizing the mania reached London by spring 1720, to be adapted and copied. Hogarth's print stands alone for subtlety and force. Drawing on Callot, he bases his symbolism on Fortune's wheels: the merry-go-round of delusion, the torture-wheel of nemesis, of reasserted reality. The Church as a source of corruption and of self-righteous pretences is singled out. St Paul's at the back with its cross is dwarfed by the Goat (which displaces the Lamb) and its motto: *Who'l Ride?* The clergy (Roman Catholic, Puritan, Jew) cast coins for Christ's robe or sanctify his scourging; on the wheel a divine rides with a whore. The doggerel verse, almost certainly by Hogarth, stresses the role of religion in demoralizing men. 'So much for Monys magick power.' Villainy removes his mask; an ape with a gentleman's sword wraps himself in Honour's robe. Women invade a house: 'Raffleing for Husbands with Lottery Fortunes in Here.' The one honest man is the scourged victim. We might say that this man, the common man who is outside the sphere of money and power, is subjected to the indignities or cruelties suffered by Christ. Religion as an institution is mocked; its imagery is used for a deep-going and passionate critique of the way that men are crucified by an unjust and corrupted society.

There is, further, the general symbolism of the whirligig of life; Hogarth recalls a Dutch print, *The Actions and Designs of the World go round as in a Mill*. But we can instructively compare with his *Scheme* the extended fantasy indulged in by Lovelace in *Clarissa* which, remembering Hogarth's print, uses the country fair as an emblem of the chase of love, its excitement, the swing of seduction. Here the flying horses and flying coaches are the 'one-go-up and other-go-down picture-of-the-world vehicle' – with the cry: *Who rides next?* The demoralizing whirl reaches its delirious point where the girl throws herself out of the coach, like the figure falling from the sky in Hogarth's *Southwark Fair*. Richardson, like Hogarth, is the inheritor of the whole puritan tradition of the emblem, and, in part learning from Hogarth, he too uses the emblem both for incidental comment or explanation and for a broad symbolism permeating the whole of a scene.

The emblem then has elements of both allegory and symbolism; and we need to understand something of the tradition that Hogarth is resuming if we are to understand his art. He himself called the *Scheme* an *Emblematical Print*; and throughout his work he makes use of emblems in the dual sense mentioned above. Every human scene, if deeply enough penetrated, has a meaning, a point at which the narrowly personal aspects merge into something greater than themselves, into some universal system of values and significances. And all the objects that man has made, all the aspects of the earth which he inhabits and transforms, have an active relation to him, are in some sense a fragment, a reflection, or a crystallization of his being, his needs, and his aims. In reflecting him, they either aid or hinder his self-realization, his movement as a human being. The idea of the emblem or symbolic object which, if grasped truly and deeply, provided a clue to man's destiny, had a long history, both learned and popular, and had played a potent part in the dissenting tradition to which the Hogarths belonged; and it was inevitable that Hogarth, seeking to interpret reality as both a composed intricacy of form and as a human scene tensely alive with meaning, would carry on that tradition while at the same time secularizing it and using it to create a pervasive dramatic tension in his works.

There was a feeling that the object in its symbolic nature had some fascinating power over men, an animist energy which could surge out and affect or control them – just as the caricature, by reducing a person to his crudest form, his sheer essential nature, was felt as dangerous exposure. The dissenters tried to rob the emblematic object of its malign force by moralizing it, by making it a vehicle through which warnings and exhortations from on high could be addressed to men, making them aware every moment of the

day of the snares and pitfalls about them, and of the need to free themselves from the pull of earthly things. In the emblem books a drawing was essential, with explanatory verses and biblical texts added, to make men realize the nature of the deadly temptations crowding around them. Seventeenth-century fables such as those of La Fontaine were closely akin to the emblem; they too consisted of a drawing with verses, were set out similarly, and drew on common sources for inspiration. Hogarth was thoroughly soaked in the emblem tradition, but he used the emblem in his own way, to make an emotional, moral, and aesthetic unity of each scene or situation. He always insisted that his prints embodied 'what cannot be conveyed to the mind with such precision and truth by any words whatsoever' and that 'ocular demonstration will convince and improve men sooner than ten thousand Vols'. In making such claims he was following the emblematic tradition. In the thought of the sixteenth and seventeenth centuries there was a strong strain based on the Neoplatonic idea that the eye was the noblest organ in man, so that an appeal to it was greater than the effect of verse on the ear. Thus in 1660 the Abbé d'Aubignac stated: 'The eloquence of images engraves better the truth in the heart than that of words, because its impressions are more lively, stronger, and last longer than simple reasonings.' The dissenters held the same views.

The reading of pictures as emblems was deeply rooted in the period; and only if we realize this point can we feel the cogency of much of the analysis of Hogarth's pictures as made up of objects with a definite significance in relation to his theme. Otherwise the analysis must seem fanciful and forced, whereas in fact the concept of the emblem lies at the heart of Hogarth's creativity, a popular concept despite the learned uses made of it. On the learned side there was the Painted Enigma made much of at Jesuit colleges: a sort of allegorical charade, which led to such odd interpretations as that of Christ's Resurrection as an Exploding Mine or that of Lazarus as an Emetic. Baroque art was much affected, and this sort of analysis was made of past artists like Raphael or Poussin. The Enigma shaded off into the Allegory proper, as expounded by Le Brun in 1671. Poetry and painting please us, said Menestrier in *L'Art des emblèmes* (1684), 'because not only do they instruct us, but they also make us think, seek inside ourselves, and dig in our spirits to discover all the mysteries that they cover'. Hogarth fully agreed with this position. The revelation of hidden meanings was part of the aesthetic pleasure involved in the creation or enjoyment of significant form:

Curiosity is implanted in all our minds and a propensity to searching after, pursuing and surmounting, difficultys, by which means most things usefull and necessary are and have been attaind and the difficulty, of obtaining often

enhauncis the pleasure of the pursuir and makes it a sport. . . . It is a pleasing labour of the mind to unfold mystery Allegory and Riddles . . . With what pleasure doth the mind follow, the well connected thread of a play or Novel, which ever encreases as the Plot thickens, and ends, when that's disclos'd the Eye had this sort of enjoyment in winding walks and Serpentine Rivers.

The emblematical image could be taken seriously as a dangerous power. Thus Henry Stubbe in *A Further Justification for the Present War* (1673) insists that a Dutch print showing England defeated has had alarming effects. 'By these Artifices not only the Merchants of England have been discouraged in their Trading, the foreign Princes alienated from her, and their Subjects induced to believe that the English were so odious, so detestable a People, that they deserve not to be considered in place of Commerce.' Congreve, in *Love for Love* (1695), shows the game with emblems as a part of fashionable wit: 'I have some hieroglyphicks too; I have a lawyer with a hundred hands, two heads, and but one face,' and so on.

The emblem had immemorial roots; in the forms we are considering there was still a strong medieval basis. Hogarth shows an odd fusion of opposing attitudes. He sums up, completes, and secularizes a medieval tradition; yet he is the first artist to look directly at the contemporary moment without imposing preconceptions on it. After him only one important artist returns, though from a different angle, to the emblematic outlook: Goya. Goya used the proverb, the enigmatical saying, the popular and learned symbol, while marrying these elements to a powerful realism. As with Hogarth, the emblematic element is transformed, given a new and urgent application to reality, to immediate experience. Only by holding fast to these points can we enter Hogarth's world and pass beyond the superficial view of him as a social commentator.

He does not seem to have issued the *South Sea Scheme* in 1721; perhaps he worked so hard on it that he did not finish it till interest in the disaster was waning. He was busy on a companion piece, *The Lottery*, and probably did not issue the pair till 1724. *The Lottery* has much the same moral as the *Scheme*, but without such tumultuous energy. Its interest lies in the stage setting and the allegorical treatment. At the centre is Suspense on a turnstile, which Fear and Hope take turns at working. Misfortune on the left has drawn a blank, but Minerva indicates the way out: Industry with beehive and spinning wheel, and so on, with Sloth, Fraud, Despair, Folly, naked Pleasure, Fame, and a Philosopher. In composition and the stage figures Hogarth is thinking of Raphael, but at the same time of John Rich's pantomimes. The

illusions setting up money madness are linked with the theatrical assumption of a character not one's own. A ceaseless choice faces men.

During these years Hogarth must often have been hard up. An obituary tells us:

I have often heard from an intimate friend of his, that being one day arrested for so trifling a sum as twenty shillings, and being bailed by one of his friends, in order to be revenged of the woman who arrested him (for it was his landlady,) he drew her picture as ugly as possible, or, as Painters express it, in *caricatura*; and in that single figure gave marks of the dawn of superior genius.

Nichols cites another friend as saying that, if the episode had happened, Hogarth would have often retailed it, 'as he was always fond of contrasting the necessities of his youth with the affluence of his maturer age'. But, knowing how reticent he was about his father's gaoling for debt, we may rather believe that he would not have revived an episode which touched on a matter so deeply buried by fear and shame. Another friend recalls him as saying:

I remember the time when I have gone moping into the City, with scarce a shilling in my pocket; but as soon as I had received ten guineas there for a plate, I returned home, put on my sword, and sallied out again with all the confidence of a man who had ten thousand pounds in his pocket.

That statement certainly seems to express the spirit of his early years: hard struggle, steady application, then the need to fling himself into the life brawling about him. Like the Poet in his 1737 print, he had sword and wig, ready to transform him into a gentleman of leisure.

He was eager to draw objects 'something like nature instead of the monsters of Heraldry'. His sense of the many difficulties he had to face, together with the business acumen he had always shown, brought him from the outset to a position of antagonism to the ruling set-up with its idealization of Italian art by dealers and collectors. Native talent seemed to have no serious role; and this fact was particularly galling to a young Englishman who in his twenties was assessing the situation and working out a strategy for developing his art skills and reputation. There was however one English artist to whom he could turn as his exemplar, despite differences in outlook. James Thornhill had mastered the grand manner of baroque decorative painting and was accepted as a practitioner of history, generally esteemed the highest form of art. Born in July 1675 or 1676 of impoverished Dorset gentry, he had come to London, become apprenticed under the Painters-Stainers' Company, and, on gaining his freedom, had won the most import-

ant commission in England: the decoration of the Great Hall of Greenwich Hospital. A capable courtier with a good business sense, he next got commissions for painting the Prince of Wales's bedroom at Hampton Court and the cupola of St Paul's (defeating two Italians and three Frenchmen). Knighted in 1720, he bought back the family seat and in 1722 was MP for Melcombe Regis, in 1723 a Fellow of the Royal Society. Here was the model that Hogarth could set before himself. Even as apprentice the latter had 'the painting of St Pauls and Greenwich hospital' running in his head.

In May 1720 the set of engravings after the St Paul's paintings were sold by subscription. Hogarth could hardly then have afforded to buy them, but he would have studied them in shops and dreamed of sets of his own. Thornhill used allegory at Greenwich and was interested in Raphael, but his strong point was his harmonious Venetian colouring. Only in a general way would Hogarth want to emulate him. He had twice attempted to start an academy, but had failed. The breakaway group, under Vanderbank, set up a new academy in Peter's Court off St Martin's Lane, which Hogarth joined. Instruction was along conventional lines. The student turned to nature only after drawing idealized statues; he made copies from books of eyes, noses, and so on, before trying outlines of the whole body. Such a method was contrary to all Hogarth's ideas and instincts; but he wanted to draw from the model, pick up hints about painting, and feel himself part of the higher art world. In later notes he says that he left Gamble because he was 'desirous of appearing in the more eligable light of an History Painter or engraver', and he repeats his objection to copying, since then, 'as the Eye is often taken off the original to draw a bit at a time, it is possible to know no more of the original when the drawing is finish'd than when it was begun'.

From the outset he argued with other students about his ideas. They used the approved methods for twenty years 'without gaining the least ground, may some have gone rather backward in their study'. On the other hand:

If I have acquired anything in my way it has been wholy obtain'd by Observation by which method be where I would with my Eyes open I could have been at my studys so that even my Pleasure became a part of them, and sweetned the pursuit. As this was the Doctrin I preach'd as well as practis'd an arch Brother of the pencil gave it this turn That the only way to learn to draw well was never to draw at all, in short these notions as they clash'd with most of the commonly receiv'd ones of the school drew me into frequent disputes with my brethren on which as the torrent was against me I seldom got the better of the argument.

Still, 'several availd themselves of the doctrines they so warmly opposed'.

He sought to simplify forms, to find a few basic lines from which memory

could build up the rest. To draw face or gesture on a fingernail involved drastic simplifications. We hear of his interest in a picture of St George and the Dragon in three lines. Few sketches of his have come down, only a few life-class drawings and direct impressions of friends, the kind of thing stuck up on tavern walls as a joke. Most of his extant drawings were made as preparations for engravings. Though he could not have aimed at carrying on Thornhill's type of work and for some time must have been unclear as to just what he meant to do, he was thinking all the while of history painting, but not of the accepted kind:

It may be easily conceived it was natural for me to make use of whatever my Idleness would suffer me to become possest of moreover I could not help thinking this way of painting might one time or other become in better hands more usefull and entertaining in this Nation than by the Eternal proposition of beaten subjects either from the Scriptures or from the old ridiculous stories of the Heathen gods as neither the Religion of the one or the other requires promoting among protestants . . .

Indeed, once confirmed in his method of memorizing forms, he could not but be drawn into depicting scenes from the life surging round him. But because he could not satisfy himself with genre pieces, he had somehow to fight for the acceptance of the contemporary scene as history. His whole career was the working out of this problem.

Among the students was John Ellys, a leading dissectionist, whose demonstrations and lectures no doubt provided the knowledge of physiology shown in the *Analysis*. Artists often attended dissections. Burke wrote to Barry: 'Notwithstanding your natural repugnance to the handling of corpses, you ought to make the knife go with the pencil, and study the anatomy in real, and if you can in frequent dissections.' At Ellys's classes Hogarth would have been led to brood on the inner systems displayed by dissection and flaying; his interest in forms in movement did not preclude a concern for structure and organic functioning. The *Analysis* mentions a plate made by Cowper for the *Myotomia Reformata* of his friend Hoadly, the physician. One of his own figures represents 'the manner in which most of the muscles (those of limbs in particular) are twisted round the bones', and he compares 'the running of their fibres' to 'skains of thread, loose in the middle, and tight at each end, which, when they are thus consider'd as twisted contrary ways round the bone, gives the strongest idea possible of a composition of serpentine-lines'. He carries on this analysis at some length and advises the reader to study a good anatomical figure.

Note how he turns to weaving, a work process, to clarify the image of bodily functioning, seeking for analogies between natural and productive

processes, for the clue to fundamental structures and formative energies. He also deals with the layers of skin in the same sort of way. 'The cuticula alone is like gold-beaters-skin'; the blood vessels lie under it, 'as throuth Isinglass, were it not for the lining the cutis, which is so curiously constructed, as to exhibit those things beneath it which are necessary to life and motion, in pleasing arrangements and dispositions of beauty.' The cutis is 'composed of tender threads like network, fill'd with different colour'd juices', which, 'together with the different *mashes* of the network, and the size of its threads in this or that part causes the variety of complexions'.

But with one part of his mind Hogarth rejected dissection, perhaps linking it with the mechanical or idealizing methods of the academies that produced dead or unreal forms. Dissection appears as the perfect reflection of the inhuman mechanisms of society which can organize for purposes of death but not for those of life. There is here an ambivalent attitude to the science of his world, felt intuitively but not worked out, as something revealing the organic nature of life, yet murderously reductive. The important point is that it was as a *process* that he recognized reality. Form involves movement; movement is not something merely mechanical; the tensions that concern him are those of organic life and process. So he sees a deep link between organic life, work process, and art activity.

An art academy in his view should then consist of persons seeking one way or another to bring out such links. But he soon found that the academy of St Martin's Lane included an arch-enemy, William Kent, recently returned from Italy at the age of thirty-six and typifying all that he most detested: the uncritical obeisance to idealizing art, the elevation of Italian over English art, the alliance of mediocre artist and powerful patron to maintain 'the Eternal proposition of beaten [hackneyed] subjects'. Kent, starting in Yorkshire as coach- and house-painter, had the trick of ingratiating himself with the gentry; he was sent to London, then to Italy, where he got on well with young nobles on the grand tour, especially the Earl of Burlington. Back in England, he settled in Burlington House, the new Palladian mansion in Piccadilly, where he painted decorations while the earl pushed him at court. 'Courtiers,' says Vertue, 'declared him the best History painter – and the first that was native of this Kingdom.' Pope and Gay supported him. Inevitably he clashed more and more with Thornhill. An inferior artist, he had stronger backing and steadily ousted him.

The Burlington group, the Palladians, saw themselves as patrician Romans. Walter Moyle started off the comparison of England with Rome, seeing it as inheritor of the ancient power and empire, and stimulating Montesquieu into his work on the Romans. Pope took up the theme,

describing Burlington as the type of Roman public benefactor, restoring Roman virtues. The Palladians were the enemies of the national tradition, of Wren and Hawksmoor, whom they saw as antiquated purveyors of baroque and even Gothic. In 1718 Wren lost his post as Surveyor General and Hawksmoor his as Clerk of the Works. Hogarth must have been angrily watching these events. Most likely he already knew Thornhill. In February 1724 he issued his print *The Bad Taste of the Town* (usually called *Masquerades and Operas*). Now he had considerable success; the print was pirated and re-issued. He returns to the crowd effects of the *Scheme* and attacks the forms of entertainment used to lead people astray, echoing old complaints of Tom Brown and Steele. The crowd rush to see the conjurer Fawkes, pantomimes, harlequinades, Heidegger's midnight masquerades, Italian opera; an old woman trundles off the works of the national poets as waste-paper. Hogarth is not attacking popular shows as such. In the *Analysis* he writes of the roars of laughter when the audience 'see the miller's sack, in Dr. Faustus, jumping cross the stage'. What he attacks are the aristocracy, the art patrons who in his view have perverted taste and confused values. In the centre at the back is Burlington House; its gate, topped with a statue of Kent, at whose feet lie enslaved Michelangelo and Raphael, is closed to the populace and represents the élite. Nobles with their ladies push into the pantomime show, while grenadiers guard the theatre doors to show royal approval and the intrusion of the state. A satyr devil leads into the masquerades, waving £1,000 (the sum given by the king to Handel's company and the prince to Heidegger). Italian opera stars were being courted by nobles; Burlington had Handel in his house and was main sponsor of his company in 1719. Hogarth shows nobles on a signboard paying homage to Italian singers; and with uncanny prescience he inscribed Burlington House as the *Accademy of Arts*.

We still see Callot's influence in the street scene and the satyr devil. Hogarth gains the power to depict crowds as if he were both on their level and looking down into them. We are reminded of the letter of Sir Robert Southwell in 1685 to his son on Bartholomew Fair, advising him to get up 'into some high window, in order to survey the whole pit at once. I fancy then you would say – *Totus mundus agit histrionem*, and you would note into how many various shapes human nature throws itself' – a market for buying cheap and selling dear, which becomes 'a sort of Bacchanalia'. The ultimate masquerade is that of the people themselves, lured and gulled into all sorts of illusions, pretences, false selves. Their clothes become their controllers. Swift had given this sort of viewpoint a cosmic dimension in *Tale of a Tub* where the universe is held 'to be a large suit of clothes, which invests everything . . . What is man himself but a micro-coat, or rather a complete

set of clothes with all its trimmings? . . . Is not religion as cloak?' And so on. 'Suits of clothes are in reality the most refined species of animals; or, to proceed higher, they are rational creatures, or men.' Smollett draws the moral that clothes make the man when his Peregrine takes a common gypsy girl, dresses her in fashionable clothes, gives her some talking lessons, and passes her off as a fine lady.

Hogarth, now at last a known figure, used the press to advertise his print and attack the piracies. He had thus early learned the value of public advertisement. In later notes, dealing with the bad treatment of his father, he says that he learned the lesson by publishing his print on his own account and promptly coming up against the 'monopoly of Printsellers equally distructeve to the Ingenious'. He was brooding over the situation on the lines he set out later when he began working for a Copyright Act for prints. Artists built up their skills and reputations, but lacked places to display their work. The printsellers got together, reached agreement, and so oppressed and kept in their power 'the very Men, without whom their Shops would soon become unfurnish'd'. First the engraver took his print to the seller who insisted 'upon a most unreasonable Share of the Profits for selling the Prints, near double what a Bookseller ever demands for publishing a Book. It is in vain for the Artist to remonstrate, or try any other Shop. They are all agreed, and no less is ever taken. So of Consequence he must submit.' Next, when the seller found a big demand for a print, he let cheap copies be made, which he sold as originals or sent into the provinces where there was less chance of comparing them with the originals. When the artist asked about the sales, he was told that the work had been copied and that the copies had sold as well as the originals, of which very few had been sold. He was 'presented with a large Remainder', which he was forced to take home. Hard up, he then had to sell his own prints back to the sellers as he had no other way of disposing of them. In despair he gave up attempting 'any thing New and Improving'. He bade farewell 'to Accuracy, Expression, Invention, and everything which sets one artist above another', and settled down to a role of mere drudgery.

Thoughts of this kind must already have been in Hogarth's mind. The addition of his address, the Golden Ball in Little Newport Street, to a later stage of *Masquerades*, may mean that he took back stock and tried to dispose of it himself before being forced to sell the plate. The address shows that he had left his mother's house and was living on his own. He had spent the first half of his twenties in finding his footing in the art world, in making a start as a book illustrator, and in striking out with a few satirical prints that revealed an artist with an original bent of mind. There was, however, still little indication of the scope, variety, and force of his talent. What he had

done was to absorb thoroughly the emblematic tradition which was still alive in the popular print; and all the while he was building up his memory-store of forms studied and grasped in terms of living tension and movement. He was steadily laying the basis on which he was soon to build powerfully.

4 Hudibras and Macheath (1724–7)

On 11 May 1724 came a solar eclipse, and Hogarth issued his *Royalty, Episcopacy and Law, or Some of the Principal Inhabitants of the Moon*, suggesting what people would see if they had good enough telescopes. He used a Swiftian fantasy with the emblematic method of constructing people out of things. The king has a guinea for head; the bishop, a Jew's harp; the Judge, a gavel. The harp's tongue is worked by a pump handle (shown as a church tower); the Bible-wrapped handle rings the steeple bell and pours coins into a chest stamped with the bishop's crest: knife, fork, and spoon under a mitre. His left foot has a cloven hoof. The courtiers and chamberlains are made up of fire screens, glasses, candlesticks, keys; a dinner-bell lady-in-waiting has teapot for head, drinking glass for neck, fan for breast. Wherever men may look, they will see money, greed, hypocrisy, dehumanized power, people turned into things.

Soon afterwards came *The Mystery of Masonry*, dealing with a breakaway group of Freemasons suspected of Jacobitism. In a processional scene an old woman on an ass has her bare bottom kissed, while Sancho Panza and a Drawer laugh: figures copied from Coypel's design of Don Quixote attacking the puppet show. The woman on the ass seems suggested by the mystery-image of Isis carried by the ass in Apuleius. Thornhill had been an early mason, and Hogarth became a member by 27 November 1725. How far he was interested in masonic symbolism and how far it stimulated his sense of allegory and emblem, we cannot estimate; but we may recall that Christopher Smart was a mason and that his masonic interests certainly played an important part in the remarkable outburst of symbolic correspondences in his *Jubilate Agno*.

To grasp the full force of *Royalty* and *Masonry* we must realize how the years after the demoralizing South Sea Bubble were calculated to deepen Hogarth's critical sense. The Layer and Atterbury court cases, bringing to light much conspiratorial activity, produced considerable panic in the government, and many repressive measures. In 1723 Habeas Corpus was suspended; dozens of arrests were made for seditious acts, including the publication of pamphlets. There was a heavy increase in indictments for riotous behaviour. Outside London there were the violent protests and depredations of the Waltham Blacks, covering much of Berkshire and Hampshire, and leading to the Black Act which established capital punishment for several dozen trivial offences. *Royalty* depicts emblematically the truth under the pomp and pretences; *Masonry* declares that the people are not deceived – Sancho and the Drawer see the act of mumbojumbo homage for the degradation it is.

The St Martin's Lane academy was in trouble. It lasted a few years, Hogarth said, 'but the treasurer sinking the subscription more, the lamp stove etc were seized for rent'. Vanderbank, badly in debt, left for France with his mistress; in October he was back, married but living in the Liberties of the Fleet. In November Thornhill took advantage of the situation to set up an academy in his Covent Garden house, exacting no fees – 'to do service and credit to our King and Country'. But the venture failed. Many artists were now living in the area, and Hogarth would certainly have joined the new academy. Thornhill had his convivial side; Prior described him as owning 'a Brownish Complection, a lover of drink'. By now Hogarth no doubt knew his son John, with whom he was soon friendly, and Jane the daughter. He himself was a short cocksure young man with sarcastic lip and jutting chin, and with a scar on one side of his brow. He was making progress with his painting and had shown himself a satirist to be reckoned with, but he still had only a very small place in the art scene. He had gained a wide knowledge of Italian, French, and Dutch art through engravings, with some slight acquaintance of originals or good copies through coffee-house auctions or collections such as that of Thornhill, in which were works by Rubens, Poussin, Caravaggio, Veronese.

The English tradition was still a narrow one, mainly based on portrait painters like Lely, Kneller, and Jervas, who tried to build on Van Dyck's work. They used a stereotyped style of beauty or dignity for sitters, and had high opinions of themselves. Jervas, making a copy of Titian, exclaimed, 'Poor little Tit! how he would stare.' Theory exalted the ancients and the old masters. So deeply ingrained was the idea that no English artist could attempt history that as late as 1760, when West produced a history painting, the

nobles would not come to see it, but had it sent round. One collector who admired it was asked why he did not buy. 'What could I do, if I had it? You surely would not have me hang up a modern English picture in my house unless it was a portrait?' What hope had a painter like Hogarth, driven ever more to tackle the contemporary scene in full seriousness?

He had already arrived at a mature judgement of his world. The cash nexus was driving out all other relationships; money with its 'magic power' had bewitched people. No one was content with his 'natural self' but wanted to assume a character more imposing, fashionable, glamorous. Life was one long masquerade of lies, falsities, pretences, in which the person making a wrong step was at once trampled down. The common folk were the victims of the upper classes, who set the tone and moral values; they were fooled by a Church that had sold out and become the tool of power and greed; they were ruthlessly held in their place by the state and its law. Yet those on top were even more distorted than those below who tried to imitate them.

An integral part of the cheating system was an idealizing art, whether it turned to neoclassic heroics or let itself go in operatic displays. Yet, bursting through the vicious circles, there was a magnificent human energy which could somehow be turned to better ends. So Hogarth is never a mere middle-class moralizer, a denunciatory satirist; he is also fascinated by the spectacle of restless human activity, of which he feels a vital part. He attacks and acclaims in the same breath, with the same brush stroke. Life is holy, in Blake's sense, and life is also corrupted. Things would be easy if one could separate the holiness and the corruption into separate compartments; in actuality they continually merge and modify one another without losing their opposed realities.

These attitudes were not the result of passing whims or random intuitions; they were integrally present in his art from start to finish; they developed but did not shift from their original bases. His social views cannot be separated from his artistic views, from his emblematic outlook, and were derived in part from his own experiences and the family tradition, in part from certain books. He had been much influenced by watching the struggles and disasters of his father; and every day in London must have brought a person of his fervid yet critical intelligence into contact with people and events that strengthened his convictions. But he needed certain forms of thought, of moral as well as artistic analysis, before his experiences could be controlled, understood, drawn together in a coherent set of values. The emblematic outlook we saw, had its links with dissent, and the Hogarths had a Presbyterian background. All events or objects affecting a man were felt to be loaded with providential or satanic force that had relevance to his destiny,

helping him forward or snaring him in evil. At every moment a man was environed with forces about which he needed to be wary; at every confrontation he had to make deep choices. Hogarth took over this attitude, but secularized it. What gave powers for good or evil to objects, events, people, was the social essence incarnated in them. Puritanic self-examination, liable to breed its own kind of hypocrisy and self-deception, had its positive side, a strong sense of the ways in which men lied to themselves in order to find pretexts for conforming with the world and its demands. Daniel Dyke's tract, *The Mystery of Self-Deceiving*, later stirred La Rochefoucauld and helped to form his method of dissecting folly and self-deception.

Besides hearing Presbyterian sermons in early years, Hogarth must have known Bunyan's *Pilgrim's Progress*, which dramatically sets out the idea of man's life as movement along a narrow path between heaven and hell. He took over the term *Progress* for his own two first series, though dealing with the downward movement. He clearly knew Swift's work well, especially the *Tale of a Tub* and *The Battle of the Books* (1704). Passages like the following, which ridiculed the multiplication of the Virgin's Milk and of pieces of the Cross, would have stimulated his irreverence and his sense of homely symbolism: 'One time he swore he had a cow at home which gave as much milk at a meal as would fill three thousand churches; and what was more extraordinary, would never turn sour. Another time he was telling of an old sign-post that belonged to his father, with nails and timber enough to build sixteen large men of war.' Textbooks like *Tabula Cebetis* helped in the secularization of the *Pilgrim's Progress*. In part, through the lack of anything like genuine political struggle throughout most of his life, he felt ever more driven to probe the social scene, the individual existence, for any kind of sign revealing a deep conflict of good and evil; otherwise he would have felt hopelessly stifled. The emblematic approach helped him to make sense of the details of a scene as well as to impart an overall meaning.

He was also much affected by Defoe, though he does not refer to him. In Defoe we find the same sense of rich and complex energies stirring in the common folk, together with a counter-sense of the dehumanizing effects of money. In his publicist works Defoe ardently supports trade and property at all costs; in his stories he shows the real conflicts going on deep down. In *Moll Flanders* and *Roxana* he brings out the ceaseless clash of human values with the cash nexus, and links dehumanization with the desire to rise in the world and imitate the upper classes. Money, the ostensible cementing force in the new social situation, is shown as destroying all natural piety or union. 'The same flourishing of pride has dictated new methods of living to the people; and while the poorest citizens strive to live like the rich, the rich

like the gentry, the gentry like the nobility, and the nobility striving to outshine one another, no wonder that all the sumptuary trades increase.' He repeats this sort of lesson throughout *The Compleat English Tradesman* (1725, 1727) in the years when Hogarth was maturing his art and its ideas.

Another writer who did much to determine Hogarth's attitudes in his formative years was Butler and his *Hudibras*. Here was a sustained attack on the old heroic ethos, which Hogarth identified with idealizing classical art, with history painting dedicated to glorifying kings, wars, aristocratic values. Butler ridicules and degrades military prowess in his account of Talgol the butcher, who carries on the same noble trade as demigods and heroes: 'Slaughter, and knocking on the head'. His Notebook shows how clear he was in his aim:

Heroicall Poetry handle's the slightest, and most Impertinent Follys in the world in a formall serious and unnatural way: And Comedy and Burlesque the most Serious in a Frolique and Gay humor which has always been found the more apt to instruct, and instill those Truths with Delight unto men, which they would not indure to heare of any other way . . . A Satyr is a kinde of Knight Errant that goe's upon Adventures, to Relieve the Distressed Damsel Virtue, and Redeeme Honor out of Inchanted Castles, and opprest Truth and Reason out of the Captivity of Gyants or Magitians.

Thus he sees Comedy, if sufficiently aware of its aims and possibilities, as taking over the role of a true heroic art. In the same way Hogarth saw his comedic works as the true contemporary history painting.

The main target of *Hudibras* is Hypocrisy, which is seen both as a conscious falsification and as a sort of crazy delusion. Through it man has so warped his sense of reality that he continually transposes the truth into illusion and uses the illusion in order to carry out a ceaseless assault on reality, seeking to impose his own falsifications and fantasies upon other people. It thus becomes the false face of consciousness, twisting the truth of things in order to justify an individual or a class in doing evil, in grasping at power. There can be no doubt then that *Hudibras* fortified Hogarth at a crucial phase of his development, convinced him that he was on the right track, and provided him with much of the primary basis from which he launched his attack on the world.

His frontispiece to the poem shows a *putto* (child) sculpting a relief in which a satyr lashes Hudibras and Ralpho, who draw his chariot and are yoked to the scales of justice. They are going round the foot of Mt Parnassus and lead the procession of Hypocrisy, Ignorance, Rebellion. The poem itself, held by a second satyr, is the model used by the *putto*, while on the other side ideal Nature, as Britannia, looks at her own face in a mirror. She thus represents

the true 'natural self', perhaps identified with common life, which is opposed to Hudibras's hypocrisy and delusion.

One aspect of Hogarth's meaning was clarified by related designs of Vanderbank and Highmore. Vanderbank explained the meaning of his frontispiece to Carteret's *Don Quixote*. Parnassus is held by the 'monsters and chimeras of the books of chivalry' (Hydra and Dragon or Python); on the right at the top a country gentleman (? Cervantes) drives them away. Hercules leads the Muses on their way to take back the heights, and is met by a satyr who gives him a mask 'representing the humourous nature of our author's performance', and implements for accomplishing his end – those of raillery and satire. Highmore, in a frontispiece thrice repeated, for Samuel Croxall's *Select Collection of Novels and Histories* (1729), also shows Parnassus; Cervantes in the foreground has presented his book to Apollo; the monsters are gone; the Muses and Parnassus hold the heights. We see then in both Vanderbank and Highmore, friends of Hogarth, the theme of the supplanting of the art monsters, divorced from reality, by the new art of deep-going satire: what Dr John Oldfield, whom Vanderbank addressed, called 'just and natural writing'. Hogarth's clearing of the ground is making possible the novels of men like Fielding.

In *Hudibras* there is a villain, the prime source of hypocrisy and delusion, but no hero. His opponents are as much astray as he is from true human values. (Only the Lady does not come under this judgement, but she represents nothing positive.) And yet there is a vigorous element of hopeful energy in the poem. 'Where else in English literature of this period do we find so full an awareness of the nature of everyday life, of the popular diversions and amusements, of the rich store of proverbial wisdom, of the traditional balladry?' (Wilding) Similarly through Hogarth's work runs a condemnation of the corrupt world dominated by delusions (with money's magic at the core), and at the same time a joyous sense of the inexhaustible wealth, the exciting diversity, of life, which manages to assert itself despite all the distortions.

In his world, however, certain tendencies, which Butler sought to link with one particular strand of contemporary life, had spread out and become general, undergoing many changes in the process. We noted how, after 1688, there was a rapid maturing of the first stages of the modern state. The Tories, in so far as they were based on the country gentry, might criticize the vast increase in patronage and money corruptions, but when in power they behaved just like the Whigs. There was no real political conflict. So Hogarth, an artistic revolutionary who for the most part condemned the main trends of his day, yet lacked all political attitudes or ideas. He assumed

that political change had no point, that the system was stable in its network of corruptions and power balances, and that any serious disturbances could only be the work of faction or treason.

With regard to *Hudibras* we may note further how the method shows affinities with some aspects of the emblematic print. There is no normal characterization; instead there is endless digression, discussion, new per-ceptives. The knight is built up out of jests, witticisms, concepts; at times he is lost in the lively confusion of elements that go to make him up, or in a generalized pattern. He is a person, a type, a collection of disorganized oddments, in a rapid change of angles of vision. We are reminded too of the kind of popular print in which many instances of some general idea or character are linked in what seems a chaotic series, with such unity as exists emerging from the recognition of common elements in diverse and random phenomena.

Hogarth did seventeen small prints and then twelve larger ones for the poem. The latter were circulating by February 1726; the book with the smaller set appeared in late April.

Here one can actually see English art taking shape before one's eyes. The figures assume real proportions and spring to life; instead of mere gestures to indicate feeling, a direct relationship is established between them and their faces acquire expression. Air is created round the figures, the masses are loosened and subordinated to the composition, light and shade are distri-buted to further this articulation and the bareness of the background is eliminated. (Antal)

The larger designs show the impact of Raphael, perhaps through Thornhill's influence, with a strong infusion of baroque energy and low-life vitality, not without touches of parody. In the last print the climax comes in the battle of Carnival and Lent at Temple Bar; the nightmare is resolved in the popular festival of death-rebirth.

We may then claim that Bunyan, Swift, Defoe, and Butler (with Cervantes) helped importantly in forming Hogarth's world picture; and in a broader way we may add Shakespeare and Milton, to whom he always paid homage. On the art side, many artists from Brueghel to Callot, from Raphael to Rubens, helped to form his style, with a wide set of baroque and rococo influences as well as the popular print. Two illustrations to *Paradise Lost* of 1725, never used, show him capable of cosmic effect with full baroque sweep and spaciousness.

We know little of his first paintings. He may well have done some signposts. Samuel Ireland stated that he owned a sign in two panels done for a paviour

(paver); and the authenticity of the work was vouched for by C. Catton who, while a coach-painter, decorated Hogarth's coach with a device called *Variety* and who painted an emblematic *Reason* in 1761. The panels showed paviours at work in the street; and the extant example is painted crudely and boldly, with thick paint. Hogarth probably also painted *The Carpenter's Yard*, more finished in handling. Two gentlemen (one not unlike Hogarth) pause to watch several men at work, who are depicted with a mixture of realistic observations and traditional systems.

Hogarth, we have noted, was deeply interested in work processes and art processes. He declared:

I, as an expedient, to make up for my deficincys in writing, have had frequent recourse to my Pencil. Hopeing, that as the mechanic at his Loom is as likely to give as satisfactory an account of his materials, and composition, of the rich Brocade he weaves (though uncouthly) as the smooth Tongue'd Mercer (with all the parade of showy silks about him) I may in like manner, make myself tolerably understood, by those who are at the pain of examining my Book, and prints together.

He identifies himself with the worker and thinks of the salesman as the smooth-tongued connoisseur. Further, he appeals to the sensations felt by the man operating machine or tool in order to explain the intuitive sense of mass and movement felt by someone creating or responding to an art form:

As to these *joint-sensations* of bulk and motion, do we not at first sight almost, even without making trial, seem to *feel* when a leaver of any kind is too weak, or not long enough to make such and such a purchase? or when a spring is not sufficient? and don't we find in experience what weight or dimension should be given, or taken away, on this or that account? if so, as the general as well as particular bulks of form, are made up of materials moulded together under mechanical directions, for some known purpose or other; how naturally, from these considerations, shall we fall into a judgment of fit proportions; which is one part of beauty to the mind tho' not always so to the eye.

Our necessities have taught us to mould matter into various shapes, and to give them fit proportions for particular uses, as bottles, glasses, knives, dishes, &c.

In this important passage he stresses the way in which the creative artist needs a dynamic sense of unity between the mass of an object and the nexus of movement in which the object is involved. Mass is not an abstract aspect of form, nor can movement be considered merely in terms of mechanics, of an abstractly expressive configuration of lines, surfaces, shapes. The form must be felt and realized also as mass and volume, its momentum as the result of its total structure and qualities. Also, Hogarth is coming close to Marx's formulation that men produce according to the laws of beauty. We see then

how important for him was the study of men at work; yet he did not depict many work scenes. *Beer Street* and the first plates of *Industry and Idleness* are exceptions. It is surprising that the large amount of building in London during these years did not intrude more on his prints. Though the first stages of industrialism were under way, the extent to which machinery would soon operate was still largely masked. Expropriation had gone far on the land, where new agricultural methods were being tried out for many years; in 1723 Parliament allowed certain parishes to combine and set up Union Workhouses, which were often let out to a manufacturer so that he had under his control a supply of cheap labour. However, for a Londoner the effects appeared mainly in the increase of the poor and demoralized in the streets and alleys. Defoe, in his *Plan of English Commerce* (1728), tells of country girls in Essex thronging to the towns to spin.

Another early painting is a deathbed scene attempting a dramatic moment; the orange-red bedding suggests a study of Thornhill's colour. A red-chalk drawing of a disease-rotten whore in a garret, with a tubby bunter or servant, has been squared up as if he meant to transfer it to canvas; possibly it comes from his first years at the academy while he lacked confidence for a direct attack.

In 1725 the Hogarth girls opened a milliner's shop in Long Walk, and the clash between Thornhill and Kent worsened. Hogarth mentions how Thornhill refused to carry on at Greenwich after his payment was much reduced and the upper end of the hall 'was left cheifly to the pencil of Mr. Andrea a foreigner'. Kent, however, brought trouble on his own head by painting for St Clement Danes in the Strand an altarpiece with a picture of St Cecilia interpreted as a portrait of the Pretender's wife. In October Hogarth issued a burlesque of it, stressing the vague forms and lack of anatomical precision. He guyed the cherubs, which in the *Analysis* he cited as the most ridiculous of monsters, an infant's head with duck wings under the chin, 'supposed always to be flying about and singing psalms'. Near his end, in *Enthusiasm*, he added duck feet to increase the absurdity. We see the sort of denigrations exchanged by the partisans of Kent and Thornhill in a letter from Gay to Burlington's wife on 26 August 1726. He and Kent had been to Bartholomew Fair to see Settle's *Siege of Troy*. They found the Trojan horse well painted and next day went to Greenwich to compare it with Thornhill's work, where Kent 'seemed to give the preference to Bartholomew Fair'. The guide confused Roman Cardinals and Cardinal Virtues. (Gay seems to be drawing on a stock joke to suggest that Thornhill too could be considered papistical; Fielding uses the joke in an account of an auction in his *Historical Register*, 1736.)

Hogarth kept up his antagonism to Kent. In a late passage he strongly argues that 'ever-varying life' always surpasses a work of art: 'How often have I drove a fair reasoner to his dernier resort viz that a man complying with custom [prejudice] gets the opinion that he [is] much the better for studying abroad tho he were the worse which oftener has been the case than the better the late Mr Kent (late kings painter) won the prize of Rome and never was there a more wretched dauber but [such] soonest get into palaces in this country.'

An edition of *Don Quixote* was being planned. Hogarth seems to have projected a series on the Don in 1724; he engraved Sancho's Feast in which Sancho, imagining himself a governor, is mockingly starved by his subjects. Mrs Hogarth said later that the stocky bewildered Sancho was a self-portrait. Hogarth may well have wanted to carry on with *Don Quixote* after *Hudibras*, continuing the theme of self-delusion and the parody of the heroic on a new level; but he got no encouragement. He turned to topical subjects. Mary Toft of Guildford claimed to have borne a rabbit in presence of a surgeon, and went on producing them. People thronged to see her for a fee. The king sent his own surgeon, who witnessed a birth; the king then sent the most famous man-midwife of the time, Sir Richard Manningtree (who had been the first to institute lying-in wards in hospitals). Under his supervision Mary failed to produce more rabbits and under threat of an operation she confessed to fraud. In his print, *Cunicularii, or The Wise Men of Godliman in Consultation*, while tilting at credulity in general and that of the learned professions in particular, Hogarth also parodies the Biblical birth scene. The Three Wise Men come to a magical birth.

Swift's *Gulliver's Travels* had recently appeared, and Hogarth, already ready to use any event that had roused popular interest, drew on imagery from the Lilliputian section to satirize the low level of political morale. *The Punishment Inflicted on Lemuel Gulliver* (for his 'Urinal Profanation of the Royal Palace') shows his large bare bottom into which an enema is being forced with much effort. The act is overseen by a first minister carried in a thimble; a clergyman officiates from a pulpit made of a chamber-pot. Church and state ignore the fact that rats are devouring children and that the worship of Priapus is going on outside. The site is a ruined temple and Gulliver's anus is where the altar should be. In a desecrated world the ruling powers submit Gulliver (John Bull, the common man) to extreme indignity and tear out his guts, but he stupidly does not realize it or use his strength to destroy the useless pack. The moment was one of frequent attacks upon Walpole; but Hogarth's print has no mere party application.

That Hogarth delighted in Swift's book is shown further by two passages

in his *Analysis*, 'Indeed it would be well for us all, if one of Gulliver's flappers could be placed at our elbows to remind us at every stroke how much prejudice and self-opinion perverts our sight.' And, discussing mechanical methods to fix proportions and ideal lengths, he remarks: 'Lomazzo recommends also another scheme, with a triangle, to correct the *poverty of nature*, as they express themselves. These *nature-menders* put one in mind of Gulliver's tailor at Laputa, who, having taken measure of him for a suit of clothes, with a rule, quadrant and compasses, after a considerable time spent, brought them home ill made.' Beyond the use of examples drawn from Swift, he clearly sympathizes with his satire on all philosophic or scientific schemes to impose abstract patterns on life with its rich organic varieties and forms of growth.

Sometime in 1727 he issued *Masquerade Ticket*, showing the entertainments as based on the cults of Venus and Priapus (with which a bishop is linked). There is a veiled attack on George II, who as prince had supported Heidegger; the Lion and the Unicorn are depicted as drunk or demoralized. (Fielding in January 1728 published his poem *The Masquerade* 'by Lemuel Gulliver" insultingly inscribed to Heidegger. A masquerade is 'a heap of incoherencies, where people 'masque the face, t' unmasque the mind'.) In late 1727 or early 1728 Hogarth issued his *Henry VIII and Anne Boleyn*. The *Craftsman* tried to link Wolsey in the print with Walpole, in the hope that the analogy would work out with the latter's dismissal. After this print Hogarth showed no direct reaction to party politics till the 1750s. Walpole indeed had made sure there would be no attacks on himself by employing him to engrave the salver made out of the silver Great Seal which had become his on George I's death. For this official job Hogarth used a Thornhillian allegory: Hercules, supporting the sky, holds down Calumny and Envy, with London in the background.

About this time Vertue in his notebook first mentions Hogarth:

The several stories of Hudibrass being designed in a burlesque manner humoring very naturally the Ideas of that famous poem. these designs were the Invention of Wm. Hogarth a young Man of facil & ready Invention, who from a perfect natural genius improved by some study in the Academy, under the direction of Cheron & Vandrbank, has produced several charicatures in print, if not so well gravd, yet still the humours are well represented. whereby he gain'd reputation – from being bred up to small gravings of plate work & watch workes, has so far excelld; that by the strengths of his genius & drawing, & now applying himself to painting of small conversation pieces, meets with good encouragement, according to his Meritt.

He had begun to attempt small family groups, it seems, of the kind that Philippe Mercier had been doing. A painting that seems to be dated about

1727 is *The Theft of a Watch,* in which four girls playfully take a watch from a gallant, with another gallant at the side. Five of the heads are more or less in the same line, but the pattern of the arms of the girls between the gallants owns a circling and broken movement that imparts a dramatic force to the scene far beyond anything in other early paintings. *The Sleeping Congregation,* perhaps of 1728, gives his first depiction of a church interior. The many strong perpendicular lines are offset by massive forms, especially that of the sleeping clerk.

Sometime in 1727 Hogarth got a commission from Joshua Morris, tapestry weaver of Great Queen Street, Soho, for a cartoon of the Element of Earth (probably for the Duke of Chandos's country house, in the decoration of which Thornhill was involved). Hogarth stated that he was 'well skilled in painting that way, and promised to perform it in a workmanlike manner', for twenty guineas. Later Morris heard that he was an engraver, not a painter. Hogarth admitted that he had never done 'any thing of that like before', but declared that 'if his master did not like it, he should not pay for it'. Morris says that Hogarth took a long time. After several enquiries, the cartoon was left, not at Morris's house, but at one of his shops. Morris consulted his workmen. 'They were all unanimous that it was impossible for them to work tapestry by it.' Morris returned the work to Hogarth, saying that he'd accept it only if finished 'in a proper manner'. Hogarth promised to get it done in a month, but took three months. Morris still found it of no use and had to put his men on to other non-commissioned work, while he ordered a design of Earth from some other artist. Hogarth decided to take him to court.

But now an event of the utmost importance for his development occurred: the production of Gay's *Beggar's Opera* at Rich's Lincoln's Inn Fields on 29 January 1728, which, with its great success, stirred Hogarth to the depths. Its mock-heroic idiom and convention, its satirical picture of the commoners, performing their crimes and villainies as imitations of the conduct of the upper classes, brought succinctly and gaily to a head all the ideas that had been seething in his mind. With his work on *Hudibras* he had sought to plumb the nature and sources of human self-delusion, of the false face of consciousness; in prints like the *South Sea Scheme* and *Masquerades* he had applied his ideas to the world about him; but he was still looking for the clue that would stably release those ideas in a way capable of dealing with every aspect of his society.

Critics attacked the *Beggar's Opera* for offering criminals as idols and ideals to the ordinary citizen. This attitude was set out, for example, in a pamphlet

Thievery à la Mode; or the Fatal Encouragement (late 1728), in which a young man, seeking his fortune in London, sees the *Beggar's Opera* and notes the portraits of Macheath and Polly everywhere – indeed they were put on fans, playing cards, screens, and snuffboxes. He becomes a highwayman and dies confessing his crimes and expressing the hope that he is alone in having been seduced by the town's praise of Macheath. Hogarth saw such attacks on the play as turning the facts of the case upside down. In his Harlot's bedroom he later put the pin-up portraits of Macheath and Dr Sacheverell, thus linking the highwayman with the acclaimed prelate who had risen in the world through his incendiary sermons.

The particular angle of social consciousness which thus equated crime among the lower classes with corruption among the powerful and wealthy, and violence below with repression above, had been much stimulated by the situation we noted as emerging with increased clarification and strength after the South Sea Bubble. The growth of London had extended the possibilities of criminal and riotous behaviour. Charles Hitchin, who knew London life well, remarked on the 'general complaint of the taverns, the coffee-houses, the shop-keepers and others, that their customers are afraid when it is dark to come to their houses and shops', being scared 'that they may be blinded, knocked down, cut or stabbed'. Throughout the 1720s the newspapers show this sort of concern, as does the correspondence of those engaged in judicial administration as well as the numerous accounts of crime. These latter include the novels of Defoe, where we find the first fictional accounts of organized crime and criminals. No doubt the increase in indictments reflects the Whig determination to crush all manifestations of disaffection in the 1720s and 1730s; but we must add that old local rights and customary procedures for keeping order were being destroyed by the very process of establishing stable Whig government with its struggles for power, its tightening of oligarchical controls, and its reduction of the electorate. The inevitable result was anger and confusion at the breakdown of immemorial systems of communal life, and a widespread feeling that the new legal controls were oppressive, one-sided, and should be resisted.

We have now come to yet another major factor in the building of Hogarth's world view: the theatre. Its effect on him was many-sided, and again it involved both popular elements and elements drawn from the higher levels of baroque culture. He was influenced, not merely by this or that aspect of theatre, but by the whole practice and theory of theatre in his world. As with the emblematical tradition, we may say that he takes the theatre into his art, extracts its essence, transforms it in accordance with

his artistic needs, and in the end has absorbed it into his new kind of realism.

He was clearly a keen theatre-goer and by 1727 had arrived at the conviction that the world was a stage and the stage the world. From the days of his childhood with Bartholomew Fair, its drolls, plays, and puppet shows, he had found an overwhelming attraction in the stage where people guised and masqueraded as others, and tried to forget themselves in the roles. The relation of actor to role, of actor to audience, of audience to actor, fascinated him as providing a microcosm of the universal situation in which people were drawn into falsifying and wrecking their lives in a struggle to seem other than they were, to impose the role on their 'natural selves' as a superior aspect of their beings. Also, the way in which the theatre could concentrate and clarify the pattern strongly affected him in his quest for effective images. In the *Beggar's Opera* he liked the satire on Italian opera and its pretensions; he liked the way in which the operatic form was reduced to a realistic comedic basis with popular types of song.

Shakespeare and Ben Jonson clearly meant much to him. About this time he drew and painted Falstaff examining his Recruits. In his remarks he refers to Bardolph's red nose, Falstaff, and Master Stephen in *Everyman in his Humour*. In his self-portrait of 1745 he added three books: Shakespeare, Milton, Swift. In the *Analysis* he twice cites *Antony and Cleopatra* as well as mentioning Hamlet's advice to the players. In discussing dances he writes: 'The figure of the minuet-path on the floor is also composed of serpentine lines, varying a little with the fashion: when the parties by means of this step rise and fall most smoothly in time, and free from sudden starting and dropping, they come nearest to Shakespeare's idea of the beauty of dancing.' He cites the lines from the *Winter's Tale*: 'I wish you a wave o' the sea . . .' He knew many actors and was a close friend of Garrick; he frequented the Clare Market Club of actors, engraving a ceremonial tankard for them.

The theatre was still primitive in form and involved much direct give-and-take with the audience. An actor looking out from the centre of the slightly raked stage, right under the proscenium, had before him a forestage extending some twelve feet or more, with a small orchestra pit beyond. On either side of him were a pair of doors for entries and exits, with openings above at which characters could appear. He saw a pair of boxes sticking out directly on the forestage and he could lean his elbow on their rails to chat with the persons inside. (Indeed the actors seldom tried to sustain their part when one of them had a long speech; they stared round, peered at the audience, and looked bored.) Further out, the actor saw the pit with a tier of boxes on three sides and another tier along two sides with a gallery at the

back. Behind him was a backstage of about the same depth as the forestage, with rows of masking flats in the wings. A series of four or more pairs of flats or shutters, painted to represent various scenes, slid in grooves across the backstage, running in from the wings to meet in the middle. Quick changes were thus possible. To exit the actor could also go through the wings or step back and pass through the opening shutters – or he might be revealed by their opening. Scene changes were made in full view of the audience; the proscenium curtain was seldom used save at the start and the end of a piece. (About 1750 the custom of using the curtain between the acts came in.) Forestage and auditorium were lit by hanging chandeliers, and there was some provision of lighting scenery from above or from the side behind the proscenium. (Footlights came later, attributed to Garrick.) There was no way of altering the house lights or of controlling the lighting except in very slight ways.

There were only backless benches for seating. A box could be hired in advance, but no particular seats in it. For the rest, ladies could only send footmen to sit in desirable places for hours beforehand. There were no queues, and brawls were liable to occur round the doors. The audiences were often noisy, catcalling, hissing, shouting; at times they fought. In 1729, at the first night of Cibber's *Love in a Riddle*, there was a tumult, which grew worse on the second night, though the Prince of Wales was present. The shouters were appeased only when Cibber came forward to say that if they were quiet 'he would not insist upon its being acted the next Night for his Benefit'. In December 1702 there was even a duel on the stage, and in the early years of the century drunks were liable to climb up among the actors. There were many cabals for or against a play, and gentlemen used to roam behind the scenes. In the ironical stage directions for *The British Stage; or, the Exploits of Harlequin* (1724) we read: 'The Audience hollow and huzza, and are ready to break down the House with Applause. They dance with the Ghosts, Devils, and Harlequin. The audience clap prodigiously.' An actor who annoyed the audience might have to beg pardon on his knees. But the most primitive feature of all was the fact that members of the audience still sat on chairs on either side of the stage.

Hogarth continually called himself the author of his designs, and looked on himself as writer and dramatist. 'Subjects I considered as writers do.' 'My picture was my stage and men and women my actors, who were by means of certain actions and expressions to exhibit a dumb show.' In praising ocular demonstration, he says: 'Let figures be considered as Actors dressed for the sublime genteel comedy.' (He ironically takes over the term 'sublime', used for idealized forms of expression, and applies it to his realistic comedy,

his form of history.) The *Analysis* shows how closely he watched dances and comedic stage movements to find out what was the clue to their forms of motion. Here is one passage:

The attitudes of the harlequin are ingeniously composed of certain little, quick movements of the head, hands and feet, some of which shoot out as it were from the body in straight lines, or are twirled about in little circles. Scaramouch is gravely absurd as the character is intended, in over-stretch'd tedious movements of unnatural lengths of lines: these two characters seem to have been contrived by conceiving a direct opposition of movements. Pierrott's movements and attitudes, are chiefly in perpendiculars and parallels, so is his figure and dress.

Punchinello is droll by being the reverse of all elegance, both as to movement, and figure, the beauty of variety is totally, and comically excluded from this character in every respect; his limbs are raised and let fall almost altogether at one time, in parallel directions, as if his seeming fewer joints than ordinary, were no better than the hinges of a door.

Dances that represent provincial characters, as these above do, or very low people, such as gardeners, sailors, &c. in merriment, are generally most entertaining on the stage: the Italians have lately added great pleasantry and humour to several french dances, particularly the wooden-shoe dance, in which there is a continual shifting from one attitude in plain lines to another; both the man and the woman often comically fix themselves in uniform positions, and frequently start in equal time, into angular forms, one of which remarkably represents two W's in a line, these sort of dances a little raised, especially on the woman's side, in expressing elegant wantonness (which is the true spirit of dancing) have of late been most delightfully done, and seem at present to have got the better of pompous, unmeaning grand ballets; serious dancing being even a contradiction in terms.

He gave much thought to the relation of character and movement in plays. Discussing how movement in waving lines could give the actor elegance, he goes on: 'So that trusting to chance only will not do. The actions of every scene ought to be as much as possible a compleat composition of well varied movements, considered as such abstractly, and apart from what may be merely relative to the sense the words.' Brooding over the nature and purpose of rhythm in dance and stage action, its relation to individual character and to the whole significance of a scene or dramatic unit, he found his ideas as to the composition of a picture much clarified. Always the stress was on movement and on character.

In the concept of the world as theatre and the theatre as world there was a powerful baroque tradition, of which Hogarth was aware in both direct and devious ways. The Church as a cosmic image had inevitably been involved; in 1653 Pietro da Cortona made important applications of the idea

of the church interior as a theatre: a semi-circular colonnade with niches holding statues that looked towards the altar, where a large golden sun poured down its rays. The altar itself was held up by two big angels. This sort of symbolism entered into the baroque paintings of God in his heaven, and may be seen in Hogarth's illustration to Milton: *The Council in Heaven*, with God and Christ in their circular constructions and a large organ up-buoyed on clouds. Andreini, in his preface to the sacred drama *L'Adamo* (which influenced Milton), shows his sense of the universe as a theatre, of the theatral nature of man's life, of the ceaseless aspiration of all poetry to drama.

A new sort of self-consciousness was built up. The individual acted a role in a great drama, whether of God or Fate; he stood outside himself and looked on; he identified himself with the allotted role. Bernini, in one of his most famous productions at Rome, showed two theatres facing one another. In one were the actors; in the other were mirrors so set that the same actors seemed to be performing there. Which was which? Bernini was much interested in all kinds of illusion.

And so with the planning of the city – it was anything but a stage-piece, but it was meant at times to seem so, and scenes were being devised to set off its life in such a way that the public might marvel at itself and might become absorbed in the spectacle of itself. (Arthos)

During the carnival of 1635, when a great lady with some twenty-five ladies-in-waiting called on Cardinal Antonio who was at dinner with Bar-berini, they were asked to join in. A group of gentlemen, also present, were put at the end of a hall behind a curtain, and when it was drawn they were seen as in a play, dicing, feasting, chatting. The talk moved towards the Carnival, and the men worked out an idea for a play; they at once began acting it. It turned on the way that gallants set about entertaining ladies. The success of the show was, a guest said, miraculous. Thus life turned into a play, and a play into life, in one succession after another. Such ideas were integral in baroque with its sense of display, of rhythms, images, structures which involved the spectator. A humorous exposition of the baroque con-cept of space, which must have delighted and stimulated Hogarth, is to be found in the account of the three Oratorial Machines (pulpit, ladder, and itinerant stage) in Swift's *Tale of a Tub*:

I confess, there is something yet more refined in the contrivance and struc-ture of our modern theatres. For, first, the pit is sunk below the stage, with due regard to the institution above deduced: that whatever weighty matter shall be delivered thence, whether it be lead or gold, may fall plumb into the

jaws of certain critics, as I think they are called, which stand ready open to devour them. Then, the boxes are built round, and raised with a level to the scene, in deference to the ladies; because that large portion of wit laid out in raising pruriences and protuberances, is observed to run much upon a line, and ever in a circle. The whining passions, and little starved conceits, are gently wafted up by their own extreme levity to the middle region, and there fix and are frozen by the frigid understanding of the inhabitants. Bombastry and buffoonery, by nature lofty and light, soar highest of all and would be lost in the roof, if the prudent architect had not, with much fore-sight, contrived for them a fourth place, called the twelve-penny gallery, and there planted a suitable colony, who greedily intercept them in their passage.

Now this physico-logical scheme of oratorial receptacles or machines contains a great mystery; being a type, a sign, an emblem, a shadow, a symbol, bearing an analogy to the spacious commonwealth of writers, and to those methods by which they must exalt themselves to a certain eminency above the inferior world. By the pulpit are adumbrated the writings of our modern saints in Great Britain, as they have spiritualised and refined them from the dross and grossness of sense and human reason. The matter, as we have said, is of rotten wood. . . .

which gives light in the dark and is full of worms, as the fanatic preacher has his inward light and a head full of maggots.

The theatre here is not directly compared to the cosmos, but the way in which it is made a place of varying levels and gravitational effects, and the stress on its existence as an emblem and symbol, gives a spacious effect of incessant analogies between theatral activities and the world of matter. Milton with his baroque theatral universe certainly had a strong influence on Hogarth, who included him with Shakespeare and Swift as a formative influence on his art. In the *Analysis* he put on the title page the quotation: 'So vary'd he, and of his tortuous train Curl'd many a wanton wreath in sight of Eve, to lure her eye.' In the last chapter he wrote:

One of the most pleasing movements in country dancing, and which answers to all the principles of varying at once, is what they call the hay; the figures of it altogether, is a cypher of S's, or a number of serpentine lines interlacing, or intervolving each other, which suppose traced on the floor, the lines would appear as in fig. 123. Milton in his Paradise lost, describing the angels dancing about the sacred hill, pictures the whole idea in words; Mystical dance! – Mazes intricate, Eccentric, intervolv'd, yet regular Then most, when most irregular they seem.

Thus he invokes Milton's central concept of cosmic movement and energy in order to explain his ideas of the most significant forms, structures, pat-ternings. His link with Milton was understood at the time; in a print,

Collection of Connoisseurs, published 1753, in his defence against the attacks on the *Analysis*, one of the connoisseurs tramples the *Analysis*, Shakespeare, and Milton underfoot.

The scene in the *Beggar's Opera* most attracting Hogarth was that in Act Three where all the principals appear. Macheath in chains stands in non-committal lordliness between his appealing 'wives', who turn to their respective fathers, the gaoler and the thief-taker. This scene Hogarth painted six times. The first version was bought by Rich, who did so well out of the play that he built a new house next to Thornhill's; before the end of 1729 he commissioned a larger version to be hung in the theatre. Hogarth painted the actors as lively portraits, with the audience seated on either side rather caricatured: all quite unlike the French paintings of scenes from the *Commedia dell'Arte* with their glamorous elegance. In his last version, however, he treated the onlookers with more realism. He had found how to link players and audience directly, the mimed life with the world that was mimed. The Duke of Bolton had fallen in love with Lavinia Felton singing as Polly Peachum the plea that had won over the first-night audience; at the end of season he carried her off as his mistress, later his wife. At first Hogarth painted the two girls with arms held out to Macheath; now Polly dropped her right arm and pointed at the duke, whose eye met hers. Life and the play are inextricably mixed.

We see Hogarth growing as a painter in the six versions, more able to relate his main figures and eliminate what was clumsily done. The protagonists grow more finished in face and body, while the persons at the back are loosely treated; the setting grows more spacious, with recessions better handled. The rear group are now the actors preparing to come on for the dance of the prisoners in chains. Bunching-up and heads in a straight line are avoided. The slope of the seated persons and the kneeling poses of the girls combine to produce the serpentine line that was to mean so much to him. On the royal arms over the stage we read: *Utile Dulce veluti in Speculum*. The Useful and the Delightful (moral impact and charms of art) are joined 'even as in a Mirror'. The audience see themselves in the play, in the painting; they stand apart and yet are merged.

There is already a variation between the method of high finish and that of more loose and painterly handling, using thin paint and concerned more with volumes than with outlines. The latter style, in which his originality lay, provided the basis of his mature style, with brushwork suggesting both volume and movement. In colour he had learned from Thornhill, developing his fondness for salmon pink and strawberry, for indigo, lilac and lemon.

Through his mnemonic system and his love for the curves and interrelations of forms in movement, what he first put down on canvas often failed to produce the complex balance or contrast of forms that he desired. He changed, added, strengthened one aspect of the pattern, diversified what had been too simple, and so on. He said of his *Garrick as Richard III*: 'I never was right save when I had been wrong.' Other artists might want to work out a composition evolved out of the act of painting itself. He tried to put the essentials of his idea, of the image in his mind, on the canvas, felt the inadequacy of the result, then set out about reshaping and balancing things till he had satisfyingly rendered the tensions of his theme. Telling how he kept up his studies amid his pleasure, he says that his studies consisted of 'the retaining in my minds eye (without drawing upon the spot) whatever I wanted to imitate and only & that but too seldom took the life for correcting the parts I had not perfectly enough remember'd when I came to put them in practise'. He mostly began with thin monochrome underpainting, cool greys and greens, sometines sienna. At times, too eager to wait for this layer to dry, he started painting in objects, using colours in a relatively transparent state without much concern for what lay beneath. For highlights he added creamy touches, at times impasto. 'Colours well prepared . . . without accidents, as damps, bad varnish, and the like (being laid separate and pure) will stand and keep together for many years in defiance of time itself.' So he was opposed to such methods as those that Reynolds brought back from Italy, with the careful laying-on of glazes. And indeed his colours survive in fresh conditions, while those of Reynolds do not.

The full impact of the theatre then fertilized the ideas and emotions stirred in his response to the emblematic tradition and to writers like Bunyan, Butler, Defoe, Swift, and Milton. It helped to provide a cosmic dimension, not in terms of spatial vastness or of man's involvement with the world of nature, but by making each realized scene a moment of total judgement, a moment when the actors, apparently alone with their problems, were exposed to the eye of man, not God, in all the fullness of their human weakness and strength. It helped to get rid of the triviality that could result from concentration on emblematic objects in isolation, and put them in their place as incidental though revelatory 'properties' of the scene, of the characters and actions that were being set out.

5 The Harlot's Progress (1728–30)

On 28 May 1728 Hogarth's case against Joshua Morris came up before the Lord Chief Justice. Morris's workers testified that the painting had been useless for tapestry; Hogarth produced five witnesses, including Thornhill and Vanderbank (whose father had made tapestry), to testify to the quality of his work. The question was whether competence here meant that he had produced a good painting or a good tapestry design; he won his case. He had now come to know Henry Fielding, some ten years his junior, and they remained good friends, with varying degrees of closeness, throughout Fielding's life. Hogarth's art was certainly of the utmost importance in stimulating the latter's concept of the novel; but we know almost nothing of their personal relations. (Later Townley remarked to Hogarth that he wished he could have been as close a friend of his as Fielding was.) Both men belonged to the middle class of the day; but in making such a statement we must carefully define just what that term meant. The middle class of 1720–1750 was very different from that of 1820–50, and so on; and inside each period continual differentiations occurred. In Hogarth's years the class was being formed on the bases of the advances made in industry, commerce, bureaucracy, farming; it included lesser country gentry like the Fieldings as well as city men taking advantage of the new chances in government contracts and trade. It included many professional men aware of the new problems coming up in science and its applications, Quakers who were turning to iron-making, mining, and banking, and middlemen of all sorts. Because of the deep turmoil of change, the new class had a strong popular or plebeian element at certain levels, and it was this element that remained strong in Hogarth despite the kinship he felt with men like Fielding and several

scientific practitioners, despite his rise in the world both socially and intellec-
tually. He had some of the most advanced aspects of the class, but also an
archaic element that resisted other aspects; he disliked the increased ex-
ploitations that resulted from the class's consolidation, and in the end he
turned on the City trading classes with their demand for imperial expansion.
To call him simply middle class (as Antal too often does) is thus to blur out
the complexity of his actual situation, his responses to a changing world.

Scandals had come up about the conditions in the Fleet Prison, where in
1713 John Huggins, a friend of Thornhill, had bought the patent for the
Wardenship. In 1728, scenting trouble, he sold out to his deputy Bainbridge,
who carried on as ruthlessly. In 1729 a committee of inquiry was set up by
the Commons, which visited the prison and examined Bainbridge. Hogarth
made a drawing of it at work. He depicted the villainous warden confronted
by the shattered prisoner in front of the committee; but the dramatic effect
was lost in a painted version where the prisoner kneels to the chairman. In
the Fleet, Hogarth must have had his memory of boyhood experiences
deeply stirred.

This year Thornhill got permission to copy the Raphael cartoons at
Hampton Court, and went on with the work till 1731. His absences may
have helped Hogarth in a daring deed. The young artist had been wooing
Jane Thornhill, and he must have been adroit in his courtship to escape
rousing parental suspicions. He may well have been attracted by Jane, but
he would also have felt that it would be a great triumph to win the daughter
of the one painter he respected. His portrait of her in 1738 shows her as a
handsome assured young woman, high-spirited and aware of her worth;
Zoffany's picture of her in old age (1780–83) brings out her independent
poise, with a sort of imperious quizzical note. In a sketch of the family by
Thornhill, she and Hogarth seem about the same height. As a widow she
showed herself very capable of looking after her interests, and she seems
to have had much of his mother's self-reliant character. The fact that she let
herself be swept off her feet by Hogarth, whom her parents must have con-
sidered very much a social inferior, proves that she had a mind of her own;
a sense of his strength of purpose may well have drawn her to him.

He took out a marriage licence from the Faculty Office of the Archbishop
of Canterbury, declaring himself to be above twenty-five and Jane above
twenty-one, and both of them to be of St Paul's, Covent Garden. On 23
March the wedding took place, but not at St Paul's. The lovers slipped
away to the village of Paddington, where they were the only pair married
that day in the parish church. Vertue reports that it was done without
Thornhill's consent; Nichols considered it an elopement. The early bio-

graphers describe Jane as eighteen at the time; but as she was said to be eighty at her death, she was probably now twenty. On 5 April the *Craftsman*, edited by a friend, Nicholas Amhurst, mentioned the marriage and called Hogarth designer and engraver. There was a tradition that the couple went to live at Lambeth, but probably this referred to the honeymoon at a summer residence, after which they returned to Hogarth's studio.

Thornhill apparently soon accepted things. We may doubt the tale about his wife's putting some of the *Harlot's Progress* paintings in his way, so that he asked who had done them, then remarked: 'Very well: the man who can furnish representations like these, can also maintain a wife without a portion.' If the tale were true, Jane's banishment must have lasted nearly two years. Most likely Thornhill was furious for a while; but he must have known already Hogarth's capacities. Anyway, it was not till 1731 that the Hogarths moved in with him in the Great Piazza. Probably the idea of a long break arose from the rumour that it was then the reconciliation took place. Previously the Hogarths seem to have been living in Tothall's house at the corner of the Little Piazza and Tavistock Court. William Tothall had run off early to sea, then worked for a woollen draper, who helped him to set up for himself. He had been captured by the Spaniards in the West Indies and collected rare shells there; later in 1746, at Dover, an unsuccessful smuggler, he dug up fossils in his garden.

Now more than ever, Hogarth wanted to raise his artistic status. He felt that he must drop engraving and at most furnish designs for other engravers at a guinea a time. Still, he did two etchings for a play and a card for his sisters' shop (now outside the gate of Bartholomew Hospital). In the years 1728–31 he worked very hard, seeking to develop in several directions. He painted social scenes and portrait groups, creating a new kind of Conversation Piece; he did six paintings of the *Harlot's Progress* and issued engravings of them. As we cannot work out any clear sequences for the various works, we may treat them as groups.

First then the single scenes. Probably of 1729 were the *Denunciation*, the *Christening*, and the *Debate*. The first (engraved a few years later by Simpson as *A Woman Swearing a Child to a Grave Citizen*) still puts the figures together in a band, finding it hard to break the line of heads or use the spaces above or below the people; the main characters are clear in focus, the others a little blurred. Hogarth employs a favourite device to suggest how life keeps on breeding the same patterns of dereliction. A child, unaware of what is going on, teaches her dog a trick, while a lover teaches a pregnant girl how to deceive the respectable citizen who, abused by his jealous wife vainly protests. (The Justice is said to be T. de Veil, used by Fielding as the typical

trading magistrate.) In the *Christening* the heads still tend to be in a line, but he tries to work from the centre out, and skilfully shows each character cut away in his or her own obsession. The officiator here is Orator Henley, an odd character who in 1726 set up his own chapel with a fee for admission and who proved from his velvet pulpit that mankind were fishes of various sorts. The lightened palette seems meant to suggest the lack of seriousness in the occasion. *The Debate on Palmistry* (not Hogarth's title) shows five gentlemen chatting round a table. The theme is the contrast of the intellectual conversation with the men's awareness of a desirable chambermaid. A sense of comedy asserts itself in an unforced way; security of tone goes with a more natural flow of pattern.

A drinking scene, engraved in 1733 as *A Midnight Modern Conversation*, is based on a seventeenth-century print against drunkenness, but also holds memories of Jordaens and Steen. The drunks could no doubt be recognized at the time. The print warned: 'Think not to find one meant resemblance here', but Dr Johnson knew one of the men as a distant relation, Parson Ford, 'very profligate, but I never heard he was impious'. The various stages of demoralization are depicted with acute observation and understanding; the table, not quite in perspective, provides a circling movement, both drawing together and disarticulating the figures who in their private dementias share a common dimension. But Hogarth still finds it hard to know what to do with the spaces round the actors.

His growing reputation for satirical verve and for catching a likeness appears in a tale dated about 1731. The Lord Mayor disliked his sheriff, a miserly man, and he paid Hogarth to depict the latter trying a dog for stealing a shoulder of mutton from the kitchen. Hogarth put the work on show in his studio, while the Lord Mayor advertised in the papers about a 'curious piece of painting', by a curious and ingenious painter, 'which is to be set up at Justice-Hall in the Old Baily'. Vertue adds that the sheriff's son came to see the picture, 'drew his sword & swore he would Sacrifice the Author or Painter of it, and immediately with a Penknife cut the picture at least the head out of it'. There is also a story of an ugly nobleman who refused to pay for the too truthful portrait he had commissioned. Hogarth sent a note threatening to add a tail 'and some other little Appendages', and dispose of the work to 'Mr. Hare, the famous Wild-beast-man'. The nobleman promptly paid up and destroyed the picture.

In turning to portraits Hogarth preferred groups, liking to show people in their interrelations and at some kind of activity. He tells us that after feeling sure he'd never gain 'the beautiful stroke on copper', he was drawn 'by this

and other reasons' to turn 'to Painting Portrait figures from 10 to 15 inches', and subjects in conversation. 'It had some novelty succeeded for a few years this tho it gave more scope to fancy than common portraits was still less but a kind of drudgery.' He disliked the portrait tradition from Van Dyck to Kneller with its idealized stereotypes. He looked on it as a foreign importation and for this reason he stressed his Englishness, signing some works: 'W. Hogarth Anglus pinxit'. A single portrait tended to look like a flattering mirror image of the sitter staring out at the spectator. The term Conversation was used to include Dutch drolls as well as small groups of polite society; Vertue applied to it Brueghel, Brouwer, Teniers. For long, artists had produced group or family portraits, pictures of festal occasions, and so on. With Dutch artists the family portrait often tended to merge with genre-work. But with Hogarth was born the rendering of a domestic moment or occasion without the sitters showing consciousness of the painter and with a certain casual drama of everyday circumstances. He completed what was a strong trend in Dutch art, but was none the less original, giving a decisive turn to the tradition. He ignored conventional poses or used them as an exposure of false pretensions; and he used the settings, the furniture, and other objects to evoke both character and social role.

He gained a dramatic effect by his liking for a frontal arrangement, suggesting a stage scene, and by his avoidance of salient points in the more or less uniform line of sitters. He tried to get variety through the irregular background made by the angle of two walls. In the Cholmondeley group a *putto* draws back drapery on the left (as in Lebrun's *Jabach Family*) to show that the woman below is now dead. On the right is also a curtain, and a strong stage effect is got by offsetting the main (pyramidal) group with the projecting library wing where the playful children introduce action, asymmetry, even a sense of impending confusion, as one child puts his foot on a pile of books liable to fall over. Hogarth likes children for introducing some spontaneous activity in the midst of the more balanced or passive family scene; again he took this motif from the Dutch but developed it more strongly. There also was a French strand in his system. Philippe Mercier, a follower of Watteau, had settled in England in 1719; and Watteau himself was briefly in England in 1720–21. Hogarth may have seen a few of his works in private collection. In the late summer or early autumn of 1729 Vertue had already noted 'The daily success of Mr Hogarth in painting small, family peices & Conversations with so much Air & agreeableness', which 'Causes him to be much followd & esteemed, whereby he has much imployment & like to be a master of great reputation in that way'. He rightly marvelled at his rapid growth. "Tis much from no View at first of being a

painter, but only vsed to Grave small works on Silver.' In 1730 he again wrote (with his odd use of stops in punctuation):

Mr Hogarths paintings gain every day so many admirers that happy are they that can get a picture of his painting, a small peice of several figures representing a Christning being lately sold at a publick sale for a good price. got him much reputation. also another peice the representation of the House of Commons. to jayles. setting upon the examination of these malefactors. well painted & their likeness is observed truly. many other family peices, & conversations consisting of many figures. done with spirit a lively invention & an universal agreeableness.

The Wedding of Stephen Beckingham and Mary Cox is a prosaic work with the heads in a line, which angels with cornucopiae and the carpet draped round the font fail to enliven. *The Assembly at Wanstead House* has too many people in it; they are bunched and static despite the effort to focus on the woman with arms out-turned. *The Woodes Rogers Family* shows a rather conventional system which seeks to give meaning to the scene. Woodes Rogers is being presented by an adjutant with letters patent for his governorship of the Bahamas; behind him is a ship, a globe, a monument with his motto; at his feet is a dog, with his wife and her maid at the side. Between the two men is a gap. In *The Jeffrys Family* a lake makes a hole in the middle. Hogarth has trouble in centralizing his composition. A gap in the middle produces a sort of inverted pyramid in the *Rich* and *Fountaine Families*, breaking up the groups. In *The Woolaston Family* Hogarth tried to connect things by putting Woolaston in the middle. Generally he tried some sort of pyramidal system and succeeded best with children, as in *The House of Cards* and *A Children's Party*. The pyramid in the first is given variety by the gestures of the children, the boy running off on the left, and the dog moving across the front in the opposite direction. In the second there is more irregularity; the girls on the right are strengthened by the monument behind them; but the gesture of the girl at the top, helped by the open space under the trees and the small boy at bottom-left turning back into the picture, provides a dynamic balance, reinforced by the falling-over tea table near the middle. Warfare and family life are parodied by the way that the children imitate them; at the same time we feel the children are being prepared for the disasters and inanities of the adult world. Yet the spontaneous element of play again suggests the 'natural element' which is being spoiled. *The Broken Fan*, still pyramidal, introduces both a small domestic incident and more solidity of construction into a family scene. In another canvas the sea-painter Monamy shows an easel picture to a commissioner of customs who collected Dutch and Italian works. The two level figures are set in rectangular constructions; walls,

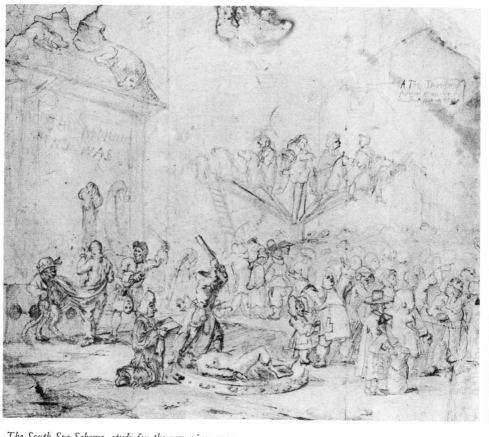

The South Sea Scheme, study for the engraving, 1721

The Benefit of Spiller, c. 1720

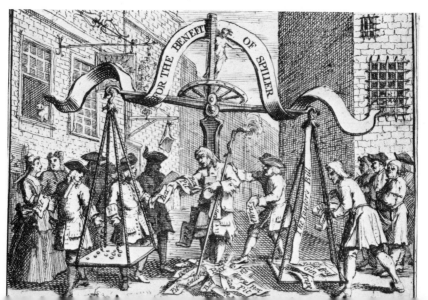

Some of the Principal Inhabitants of yͤ MOON, as they
Were Perfectly Discover'd by a Telescope brought to yͤ Greatest
Perfection Since yͤ last Eclipse; Exactly Engraved from the
Objects, whereby yͤ Curious may Guess at their Religion,
Manners, &c.

1725 Price Six Pence

Royalty, Episcopacy and Law, 1724

opposite top *Hudibras's First Adventure, 1726*

below *Sancho's Feast, 1738*

The Punishment Inflicted on Lemuel Gulliver, 1726

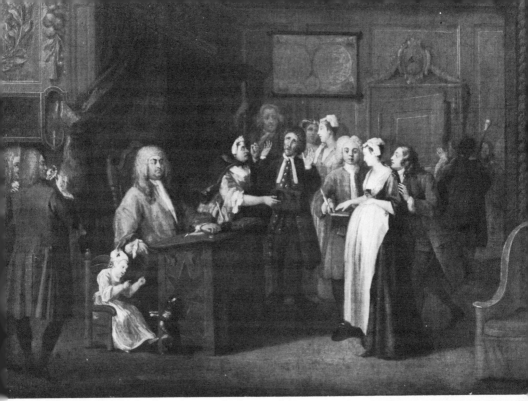

NATIONAL GALLERY OF IRELAND

The Denunciation, c. 1729

The House of Cards, 1730

PRIVATE COLLECTION

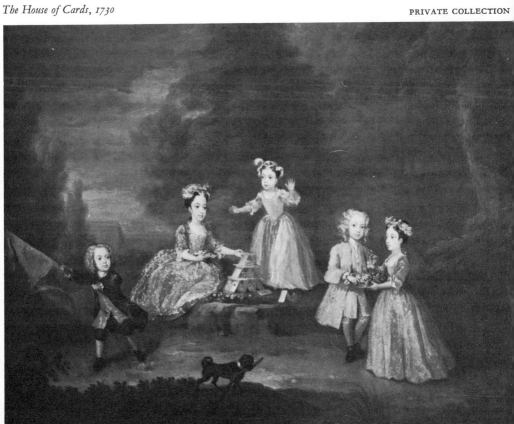

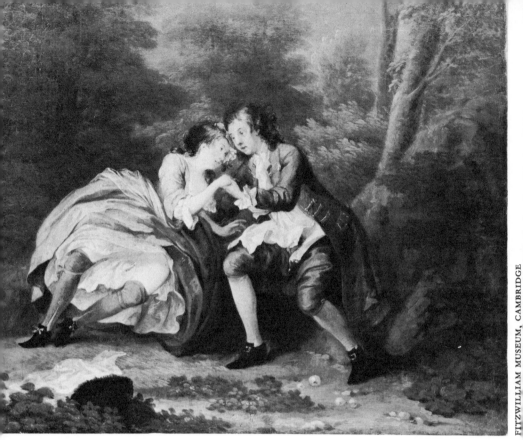

'*After*' (*in the open*), *1730–31*

A HARLOT'S PROGRESS, PUBLISHED 1732 *1. Ensnared by a Procuress*

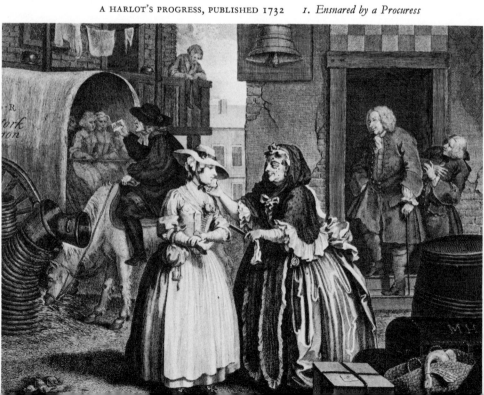

Sarah Malcolm in Prison, 1732–3

'Breakfast' from Peregrination, *1732*

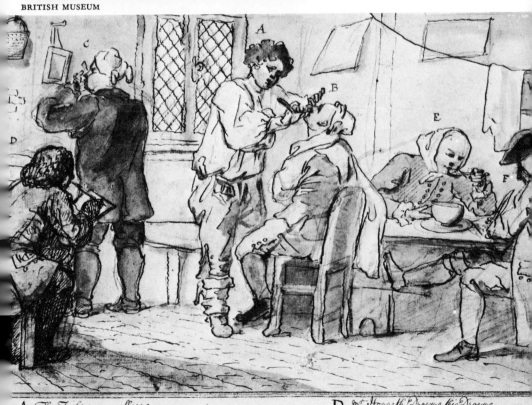

A *The Fisherman Shaving.*
B *Mr Thornhill*
C *Mr Tothall Shaving himself*

D *Mr Hogarth Drawing this Drawing*
E *Mr Forrest at Breakfast*
F *Mr Scott Finishing a Drawing*

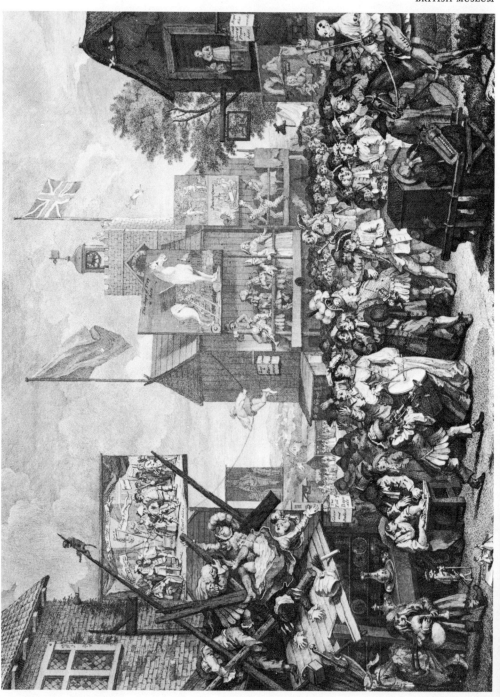

carpet, pictures. A painting inside the painting occurs again in the work where Sir Andrew Fountaine, Queen's Vice-Chamberlain and Warden of the Mint, is being shown a picture (with a punning reference to his name) by his son-in-law, the auctioneer Cock. The younger Richardson says that Sir Andrew 'out-Italianized the Italians themselves', and Hogarth expresses his character by the rich garden setting, the landscape which is the most Watteau-esque of anything in his paintings with its elegant air of a French picnic. From 1731 on he began making his figures larger in relation to the picture's space, achieving a more compact composition with no meaningless portions.

In late 1731 the Hogarths were still at Tothall's, for that was the address given in an advertisement inserted by William in the *Craftsman* for 5 December, offering half a guinea reward for a lost 'light-colour'd Dutch DOG with a black Muzzle' answering to the name of Pug. He had already attached a dog to himself as part of his settled image. (The pug seems to appear in *The House of Cards*, and about 1738 in *The Strode Family*.) But early in 1732 he was in the Great Piazza, accepted as one of the Thornhill family. He never called this address a shop, though he later engraved and sold the *Harlot's Progress* from it as well as a few other prints. For studio he no doubt used Thornhill's old academy-room.

In February 1731 Joseph Mitchell published *Three Epistles*, one of which was to Hogarth. He called him '*Shakespeare* in Painting', uniting Dutch and Italian schools, and drawing the Heart though 'the silent *Hypocrites* exert such Pow'r'. He suggests that Thornhill watches him with jealousy, though more likely with pride, and won't destroy himself by trying to rival his son-in-law. Hogarth may have been talking about his resolve to outdo Thornhill, for soon afterwards another writer says that Fame first picked him out as Thornhill's son, then Heaven gave him Thornhill's genius. On 22 April Fielding staged *The Welsh Opera*, using the theme of the lower classes imitating the vices and follies of their betters. This theme, important for all his work, he shared with Hogarth and at least in part drew from him; the two men clearly stimulated one another. Hogarth did designs for Fielding's revised *Tom Thumb* (1731) and the Molière in which he was involved. In July 1731 we catch a glimpse of him at work. Mrs Pendarves told her sister Anne: 'I have grown passionately fond of Hogarth's painting, there is *more sense* in it than any I have seen.' She had watched him paint the Wesley family. 'He has altered his manner of painting since you saw his pictures; he finishes more a good deal.' She notes his power to catch likenesses, and she has released Lady Sunderland from a promise of a picture of herself by the enameller Zincke. Now she wants it done by Hogarth. 'I think he takes a much better

likeness, and that is what I shall value my friend's picture for, more than for the excellence of the painting.' She adds: 'Hogarth has promised to give me some instructions about drawing that will be of great use, – some rules of his own that he says will improve me more in a day than a year's learning in the common way.' We see how far he is advanced in control of his system.

In 1730–31 Hogarth painted two versions of a seduction scene, each taking two different moments: *Before* and *After*. John Thomson, MP for Great Marlow, who had been on the Fleet committee, commissioned the first set, where the lovers were out of doors, amid foliage of a deeper green or blue-green than is usual in Hogarth's trees; blues, reds, and whites enliven the scene. In *After* the girl is woebegone with her legs open and we see (as a recent cleaning has brought out) the boy's inflamed penis as well as his reddened face. The indoor version (perhaps done for the Duke of Montagu) uses emblems; the shattered mirror, the worn-out dog, a paper in the drawer: 'will agree that she did not die a maid'. Here the colour is gentler: lighter greens and salmon-pink, ivory and a little blue. (Thomson never claimed his set and he fled the country through frauds he had carried out in the Charitable Corporation for the Relief of the Industrious poor.)

From sometime in 1730 Hogarth had been working on an ambitious project. Vertue tells us how it arose. 'Among other designs of his in painting he began a small picture of a common harlot, supposed to dwell in drewry lane, just riseing about noon out of bed, and at breakfast, a bunter waiting on her.' We recall the early drawing of a whore, but here the girl had 'a desabillé careless and a pretty Countenance & air – this thought pleased many, some advised him to make another, to it as a pair, which he did, then other thoughts encreas'd, & multiplyd by his fruitful invention. till he made six. different subjects which he painted so naturally, the thoughts, & strikeing the expressions that it drew every body to see them.' We see how, under the stimulus of the viewers, he tried a set like *Before* and *After*, then made the crucial step into a narrative series.

The theme of the newly arrived country girl drawn into vice is nothing new. Steele in the *Spectator*, January 1712, described a visit to an inn to see about some expected provisions, 'but who should I see there but the most artful Procuress in the Town, examining a most beautiful Country-Girl, who had just come up in the same Waggon with my Things'. Tom Brown had depicted a bawd giving advice: 'Ply close at inns, upon the coming in of waggons and gee-ho-coaches, and there you may hire fresh country-wenches, sound, plump, and juicy, and truly qualified for your business.' What was new in Hogarth was the realistic force and thoroughness with which he depicted the situation and its consequences. A friend in an obituary said that

he was replying to the comment of the Abbé du Bos, in *Réflexions critiques sur la poésie et sur la peinture* (1719), that no history painter went through a series of actions, and thus, like an Historian, painted the successive fortunes of an Hero, from the cradle to the grave. Hogarth did not know French and the book was not translated till 1748, but he may well have heard the passage cited in argument. It would have stirred his emulous spirit, especially as coming from a Frenchman.

There was a long popular tradition in English behind such tales as that of the harlot, for instance Greene's *Groatsworth of Witte, bought with a million of repentance* (1592); and Hogarth knew to some extent the popular sets of Italian prints showing the rise and fall of harlots and rakes. His friend Pond, who copied the caricaturist Ghezzi, would doubtless have had such sets in his stock; and nobles on the grand tour brought copies home. Typical was *Lo Specchio al fin de la Putana* by Curtio Castagna (1655–8). The inexpressive figures in big empty spaces bore no likeness to Hogarth's compositions, though he would have enjoyed the use of animal correspondences, such as a cat creeping up on a chicken as the bawd approaches the girl. In his series Moll, succumbing to the bawd, is linked with a neck-wrung goose. Also we find the motif of children prefiguring the adult fall. In *Lo Specchio* the girl loses her virtue at a country dance; two children in the foreground suggest the early roots of her lapse. But in all the seventeenth-century cycles, as in those dealing with the Prodigal Son, we are in the world of medieval moralities; it is Hogarth who first gives the themes a realistic impact.

But the realistic vision is only one aspect of his aim; he wants to give the contemporary scene all the artistic virtues hitherto considered the sole property of history paintings of gods, heroes, kings. Hence his turn to Raphael, whose cartoons he must often have discussed with Thornhill. He now uses less people than in the band system of *Hudibras*, brings them closer so that they gain in dignity and force, and with his realism gives them an enhanced solidity and energy. He learns too from Raphael to use architecture to strengthen the composition, balance the figures, draw them together with strong verticals and horizontals; but now the structures enclose and imprison people. The world of his rooms and streets is seldom far from evoking a claustrophobic gaol-sense; his people almost palpably react against the heavy social pressures all round them, whether they resist or try to conform.

Here we see Hogarth as the first depicter of modern life, the city of alienation, the deep loneliness in the midst of the crowd: a theme which reached its climax with Baudelaire. London was still far from being an industrial city, but its inhabitants already had many of the characteristics of

isolation and anonymity that were steadily to deepen as the cash nexus took over. After 1660 had come a vast growth of river traffic, docks, warehouses, shops displaying goods. Adam Smith contrasted the old ways, in which a man was known to his fellows and might 'be attended to', with the city life where a man was 'sunk in obscurity and darkness', so that 'his conduct is observed and attended to by nobody and he is therefore very likely to neglect it himself, and to abandon himself to every sort of low profligacy and vice'. The police activity of the state had to take the place of social controls. Fielding put the matter with terse irony: it was necessary for the good of society to compel 'the poor to starve or beg at home: for there it will be impossible for them to steal or rob without being presently hanged or transported out of the way'.

At all times Hogarth listened keenly to gossip and read news items that seemed to reveal the typical disorders and corruptions of his world. As the scheme of the *Harlot* matured in his mind, he listened ever more avidly. We can make out many items that fed his imagination. In December 1729 James Dalton, highwayman, was caught; he stabbed a fellow-prisoner and in April 1730 was sentenced to death. From December 1710 there had been much scandal about Col. Charteris, called Rape-Master of the Kingdom; in February 1730 he was convicted of raping his servant Anne Bond, but the king pardoned him on the very day that Dalton was hanged. He used bawds to pick up newly arrived country girls; and in March 1730 an account of his misdeeds, calling him Col. Don Francisco, was published. A highwayman, Francis Hackabout, was hanged about this time, and Charteris, seen in a coach with two women, was attacked by a crowd and beaten. In June came Fielding's farce, *Rape upon Rape*, with its venal magistrate. On 1 August the magistrate Gonson, known for his zeal against whores, committed to Bridewell several keepers of brothels, including Katherine Hackabout. On 4 August it was announced that Col. Charteris and his lady were to be presented to their Majesties.

All these events helped to shape the Harlot's story. A country girl, M. Hackabout (Mary or Moll), comes up to London, is carried off by a bawd, seduced by Charteris, turned out to become the mistress of a rich Jew. Taking another lover, she is again turned out, sinks to the level of a common harlot, is arrested by Gonson and sent to Bridewell. She is with child, apparently by Dalton; she sickens of venereal disease and dies. When, still in her finery, she beats hemp in Bridewell, Hogarth seems to be recalling Mary Muffet 'beating hemp in a gown very richly laced with silver' (*Grub-street Journal*, 24 September 1730).

Moll is no ravished Anne Bond. As she waits at the waggon-stop, she is

fascinated by the bawd and the prospect of an easy life; she makes no resistance and wants to be a lady, holding fast throughout to her genteel airs. (Hogarth may be thinking of Moll Flanders and her hopes of being a gentlewoman.) The bawd is Elizabeth Needham, much in trouble 1730-31, who died after bad treatment in the pillory only just over a month after Hogarth opened his subscription list. The clergyman is based on Gibson, now a bishop, who had come up with Richard Hogarth; concerned only with his own advancement, he studies a letter of recommendation. His neglected horse forages for itself and knocks over a pile of buckets; their confused clattering fall expresses Moll's surrender. In plate 3 Dr Sacheverell, ranting reactionary prebate, is the pin-up by Macheath, and one of Gibson's *Pastoral Letters* is used to hold butter.

Hogarth had been encouraged by the success of George Lillo's *London Merchant* at Drury Lane in the summer of 1731, a play written in prose and dealing with the middle and lower classes. The main character is George Barnwell, apprentice, but the most unusual and forceful is Sarah Millwood, whore, who rounds on her accusers as they lament her abuse of 'such uncommon perfections of mind and body'. She cries: 'if such I had, well may I curse your barbarous sex, who robbed me of 'em, ere I knew their worth, then left me, too late, to count their value by loss!' Lillo too took up the morality tradition and gave it a new birth through realism. Rouquet says that Moll was a clergyman's daughter, and adds that many clergymen with big families had troubles with daughters who had tastes beyond their means, also that whores often claimed such parentage 'to affect a more interesting air'. These points may well have come from Hogarth in conversation without his claiming Moll as a parson's daughter. He may have been recalling Tom Brown's bawd: 'The clergy, I am sure, were much beholden to me, for many a poor parson's daughter have I taken care of, bought her shifts to her back, put a trade into her belly, taught her a pleasant livelihood, that she might support herself like a woman, without being beholden to any body; who otherwise must have turn'd drudge, waited upon some proud minx or other, or else have depended upon relations.' She refers to her trade as having brought up 'whole waggon-loads' of country girls. In the print Moll's goose (who has a certain likeness to her) has a label: 'For my Lofing Cosen in Tems Street in London'. Clearly her relations have not bothered to come to meet her. When we next see Moll she has become the mistress of a rich Sephardic Jew; a mask on the table shows that she goes to masquerades, and symbolizes her deceits. To create a diversion she upsets the tea table while her maid smuggles out the lover she has been entertaining. Why Hogarth brought in a Jew is not clear; he may have wanted to pair two

outsiders, who are trying to gain status in a world not really theirs. But Tom Brown shows that the idea of a whore cheating or fooling a Jew was considered a good joke. 'I sold my maidenhead to fifteen several customers, by the same token seven of them were *Jews,* and it pleases me to think how I cheated those loggerheads in their *Mosaical* indications.'

We have seen that already Hogarth was attracted by the image of something falling or breaking to suggest a moment of crisis, the narrow edge that separates the apparently stable world from chaos. The nature of the situation is further defined by the pictures on the wall. We see Uzzah blasted for touching the Ark of the Covenant, just as the Jew has taken a forbidden Christian girl. Uzzah tries to steady the dangerously tilting Ark as the Jew does the table. A priest stabs Uzzah in the back while the escaping lover's sword seems (by false perspective) to stab the Jew in the back. An antler pattern in the wallpaper expresses the cuckoldry of the Jew, who is parodied by the monkey on the floor. In a second picture Jonah sits by the withered gourd, punished for wanting Nineveh punished after its repentance; clenching fists, he looks towards Uzzah. We are confronting problems of justice and mercy. Moll, though still confident, is about to crash like the tea set that the Jew seeks vainly to save. (*Lo Specchio* shows a lover slipping out as the girl's rich Pole turns up.)

Jews were much in the news round 1732, when they set up a Talmud Torah school. One Osborne wrote a pamphlet accusing the Portuguese Jews of murdering the child of a Jewess married to a Christian; Jews were attacked in the streets till Osborne was arrested and his story disproved. This episode was too late to have affected Hogarth in his choice of the Jew for Moll's keeper, but it shows the sort of emotion liable to erupt in London and make the Uzzah theme all too topical.

Next we see Moll in squalor. On the wall her witch-masquerade costume with its birch broom suggests she has sunk to ministering to perversions. The medicine shows that she is already tainted. She plays with a stolen watch as the cat plays at her feet; she is stupidly amused at the role that betrays her. No fine pictures now. Instead, the two pin-ups and an engraving (after Titian) of Abraham about to sacrifice Isaac, his hand held by an angel. But there is no mercy for Moll. The knot in the bed curtain is twisted into a monstrous face, her nightmare; an unavailing cry out of the human depths comes from the misshapen mouth. The forces of justice are upon her, standing on the doorstep on the right (where Charteris and his pimp stood in the first print). Gonson has come with his warrant.

Now Moll is in Bridewell, worn out and unable to grasp what has happened. The prisoners beat hemp from 6 a.m. for twelve hours; the warder sold the

product and used a little of the food to keep the prisoners just alive. Hence the inscription on the whipping post: The Wages of Idleness. (The scene is thus a parody on the ethic of thrift and hard work.) An effigy of Gonson on the gallows has been scrawled on a shutter, and the hoop-petticoat on the wall has the effect of a huge distorted face crying in agony.

Next we see Moll dying of syphilis, the quarrelling doctors concerned only with the prestige of their curse. Moll still has gowns and masquerade costumes, but her things are being rifled. The table has been overturned, this time decisively by the doctors of her doom. Her small son is absorbed in warming his supper. (The doctors are Rock and Misaubin; Fielding satirized the latter in *The Mock Doctor*, 23 June 1732.) During the 1720s the problem of VD had grown ever more acute, and advertisements making extravagant claims for cures multiplied.

Finally we see Moll's death. The date on the coffin (2 September 1731) gives the date of the set's completion; it is also the anniversary of the Great Fire, a world-end moment. The funeral escutcheon on the wall shows that Moll carries her social pretensions into death. Surrounded by whores and bawds, she is mourned only by her bunter, the most hopelessly lost of all the characters in the story. Death does not halt the lewd game. The parson with glazed eyes has his hand up a whore's petticoat, and she demurely covers it with her hat; the mercer makes advances to another woman.

Richardson, in *Clarissa*, drew on these last two prints. The deathbed of the bawd Mrs Sinclair has its rival doctors more interested in proclaiming their cures than in curing the patients; and there is a group of harlots round the bed. Richardson also uses art symbolism in Hogarth's way. There is Clarissa's portrait in 'the Vandyke taste' and the engraving of St Cecilia over the door that is linked with her fate; other art works are used in description, are recollected or dreamed. As Walpole was a friend of Charteris, Hogarth's prints could be given a political slant. Walpole-Charteris has started off a series of actions and reactions that draw the once-innocent person into an ever worse quagmire of corruption and disaster. We are told that the Opposition asked Hogarth to make the direct application, but he refused. However two pamphlets, one with eight prints, made the point: *Robin's Progress* and *The Stateman's Progress*.

Deeper than any political reference went the religious symbolism. Here again we are at the emblematic level, but concerned with total effect rather than incidental details. Moll's death scene seems derived from an *ars moriendi* blackbook. Certainly Hogarth thinks of the Last Supper. There are twelve mourners; the small boy in whom Moll still lives is in the middle. The coffin is made the table of a funeral supper; by the boy is a plate with

clean-picked fishbones; wine is drunk or spilt. The turned-on tap of the *Nants* jar near the bunter represents the wasted spirit of life; and yet life goes noisily on, with no lesson learned and the child outside it all. That Hogarth was well aware of his under-meanings is shown by his adding of the name Woolston to the authorized copy of plate 2. Woolston was well known for his allegorical interpretation of the Scriptures, which he applied to himself and his world. At times he rationalized: Jesus' miracles were mostly 'foolish, trivial, contradictory, absurd', unworthy of a divinely appointed teacher, and characteristic rather of a sorcerer or wizard. He wrote two letters supposed to be the work of a rabbi against the truth of the Resurrection. Gibson attacked him; the hacks derided him; *Grub-street Journal* commented on 'current happenings in the Woolstonian manner'.

So much of the iconographical tradition indeed had been concerned with sacred subjects that we should expect patterns from the latter to carry over into secular themes. Here we meet the Visitation (1), Annunciation (3), Death of the Virgin (5), her Laying-out (6). Moll is herself M. Mary. In his *Battle of the Pictures* (1745) Hogarth sets against plate 3 a picture of Mary Magdalen at the foot of the Cross, a skull on a rock instead of the breakfast table; Moll is the Unrepentant Magdalen. No Angel visits the Chosen Woman; instead the Bawd appears as one from a better world (of wealth and indolence). The Bell sign above can be taken to mean Belle or the Death-Toll, the reality of the road that Moll chooses. Print 1 is thus a version of the Choice of Hercules. Moll, between irresponsible Duty (the parson) and Pleasure (Mother Needham), turns to the latter.

The breaking down of traditional religious imagery into secularized effects, which is important for Hogarth, is an aspect of his emblematic approach. Once again we find him summing up a tradition that has roots deep in the medieval world, and at the same time ending it by the dominant realistic effect which absorbs the symbol. In the medieval world the system of symbols, the types or objects which had symbolic meaning, were generally understood, and people could take them in and apply them to their lives without much difficulty. But as the medieval synthesis was disintegrated, this method more and more failed to work. Yet the system was deeply rooted in culture at all levels, and it carried on in limited ways for a long time: for instance in satirical broadsheets of the seventeenth century. One way of helping the public to grasp the meaning was to add texts or labels of various kinds to the emblems or hieroglyphics which would not have made any coherent sense otherwise. Or the artist, as with the Dutch, might gain a humorous effect by providing a realistic basis for the symbolic effect: the sort of trick that Hogarth took over when he depicted a man with the horns

of cuckoldry, though the horns in fact belonged to a bull standing behind him. When Moll in her death-throes is merged with the iconography of the dying Virgin Mary, the main effect is realistic, but a lingering effect of the religious image is present, to raise disturbing emotions and to stir questionings in the mind of the spectator. No figures could be less similar than Moll and Mary; and yet they both share the death experience, they both share the essential life–death pattern of humanity. Where does dissimilarity end and similarity begin? How far does Moll as victim repeat an immemorial sacrificial pattern? and so on.

We noted how Hogarth took over from Bunyan the term *Progress* to express the deep pattern of human experience. Bunyan used the emblematic tradition in which every action or event is seen as a spirit intervention helping a man forward or thrusting him down. A stumble in the street is a warning against moral lapse; a bailiff clapping his hand on a man's shoulder speaks of the moment of final arrest when a man must account for all his deeds, and so on. The deep fusion of everyday event and moral significance is what gives Bunyan's work its great force. Hogarth carries straight on from Bunyan, while making the ethical system quite secular. We may add that there is a point where the obsession with emblematic meanings shades over into paranoia. Many times in Hogarth's work an object suggests the gallows. For the paranoiac equivalent we may take D. G. Rossetti's behaviour in June 1872 after his breakdown. He 'showed signs of violence, a party of merry making people passed going to Richmond Park carrying a kind of double pole with a flag. This he called a gibbet, and that it was for him, they being on their way to gibbet him in the Park, and he rushed out of the house shaking his fists at the crowd.' That could be Tom Rakewell in his last stages of collapse.

How then to sum up Hogarth's use of religious symbolism here and elsewhere? In part it is parody. The pattern once handed over to a few divine figures becomes that of all men. Its meaning has been lost or clouded in idealized versions; but, brutally related to the facts of life, it regains force and significance. And so it ceases to be parody. It gives depth and dignity to a life that seemed hopelessly ruined and worthless. Poor Moll has gone the way of Golgotha. In one sense she can only blame herself; she made her choice in plate 1. Yet if we are to evaluate truly the forces at play on her at that moment, we see her as a pathetic puppet. Here then the political and social aspect comes in. Hogarth rightly refused to make any single man, such as Walpole, the villain of the piece; he was indicting society and the class who dominated values. Yet he was not making Moll a mere cipher, an emblem of the destructive forces. She is a living person, who wants to live

her life out to the full. The religious symbolism gives her tragic depth, and also asks the question: Is this recurrent pattern of sacrifice and death the only possible human pattern? What is going to happen to the small boy, who is both inside the events and outside them?

Thus Hogarth achieves a new kind of art, in which everyday life draws on the patterns assumed to apply only to gods and heroes; he declares that life has as rich and great a significance as any of the ideal themes. This revolutionary act was so far-reaching that he himself could face only some of its aspects; and the men of his age, while feeling intuitively the challenge of his art, reacted mostly by jeering or seeing only the more superficial aspects of his deepgoing revaluation. For long the trend was steadily against him and his work. Despite the intrusion of a few realistic elements, portrait painting went on idealizing its subjects, with Reynolds setting out its doctrine. West did at last introduce the contemporary scene into History, but only with a grand imperial theme. He could show as a *Pietà* the death of General Wolfe, not that of Harlot or Rake. The sentimental approach to the everyday scene triumphed. Not till we come to Blake and Turner, to David and Goya, do we find in varying ways the new approach created by Hogarth invading the many fields of art.

Creating such a new kind of art, he was never sure what name to claim for it. Since History was the term used for the highest level of art, he wanted to appropriate it, and perhaps he should have called his work Modern History. But that would have suggested battles and the like to most people, so he fell back on speaking of 'this uncommon way of Painting', or 'a Field unbroke up in any Country or any age', or else 'modern moral subjects', the term moral meaning not so much works that inculcated a lesson as works that dealt with the actual manners and human problems of the day. In hurried notes jotted down some twenty years after the *Harlot* he remarks:

Painters and writers speak and writers never mention, in the historical way of any intermediate species of subjects for painting between the sublime and the grotesque. We will therefore compare subjects for painting with those of the stage – and first of the sublime in both.

But he finds it hard to come to the point. 'Works that most entertain and Improve the mind and are of public utility' are what is with 'most difficulty attain'd if this is true comedy in painting stands first as it is the most capable of all these perfections the latter has been disputed with the *sublime* as it is called.' But 'ocular demonstrations will convince'. He ends, 'the decision left to evry unprejudiced Eye, let figure be consider[d] as Actors dressd for the sublime genteel comedy or same in high or low life'. In desperation he

appeals to the stage for the meaning of the 'sublime genteel comedy' of his work.

In another text he comes down on the term Comedy, which 'represents Nature truely in the familar manner tho not in the most common' – that is, not as in Dutch drolls, in mere genre paintings. The subject is then 'what might very likely have so happen'd' or 'have been so spoke and acted in common life'. Tragedy, however, is 'composed of incidents of a more Extraordinary nature, the language more Elevated and the manner both of acting and speaking more heightened than in common life'. That is, he thinks of tragedy, despite Lillo, in terms of heroic bombast and grandiloquence, 'exaggerated Elevated swoln not only in the language but in all its imports'. In tragedy (on the contemporary stage) 'the actor must swell, the voice enlarges his movements and even his dress is expanded to give it dignity equal to his deportment'. Such a form is so blown up that it has more affinity with burlesque or caricature than with comedy based 'in common life'. He says, 'Tragedy is still true nature but *outréd* to a certain degree so as to fill the idea.' Contemporary practice has so convinced him that tragedy cannot escape this *outré* element that he fails to note the tragic-comic element of his *Progresses* – an element that makes them quite unlike anything ranked as tragedy in his world, but gives them affinities with Shakespeare's method. (These formulations matured round 1750, but the implied attitudes were present from the start.)

He may have been helped by Addison's suggestion in *Spectator* no. 413 of an art category between the Great and the Beautiful, which 'fills the Soul with an agreeable Surprise, gratifies its Curiosity, and gives it an idea of what it was not before possest'. Its virtue was 'to vary Human Life'. Though by no means expressing all that Hogarth saw as the content of the new art, it suggestively pointed in its direction.

A radical change in the form and content of art implies *a change of audience*. Hogarth was bitterly aware that he could get no true response from the main body of existing collectors, critics, connoisseurs, not to mention the dealers who lived by supplying artworks to that body. In the *Harlot's Progress* he made the decisive act which involved the quest for a new audience. Though it was in terms of painting that he thought, he had to find means of translating his paintings into prints. Not just any kind of prints, but the kind that would interest as wide a section of the public as possible. Whereas paintings had a very limited audience, prints could appeal to almost anyone; they ranged from fine reproductions of the works of Old Masters to the crudest of popular woodcuts. Hogarth's problem was to find how to

maximize the appeal of his prints without surrendering his art principles. Literature had been widening its public as the new middle class emerged. Addison and Steele addressed the more genteel sections; Defoe flung his net far wider. He looked mainly to the lower middle class, the social layers that merged at one level with the more genteel sections, but also went down almost to the lowest levels at all literate; he was reaching out to some extent to the same sort of people as those who read Bunyan. Not all the persons in the described layers, of course, in fact read his works; but they were his potential readers. Hogarth appealed to the sort of public that Defoe had attracted, though he also reached out to wider areas of the middle class, such as the respectable tradesmen who were Richardson's readers or the professional groups and the more intelligent gentry who were admirers of Fielding's novels. Thus, a large number of the persons whom he affected or won over were not in any sense art patrons, though they would already have taken some sort of interest in popular prints. This new and large audience was gained entirely by the engravings of his work, whether made by himself or someone else; it was not interested in his paintings. To sell the paintings he had to look more or less to the connoisseurs, who might have a word of mild praise for his Conversation Pieces, but who were not at all ready to buy his new kind of History, whatever name he or others gave to it. Hence a set of difficulties and contradictions that dogged his development and in certain ways inhibited it.

He was not painting works which subservient engravers would then do their best to reproduce in all their qualities; he had to think of the engravings to come even when that went against the grain of his painterly impulse. He packed his spaces, worked out systems of light and shade that would be effective in engravings rather than using a method of baroque gradations towards a light centre, and yet he could not bear to hold himself in and reverse the hands with pens or cups, and so on, so that they would be correct in the print. He had to fight against his wish to paint loosely and fluently, developing his rhythms and his forms by the movement of his brushwork and enjoying the deployment of rich colours and soft tones. He had to keep reminding himself of the need for precision. Early he had failed to control his brush when making the tapestry design for Morris; now he had the same sort of problem from a fresh angle. And yet he could not accept himself as a mere painter of designs for engravers. He had to give some rein to the demand of his brush for free rhythms or he would have been betraying what went deepest in his whole art impulse. So, while accepting the need for some sort of compromise, he did his best to maintain a balance between his feelings and aims as a painter and his need to produce works that could

be reproduced in forms capable of evoking the responses of the new audience at which he aimed. In any event his paintings were too original to sell except to a few eccentric individuals; and if he had carried on their possibilities at all fully he would have lost all contact whatever with the art of his world.

Some of his prints, such as *A Chorus of Singers*, show a sketchy style with broken contours that comes close to the flowing style that he liked in painting; but even when he used a more controlled system of drawing he could not resist broken wavy lines that suggested volume rather than outline. With the *Harlot's Progress* he realized that he must make an effort to imitate the paint effects of tone and texture which buyers had come to expect in fine reproductive prints; otherwise the middle class would not want to hang or paste them on their walls. He tried to carry over the qualities of his paint to some extent in systems of intersecting lines. He used etching for a basis, then turned to the burin to produce the finer effects. Even so, compared with the professional engravers, he neglected the imitation of paint textures, using slight irregularities to gain bolder contrasts and a more vigorous effect of movement. His paintings and his engravings, from the *Harlot's Progress* onwards, reacted on one another, determining the kind of art, at once both popular and learned, which he achieved.

In linking his art with the theatre, Hogarth was able to give a deepened strength to his urge to find a new audience. For what was considered serious art there was only a small audience, largely aristocratic, but the theatre could claim something like a representative section of society. The main body of patrons were upper middle class, no doubt, but there was the footman's gallery and the green boxes of the whores and a sprinkling of odd characters. When Steele in 1720 worked out his playful scheme of a governing board at Drury Lane 'stil'd auditors of the drama', he suggested that they should be elected to represent the ladies, the cits, the wits, and that even a footman who could read and write should be among them. We may add Farquhar's comment in his *Discourse* (1702), that 'the rules of English comedy don't lie in the compass of Aristotle or his followers but in the pit, box, and galleries'. Throughout the century the 'rights' of the spectators were strongly stressed, and they are described as judges or jury. We can see then how Hogarth would find here a relatively popular or democratic system, untrammelled by narrow rules and notions of the ideal, and how he would hope to see such a system active in the realm of art. But despite his efforts to inculcate his ideas on other artists and to find ways of building permanent or temporary art shows, he was in the main limited to his own personal appeal direct to the public over the heads of the connoisseurs.

With his keen eye and mind he must also have noticed how musicians had

found ways of reaching the general public through concert rooms. Their example would have helped him to feel that artists should be better organized and should break through the narrow basis of their patronage.

The paintings for the *Harlot's Progress* were destroyed by fire in 1755, so that we cannot compare them with the engravings. Often in his eagerness to carry out the impulse that led him into a picture, we noted, he did not pause to consider that the work would probably be reversed when an engraving was made; and he himself does not seem to have worked with a mirror when transferring the painted image on to the copper, so that the same relations of left and right were kept. Yet those relations were his pictures. He often speaks of himself as Author rather than Artist, and the term 'reading' has often been used to define the way we look at them. Reading, we begin from the left; and though at first glance we may look at the centre of the picture, we tend to unravel the action by a movement of the eye from left to right. This procedure works well with four of the prints of the *Harlot's Progress*. It is natural to move in print 1 from the waggon and the negligent parson to the girl herself, then to the woman accosting her, and after that to the lechers waiting in the rear on the right. Again in plate 3 we move from the squalid breakfast scene and its various ingredients to the intrusion of Gonson; in plate 5 from the rummaging woman and the disputing doctors to the woman who seems already in her shrouds. In plate 6 the composition is fairly symmetrical, though it is best to have the window looking out into world and thus suggesting a possible escape from the crowded horrors of the room, at the point where we finish scrutinizing the scene. But in plate 2 it might have been better to work from the girl to the startled Jew and then on to the door and the escaping lover; the art works would then read in a better order, the disastrous act of touch leading on to the question of justice and mercy posed by Jonah. And in plate 4 the situation would be better defined if we come up from the squalid pair, out of the gloomy shed, on to the dazed Moll caught between her two tormentors. In any event Hogarth is much concerned with the way he organizes the time sequences inside a scene. Strictly all the actions are going on at the same time; but by the way we analyse the cause and effect inside the situation there is a distinction. Moll is having her breakfast and dangling the watch at the moment Gonson comes in; but we feel that she has been doing these things for some time, and that they are the cause of Gonson's sudden intrusion. The two sets of action do not quite come together emotionally. As we look we wait for the moment when she will be aware of the calamity come upon her, and Gonson will be hurried into movement and direct menace.

But however we analyse the detail, we cannot but feel that time has assumed a new significance in the work of Hogarth. Le Brun had stated that the painter as historian should at times link incidents from different moments so that he might combine the beginning, middle, and end of a theme in a single picture. There is something of this notion in Hogarth's method, but he approaches the combination of moments in a more dynamic and concentrated way than Le Brun could have conceived. His connection of various phases of a situation is made, in part, by his power over the interrelation of forms in movement, in part by the depth of his penetration into the human issues, into the moral cause and effects, which in turn links with the physical concatenation of causes and effects. We should not perhaps make too rigid an application of the left-to-right formula. Thus, in plate 2, the set of strong uprights, door, table drapes, picture frames, curtains, and all the five figures, has the effect of making us look first at the Jew, then, because of the tension between him and Moll, given much force by her outstretched arm, the sweep of her skirts, and the unstable rectangle of the table top, our glance moves round the pair before it looks up to the pictures (first to that dealing with Uzzah) and on to the lover trying to slide out in the background. However we set about the analysis, we find a network of tensions operating inside the pictorial image, drawing all the elements together in a framework of moving time and bringing us as spectators inside the situation in a new way.

6 A Jaunt and Southwark Fair
(1731–3)

*I*n early March 1731 Hogarth issued the subscription ticket for the *Harlot's Progress*, known as *Boys Peeping at Nature*. The composition was adapted from Rubens's *Nature Adorned by the Graces*, which Thornhill had owned. There the three Graces veil the goddess; here three *putti* and a faun show various ways of treating her. One *putto* paints her many-breasted torso; the faun lifts her skirt, obstructed by a second *putto*; the third *putto* draws with his back turned to her; he is the idealizing artist. Nature can be expurgated, ignored, or fully revealed. A tag from Virgil runs: *Seek out your Ancient Mother*. Return to origins, defy contemporary taboos and veils. 'Mother' further suggests a bawd such as Mother Needham, all too ready to lift the veil. The pun is a wry adaptation of the 'old iconographical tradition of lifting the veil from Nature to see her true beauties long concealed by convention, which later in the century became a revolutionary symbol' (Paulson). A tag from Horace runs: 'We have to show a difficult [hidden, *abdita*] subject in new or modern terms; licence is allowed if used with respect or care [*pudenter*].' This may be the advice of the restraining *putto*: Show the truth but in a way that respects Nature. Hogarth is seeking terms acceptable to his world in putting over his new art; by bringing in Antiqua Mater he insists that his modern subject has as much right to serious attention as any bit of mythology or ancient history.

The use of subscriptions for selling books of verse went back to John Taylor the Waterpoet, but it was Dryden's *Virgil* that had proved how profitably the method could be employed. Pope, Gay, and Prior followed the example; Pope's *Homer* brought in nearly £9,000. The poets used prospectuses, advertisements, and personal appeals. Hogarth, with his keen

business eye and his desire to by-pass middlemen, saw how the method could be applied to prints. In place of the modest call for subscriptions by the printsellers, he displayed his work in his studio and developed a high-powered sales technique. He began his advertisements in January 1732, at first giving no name or address, as if he already had his body of ready collectors. Certainly, in the relatively small London of his day, where any celebrity was widely known and talked about, the news of his new venture would have got around among all persons at all interested in art. Fielding's play, *The Lottery*, produced on New Year's day, 1732, told how young Lovermore had come up to town in search of his sweetheart; he finds her in rich lodgings in Pall Mall. 'Ha! by all that's infamous, she is in keeping already; some bawd has made prize of her as she alighted from the stage-coach. – While she has been flying from my arms, she has fallen into the colonel's.' Charteris does not appear in the play, and Fielding must have made the reference to him with knowledge that many in the audience would at once think of Hogarth's print. Charteris himself helped to advertise the print by dying on 24 February; rubbish and dead dogs were thrown into his grave after the coffin. Help was also given by a much talked-of scandal, on which Fielding wrote a play, involving a Jesuit and his 'harlot'. Finally the series was completed to Hogarth's satisfaction and delivered to subscribers. There was to be no reprint, and Hogarth kept his word till 1744 when the re-issue, as well as embodying minor revisions, was marked with a cross at the bottom of each print. Authorized copies (at 4*s* or 5*s* a set as compared with Hogarth's guinea) were issued by Giles King. The advertisement of 18 April, announcing publication and warning against piracies, held the first mention of Hogarth's connection with the series.

Vertue says that 1,240 sets of the guinea series were sold. So Hogarth gained 1,240 guineas, minus the costs, the payment to printing assistants, and the charge for the advertisements. When we add to these figures the large number of persons who must have bought the cheap copies as well as the pirated sets, we see that he had reached an audience running to several thousands. Many thousands more must have looked at the sets on the walls of friends or in the print shops. On 21 April came out a shilling prose pamphlet, *The Progress of a Harlot, As she is described in Six Prints, by the Ingenious Mr. Hogarth*; it seems to be a hack work which had perhaps been lying around and which with a few adaptations was linked with Hogarth. Three days after that came *A Harlot's Progress, or the Humours of Drury Lane*, another shilling pamphlet, but this time genuinely based on the series and including a set of small copies. In little more than two weeks the poem went through four editions, rising in price; and the second edition had its Epistle

to the Ingenious Mr Hogarth. By 5 May the same author produced *The Progress of a Rake* in ten Hudibrastic cantos, which may have given Hogarth the idea for his next series. By the end of June a fan with the scenes of the *Harlot* printed on it was advertised. Pirated sets of prints had promptly accompanied Hogarth's issue. Joseph Gay (J. D. Breval) prefaced *The Lure of Venus; or, a Harlot's Progress* with a rebuke to the pirates, but himself added copies of Hogarth to his poem. By using his pseudonym he hoped to be taken for John Gay.

The stage was not long in cashing in on Hogarth's success. By November Charlotte Charke's comedy, *The Harlot*, was printed, 'shortly to be acted'. In February came *The Decoy, or the Harlot's Progress* (soon renamed *The Jew Decoy'd*), a ballad opera at Goodman's Fields. In March Sadler's Wells had a pantomime on the series, and next month Drury Lane staged T. Cibber's *The Harlot's Progress, or The Ridotto-Al-Fresco*. In June Fielding's *Covent Garden Tragedy* had many references to Hogarth. Stormandra asks: 'Dost think I came last week to town, The Waggon straws yet hanging to my tail?' Lovegirlo boasts: 'The mistress of a Jew shall envy thee; By Jove, I'll force the sooty tribe to own A Christian keeps a whore as well as they.' Stormandra steals a watch from a pocket; hemp-beating is brought in; there is a harlot's funeral and a bawd Mother Punchbowl who rehearses her wretched pillory end.

Thus Hogarth had an unparalleled effect with a set of art works and captured a large popular audience reaching from tavern gossips to professionals and intellectuals. The connoisseurs might ignore the event, as indeed it ignored them. To Vertue and such others it was a successful venture by the Ingenious Mr Hogarth, not a great moment in art history. Supporters like James Ralph in the *Weekly Register* could at best make merely partial defences or panegyrics. Only Hogarth, in a mixture of intuitive insight and theoretical self-justification, understood at all what the event portended.

He must have been deeply excited at his success; at the same time he seems to have felt the need for some sort of holiday after the long strain. On 26 May he was at the Bedford Arms in the evening with some of his best friends: young John Thornhill, Will Tothall, Ebenezer Forrest, Samuel Scott. Forrest, a lawyer, had composed for Rich a ballad opera inspired by the *Beggar's Opera* in 1729. Scott had been painting the settlements of the East India Company in 1731. He was small and solid like Hogarth, his temper made him an easy butt and his friends mocked him for being afraid of his wife. One of the group, perhaps Hogarth, suggested a jaunt. They all went home for a change of clothes, then walked to the Thames side and set off, singing 'Why shou'd wee Quarrell for Riches?'

They arrived first at Billingsgate, where Hogarth made a drawing of a porter who called himself the Duke of Puddle Dock, and pasted it on a cellar door. Hiring a boat, they set sail for Gravesend, trying to sleep in straw despite the rain. Each of them decided to assume a special role. Forrest kept an account of their travels, Hogarth and Scott made drawings, Thornhill produced a map, Tothall acted as treasurer. In Forrest's lively narrative we can follow them throughout the jaunt in all the details of its jollity.

At Poorfleet they drowsed while a pilot told them of 'an Insult offer'd him by the Spaniards and other Affairs of Consequence'. Hogarth, waking up, 'was going to relate a Dream he had, but falling asleep again, when he awak'd had forgott he had Dream'd at all'. They had trouble getting ashore over an obstructing boat, but reached Mrs Bramble's at six, washed themselves, had their wigs powdered, drank coffee, ate toast and butter, and left at eight. After some beer, Scott floundered in clayey ground, then at Rochester they had a fine view of river and ships. At noon they reached a tavern and slept on chairs till dinner. Hogarth and Scott played hopscotch in the colonnade. Then they walked to Chatham, bought shrimps, and boarded two warships. They returned to Rochester to sleep.

Waking at seven on Sunday, Hogarth and Thornhill recounted their dreams, 'and wee entered into a Conversation on that Subject in Bed, and left off, no Wiser than wee begun'. After breakfast they went over the bridge and through Strood. Under a hedge Scott got wet cow dung on his clothes. At Frendesbury they inspected the church and read some bad epitaphs. At Upnor Hogarth drew the castle, and Scott the ships. Forrest bought cockles from a blind old man and a half blind woman in a little cockboat. After a hurry-skurry dinner they had a battle with sticks, pebbles, and pig dung. At Hoo Yard Hogarth was defecating in the churchyard when Tothall applied nettles to his behind; after a scrimmage 'Hogarth Finish'd his Business against the Church Door'. While Scott was talking, one of them filled his pockets with pebbles. After a mock fight with water from a well, they went to the Nagg's Head at Stock. Waiting for supper, they took a walk and fought with soft cow dung. There were only three beds, so they drew lots to see who would sleep on his own. Sheets were damp and gnats stung them badly. Next morning, after a fisherman floured their wigs, they left for Sheerness. The night had been rainy and the going was heavy. An attempt at a short cut led them two miles astray. At the Isle of Grain they stopped at the alehouse of Goody Hubbard; but in the strong wind they had trouble in getting a boat for Sheerness. They managed it by noon and had a look at the fort, with 'Delightful Prospect of the Sea and the Island of Sheppy'. Hogarth was laughed at for 'Sitting Down to Cutt his Toe Nails in the Garrison'.

They walked along the beach in flying spray and Thornhill hurt his leg, but they reached Queensborough about two. Once more they read epitaphs. After supper, walking up a hill where they were told there had once been a medieval palace, they had a talk with two sailors who, with two others, had been left in a creek by the midshipman in charge, the son of a general. They had no money and were half-starved. The jaunters gave the sailors sixpence for victuals. Later one of the sailors came up again and offered them some cockles. 'This Seem'd an Act of so much Gratitude that wee follow'd the fellows into the Town and gave them another Sixpence and they fetched their Companions.'

The jaunters chatted with some pretty women in the town, and put Hogarth in a wooden chair in the street, where he drew with a crowd watching him. At the Mayor's door they met the sailors again, who told them that the midshipman, returning, had come to complain to the Mayor that another sailor would not let him be free with a woman whom he insisted was his wife. At the inn they were outsung by some Harwich men. Next day they climbed up to Minster, read more epitaphs, and inspected the monuments in the church. Hogarth and Scott each drew a tomb and Forrest set down a local legend (later used in the *Ingoldsby Legends*). After dinner they walked to Sheerness and, about five, set sail in a fresh gale for Gravesend. It rained hard and they watched porpoises. They stuck in Blye sand but with Tothall's skilful aid got off again and arrived about ten at Gravesend.

On Wednesday they walked about the town, then hired a boat with clean straw, and set off in a mackerel gale with wine and pipes of tobacco. Scott was drawing some ships when he was drenched by a wave. They left the boat at Billingsgate, got into a wherry, and were taken to Somerset Watergate: 'whence wee walk'd all together and arrived at about Two at the Bedford Arms Covent Garden, in the same Good Humour wee left it to Set out on this Very Pleasant Expedition'. In a few days the account with maps and drawings was bound up with the title: *Five Days' Peregrination*. Tothall added a list of expenses in commercial style, and Hogarth a frontispiece and tailpiece. The first depicted Somebody, a trunk with no head or legs, split down the middle and put together with one side reversed; one half, aided by a stick, turns to Rochester Castle, the other, grasping a spritsail, moves towards the spectator. The tailpiece shows a grinning head with three-cornered hat, legs sticking out straight below. Here is Nobody (No Body), with knife, fork, and spoon round his neck and crossed oars below.

From one angle Forrest's account is a parody of antiquarian trips such as Lambarde's *Perambulation of Kent* (1576), of books like those of the Rev. John Harris. So Hogarth shows his group as Nobodies next to the Anti-

quaries, who are Somebodies. The latter are pretentiously self-important; the former are alive and kicking, interested in eating and rowing. The antiquaries are equated with the connoisseurs who respect anything old and denigrate the work of the present. The two drawings belong to a popular tradition reaching back into the medieval world. Nobody was the original figure, a solitary and a scapegoat; but in England he was paired off with an antagonist, the socially superior Somebody – as in a popular play, printed in 1606, *No-Body and Some-Body*. The actor playing No-Body had huge breeches coming up to his neck – Shakespeare in the *Tempest* refers to a picture of Nobody – while Some-Body wore a jacket exaggerating his trunk and minimizing his legs. (There was a bodiless monster carved over the west door of Chalk church, passed on the way to Rochester; it later fascinated Dickens.) Hogarth's Nobody also had links with the grotesques on the margins of early eighteenth-century prints inspired by Callot. The divided trunk of Somebody reminds us of the popular image of the Hypocrite as a bisected man. An 1689 print shows a man half-priest, half-tradesman, recalling the *Hudibras* couplet: 'Of a Mungrel, diverse kind, *Cleric* before, and *Lay* behind.' In Fielding's *Author's Farce* (1730), puppets of Nobody and Somebody dance to the tune of *Black Jack* (a bawdy ballad referred to in Hogarth's *Rake*). Somebody stands for the Great, the 'knaves or fools, in coat or gown', while jolly Nobody does nothing all his life but snore, drink, roar, rolling from whore to tavern and tavern to whore. Philip Benet's farce, *The Beau's Adventure* (1733) has a hero who confuses everyone by assuming the name of No-body.

We have a manuscript of Hogarth's which shows that he meditated dedicating some work, hardly the *Analysis*, to Nobody:

The no Dedication Not Dedicated to any Prince in Christendom for it might be thought an Idle piece of Arrogance Not Dedicated to any man of quality for it might be thought too assuming Not Dedicated to any learned body of Men, as either of [the] universitys, or the Royal Society it might be thought an uncommon piece of Vanity. Not Dedicated to any particular Friend for fear of offending another. Therefore Dedicated to nobody But if for once we may suppose nobody to be every body, then is this work Dedicated to every body by their most humble and devoted . . .

Finally, Fielding in his *Modern Glossary* (in the *Covent Garden Journal* of 14 January 1752) defined Nobody as 'All the people in Great Britain, except about 1,200'.

Over the last couple of years Hogarth had been busy with the Harlot and various conversation pieces. An important commission was that of *The*

Indian Emperor or The Conquest of Mexico. Dryden's play of that name had been revived in 1731 and was staged before younger members of the Royal Family, mainly at the house of John Conduitt, who had succeeded Newton as Master of the Mint. His daughter Kitty and other youngsters of the upper classes acted the parts. Hogarth chose the moment when Cortez stands between two Indian princesses in the same sort of choice as Macheath in the *Beggar's Opera* pictures. Here the heroic is mocked, not by being aped by criminals, but by being enacted by children in doll-like serious poses. Host and hostess are represented by paintings on the wall, with the presiding bust of Newton. The composition is in two halves: the stage on the right with upright lines – the spectators on the left with their heads going down in a line to the little girl turning back on the front bench, but with further uprights leading to the bust and across to the upper part of the stage. A statue divides and unites the two sections: while there are revolving movements, from the two portraits down into the watching group with its three interrelated circles of interests, across into the four actors, the ring of candles above their heads, the semi-circular window. Probably Hogarth attended a performance, then filled the faces in at separate sittings. The work is his most successful Conversation, elegant and yet strong, formal and yet casual. The two little girls at the front, one absorbed, one turning round for her dropped fan, show how fully he could enter into the emotions and impulses of childhood.

He had come high into the patronage of the great world. In a way he was faced with a choice: to go on with realistic drama or to extend works like the *Emperor* into yet more elegant rococo forms. He must have been tempted by the chances of becoming a very fashionable painter; but circumstances – not the result of mere accident, but the inevitable consequences of his character – were to put an end to any such temptations. Meanwhile he painted the Duke of Cumberland, probably in connection with the play. In 1732–3 he made a *modello*, no doubt to impress the duke, of the Royal Family in a garden setting with table and rotunda; in a more summary version he used an arched interior. (He seems to have had a sitting only from the Prince of Wales, who was in a state of emnity with his parents.)

In later 1733 he took his painting of the drinking club and issued it as a print, *A Midnight Modern Conversation*, though discourse is the last thing that interests the drunkards, each lost in his own sphere of madness. He filled in the space far better than he had done in the painting, balanced the figures, set a man leaning back at each side, made the peri-wigged head at the back a centre to control the staggering outward movements, and strengthened the circular force of the table with a tureen (a little off centre). On 18 December 1732 he advertised the print, saying that he would use sale by subscription to

prevent piracies; five shillings down gained an etched receipt; delivery was to be on 1 March 1733 – earlier if the subscriptions were closed. Picture and print could be seen at his house. This time he had given his own name and address. Advertisements went on, that of 25 January raising the price after publication. The print, when issued, was extremely popular, with many piracies, copies, adaptations; it appeared on saltglaze mugs, punchbowls, snuffboxes, and fan mounts.

The year 1733 was mainly taken up with work on a new series of paintings and engravings. But Hogarth as usual had many other interests. On 5 March he went with Thornhill to see Sarah Malcolm, an Irishwoman, convicted of the murder of two old women and their maid. He painted 'a very exact likeness', said the *Daily Advertiser*. She sits on the left, turning right, her massive form balanced by the bars of the cell door and her bare muscular arms resting heavily on the table. Hogarth remarked to Thornhill: 'I see by this woman's features, that she is capable of any wickedness.' She was hanged two days later. The print from the painting was issued by a printseller, who must have made a large lump offer. It cut down the cell space, made the arms lighter, and lacked the considerable power of the painting. In the latter the grasp of character, the weight of form and simplified design, and above all the fully serious way in which a common woman is treated, make the work a portent, looking forward to the kind of portrait that emerges with the French Revolution, in the work of David and Guéricault.

Hogarth had become friendly with Jonathan Tyers, who had taken over Spring Gardens, Vauxhall. The story goes that Hogarth one day found Tyers in a suicidal mood as a result of his lack of success, and made various suggestions which led to the first Ridotto al Fresco at the Gardens. The grateful Tyers sent him a gold medal which would admit him and a 'coachful' (six persons) at any time. Hogarth liked helping friends and working out schemes; he liked the combination of business and pleasure. And he realized that here was a chance of bringing art, including his own, before the general public over the heads of the connoisseurs. He seems already to have moved to a house in Leicester Fields; he was certainly there by October. On the north side of the Fields stood the House used since 1718 by the Prince of Wales as a lesser court in opposition to his father's. Hogarth took the next-to-last house on the east side; it was three-windows wide and had four storeys with a basement; the door had flanking pilasters and a cornice hood on carved consoles. Above the hood was his sign: a bust of Van Dyck as representing the English school of portraiture, linked with Flanders and Holland, as against the schools of France and Italy. (An unused passage of the *Analysis* gives his opinion of Van Dyck, scholar of Rubens, who 'perhaps for fear of

running into what he might think gross in his masters manner, Imitated Nature just as it chanc'd to present itself, and having an exact Eye produced excessive true imitations of it with great delicacy and Simplicity, but when Nature flag'd he was Tame not having principles which might have raised his Ideas, however grace often appears in his best works'.) The house faced east and west, so that he needed north lights; he built a studio. A showroom for *modelli* and samples, where paintings or engravings could be open to the public, was doubtless on the ground floor. The servants would have inhabited the top, the family the other upper floors, with kitchen and menials in the basement or cellar. By the 1750s he had at least six servants; for his new house he would have needed at least three or four.

In the autumn he saw the chance for a spectacular work that would open up royal patronage: the marriage of the deformed Prince of Orange with the fat lump of a Princess Royal. He applied to the Queen (Vertue says to some Lady about her) for leave to 'make a draught of the ceremony & chappel & paint it & make a print of it for the public'. Hervey, Vice-Chancellor, may have helped, out of a malicious interest in seeing what he would make of the odd couple. Some courtiers, however, may have brought up the fact that he was understood to have been joking at Anne's solid thick-necked figure in his print for Fielding's *Tragedy of Tragedies* (1731), a second version of *Tom Thumb*. Anne was shown as Huncamunca: 'Thy pouting breasts, like kettledrums of brass, Beat everlasting loud alarms of joy.' But more likely the interference came from Kent as Master Craftsman, who may well have been reminded of Hogarth by a print of this year, which revived his depiction of Burlington House with Kent's statue above the Gate; Pope and Burlington, whitewashing the Gate, spatter Thornhill's patron, the Duke of Chandos, as he passes. Many contemporaries, as well as later critics, took it for granted as Hogarth's work, and in any event it would have reminded Kent of *Masquerades*. He complained of Hogarth's intrusion on the marriage, and was supported by Grafton, Burlington's son-in-law and Lord Chamberlain.

The French Chapel by St James's Palace was being redecorated and a passage to it constructed.

When Hogarth came there to begin his draught, he was by Mr Kents interest ordered to desist. Hogarth alledged the Queens orders, but Ld Chamberlain himself in person insisted upon his being turned out, and not to pursue any such design. at least he was deprivd of the oppertunity of pursuing it of which, when the Queen had notice, she answerd she had granted such a leave but not reflecting it might be of use or advantage to Mr Kent, which she wouldnt interfear with, or any thing to his profit.

Vertue adds that Hogarth complained that 'he had some time ago begun a picture of all the Royal family in one peice by order the Sketch being made. & the P William the Duke had sat to him for one. this also had been stopt. so that he can't proceed.' Vertue, who seems to have been jotting down comments that he heard Hogarth make, goes on:

these are sad Mortifications to an Ingenious Man But its the effect of carica-tures wch he has heretofore toucht Mr Kent. & diverted the Town. which now he is like to pay for, when he least thought on it. add that there is some other causes relating to Sr James Thornhill, whose daughter is marryd to Mr Hogarth. and is blended with interest & spirit of opposition – Hogarth has so far lost the advantage of drawing but has mostly encouragement from the subscriptions for those designs of inventions he does. – this prodigious genius of invention characters likeness. so ready is beyond all others.

As Vertue says, the check was inevitable. Hogarth could not combine the roles of courtier and free commentator. The meek Mercier was now Gentle-man Usher to the Princess Royal, painting the three elder princesses, but such preferments were not for Hogarth. (The marriage was postponed through the prince's illness to 14 March 1734, when Kent made a dull print of it.)

During 1733 Hogarth met a much more suitable patron than the royal family. Mary Edwards in 1728, aged twenty-four, had inherited the largest fortune in England, bringing in some fifty to sixty thousand pounds a year. It had been built up by such works as the building of new roads and the reclamation of a large portion of Lincolnshire from the sea. In a hasty Fleet wedding, 1731, she married a son of the Duke of Hamilton, five years her junior, who took the name of Edwards to assure his control of the money. But she, strongly independent, chafed at his attempts of domination and had all records of her clandestine marriage erased. Her child was made illegiti-mate, but she recovered her property and all its rights. She inherited an interest in Hogarth from her father, who had been an early collector of his work, and commissioned a painting of her son in his cradle.

By October he was working on his new *Rake* series and on a single print depicting Southwark Fair. He seems to have tried to shift from the king's camp to that of the Prince of Wales, painting the heads of the prince and some of his associates; he also did the faces in works by the horse-painter J. Wootton, who generally used Jervas. On 9 October he advertised a print on the Humours of a Fair and others on the Progress of a Rake. The *Fair*, already completed, would be delivered on the first day of 1734 at five shillings a copy; the *Rake* would cost a guinea and a half, the half being paid in advance. Again he stressed that his procedure was aimed at preventing

the production of 'base Copies, before he can reap the reasonable Advantage of his own Performance'. The ticket was an etching of a theatre audience. It showed the unconcerned musicians in front, the relaxed jovial pit, lecherous gentlemen accosting orange-sellers or other women. The lines converge on the critic, the one bored self-conscious face.

Why did Hogarth paint Southwark Fair instead of Bartholomew Fair with its deep memories? He may have been put off by a print of the latter issued that August; or he may have been drawn to Southwark (according to a story) through rescuing a beautiful girl, shown in the print as the drummer at the centre, from an insolent roysterer. But he may have grown interested in Southwark for itself. There, unlike the City, was a thick industrial area, stinking with tanneries and breweries, its dockside taverns full of sailors, beggars, uprooted men. In the print, all round the girl, are merrymakers, with booths and signs above. On either side, beyond the church, we glimpse open country. For the first and almost the last time Hogarth uses nature for a peaceful contrast with the human hurly-burly. At first glance we see a scene of jollity, but a closer look shows conflict and disaster everywhere. An actor in a rich costume is being arrested by a bailiff. The rope-dancer or plunger evokes memories of the many attempts to 'fly' from heaven to earth, usually down a rope attached to church tower or steeple, which often ended in a crash. On the right, near the tower, a man is in fact falling as if out of the sky.

The supreme crash occurs with actors playing kings in the *Fall of Bajazet*. Toppling from their rickety stage, they are about to land on unsuspecting gamblers and on a china shop. (Scaffoldings often broke down, as at Sarah Malcolm's hanging.) Swift in his *Bickerstaff Papers* links the fall of a booth at Bartholomew Fair with the confused crashings in the kingdom of Poland. Hogarth may also be thinking of Coypel's Don Quixote smashing the puppets; the threshing legs of the actress among the timbers may come from Brueghel's *Fall of the Magician*. The ominous situation is stressed by booths advertising the Siege of Troy and the Fall of Man, and by the fate of Punch's victim. The man falling out of the sky is just above Adam and Eve.

The players, acting the Fall of Man, are themselves rent by conflict. Above the collapsing booth is a copy of a print by John Laguerre which depicts the two groups locked in struggle at Drury Lane after the retirement of the old patentee. The group led by T. Cibber (who had helped the company in hard times by his version of the *Harlot's Progress*) finally broke away and moved to the Little Theatre in the Haymarket. Hogarth was in the midst of the disputes, for two of his best friends, Ellys and Fielding, continued to work with the group led by Highmore; but his version of Laguerre's print takes no

sides. (Throughout the season two versions of the *Harlot* played at both Bartholomew and Southwark Fairs; as he announced his plate one such play, 'with the Diverting Business of the Yorkshire Waggoner', was still to be seen.)

The theme of the Fall takes many minor shapes among the crowd. A man has his pocket picked; a quack pretends to swallow fire while his zany sells medicines; a man decoys two country girls – one is a close copy of Moll in the *Harlot* (1). A Savoyard woman, with hurdy-gurdy slung on back, works a peepshow; a broadsword fighter, probably James Figg, sits on a blind horse awaiting a challenger. Hat and chemise on poles seem to represent prizes for wrestling, racing, and such contests. The rowdy ravenous scene goes on under the booths or balconies of the dramas, as if its shifty and shifting confusion mirrors in broken ways the themes of gods aloft; the fliers vainly try to link the two spheres. The church is masked by booths and play-signs, but the bell of doom hangs in the sky, which in its spacious depth merely brings out more starkly the pathos of the massed human effort to find joy and release by self-destructive means. The crash of the upper world on to the unregarding crowd below means the end of all illusion.

Mary Edwards bought the painting; another example of her unconventionality. During 1733 she commissioned a conversation piece of her family. They appear on the terrace of her Kensington house. She holds a copy of the *Spectator* and reads out a passage on the virtuous way to rear children.

The years 1731–3 were then rather a lull for Hogarth, who needed to reconsider his position. He had achieved a great success, but its nature had distanced him from the accepted art world and its values rather than brought him into its fold. Thrown back on himself, he discovered the mass scene as an engrossing subject. In his *South Sea Scheme* he had depicted a number of people acting together in terms of a worked-out allegory; in *Southwark Fair* the drama with its contrast of free energies, and tragic frustrations had come out of the gathering of people itself. We may further note the complexity with which the theatral concept is used. First we have the Fair itself, a scene of entangled entertainers and audiences. Here life is always ready to intervene in the show, and the show to stimulate or upset life. Everyone is simultaneously audience and performer. But above this mass involvement of art and life there are the more detached booths of performers, in which the comment of art on life is more concentrated; yet even here too, as with the collapsing platform, the theatral show is liable to break up or irrupt into the life it depicts. The symbolic fall becomes an actual fall. Finally the stage world itself is rent by conflicts or mutinies from within. At all levels there is both union and contradiction between the representation and what is represented.

7 Rake's Progress (1734–5)

The Grand Lodge dinner for 1734 came on Saturday 30 March. The Freemasons marched in white aprons and gloves to Cheapside. After dinner the twelve stewards named their successors for the year; Thomas Slaughter, coffee-house proprietor, chose Hogarth. Slaughter's place was a centre for wits and artists on the west side of St Martin's Lane. One frequenter was Francis Hayman, who made many paintings for Vauxhall Gardens. Once, it is said, he and Hogarth were in a brothel; two whores quarrelled and one squirted a mouthful of wine at the other. Hogarth cried in delight: 'Frank, mind the bitch's mouth!' He seems to have used the episode in his *Rake*. There were many clubs to which it was useful for an artist to belong. The Society of Virtuosi of St Luke had many influential members. Vertue was a member, as was Laroon, who, challenged about a picture he had advised Walpole to buy as a Van Dyck in 1729, replied very much in Hogarthian vein:

I Challange any or all of your Top Tip Top Top-most Conoisseurs, Proffessors & Judges in the Art of painting (beside all Pretenders.) From the Highest to the Lowest, of every degree whatsoever Chafferers bidders & buyers of pictures. their Bullies Baudes & Panders. From the Great great. Director & privy Councellor to Noblemen & Gentlemen that purchase Pictures – Down to the lowest scrubb even to *Nunis* the Jew all I do solemnly Challenge & every one of them defy to compare with me in Judgment & Art – wittness, *my hand* with sword & Pencil.

There was also the Rose and Crown, whose members called themselves Rosacoronians, not so reputable. And 1734 saw the exclusive Society of Rosicrucians, composed of gentry who had made the tour to Italy and

wanted to encourage 'a taste for those objects which had contributed so much to their entertainment abroad'. They included a few learned men and had an artist to paint their portraits, but at core they got together for hard drinking. There were also music clubs, one of which met for years at the house of Samuel Scott. (The 1730s saw the rise of the public concert, the music club and conversazione, so that theatre attendances were affected.)

The formation of the Dilettantis represented a setback for the principles for which Hogarth was fighting. There was a fresh influx of continental artists such as Amigoni and Vanloo. Amigoni decorated Rich's new theatre in a weak Venetian style, and painted many high personages. Hogarth, looking for ways to counter the invasion, found a confused ally in Ralph of the *Weekly Examiner* who, in essays from mid-October 1733 to April 1734, attempted a review of public buildings, statues, ornaments in and about London and Westminster. Unfortunately he attacked the 'gothicism of Hawksmoor' and supported Palladianism; but on 27 April he remarked that Protestantism hindered the growth of religious art so that commissions should be sought from 'Hospitals, Courts of Justice, Theatres, City-Halls', and the like. Hogarth had learned that Amigoni was discussing with the governors of St Bartholomew's Hospital the decoration of the new staircase and perhaps the great hall. He intruded and offered to do the staircase free. Agreement was reached by 20 February 1734, and three days later Ralph announced that Hogarth was to paint 'the Histories of the Pool of Bethesda and the Good Samaritan'.

On 4 May Thornhill died. His death ended the period of baroque decoration in England. The obituaries were laudatory. The *Daily Journal* called him 'the greatest history painter' produced by England: an opinion repeated in the *Grub-street Journal* and the *Weekly Register*. The *Gentleman's Magazine* referred to his son-in-law as 'admir'd for his curious Miniature Conversation Paintings', ignoring the engravings.

In July Hogarth was nominated and elected as a governor of the Hospital. In November he announced delays with his new series of prints; he wanted to introduce new characters. Probably he was merely holding things up till he had a safeguard against piracies. He wrote, or got a friend to help him in writing, a pamphlet in the form of a petition to Parliament. No doubt he had discussed the whole thing with Thornhill and friends at Slaughter's, with Huggins brought in to make the legal draft. The Act for which he hoped was based on the 1710 Act covering literary copyright. The pamphlet declared that artists were 'oppress'd by the Tyranny of the Rich', and makes references to the 'Monopoly of the Rich' – 'Not the Rich, who are above them; not the Rich of their own Profession; but the Rich of that very Trade which cou'd

not subsist without them', the printsellers who exploit the designer, his engraver, and the hacks doing cheap copies: 'Men who have all gone through the same Distress in some degree or other; and are now kept Night and Day at work at miserable Prices, whilst the overgrown Shopkeeper has the main profit of their Labour.' Further, if one of the printsellers 'should dare to exceed the stated Price for any Print he should think more valuable than ordinary; Copies are immediately procured by the others, and sold at any Price, in order to suppress such a Rebellion against the Monopoly of the Rich'.

Artists themselves lack houses 'conveniently situated for exposing their Prints to Sale', or they have 'much more advantageous Ways of spending their Time than in shewing the Prints to their Customers'. All artists, including those who design buildings or gardens, need protection by the law. There must be sanctions against any artist copying another's design, even if he makes some slight alterations to it. The moral drawn is that the improvement of the arts in England depends on the artists' getting their just profits, a chance to sell their wares, and the possibility of having their works well engraved. Also, 'when every one is secure of the Fruits of his own Labour, the number of Artists will be every Day increasing', so that a bigger choice of works will be available at lower prices and even the villainous printsellers will in the end do better.

There is a strong personal emotion in the pamphlet, and the term used, 'the Monopoly of the Rich', keeps on appearing to give the accusations a far more comprehensive reach than is borne out by the facts. The proclamation of a brotherhood of artists ends with the prophecy of increased competition among them.

The Rake's Progress, which Hogarth wanted to protect, consisted of eight plates. First we see Tom Rakewell, come down from Oxford to take over his inheritance in the meanly furnished room where his miserly father used to work. The latter's penurious ways are stressed in object after object; even the Bible has had its cover cut to provide a shoe-sole. Tom is trying to buy off Sarah Young whom he has got pregnant at Oxford; he offers some of his father's money while a steward (or lawyer) steals coins from the table. All the while the tailor measures Tom. Next we see Tom, still wearing his nightcap, at his morning levee, surrounded by his hangers-on: landscape gardener, musician, jockey, dancing master, fencing master, hireling man-of-honour (in case of duels), and so on. The painting on the wall, *The Judgement of Paris*, suggests his disastrous moment of choice and shows him as a duped buyer of dark pictures.

Next we see him in the Rose Tavern, Drury Lane. He has been in a drunken brawl with the watch. Almost everything in the room is broken and a neglected girl sets fire to a map of the world on the wall. Tom's watch is being stolen. The porter, Leather Coat, brings in a platter on which the posture-woman, busily undressing, will squat naked and whirl about. The porter holds a candle: 'You may be left to guess,' says Rouquet, 'what is its destination.'

Next Tom is in St James's Street with the palace at the back. Like the others in sedan chairs he is on his way to a royal levee on the Queen's birthday: St David's Day, shown by the leeks in Welshmen's hats. Two bailiffs stop Tom's chair and arrest him for debt, while Sarah offers her purse to save him. (The sewing-box shows that she is a seamstress; she has chanced to pass at this moment.) Tom has become a place-seeker, hoping to recoup his losses by high patronage. In the first state of the print the sky is clear; in the second, boys gamble with cards close by him and the building by the palace is labelled White's. Tom has destroyed himself by gambling and the darkened sky is rent by lightning that points down to the club. (Thomas Wilson wrote in his diary, 23 December 1750: 'Gambling and Luxury and Extravagance amongst the great being never at a higher or more shameful height, no government upon earth but ours would suffer such a place as White's Chocolate House in the sight of the Court.')

Next we see Tom marrying an old woman for her money in Marylebone Old Church, often used for hasty or secret unions. Sarah and her mother vainly try to get in. The church is in a bad way, suggesting malpractices by the churchwardens, whom an inscription names as doing renovations in 1725; the charity boy with the cassock is ragged; the poor-box is cobwebbed. The IHS on the pulpit cloth makes a mock halo for the old woman; and two courting dogs (the bitch one-eyed like the woman, the other apparently Hogarth's pug) symbolize the degraded marriage. Evergreens on the altar suggest the wife's unfailing lust and her wintry wedding. The Creed is torn or decayed; a crack stops at the tenth commandment, which forbids the coveting of someone else's wife. (Bishop Horne, in a sermon, cited a Cirencester bill: 'To mending the Commandments, altering the belief, and making a new Lord's Prayer, 21*l* 1*s*.') Tom has cocked an eye at the bridesmaid.

But he goes on gambling and losing. We see him in a gambling hell, no doubt White's where a fire broke out 3 May 1733. Here flames are about to burst through the wall, unnoticed by the obsessed gamblers. By the hearth sits a highwayman who has lost his loot, while a watchman with lantern comes in at the opposite side. The gamblers show all the stages of mania from

keen hope and fierce involvement to misery and apathetic breakdown. Tom is at a dead end. Wigless, he has knocked his chair over and fallen to his knees, with a scared dog barking at him; he flings up his right arm with clenched fist in a blind defiance of heaven. His next destination is the Fleet, gaoled for debt. His old wife shouts abuse in his ear, while Sarah, accompanied by their child, is in convulsions. Tom is absorbed in his misery, failing to note the boy with beer like the highwayman in the previous plate. The wild schemes of the prisoners repeat what Hogarth knew from his experiences with his father. Tom tries to write a comedy, which Rich rejects; other debtors try alchemy, astrology, flight by means of wings, projects for paying the national debt. A turnkey demands garnish money.

Bedlam is the only end for Tom now. We see him there in his final paroxysms. Two fashionable young women have come to amuse themselves at the sight of the lunatics. A religious fanatic adores a wooden cross; a man who thinks himself a king pisses unconcernedly towards the visitors. A man calculates the longitude on the wall, with an astrologer and a mad tailor. By the stairs is a musician who thinks himself the Pope, and a melancholy lover. In the foreground Tom lies nearly naked in a fit, attended by Sarah, while an attendant claps on (or removes) his manacles. His pose, especially in the painting, is that of a *Pietà*.

Behind the series lies ultimately the Italian prints as well as novels like Mrs Davys's *Accomplish'd Rake* (1727). In general the theme of the rake and his downfall was common enough. Steele had cautioned against imitating the rakes and Fielding wrote a play, *The Temple Beau*. We have a painting by Hogarth which may represent a first attempt to tackle the subject, though it could not have been meant for the existing series. Here the rake marries a rich old lady, amid a litter of art objects (connoisseurs' rubbish), with his hangers-on at the back.

Even plainer than with the *Harlot* is the theme of a disastrous imitation of the upper classes. Tom, like a character in Colman and Garrick's play, the *Clandestine Marriage* (itself suggested by the later series *Marriage à la Mode*), feels sure that he was 'born to move in the sphere of the Great World'. As a newspaper of 1756 wrote: 'The imitating of every station above our own seems to be the first principle of the *Genteel Mania*, and operates with equal efficacy upon the tenth cousin of a woman of quality and her acquaintance who retails *Gentility* among her neighbours in the Borough.' Such complaints are sure to arise in a society that inherits and seeks to maintain rigid class limits, yet is being submitted to sharp changes through the impact of money; but the force of Hogarth's presentation of the situation is all his own. He is condemning both the imitated values and the dupes who feel driven to

imitate. Since clothes in such a world become to a large degree the measure of status, of worth, they play an important part in the drama. The tailor measuring Tom for a new suit in the first plate is the man who stands between his old and his new life, while the portrait of the muffled-up miser-father at the back provides the contrast. In the next plate the elaborate dressing gown sets the key of Tom's swaggering changes, as his disordered clothes among the whores his way of life. Turning to the court, he seeks to be elegant, and he is dressed up in all dignity at the marriage. His decline appears in the loss of his wig, his poor gaol-clothes, his final stark nakedness.

The *Analysis* testifies to the amount of thought Hogarth gave to the question of dress. He discusses it in relation to Quantity, and again in relation to Uniformity and Variety. 'Dress is so copious a Topick, it would afford sufficient matter for a Large Volume of itself.' He dislikes all forms that distort or injure the body's natural shape, and insists that costume is an aspect of character. Drapery

also gives a fine latitude to light Shade and colour so that it makes History painting in what is called the grand stile so much less difficult to perform than storys of the present age were every part of dress is known to be a part of character, as writing comedy is more difficult than writing Tragedy. we speak of true comedy in painting not of dutch drols.

As usual the Tragedy he envisages is the inflated type that had ruled ever since the Restoration. Against it he sets his own form of True Comedy, which included the tragic consequences of folly and vice. Dress both reveals and masks character; it has the emblematic quality of taking on a life of its own, which either enhances or destroys the nature of the wearer. We must turn to Swift for the fullest working-out of the satirical symbolism here involved. His fantasia on Clothes brings out with great force his closeness to Hogarth in idea and method. In the *Tale of a Tub* he describes a Sect whose tenets have spready widely 'especially in the grande monde, and among every body of good fashion. They worshipped a sort of idol, who, as their doctrine delivered, did daily create men by a kind of manufactory operation.' The belief of these worshippers 'seemed to turn upon the following fundamentals':

They held the universe to be a large suit of clothes, which invests everything: that the earth is invested by the air; the air is invested by the stars; and the stars are invested by the *primum mobile*. Look on this globe of earth, you will find it to be a very complete and fashionable dress. What is that which some call land, but a fine coat faced with green? or the sea, but a waistcoat of water-tabby? Proceed to the particular works of the creation, you will find now curious journeyman Nature has been to trim up the vegetable beaux; observe how sparkish a periwig adorns the head of a beech,

and what a fine doublet of white satin is worn by the birch. To conclude from all, what is man himself but a micro-coat, or rather a complete suit of clothes with all its trimmings? as to his body there can be no dispute; but examine even the acquirements of his mind, you will find them all contribute in their order towards furnishing out an exact dress: to instance no more; is not religion a cloak, honesty a pair of shoes worn out in the dirt, self-love a surtout, vanity a shirt, and conscience a pair of breeches, which, though a cover for lewdness as well as nastiness, is easily slipt down for the service of both?

It follows that what the world 'improperly calls suits of clothes, are in reality the most refined species of animals; or to proceed higher, that they are rational creatures, or men'.

For is it not manifest that they live, and move, and talk, and perform all other offices of human life? are not beauty, and wit, and mien, and breeding, their inseparable proprieties? in short, we see nothing but them, hear nothing but them. Is it not they who walk the streets, fill up parliament, coffee-, play-, bawdy-houses? It is true, indeed, that these animals, which are vulgarly called suits of clothes, or dresses, do according to certain compositions, receive different appelations. If one of them be trimmed up with a gold chain, and a red gown, and a white rod, and a great horse, it is called a *lord mayor*; if certain ermines and furs be placed in a certain position, we style them a *judge;* and so an apt conjunction of lawn and black satin we entitle a *bishop*.

In a plate like that on the solar eclipse Hogarth was using exactly the same method as Swift here, declaring that persons who think themselves distinctive in their roles of power and display are in fact degenerating into mere social stereotypes, into things. In a work like the *Rake* he is, however, a satirist only at one level; he is also a poet with a tragic sense who shows how the domination of the human being by things involves a dark struggle liable to end in the dereliction of the human essence. Swift, we may note, begins his list of eligible persons, in *A Serious and Useful Scheme to Make an Hospital for Incurables*, with the extravagant heir who ruins himself, and then goes on to the miser. In *An Essay on Modern Education*, near the end, he deals with the son of the avaricious rich-man, who becomes 'a spendthrift, a cully, a profligate, and goes out of the world a beggar. . . .'

Foreign visitors agreed that there were extreme strains in English life which brought about an appalling prevalence of suicide. De Saussure in 1722 'fell into the deepest and blackest melancholy', but was saved from suicide by removing to a village on a course of fresh air and milk. George Cheyne in 1733 saw nervous disorders as the English disease and denounced the idea that riotous living, which caused the trouble, could alleviate it. A mock advertisement in the *Gentleman's Magazine* in 1755 offered a Stygian

spirit by which men could commit suicide 'even when in company without distressing or inconveniencing those around them'. It addressed itself to the men of pleasure who destroyed themselves prematurely 'by *fast living*, now commonly called *sporting*, formerly stigmatized by the name of *whoring* and *drunkenness*'.

England, where the feudal structure had been decisively ruptured by the Cromwellian Revolution, showed far greater social mobility than the continent. Voltaire, visiting in 1726, was amazed at the elegant dresses of servant girls at Greenwich Fair, who managed their hired horses with such ease that he took them for 'people of fashion'. Defoe, in *Everybody's Business, Nobody's Business*, said that it was hard to tell mistress from maid; the maid was often the finer. Though she might earn up to £8 a year, she could not dress on that; hence the crowding of the assizes with maids who had robbed mistresses. No doubt he exaggerates, but he notes a definite tendency. Hogarth's four series all deal with the question of rising in the world. The Harlot takes the easy way to being a lady of leisure; Tom, a merchant's son, apes the young noble; the merchant's daughter ruins herself by marrying above her class; in *Industry* the good apprentice rises high in the City by marrying his master's daughter. Richardson's *Pamela* dealt with the chaste servant who teases her master into marrying her, and such unions did occur. Fielding's second wife was his own housemaid, who bore him a son. Sterne is recorded as saying of Dr——'s marriage with his housemaid: 'Ay, I always thought him a genius and now I'm sure of it' – meaning that the Doctor could see virtues where others missed them. In Townley's play *High Life Below Stairs* the servants snobbishly assume among themselves the titles of their masters. At Vauxhall 'Lady Char' cries out: 'O, my stars: Why, there's nobody here but filthy citizens!' The servants known as the Duke and the Baronet challenge one another to a duel.

The choice-theme appears throughout. Tom at the outset stands between money (high life) and love (Sarah). He next stands amid competing pleasure under a painting of Paris; then amid the various charms of the whores. After that he is caught between bailiff and Sarah, again money and love: between different forms of dissipation and crime; between the old wife (money again) and Sarah; finally between Sarah and warden (clergyman in the second state). Sarah, except perhaps in the first plate, has a forced role; we cannot believe in her as a person. But Hogarth needed her to keep on stressing the aspect of choice and to remind us that there is another way of life than self-destruction. Sarah is a symbol of the 'natural way of life' as opposed to the way of false social objectives; in the *Harlot* the 'natural girl' and the creature perverted by the lures are both inside Moll. (In the *Harlot* pantomime at the

end, the scene changes to the Ridotto al Fresco, Vauxhall, where a masque, *The Judgement of Paris*, is performed.)

Hogarth must often have visited Bedlam, where in 1734–5 the governors were seeking subscriptions to pay the debt for the new wing to house female incurables. Two statues by Gaius Gabriel Cibber stood over the big gates (on the model of Michelangelo's *Night* and *Morning*), representing Raving Madness, chained and about to burst out, and Melancholy Madness, staring round vacantly. Hogarth used the first in his depiction of Tom, the second in that of the fanatic. The more he considered the world and his own art, the more he felt that Bedlam was England and England was Bedlam. Swift recognized his kinship with Hogarth in the construction of such an image. In 1736 he ended his *Legion Club*, a tour of the Irish House of Commons as if it were a Bedlam, with an invocation:

> *How I want thee, humourous* Hogart?
> *Thou I hear, a pleasant Rogue art;*
> *Were but you and I acquainted,*
> *Every Monster should be painted;*
> *You should try your graving Tools*
> *On this odious Group of Fools;*
> *Draw the Beasts as I describe 'em,*
> *Form their Features, while I gibe them;*
> *Draw them like, for I assure you,*
> *You will need no* Car'catura;
> *Draw them so that we may trace*
> *All the Soul in every Face.*

Hogarth sent Swift a set; but it was not till 1740 that he received a grateful reply via Swift's publisher, George Faulkner, Swift being unable now to reply for himself. Faulkner said that Swift 'is a great Admirer of yours'. There had been a link through Mrs Delaney (Pendarves). It is pleasant to be able to record that Swift and Hogarth, who, for all their differences, had something deeply akin, thus exchanged tokens of regard and recognition.

A world-end image occurs also in plate 3 where one of the whores sets fire to the map of the world; VD has already infected the Rake and ensured his doom, as it did that of Moll. The compositions tend to be far more dramatic than those of the *Harlot;* Hogarth has broken away from the Raphaelesque band and (especially in plates 3, 6, 7, 8) is not afraid of a scene of disorder and confusion which he controls by complex balances and bold emphases. Generally the effects are superior in the paintings than in the engravings where left and right are reversed. Thus in plate 3 we start from

the Rake and move across the table of whores to the posture-woman and the platter; in the painting our eye moves up the leg of the posture-woman and is drawn by her turned head towards the entangled but circling group that comes to rest on the sprawling Tom. In the painting of the gambling hell we move from the relatively quiet nook of the highwayman into a scene which again has its circling structure, broken in various ways and dominated by Tom. His arms make a long tense line of rage and madness, which both disrupts the scene and controls it, reaching up and out towards the candle-stand with its flames. The smoke pouring out above makes it seem that the whore of plate 3 has truly set the chaotic world on fire. Here then the arms swing us into the tumult; in the engraving we are led along the fallen chair to come up against the arms as a barrier, and the entry at the door occurs at the beginning instead of the end.

The inequalities in treatment, both in the paintings and the plates, may come from a certain inner agitation caused by the theme; or from the strain put on his powers by the more ambitious systems that he seeks to devise. Oddly he makes all the whores brightly white-and-rosy in their complexions as if they were pampered ladies; but the tavern painting is wonderfully vivid and rich in its handling, and the yellow-green light that drifts through Bedlam (contrasted with the salmon-pink in the dress of the lady come from the outside world) is powerfully evocative. The salmon-pink carries one's mind back to the Rake in his dressing gown, in his brief days of glory, and thus suggests a different relation between the outer world and Bedlam; the gay colour is not merely the sign of the carefree world which finds Bedlam a source of mocking merriment, but also stands for the flaunted disregard of reality which leads to Bedlam in the end.

Hogarth sets out his ideas on colour in Chapter 14 of the *Analysis*. He concentrates on flesh colour, 'the nature and effect of the prime tint of flesh; for the composition of this, when rightly understood, comprehends every thing that can be said of the colouring of all other objects whatever'. He then discusses 'nature's curious ways of producing all sorts of complexions, which may help to further our conception of the principles of varying colours, so as to see why they cause the effect of beauty'. He analyses the cutis on lines that we noticed above when considering the way in which work processes (here weaving) affected his thought. He has clearly read or listened to discussions on the prismatic analysis of light:

There are but three original colours in painting besides black and white, viz. red, yellow and blue. Green, and purple, are compounded; the first of blue and yellow, the latter of red and blue; however these compounds being

so distinctly different from the original colours, we will rank them as such. Fig. 94 [of his second plate] represents, mixt up, as on a painter's pallet, scales of these five original colours divided into seven classes, 1, 2, 3, 4, 5, 6, 7. – 4, is the medium, and most brilliant class, being that which will appear a firm red, when those of 5, 6, 7, would deviate into white, and those of 1, 2, 3, would sink into black, either by twilight or at a moderate distance from the eye, which shows 4 to be brightest, and a more permanent colour than the rest. But as white is nearest to light it may be said to be equal if not superior in value as to beauty, with class 4. therefore the classes 5.6.7, have also, almost equal beauty with it too, because what they lose of their brilliancy and permanency of colour, they gain from the white or light; whereas 3, 2, 1, absolutely lose their beauty by degrees as they approach nearer to black, the representative of darkness.

We see then that he quite consciously wanted to drive his palette up towards the level of light, while at the same time keeping a realistic basis of analysis. He suggests that we call class 4 of each colour *bloom tints*, 'or if you please, virgin tints, as the painters call them', while recollecting that, in the disposition of colours as well as of forms, variety, simplicity, distinctness, intricacy, uniformity, and quantity,

direct in giving beauty to the colouring of the human frame, especially if we include the face, where uniformity and strong opposition of tints are required, as in the eyes and mouth, which call most for our attentions. But for the general hue of flesh now to be described, variety, intricacy and simplicity, are chiefly required.

He then imagines that he is painting the bosom of a girl. He takes the bloom tints of each colour in class 4, 5, or 6 according to the degree of floridity of fairness, and lays them on close to one another but separately: red, yellow, blue, purple, or lake tint. This is done till the whole neck and breast are covered, 'still changing and varying the situations of the tints with one another, also causing their shapes and sizes to differ as much as possible; red must be oftenest repeated, yellow next often, purple red next, and blue but seldom, except in particular parts as the temples, backs of the hands, &c. where the larger veins show their branching shapes (sometimes too distinctly) still varying those appearances'. Next he considers the whole process as made up of the tender tints of class 7, with red, yellow, blue, green, and purple underneath each other. Then 'the general hue of the performance will be a seeming uniform prime tint, at any little distance, that is a very fair, transparent and pearl-like complexion; but never quite uniform as snow-ivory, marble or wax, like a poet's mistress, for either of these in living, flesh, would in truth be hideous'.

Further, as in nature the general yellowish hue of the cuticula brings

about a fine gradation of colours, 'delicately soften'd and united together', so the oils that the colours are ground in makes them seem united and mellowed, with 'a yellowish cast after a little time'. But this yellowing can do much harm and only the clearest of oils should be used. (In a long note he divagates into an attack on the idea that pictures, darkened by time, are thereby bettered.)

He sums up: 'The utmost beauty of colouring depends on the great principle of varying by all the means of varying, and by the proper and artful union of that variety.' The complexity of the problem has 'made colouring, in the art of painting, a kind of mystery in all ages', with few artists truly successful at it. Rubens was the master.

Rubens boldly, and in a masterful manner, kept his bloom tints bright, separate and distinct, but sometimes too much so for the easel of cabinet pictures; however, his manner was admirably well calculated for great works, to be seen at a considerable distance, such as the celebrated cieling at Whitehall-chapel: which upon a nearer view, will illustrate what I have advanc'd with regard to the separate brightness of the tints; and shew, what indeed is known to every painter, that had the colours there seen so bright and separate, been all smooth'd and absolutely blended together, they would have produced a dirty greay instead of flesh-colour. The difficulty then lies in bringing *blue* the third original colour, into flesh, on account of the vast variety introduced thereby; and this omitted, all the difficulty ceases; and a common sign-painter that lays his colours smooth, instantly becomes, in point of colouring, a Rubens, a Titian, or a Corregio.

We see how much thought he gave to colour relations and the use of pigment; it was no mere chance that he was the most experimental of eighteenth-century painters in the use of bold brushwork, fluidity of handling, and broken colour effects. His three-colour theory was derived from Rubens. That painter's biographer, Deschamps, included among the master's maxims the advice that in painting flesh the strokes of colour should be set separately side by side, only lightly blended into one another. De Piles, no doubt drawing on this source, advocated the same method, though he referred to a four-colour scheme (including green). Rubens's own manuscript treatise was lost this century, but by 1750 his system was interpreted in terms of the primaries red, yellow, blue; and Hogarth clearly accepted this viewpoint, which was later taken over by Delacroix. In his *Portrait of his Sister*, indeed, he evolved a system that was 'followed a century later by Delacroix, who was under the impression that he was its inventor . . . The high lights and deep shadows are in each case two primaries, which unite to form the half-tone. The dress which produces the effect of yellow is yellow in the high

lights, red in the deepest shadows, and orange in the transitions; so with the scarf, the three tints of which are orange, green and blue' (Armstrong).

Hogarth belongs to the great line of colourists that runs on from Titian and Rubens to Turner, Delacroix, Monet. He was totally opposed to the painters seeking preconceived harmonies, such as Reynolds – indeed to any painters who did not seek to link the prismatic analysis with the ceaseless study of nature. He himself varied in his use of paint, learning from men like Watteau and La Tour as well as from Titian and Rubens. No doubt he would have needed to release his forms of Comic History on a large scale before he could have fully realized the potentialities we find showing up in his use of colour and pigment. But from his practice and theory alike we can see that he had a deep understanding of colour and pigment as defining form, not as something merely added to it. Here it is that he linked with Rubens in the past, and with Turner and Delacroix in the future, even if it was only at moments that he achieved full freedom in handling paint. The essential thing was that his concept of form as movement involved a dynamic concept of colour and brushwork, in which these aspects of the art work were integrally related to the pervasive questions of intricacy, variety, and simplification.

In January 1735 he joined with twenty-two friends in forming the Sublime Society of Beefsteaks with the motto: *Beef and Liberty*. They met on Saturdays from October to June and ate steaks in a mock ritual somewhat masonic in character; they were given to hoaxes and there was much singing, especially by those who couldn't sing. The society was anti-aristocratic, a plebeian version of the Liberty or Rumpsteak Club founded in 1734 by Whig peers to whom George II had shown his backside at levees.

Meanwhile the copyright petition had gone to the Commons on 5 February. On 25 April it had its third reading in the Lords and was sent back, approved, to the Commons. It gave protection against unauthorized copies of prints for fourteen years, from 25 June next, with a 5*s* fine for each offending print. Hogarth put off publication of the *Rake* till the day when the Act became operative. But before then an engraver sent men to look at the pictures and memorize them; he hastily got out copies, with motifs from the *Harlot* or elsewhere to fill in when memories failed.

In June Hogarth had a sad blow. Soon after he went to Leicester Fields, his mother and sisters moved to a flat in Cranbourn Street. On the night of Monday 9 June, shortly before midnight, a fire broke out in Duke's Court, a few blocks off. By 3 a.m. twenty houses were blazing. The fire had started in a brandy shop in Cecil Court, spreading into St Martin's Court and burning for some two hours 'before Water could be got to supply the

Engines'. The house with the Hogarths must have been at the corner of Cranbourn Street running into St Martin's Court. Mrs Hogarth was upset and died next morning 'of a Fright'. She was 'in perfect health when the unhappy Accident broke out, and died before it was extinguish'd'. On the 12th she was buried at St Anne's, Soho.

This year, perhaps after her death, Hogarth painted her. Here, as with Sarah Malcolm, he advanced into new portrait territory. The figure fills much of the picture space with a mixture of the homely and the monumental. Hogarth's emotion is packed in the inscription calling her 'his best friend', but there is no attempt to idealize. She sits there erect, ageing, hard, and unglamorous, with her slightly forbidding dignity, yet with nothing of the grand lady. 'Although throughout contemporary Europe portraits of an artist's family were the first to acquire a bourgeois character, none can really hold its own beside this one of Hogarth's. In comparison, Rigaud's portrait of his mother, also an elderly middle-class woman, although the most realistic he ever painted, strikes one as "artistic" and contrived' (Antal).

By early June the plagiarist had announced his *Progress of a Rake*. Hogarth on the same day printed a denunciation of the printsellers who had sent spies, 'mean and necessitous men', to study his works. He now decided to have his own cheap copies made, for sale at 2s 6d each. On the 21st the pirated set was issued and Hogarth denounced it in the *London Daily Post* on the 27th. His own set did not appear till 16 August. It was successful, though it did not take the world by storm as the *Harlot* had done. The Abbé le Blanc later remarked of Hogarth's prints that 'the whole nation has been infected by them'. He added, with irony in his use of the term *moral*: 'I have not seen a house of note without these moral prints.'

The piratic copies show many variations from Hogarth's work and interestingly reveal what confusions and errors, as well as vacancies, occurred in the minds of the spies. One print is an invention: 'He and his drunken companions raise a riot in Covent Garden', but the idea seems to come from the signs of a fight with the watch in Hogarth's plate 3. He had now established the practice that after subscription his prints were to cost more and be buyable by other dealers 'with the usual allowance'. His Act seems to have worked well for him, though it could not prevent cheap popular copies being made of later works like the portraits of Lovat or Wilkes. Later he claims that it

not only has so effectualy done my business but has made print a considerable [product] of this country there being more business of that kind done in this Town than in Paris or any where else and as well. Such innovations in these arts gave great offence to dealers both in pictures and Prints their trade

of living estates by the inginuity of the industrious has I own suffer[ed] much by my [Act] if the detecting of Rogurys of these opressers of the rising artists and imposers on the public is a crime I confess myself most guilty.

Only in June does he seem to have started on the paintings at St Bartholo-mew's. He used oils. True fresco was seldom tried in England because of the damp; even foreign fresco painters turned to oil. For the latter part of 1735 and well into 1736 he seems to have worked at the *Pool of Bethesda*. Vertue's notes show that most observers expected him to fail. Vertue agrees as to his extraordinary Genius, so far displayed 'in designing, graving painting of conversations charicatures. & now history painting – , joyn'd to a happy – natural talent a la mode. – a good Front and a Scheematist – but as to this great work of painting it is by every one judged to be more than could be expected of him'.

In the winter of 1735 an academy for artists was set up in St Martin's Lane. 'Mr Hogarth,' says Vertue, 'principally promotes or undertakes it.' Elsewhere he adds Ellys as a proprietor and mentions that Gravelot taught drawing, Hayman painting. The site was that of the old academy of Vander-bank. Each subscriber paid two guineas for the winter season this first year; after that, only a guinea and a half. In his last years Hogarth wrote in rambling incoherence: 'Sr James Thornhill dying I became [proprietor] of his neglected apparatus and began by subscription that in the same place in St martins lane as it was founded upon a still more free footing each [sub-scriber] having equal power, which regulation has [been] preserve[d] to this day. as perfect an academy as any in Europe but and with good manage had a bank and their bank of about £30.' He had a room big enough 'for a naked figure to be drawn after by thirty or forty people'. After enough subscrip-tions came in, 'he presented them with a proper table for the figure to stand on, a large lamp iron stoves and benches in a circular form, he became an equal subscriber with the rest signifying at the same time that superior and inferior among artists should be avoided especially in this country adding that the having directors with and imitation of the foolish parade of the french academy' was to be also avoided. He proudly adds that the place was 'still subsisting in the same place about 30 years' after. Throughout his life he remained militantly faithful to his ideal of a democratic academy, strongly opposed to any controls by state or crown.

At his academy most of the artists of the period were trained. With his stress on direct observation of forms, expressions, and movements, he was no conventional teacher; he referred the students to prints or casts only for some aspects of composition, light, and shade. His school was more like a guild than the continental academies which were founded to break down the

role of the guilds, to bring about a different sort of attitude to art. (Note that David came originally out of a guild, as did Chardin.) The academies wanted to provide art suited for the king and the nobles; Hogarth wanted to give art a social use through institutions, hospitals, and the like. True, he had tried to gain royal patronage, though not in order to put it at the centre of his system. Blocked by the Burlingtonians, he had turned with renewed force to the middle class and the general public.

At some date between 1735 and 1740 he painted a self-portrait, which brings out the eager and keen-eyed curiosity of his character. His slightly drawn-back head has a poise of mingled sympathy and readiness to retort at the least insult. All but the head is roughly sketched in. We feel here an attractive aspect of his personality which hardly appears in the more pugnacious heads.

8 Which Turn? (1736–41)

With the success of the *Harlot* and the *Rake* behind him, and with the large paintings for St Bartholomew's on his hands, Hogarth must have often tried to decide just where he was going. He was essentially a painter; but his large success had been through the engravings. There was no sign that the connoisseurs would accept him except to a limited extent as a painter of conversation pieces. He wanted to force them to recognize him as a painter in the most serious sense of the term, and the hospital decorations seemed to give him a chance to prove himself. At the same time he knew how deeply entrenched were the prejudices against which he had to contend. Further, though he must have had a deep faith in his painting powers, were the hospital decorations the sort of thing that really suited him? He probably felt sure that he could do them better than anyone else in England, as was indeed the case; but even if he proved that point, how far did it get him? He was right up against the problem that was to dog him all his life. To gain acceptance as a history painter, he had to work in a convention which, however he modified it, was not really the sort of thing that suited him, while if he followed up the trails in which he was truly creative, he earned a reputation which, however gratifying in many respects, was not really what he wanted. He wanted what he called the 'modern moral Subject', to be seen as every bit as serious and important as idealized history works; but he was far ahead of his times and had no hope of gaining the understandings that he desired. His notes tell us in a summary of his career from the early 1720s up to round 1735–6:

Engraving in the first part of life till near thirty did little more than maintain myself in the usual gaieties of life but in all a punctual paymaster.

Then maried and turnd Painter of Portraits in small conversation Peices and great success – but undertaking besides that manner of Painting was not sufficiently paid to do every thing my family required I therefore recommend those who come to me for them to other Painters, and turn my thoughts to still a more new way of proceeding, viz painting and Engraving modern moral Subject a Field unbroke up in any Country or any age. but not before I had entertain'd some notions of succeeding in what is call[ed] the grand stile of History I then as a specimen without having done any thing of the kind before Painted the staire case at St Bartholomew Hospital gratis from which I found no Effects and the reason upon consideration so plaine that I dropt all the old Ideas [two illegible words] of that were to be collected for this purpose and pursued the former Dealing with the public in general I found was the most likely do provided I could strike the passions and by small sums from many by means of prints which I could Engrav from my Picture myself I could secure my Property to my self.

On 8–10 April the *London Evening Post* announced that the *Pool,* 'a very fine Piece of Painting', had been completed and hung on the staircase. Vertue thought the account an advertisement inserted by Hogarth himself; but the *Post* was the paper used by the Hospital for news items. On 7 June Vauxhall displayed the new decorations which Hogarth had helped Tyers to get. There were fifty supper boxes round a quadrangle, all with paintings mostly eight feet across. Elsewhere even larger pictures were hung. Hogarth's first contribution was Henry VIII and Anne Boleyn (removed some fifteen years later). Hayman and his assistants were mainly responsible for the works, of which fifteen survive, together with engravings of others that have been lost. Hogarth probably did more work for the Gardens than has been thought, and also exerted a certain influence on the whole system of decoration.

The importance of the Vauxhall scheme was that it gave a chance for artists to do large paintings with popular themes and thus in time to make a valuable contribution towards the founding of a national school. One surviving work, hard to date, which may well be Hogarth's, is *Fairies Dancing on the Green by Moonlight*, which hung in a supper box on the south side of the Grove. It may have been connected with the season when musicians played out of holes with shrub-covered openings: 'Some styled the sub-terraneous sounds heard there the Fairy Muse.' The damp, however, affected the instruments and the device was given up. In *Fairies* the setting is a meadow and wooden dingle with hills around, a scene not unlike that of the only extensive landscape that Hogarth ever painted: *The Pilgrims at Cumbers* (1740). The dance has a fine flowing grace in the double lighting (moon and lantern). There is a painterly quality and a solidity of modelling about the arm of the lantern-bearer; the colour is subtly lyrical – cool silver grey, ochre, powdery blue, saffron, brownish pink. Radiography shows an

underpainting of a man with thorn staff fighting a crone who tears at his neckcloth, a gesture found in *Southwark Fair*. There is a delicate fantasy in the *Fairies* beyond anything we know of Hogarth's work, yet it is hard to think who else could have done it.

About this time he did the engraving, *The Sleeping Congregation*, which shows a service in a country church. The royal arms are supported by an angel with too many joints: a parody of bad church art reminding us of his caricature of Kent's altarpiece. The motto *Dieu et Mon Droit* is done so that *Dieu* is lost: to infer that God is absent though state power isn't. The one person awake besides the preacher is the reader who squints at the bosom of a sleeping girl; she dreams of marriage, a book *Of Matrimony* in her hand. The composition has a likeness to Laroon's *Alms-men* (1730) with its bored congregation; but Hogarth seems also to be thinking of Thornhill's *House of Commons* – raising the Speaker on to a pulpit, turning Walpole into the girl, and the clerk into the reader. The work would then be a burlesque on Parliament, where *Droit* also rules. Church and State are alike dead slumbering systems, masking the real power structure.

In December came the engravings of the indoor versions of *Before* and *After*. Some objects from the paintings have been omitted; the lover has no wig and is younger, less coarse; and there are new items. In *Before* we see on the wall a picture of Cupid lighting a rocket; in *After* the dressing table has fallen forwards and enabled us to see the picture below, where the rocket has exploded and returns to earth. The girl is pleading instead of merely looking exhausted: she has been reading *Novels* and *Rochester's Poems*, with a pious work open to deceive anyone looking in. Hogarth later included the pair of prints in his collected work to the dismay of moralists.

Richardson uses much the same symbolism for seduction, but with tragic overtones. Clarissa is put in a prison that is described in terms of decay, breakages, cracks. Her body has been broken, as Mowbray jeers: 'When will she mend herself?' The cracked mirror is her lost virginity, her disordered self, the general fragmentation of reality that has resulted. Lovelace speaks of 'an incurable fracture in her heart'. Richardson completes the prison effect by a bottle full of emblematic flowers and herbs, a bouquet of remorse, regret, death – in which the yew reminds us of the hedge separating Clarissa from her family in the Harlowe garden.

This year the authorities were forced to make some attempt to reduce the filth and confusion of the city, and to start the hanging of lamps at night; the open drain of the Fleet was being filled in. In July there were Smithfield riots against the Irish who displaced English weavers by taking low wages. Pond began issuing caricatures in the Ghezzi style; Hogarth would have been

annoyed as they stimulated people to use the term for his own work. No doubt it was used for two prints of his, *Scholars at a Lecture* (January 1737) and *The Company of Undertakers* (March), done in coarse popular style. In the first the snoutish stupid-faced undergraduates are lectured by the Registrar of Oxford University. The second, in a parody of heraldry, attacks the quacks. Three are singled out: John Taylor, oculist; Mrs Sarah Mapp, bonesetter with cross eyes; Joshua Ward with pill of antimony and arsenic. The trio had been much in the news, provoking songs and epigrams; there was a crowd when they went together to a comedy in Lincoln's Inn Fields. Hogarth is also attacking royal patronage. Ward was granted an almonry office in Whitehall as a dispensary for the poor after setting the king's sprained thumb; Taylor, presented at court, had become the king's oculist; Mrs Mapp had recently waited on the queen.

Hogarth now had a large market for prints. He had arranged for Bakewell in Fleet Street to sell his works, relieving the pressure on his home. He now issued *The Distressed Poet*, returning to the theme of self-delusion. The poet works on a poem (given in different states as dealing with Poverty and with Riches). Lost in his dream of fame, he cannot pay the milk girl, with whom his wife, mending clothes by the wretched hearth, has to deal. Hogarth links the poet with the *Dunciad* and with Grub-Street, the term contemptuously devised by Pope and the wits for the new sort of non-aristocratic writer coming up, such as Earless Defoe, who lived on his writings. He may be thinking in part of his old enemy Breval-Gay, who is satirized in *An Author to be Lett* (1729). 'He arrested me for several Months Board, brought me back to my Garret, and made me drudge on in my old, dirty work.' The exploiter here is the publisher-bookseller Curll, whom Hogarth put into the first state of the print, in the wall picture; in 1740 he substituted a Map of the Gold Mines of Peru. The milkmaid may be taken to represent Nature, Country Life; she brings the Milk which the experts on nervous diseases, anatomizing the evils of urban life, were advocating. Nature is then bilked by the Poet caught up in the cash nexus and its anxieties; in the last resort his hopes merge with those of the cheaters and the cheated in the South Sea Bubble, the new systems of financial investment, as is shown by the dream of Peruvian gold. In the painting we start with the obsessed Poet on the left and move on to the intruding World with its bill; in the engraving we start with the Milkmaid and move for explanation to the Poet. In either case the wife is the mediator between the lost dream and the remorseless world.

With the *Poet* Hogarth announced bound volumes of his work. The *Hudibras* plates, still advertised by P. Overton, were omitted, with some minor pieces; the *Harlot* was added later. From now on this system was at

the back of his mind; it enabled him to feel that he was not scattering ephemeral prints but was building up a lasting corpus. He was not very active as hospital governor and served on no committees. There were five general courts a year, and he attended his first on 25 March; he may have wanted to explain the delays in work on the staircase. He had been busy on the set, *The Four Times of the Day*, to provide the bases for large Vauxhall designs, and *Strolling Actresses in a Barn*. He announced all these in May, and repeated the notice six times; then nothing more was heard of the prints for nearly a year.

On 7 June he began on the second hospital painting; by working on the spot he ensured that it would be able to stand up against the finished pictures by it. He would have been deeply interested in the measures being taken against Fielding, whose *Historical Register for the Year 1736* depicted Opposition MPs taking bribes to vote for the ministry. The politicians who had been resenting his satires had their chance. Waiting till many independent members had returned to their counties, they brought in a Bill forbidding all plays not licensed by the Lord Chamberlain. A foreign visitor noted 'a universal murmur in the nation. . . . It was treated as an unjust law and manifestly contrary to the liberties of the people of England.' But on 21 June the Bill received the Royal Assent. The newspapers reflected little of the angry talk in the coffee-houses; there was no strong opposition even from the theatre world, where the two royal houses, Drury Lane and Covent Garden, felt their position strengthened. Unlicensed houses had to close, though most London managers soon obtained the patronage needed for carrying on. But Fielding was driven out of the theatre, and itinerant companies bringing drama to fairs, markets, country towns, were hard hit, even if some JPs refused to do much to implement the Act. Hogarth used the situation in his *Actresses*, though it can hardly have inspired his picture; he added pathos and protest by making the show for which the women prepare 'the last time of acting before the Act commences'.

The *Daily Post* had reported the suicide in Paris of F. Lemoyne through critics' finding four faults in his work; Thornhill at Greenwich had had more resolution. 'Notwithstanding as many Faults as Figures in that Work he died a natural Death, tho' an Englishman.' Hogarth, stung, set out to defend Thornhill and English art in *St James's Evening Post* of 7–9 June. Critics depreciated that art by picking on small details, ignoring wholes, while dealers made their money through foreign works. Some of his points had been made before, but he was the first to fix on the harm done by the dealers.

your *Picture-Jobbers from abroad*, who are always ready to raise a great cry in the Prints, whenever they think their Craft is in Danger; and indeed it is in

their Interest to depreciate every *English* work, as hurtful to their Trade, of continually importing Ship Loads of dead *Christs, Holy Families, Madona's,* and other dismal Dark Subjects, neither entertaining nor Ornamental, on which they scrawl the terrible cramp Names of some Italian Masters, and fix on us poor Englishmen, the Character of *Universal Dupes.*

He probably had some literary friend revise his statement, but much of it has the irrepressible note of his voice. The best passage is that depicting a dealer at work on a client. The latter says: 'Mr Bubbleman, that Grand Venus (as you are pleased to call it) has not Beauty enough for the Character of an English Cook-Maid.'

Upon which the Quack answers with a Confident Air, 'O L—d, Sir, I find you are no Connoisseur – That Picture, I assure you, is in Alesso Baldovinetto's second and best Manner, boldly painted and truly sublime; the Contour gracious; the Air of the Head in the high Greek Taste, and a most divine Idea it is'– Then spitting on an obscure Place, and rubbing it with a dirty Handkerchief, takes a Skip to t'other End of the Room, and screams out in Raptures,– 'There's an amazing Touch! A man shou'd have this picture a Twelve-month in his Collection, before he can discover half its Beauties.'

The buyer, even if his taste is good, is browbeaten and afraid of being thought ignorant and out of fashion. Hogarth, indeed, was not exaggerating. Throughout his lifetime the influences he fought grew stronger. In 1763 a traveller, describing Lord Tilney's magnificent mansion at Wanstead, found that the gallery of Old Masters housed in every case obvious and badly executed copies. By the 1730s the cult of antiques, mainly statuary, had so grown that all over Italy English patronage was a byword for lavish lack of discrimination. The people of Rome used to say: 'Were our amphitheatre portable, the English would carry it off.'

In July the scaffolding was removed from the *Good Samaritan* and a General Court thanked the artist, who was absent. The *Evening Post* said his two works were 'esteem'd the finest in England'. He himself stressed the size of the figures, some seven feet tall, to show that he was no mere painter of small scenes. Indeed the works were impressive in their way, but they quite lacked the originality of his Modern Moral Subjects. He was drawing on various aspects of tradition: Dutch and Flemish elements given his own baroque organization, elements of both Venetian mannerists (Tintoretto) and rococo. The *Pool* has memories of Callot, Raphael, Rembrandt, Pannini. To some extent Hogarth integrates the borrowed elements in terms of his own vision, with bold loose handling of paint helping to determine the forms; there is a greater secularization, realism, what may be called a

democratization (Antal) of the themes. But except in lesser ways, the works open up no new vistas of aesthetic experience, no new union of art and life, as do the smaller paintings.

He put most of his effort into the *Pool* with its crowd of figures and its particularizing of the various diseases, as with the unhealthily fat girl, the shrivelled old woman, the rickety child with enlarged joints, curved spine, and jutting brow. He introduced realistic touches, though he knew they'd annoy the exponents of the grand style. The servant of an ulcerated lady drives off a poor man, a blind man knocks with his staff a gouty hand, a dog peers down from above. And he couldn't resist bringing in an unsuitable nude, which seems drawn from an old classroom study. (The rich lady, said a friend, was based on the harlot Nell Robison, whom they had once known well.) There is no unity between the stiff Christ and the cripples and other sufferers, no relationship. The landscapes in both pictures were done by Lambert. No important commissions were forthcoming, though the works became one of the sights of London.

Round this period, 1737–8, Hogarth made some more ventures into history in the grand style. Turning to the stage, he painted the meeting of Ferdinand and Miranda in the *Tempest*. Prospero stands between the pair, with Ariel above, so that we get a pyramid, with open sea on the left and Caliban on the right. The pyramid is broken by the punctuation of the heads, up, down, up, with a leap to Ariel, so that a moving balance is achieved. As with the *Falstaff*, the importance of the work lies in the use of Shakespearean themes for History. It was adapted, no doubt by Hayman, for the Prince's Pavilion at Vauxhall.

We hear of a *Danae*, sold at his 1745 auction, in which he may be replying to Kent's *Danae* on the ceiling of the king's drawing room. The work is lost, but Walpole said of it: 'The old nurse tries a coin of the golden shower with her teeth, to see if it is true gold.' Even in trying to prove he could do accepted history, Hogarth could not help making fun of the genre. Dr James Parsons, in lectures on the muscular structure of physiognomy in 1745, wrote:

But if the Passion of Desire be prompted and accompanied by any more engaging Circumstances, then the *Elevator* of the Eye will act strongly, causing the *Pupil* to turn up, at the same time that the Action of the *Aperiens Palpebram* is more remitted, whereby all the *Pupil*, except a little of the lower Edge, will be hid, and the Lids come nearer each other; the Mouth being a little more open, the End of the Tongue will lie carelessly to the Edge of the Teeth, and the Colour of the Lips and Cheeks be increased. Thus yielded Danae to the Golden Shower; and thus was her Passion painted by the ingenious Mr. *Hogarth*.

He may have been mocking Correggio's *Danae* (one of the four *Loves of Jove*, two of which he used in the Countess's room in *Marriage à la Mode*); a Love in it was incorrectly taken by critics as testing one of Jove's gold pieces.

An unusual work, hard to date, is *Satan, Sin, and Death*, probably stimulated by a passage from Richardson's book on Milton read at Slaughter's. Richardson found in the allegory of this trio the main point of *Paradise Lost*. Hogarth takes up the idea, but is concerned to bring out the interrelations of the three figures. Sin comes between her father–lover, Satan, and her son-lover, Death, holding them apart; we are reminded of Polly between her father and Macheath. The trio may have been suggested by a version made by Giacomo del Po, probably for an English patron; but Hogarth gives them a primitive imaginative force, crude and lurid, yet powerful in impact, with a sense of immensity. Here he has leapt far ahead into the romantic epoch. In 1767 the painting was engraved, and in this form it affected Fuseli, Romney, Barry, Blake; Gillray used it in depicting Queen Charlotte as Sin, and his work influenced David's *Sabine Women* (as the final watercolour shows). The painting is thus of much importance in proving the great potential range of Hogarth's sensibility. He could depict, as with the Rake, the onset of madness from outside; he could also create wild and stormy images that revealed the inner content of terrible stress.

About this time we may set the anecdote told by the Rev. William Cole, who had called on Hogarth and when leaving offered his servant a vail (tip) as was the custom. 'But the man very politely refused it, telling me that it would be as much as the loss of his place if his master knew it. This was so uncommon and so liberal in a man of Mr. Hogarth's profession at that time of day, that it much struck me, as nothing of the sort had happened to me before.'

Hogarth was infuriated at the success among the fashionable people of the French painter Vanloo. He remarks that portraits need mainly much practice and 'an Exact eye', and have been always 'engrossed by a very few Monopelisers whilst many others in a superior way more deserving both as men and artists are every where neglected and some starving . . .' He felt that 'it was impossible not to resent the partiallity of the publice in their behalf. Veloe a freinch portrait painter being told by [?whom] the English are to run away with . . . & Puffing monopolised all the people of fasheon'. He called on the other artists 'to bear up against this torrent', a monopoly 'aggravated by being by a foreigner'. He adds: 'I spent my own in their behalf which gave me enimes among his espousers.'

On 1 May the *Four Times* and the *Actresses* were published. The latter is a very detailed plate. The rehearsed play is *The Devil to pay in Heaven*. Coffey

wrote a play of that name, but Hogarth seems to be thinking only of the suggestive title. The odd medley of his characters rather reminds us of a Fielding burlesque. (In *Life and Death of Common Sense* an extra two-penn'orth of lightning is ordered against the first night.) Endless ingenuity is used to make the gods ridiculous and to mock at their pretensions, and the earthly powers are implicated in the exposure. A crown, set by a chamber-pot, is a stand for a porringer of baby food; in the same place on the right a monkey pisses into a plumed helmet. Ganymede, suffering from toothache and wearing no trousers, is fed gin by a Siren whose costume is adjusted by Aurora. The mother dressed as the ravishing Eagle scares her own baby. Behind, the elements are confounded in the scenery. Cupid climbs a ladder to fetch stockings that dry on the clouds while Apollo in sun-crown points them out with a bow; chickens perch on rollers that represent seawaves. Two devil-boys (parodying the boys at the altar in Raphael's *Sacrifice at Lystra*) tussle over the mug of Diana which stands on the baroque altar with bread, tobacco-paper, and pipe. A page-woman holds a struggling cat while a one-eyed hag cuts its tail to draw blood (for some stage effect); she may be a ghost with shroud and dagger, but the dagger looks like a cross in a nun's habit. Two kittens play with a royal orb, and so on and on.

Here is a gay and complex variation on the theme of people dressing up to be what they are not. In one sense the work is a burlesque of mythological history and high-faluting tragedy on Fielding lines; in another sense it sets out to degrade the emblems of religion and state power, to bring them down to earth. The 'nun' seeking to draw blood close to the sacrificial altar, and the bread and drink on the altar itself, over which devils fight, are parodies of the Eucharist. In composition the work is rich and entangled, yet the whirl of confusion is deftly held in control. There are strong diagonals, horizontals, pyramids, which give a spatial structure to the involved flow of serpentine lines; and there is an in-and-out movement of light and shadow, sinuous depths returning in on themselves. Everything leads to Diana. Her pose, as a statue, as a dancer, catches all the lines into a centralizing spiral. Her fallen girdles bare her sturdy thighs as she mimes the drawing of an arrow from its quiver. The Actaeon spying on her is the voyeur peering through a hole in the barn roof; this observer is also the artist, the man who looked down into the cosmic swirl of Bartholomew Fair, enjoying all the guises and yet seeing through them. There is indeed a three-level division: the heaven of clouds and washing, the earth of the main scene, and the underworld across the right-hand corner, in which is the Negress Night. (The painting was unfortunately burned in 1874.)

The Four Times of the Day were made, tradition said, for the Vauxhall

supper boxes, where copies later were hung. The same characters do not re-appear, but in a diffused way the set represents the four seasons and the four ages of man. First comes Morning, which is also Winter. A prim and stiff old maid in Covent Garden crosses to the church with a footboy who carries her prayer book. She is disapprovingly isolated from all the others around, and in a way she embodies the sharp chill. (She is said to have been a relation or acquaintance who cut Hogarth out of her will on seeing the picture. Fielding used her for Bridget Allworthy in *Tom Jones* and Cowper for the prude in *Truth*.) Her distance from the life around her is emblematized by the skeleton shape of the scissors (or nutcracker) at her girdle. The time is 6.55 a.m. Tom King's tavern (which opened at midnight) obscures the church; and since it was in fact on the south side of the square, Hogarth must have shifted it to symbolize the fact that tavern blots out church for the people. Father Time is on top of the clock, with tavern-smoke coming up to blur the church further. A brawl is going on inside King's, and a wig flies through the door. A pair of lovers stand in the way of the old maid, another pair kiss close by, and two tough women and a beggar are bunched up by a small fire. Two small boys, on the way to school, stop to watch a woman with a huge basket of vegetables on her head and a lantern at her girdle. Further back, a small crowd listens to a quack (perhaps Dr Rock in person) who hawks Rock's panacea. Once again Hogarth attacks the royal patronage of quacks, by showing the king's arms on the man's board. The general point of the print is the opposition of repressive religion, which thrives on the chill, and the spirit of life among the people, which seeks some way out of the misery: by drink, love-making, panaceas, brawling, companionship.

In Richardson's novel, Clarissa is arrested outside Covent Garden church and forced into the officers' chair amid the jeers of the enclosing crowd. She is thus as isolated in the scene as the Prude is in *Morning*. We have noted the sort of claustrophobic pressure in much of Hogarth's world. Richardson himself could not bear a crowded place and in his later middle age was unable to go to the theatre or to church. This sense of an impinging and destructive world is powerfully expressed in *Clarissa* with its climax in the scene of the girl's return to the brothel. Rape is felt as the breaking-in of doors. (We may note how important in Hogarth's themes is the opening of the door that lets in the enemy: in the *Harlot*, the *Rake*, *Marriage*, *Industry and Idleness*.) Clarissa needs the key to block the keyhole so as to prevent the penetrating forces from assailing her. In Hogarth the intrusive force is the watch, the police, the law – society in its hostile aspect.

The second print, *Noon*, again opposes religion to common life. The street seems to be Hog Lane, with the church of St-Giles-in-the-Fields at the

back, its clock marking 12.30. Two taverns on the left confront a chapel used by French refugees of Soho. The emerging congregation are dressed in modish finery, and the man at the front has the self-conscious posture of a dancing master. By him, his wife, and fat foppish son, two old women kiss. In the same place on the opposite side a Negro kisses a plump girl holding a pie-dish; the juice of the pie slops over as she tilts the dish in her kiss-daze, and drips into a rubbish-tin where two poor children are foraging. The near tavern advertises *Good Eating* under its sign of the Baptist's head on a platter. At a window a man, catching hold of a girl, causes her to drop a leg of mutton into the street. A gutter with a dead cat in it divides the pious from the profane. Here religion is a matter of pompous show, opposed to the hearty enjoyment of life. The head on the platter, with meat-dish a little above and pie-dish below, is again a parody of the Eucharist; the sign seems to be calling on the hungry to eat the martyr's head. By putting in the two starveling children, Hogarth is careful to add that not everyone is permitted by society to partake of the good things. We may notice too the way in which the Negro is accepted as a lover of the fat girl whose breast he feels.

Evening shows the countryside north of London. A couple, dyer and wife, are walking by the New River, visiting Sadler's Wells (frequented for its rope-dancers and burletta); citizens tended to go to the Wells while the more fashionable folk liked Vauxhall. The day has been extremely hot; foliage wilts, two women and a man in bagwig sit outside the tavern, though two men sit inside in the smoke of their pipes; a tail-swishing cow is being milked. But the main attention is centred on the promenading couple. The worried man sweats as he carries the baby beside his stern stalwart wife; his cuckoldry is emblematized by the cow's horns sticking up behind him as if they grew out of his head (at the cost of impossibly elongating the cow). At the couple's rear the small over-dressed daughter nags at her younger brother, who weeps. Here the repressive factor is not the church but marriage, at least middle-class marriage, which is seen as involving a relentless pressure to keep up standards of respectability, even if there is betrayal behind the scenes (the wife's infidelity). Both mother and daughter wield fans as a sort of weapon.

An episode in the pantomime made on the *Harlot's Progress* brings out how certain effects in Hogarth's art were connected with transformation tricks on the stage and how the way in which he used art objects in his prints was well understood. 'The Subject of a Picture which was before an Historical Story is now chang'd to a Representation of the Jew with Horns upon his head. – While he stands in astonishment the other Picture changes likewise and represents Harlequin and Kitty embracing – upon which the Jew runs

out in the greatest surprise. Scene changes to the Street.' Pantomimes must have had many episodes when cuckolds had horns clapped on their heads; and the friendly or malevolent life we often feel in Hogarth's objects reflects the way in which things were liable to come alive in pantomimes and play their part in the action. Thus a chair sneezes and embraces Harlequin in Hill's *Merlin in Love; or, Youth against Magic*. In the pantomime *Harlot's Progress*, the blocks at Bridewell come alive and take the gaoled women off to Vauxhall.

Finally *Night*, set in a street near Charing Cross, shows the breakdown of all controls in the dark. In front, a drunken Freemason (said to be De Veil) is led by the tyler or doorkeeper of his lodge while a woman empties a chamber-pot on him. Under the bulk before the barber-surgeon's house are two sleeping beggars and a linkboy blowing on his torch; inside, the barber shaves a man. A fire in midroad has caused the overturning of the Salisbury Flying Coach (which did the trip in one day); a man in butcher's apron and a smaller man with wooden sword seem to be trying to make things worse for the stunned passengers by throwing links among them. In the street are brothels and taverns. Far at the back a tenant goes in a furniture-loaded cart across the square, flitting by night to escape a threatening landlord. Further back is a fire, with smoke pouring up over a house. Oak leaves in a man's hat and the barber's sign show the date is Restoration Day, 29 May, which the Jacobites kept as a festival; Charles I's statue is far at the rear. De Veil, a keen Hanoverian, has got drunk on the night when he should be watchful. The print thus depicts the confusion, disorder, violence, which is partly hidden by day but is always ready to erupt as soon as controls stop and their supposed guardians succumb to the temptations they should curb. (De Veil had twenty-five children by four marriages and was said to frequent the Covent Garden whores. He was indeed a figure typifying the contradictions in question. Personally corrupt, he did his vigorous best to put the law into action, even provoking the mob to fire his house.)

There seems to be a symbolism of milk and water in the plates to express the free flow of life, also perhaps to suggest waste. In the first two plates men squeeze the breasts of girls; in the second plate the girl spills pie-juice as if to represent the flow of milk, of the life-force. In the third plate a cow is milked and water flows for Londoners to drink (a pierced trunk is shown as a water-pipe); in the fourth the urine descends from the rounded chamber-pot as a man pours gin into a barrel.

From the paintings for the *Rake, Southwark Fair, Poet*, and *Four Times*, we can estimate how Hogarth had developed in the handling of pigment and colour for his variety of history. His mastery was now very great. He had

control over depth and distance, sharpening or softening his forms as required; and he knew how to fuse colour and brushwork to bring out contrasts and connections, oppositions and unions. In *Morning* the prude is both drawn into relations with the boisterous common folk as well as opposed to them; we feel that there is the spring of life in her too, though held down and distorted. Around the fire is an exuberant skurry of life, while the buildings are held back and massed in an atmospheric distance. A fascinated love of love emerges in the paintings as it cannot in the prints: a far greater aesthetic unity, with brushwork expressing charm or repulsion, repose or agitation. In comparison the black-and-white of the prints seems to impose a simplified judgement and set of relationships. At the same time Hogarth feels freed from the need to think back to the Old Masters, especially Raphael. He can forget what the schools taught about composition and rely on his sense of mass and movement, whether he deals with crowds or a few persons; he can use the rococo S and C curves to control the material, to express its tensions and movements inwards or outwards, or a changing focus to define varying levels of space.

Yet his colour and masterly brushwork did not impress the critics, patrons, or artists of the period. His admiring friend Morell said apologetically: 'But it is granted that colouring was not Mr Hogarth's forte.' The obituary in the *Public Advertiser* remarked that 'his colouring is dry and displeasing'; he 'could never get rid of the appelation of mannerist, which was given him early in life'. (The term 'mannerist' was used very loosely, meaning little more than that an artist had a particular manner of his own.)

The crucial question is why Hogarth did not ever attempt to paint a life-size picture in his own history style. In the few cases where he produced large pictures he fell more or less into the conventional style of the period, adding some characteristic touches, but making no effort to transform the whole method as he did in his small works. Many factors, however, stopped him from the bold step of painting large works with themes like *Southwark Fair* or *Morning*. He knew that he could not possibly sell such pictures or gain anything but derision for them. Also, he had nowhere to exhibit such works, except perhaps Vauxhall, a location that would have stamped them as frivolous products unrelated to serious art. By hard work and a remarkable grasp of the possibilities of his situation, social and artistic, he had created a public for the engravings made from small paintings; but he could see no hope outside this field, apart from the accepted grand style of history and the sphere of portraits. In these two latter types he kept on trying to compete with the masters of the day, with varying degrees of success, but with no chance of compelling acceptance on the terms he wanted.

He had to fight prejudice all along the line. In such a situation, if the idea of a *Morning* with figures at all near life size did momentarily come up in his mind, he would have dropped it at once. We can get some notion of the problem he faced if we realize that it was over a hundred years before Courbet could think of painting *Stone-Breakers* on a monumental and heroic scale, and even then the result was a vast scandal. Yet he had behind him all the development between Hogarth and Géricault, several deep-going political revolutions, and the immediate stimulus of 1848. Only after 1848 did it become possible for the full implications of Hogarth's art to be faced and worked out.

Nothing could be achieved by his attempts to conquer conventional history. Probably he felt that if he forced the connoisseurs to accept him in that sphere they could be induced to look with different eyes on his modern history. But this line of thought had two fallacies. The very qualities that made him a highly original painter of modern history prevented him from excelling in the conventional style; and if by some chance he had managed to impress collectors in the latter style, they would have wanted him to go on working in it and drop his modern history.

In his account of the hospital pictures he stated that 'he found no Effects and the reason upon consideration so plaine that I dropt all the old ideas'. He thus expresses his disappointment at the lack of response and the absence of commissions. He seems for a while to have lost his impulse for history, original or conventional, and turned to portraits. In later notes, after saying that still life is 'a species of painting in the lowest esteem because it is [in] general the easyest to do & is least entertain[ing]', he argues that portraits are not much higher as an art form. To draw a statue is still to make a still life, and 'face painting comes under this denomination'. It 'is almost as still as a post', and the 'posture is generally done [by] a drapery painter'. The coat to be painted is put on 'a wooden figure like a jointed doll', while 'the face painter himself who is in great general vogue repeats the Eyes nose and mouth may be three or 4 times [a day] – nay before he is thirty [he will] have drawn about a thousand faces'.

Further, though he felt sure of his capacity as a portraitist, he was highly sceptical that his powers would ever be acknowledged. He says that some twenty years back he became convinced that he could paint a portrait as well as Van Dyck. He asked 'all the painters then at the academy', but particularly Ramsay, 'whether a man could get it acknowleg[ed] in his life, the unanimous answer was possitively no. Ramseys answer was a like question we (meaning my Brothers) must allow it before it will be [be]leaved, and we never will.'

An anecdote told by the surgeon Belchier is probably dated about this

time. Hogarth, dining with the anatomist Cheseldon, was told that Freke, surgeon of St Bartholomew's, had called a minor composer Greene 'as eminent in composition as Handel'. He cried, 'That fellow Freke is always shooting his bolt absurdly one way or another! Handel is a giant in music; Greene only a light Florimel kind of composer.' 'Ay,' said the speaker, 'but at the same time Mr. Freke declared you were as good a Portrait-painter as Van Dyck.' '*Then* he was in the right; and so by G— I am, give me time, and let me choose my subject.'

Ramsay, young son of the poet, had returned from Italy this August and set up as a portraitist in the Great Piazza, where he was soon doing well. He kept a note of aristocratic formalism to please his sitters, but with a touch of intimacy amid the elegance which seemed 'rather lick't than pencilled' (Vertue). Still, he was the main introducer of the Italian grand manner, a precursor of Reynolds; and Hogarth saw him as only another 'face painter from abroad', who used 'some new stratagem of painting a face all red or all blue or all purple at the first sitting', one of the 'painter taylors'. But Ramsay, talkative and amiable, never forgot how he had pored admiringly over Hogarth's engravings in his father's Edinburgh shop.

For the next five years, despite misgivings, Hogarth kept mainly to portraits. So far his single figures had been almost all of his own family or of a notorious character like Sarah Malcolm. He started off with the usual kind of portrait, painting the Duke and Thomas Western round about 1736. In 1737–8 he portrayed Dr Benjamin Hoadly, still daunted by the problem of the single sitter, then he tried a small full-length of Bishop Hoadly. Perhaps Roubiliac's statue of Handel convinced him that it was possible to define clearly a man's character in isolation from his fellows and a social setting. In his first version of the bishop he surrounded him with the insignia of his office, the towers of Windsor Castle in the distance, but he did not heap up detail to produce a commanding figure. Instead of a tension between man and man, he sought to express a tension between a man and his status, and thus to internalize conflict.

Not that he dropped group portraits. About 1738 he did the Strode and the Western Families. He was now able to set the people about a room with more ease. *Lord Hervey and his Friends* is set in the open, probably at Haddington. Now he uses his serpentine line to link the five men in a loose lively way, and he inserts the motif of stability–instability at the sides. On the right sits the secure statue of Britannia: on the left a clergyman, standing on a chair, looks through his spyglass at a steeple, his balance about to fail and topple him back into a pond. The line of the spyglass and the two gate-uprights just manage to keep him from upsetting the pattern of the rest of the picture.

We know little of Hogarth's activities in 1739. On 17 October he was named on the charter founding the Foundling Hospital, and he was present as a governor at the first meeting at Somerset House on 20 November. He subscribed his money and attended the courts as an active member, unlike most of the 375 governors. His friend Coram was the main mover in the scheme, and he set about painting his portrait. The winter of 1739–40 was extremely cold.

On 14 May it was announced that he had given the Coram portrait to the hospital. He was staking a lot on it, as he had on the histories for St Bartholomew's. Later he commented:

He painted Portrait[s] occasionally but as they require constant practise to be reddy at taking a likeness & as the life must not be strictly followd they met with the like approbation Rembrant's did, they were said at the same time by some Nature itself by others exicrable. So that time only can shew whether he was the worst or best Portrait [painter] living for no medium was so much as suggested how this could be can no otherways be accounted for but by the prejudices (or fashion) of the times in which he lived is it not strange that one of the first portraits as big as the life of Captain Coram in the foundling hospital should stand the test of twenty years as the best Portrait in the place notwithstanding all the first portrait painters in the Kingdom had exerted their talents to vie with it.

Here, as the genre was an accepted one, Hogarth painted on a scale close to that of the St Bartholomew's works. He sought to preserve the cheerful coarse plebeian vigour of the man who seems about to move forward with his big coat flopping open and his legs in an ungainly pose. As with the bishop, he used the sitter's insignia to merge man and office and yet contrast them. Coram, by his honest confident presence, dignifies the insignia, which yet fit him into the aristocratic world he denies. He sits in a stepped loggia, with curtain and column at the back, with sea and ships in the distance – as if he were an Admiral of the Fleet, though Hogarth wants to say he won his fortune in trade. On the table at his side lies the charter with a huge seal which he holds; on the steps stands a large globe. Hogarth adopts many attributes of the baroque aristocratic portrait, yet in the last resort what comes over is the solid homely figure sitting among the attributes as among a litter of aristocratic paraphernalia, through which he has burst.

As Hogarth's remarks show, most persons who thought themselves judges of art could not stomach the plebeian elements, the rejection of idealization. Hudson, Ramsay, Reynolds, ready to take in a little of the new middle-class intimacy as long as they could accommodate it to the grand style, were seen as the masters; Hogarth as an upstart braggart who confused all the issues. Indeed his realism, with its deep feeling and penetration,

was the force disturbing the elements that he took over from the conventional tradition; but this fact was considered a weakness, not a witness of great and original strength.

He may have been at work since well back in 1739 on Coram. We know how he liked to keep returning to a work, reconsidering it, testing its insufficiencies, adding and changing. At times he asked to have back a picture he had sold, so as to work further on it. Such an attitude seemed to the fashionable buyer to show uncertainty and incompetence. *Captain Coram* seems to have brought in no commissions for portraits, as the hospital works had gained no commissions for decorating country mansions. Hogarth went on mostly painting friends, acquaintances, or eccentrics like Mary Edwards.

Still, he did not lack sitters. Convention tends to rule in the portrait of a son of a director of the Bank of England; but with George Arnold, retired merchant, the spirit of *Coram* reasserted itself; we are on the verge of the new realistic classicism that matures with the French Revolution. Arnold's daughter, however, is shown with all the assured gentility of the generation following a self-made father. As independent in her way as Arnold, though depicted with more apparatus of wealth, is Mary Edwards, painted in a striking red dress and holding the lines: 'Do thou great Liberty inspire their Souls.' In such portraits Hogarth reaches his highest point as depicter of the new solid force of the bourgeoisie; the character definition is matched with the weight and certainty of the aesthetic image.

In April Drury Lane staged R. Dodsley's *Blind Beggar of Bethnal Green*, in which something of the *Beggar's Opera* idiom is applied to beggary. 'All men are beggars in some shape or other . . .' On 10 June Fielding published an essay on satire in the *Champion*. 'The force of example is infinitely stronger, as well as quicker than precept, and our eyes convey the idea more briskly to the understanding than our ears'. Also, 'we are much better and easier taught by examples of what we are to shun, than by those which would instruct us what to pursue'. Take 'the ingenious Mr. Hogarth', who is 'one of the most useful Satyrists any age hath produced'. For 'in his excellent Works you see the delusive Scene exposed with all the force of Humour, and, on casting your Eyes on another Picture, you behold the dreadful and fateful Consequences'. The two Progresses are 'more calculated to serve the Cause of Virtue, and for the Preservation of Mankind, then all the Folios of Morality which have ever been written'. Later this year Richardson published *Pamela*, to which Fielding replied with *Shamela*. Richardson approached Hogarth for illustrations. We do not know if Hogarth refused or if he made designs that were disliked. This year also saw the burlesque poem, *Hobbino, or the Rural Games*, by William Somerville, dedicated to Hogarth, 'the

greatest Master in the Burlesque Way'. Hogarth was to treat the Town while Somerville took the Countryside. (He would not have been pleased at being thus singled out as a burlesque artist.)

The Foundling Hospital had taken temporary premises in Hatton Garden and on 25 March opened to take in thirty children. Hogarth was one of the four governors who volunteered to attend the pathetic occasion, which carried on till midnight. Two days later he attended again, and on 1 April he donated a gold frame for the Coram portrait. He was present on 13 May when officers were elected; then, though still ready to aid the hospital, he missed the meetings for a couple of years.

On 19 October a young actor, Garrick, caused a stir as Richard III. In November Hogarth issued *The Enraged Musician* satirizing the artist who is demoralized by life breaking in on him, and stressed the link with the poet, by calling it a companion piece. The musician stands furious and frustrated at the window while in the street noisy people pass or loiter: an itinerant hautboy player, a dustman with basket on head, a paviour (with an Irish cap of beehive-shape), a sowgelder blowing a horn, a fish-peddler, a milk-girl with a pail on head, a pregnant ballad-woman with swathed baby singing *The Ladies Fall*, and so on. Under the window is an odd episode: a boy and girl making a little pavement garden and trying to catch birds; the girl holds a rattle and apple (or ball). They have a detached idyllic note and may represent nature, leading on as they do to the milk-girl and suggesting that, for all the noise, one can still concentrate if one's purpose absorbs one deeply enough. A poster announces the revived *Beggar's Opera*.

At Vauxhall Hayman and his assistants were carrying on, with four marine subjects by Monamy soon after 1740. Before 1745 Hayman painted Shakespearean themes. Earlier pictures showed scenes from plays, novels, ballads, and rustic feasts, leading on to a series of country games and pastimes. Though French elements crept in, Hogarth's influence played a part in the whole development, and it is a pity that he did not do more directly for the Gardens. Here he would have had a freer hand than in the hospital paintings or the large portraits. Perhaps he feared that the link of his modern moral subjects with a pleasure garden would be used by his enemies to depreciate him still further. Sometime in 1740–41 Roubiliac did a bust of him with a separate statue of the pug Trump. He appears more thoughtful than in his own first self-portrait; the strong large sensitive face has a compact sense of power, with something in the tightening jaw that suggests a capacity for aggressive action.

The years 1736–41 saw him uncertain in what direction to concentrate his efforts: hoping to prove himself preeminent in portraiture, not sure what the

Rake led to in comic history. He broke new ground in *Four Times,* with the contrasts of rowdy popular life and religious or social pretences; and again in *Actresses* expressed richly the contrast of outer display and reality. But in general he was feeling his way forward without being quite clear where he was going.

9 Marriage à la Mode (1742–6)

The year 1742 saw Hogarth still rather lost. He painted some portraits. One sitter was Martin Folkes of the Royal Society, another large confident man, raising an admonitory finger; President of the Society of Antiquaries, he was interested in archaeology (represented by a broken column in the picture). Hogarth's sitters were mainly professional men, rarely done in full-lengths; 'The largest and most interesting single group, indeed, is medical: from the surgeon Caesar Hawkins to Thomas Pellett, President of the College of Physicians, and to the biologist Edwin Sandys' (Paulson). He is not likely to have read many works of science, though he may well have looked to see what Newton and others had to say on optics and prismatic colours; but he probably listened intelligently to others conversing on learned matters. He no doubt knew the *Principles of Painting* by De Piles (translated 1743), and he developed a fantasia on the theory linking the faculties of sight and hearing:

The knowledge of colours bears so strong an analogy with the science of Musick that some have been Induc'd to think that the Identical principles, for the composition of musick would equally serve for those of colours.

So much was Pare Castle Dr. of the Surbon & a great projector at Paris perswaded of this that at a great expence of time and trouble he contriv'd a harpsicord to play harmonious compositions of colours, and on which he wrote a pretty large Treatise. The Prism colours were his notes which the Keys of the Instrument were to make appear at Pleasure. but sure he would [not] have been drawn into makeing this extraordinary experiment if he had not taken it for granted that colours and sound were of the same Nature and that the like dispositions, of them both would answere the same purpose i.e. that a jig in notes would be literally a jig in Colours.

It would not be surprising to hear of an Instrument invented by that nation of Tast formd upon some such plan for Cookery which no doubt would soon be brought over to England where it would certainly meet with great encouragement. Would it not be pleasant to see Mounsieur l'Quisinier at his harpsicord in a Morning composing a grand festin for the entertainment of foreign ministers?

Such an Improvement of this Instrument could not but be very agreeable to a certain eminent composer, nor could he fail getting the hearts of all the court as well as of the city by composing a banquet for an instalation or a lord mayors day.

About this time he painted his two largest pictures of children. The Mac-Kinnons, elegant yet solid, stand in lively postures on a terrace. The idyll of childhood is carried to its limit, but mocked by the rich clothes, the precocious graces. The girl has fallen flowers in her apron, the boy reaches for the butterfly on the tall sunflower. The loss of innocence, the spoiling effects of time, are prefigured. The paradisiac tree (the sunflower) for the moment absorbs all the children's happy attention, yet betrays them into vanity. Colour effects utter the meaning. The round-faced sunflower is the centre, its pale ground drawing boy and girl in and connecting them with their slight violets and hues of brown-green. The Graham children, four in number, are indoors and show a less monumental simplification of pattern; but the same moral is inferred by the use of bird as emblem. The boy turns a bird-organ painted with Orpheus charming the beasts while a greedy-eyed cat above thinks how to get at the caged bird; the only bird flying free is a carved one. The harmony of man and nature is soon to be broken by the emergence of rapacious impulses and demands. (In the Salon of 1751 Chardin painted a lady with caged bird and bird-organ; the theme is the link and contrast between nature and artifice.)

Mary Edwards, whose friends joked at her old-fashioned dresses, commissioned Hogarth to depict satirically the modes they admired; she is said to have provided the ideas for his design, in which we see two women, a tottering fop, a black page, a monkey. The woman at centre, with her exaggerated finicky pose, has a hooped dress that swings like a huge pyramid with curved base; the modishly dressed monkey studies a bill of fare through a magnifying glass – a motif perhaps from Teniers, Gillot, or Watteau. The pictures on the wall stress the satire. We see the back of the Medici Venus, nude save for stays and high-heeled shoes; a big half-hoop covering her front; cupids paring superfluous flesh from another woman or bracing the hoops and stays. The ballet-master Desnoyer is shown in a pose that reduces him to a doll, a geometrical pattern; a lady wears a very wide pyramidal hoop stereometrically folded; on a fire screen another lady is compressed into a rigid

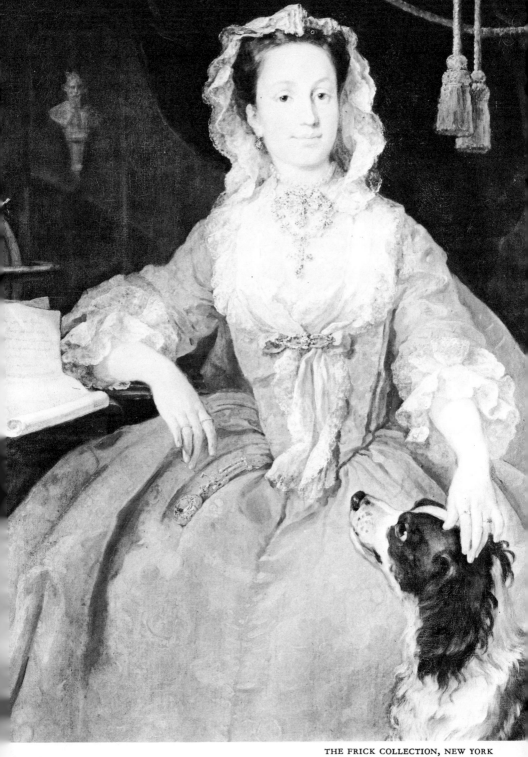

Miss Mary Edwards, c. 1740

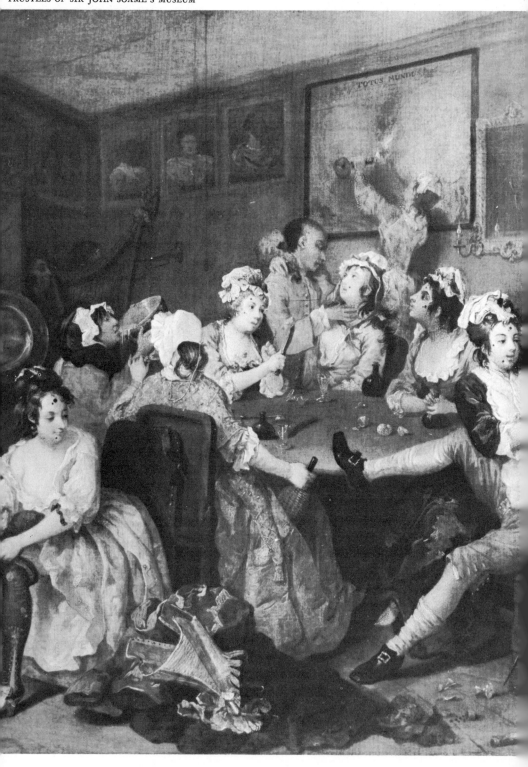

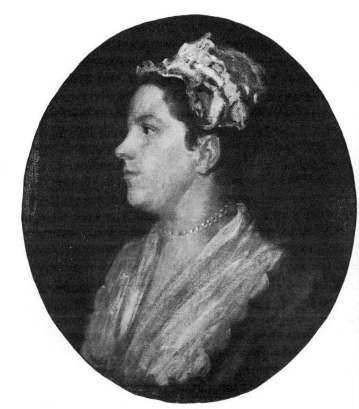

Hogarth's Younger Sister, Anne, c. 1745

THE RAKE'S PROGRESS, C. 1733
3. The Tavern Scene

Hogarth's Elder Sister, Mary,
c. 1740–45

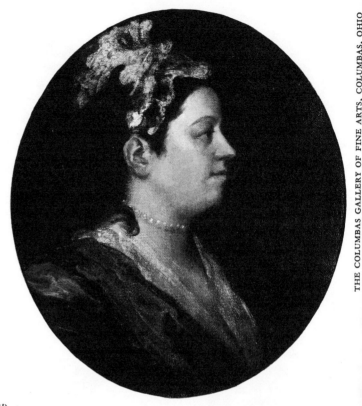

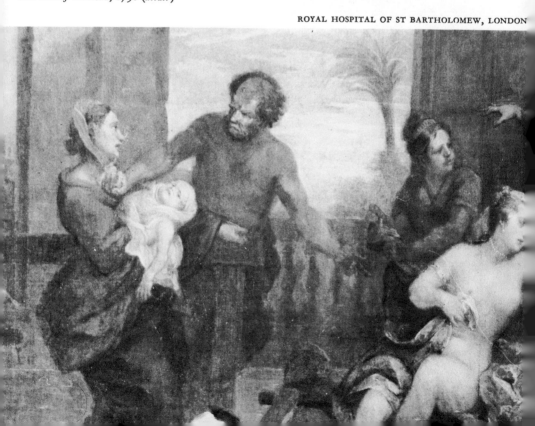

The Pool of Bethesda, 1736 (detail)

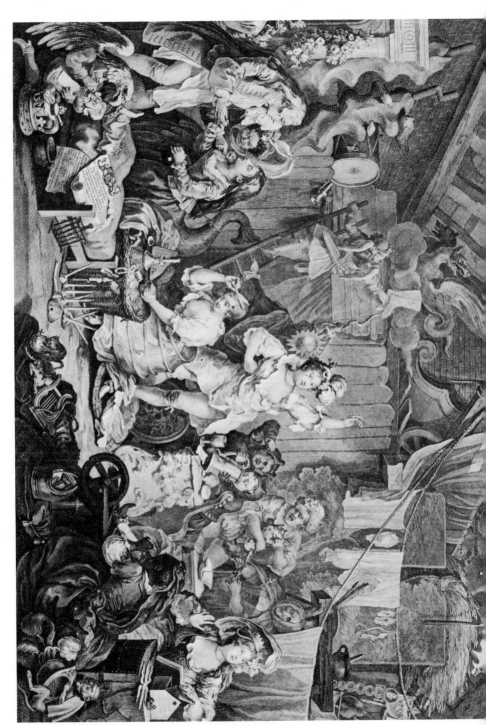

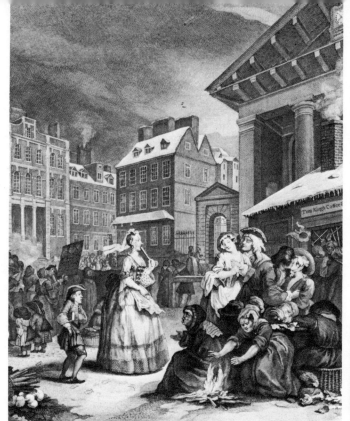

Morning

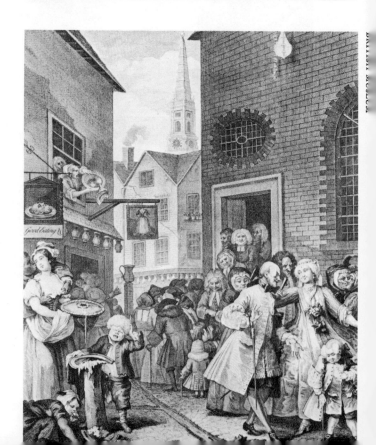

Noon

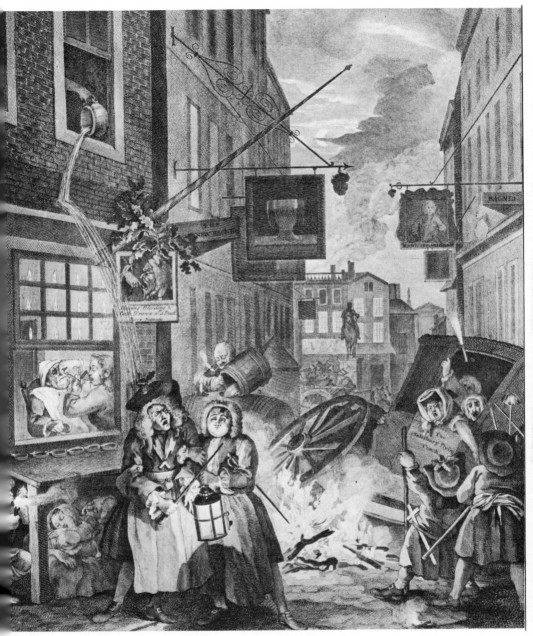

THE FOUR TIMES OF THE DAY, C. 1736

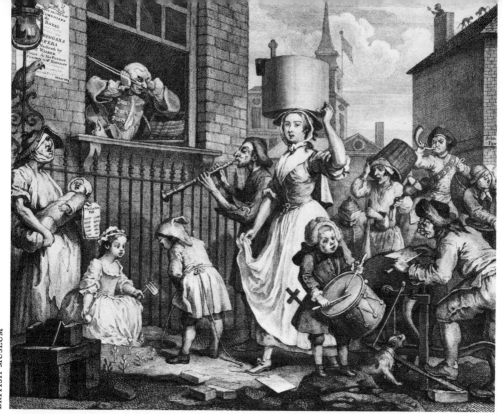

The Enraged Musician, c. 1739

The Distressed Poet, c. 1736

pattern by her dress. 'The ensemble – sedan-chair, steps beneath – is built up from cubic volumes and is presented as an independent composition; even the single leg of a chair-carrier, the only visible motive connecting it with the outside world, seems abstract-cubist' (Antal). Hogarth's strong analytic interest in volume and structure leads thus at times towards abstraction, which he uses to represent anti-nature and dehumanization. The artist needs to understand it experimentally and at times to venture into it, but always understanding what it implies: the death or disintegration of man. If these points are kept in mind, we can say that Hogarth was the first artist experimenting with abstract systems; a design for the *Analysis* has been called (by Herbert Read) the first abstract composition.

About the same time as *Taste à la Mode*, he made a sketchy etching *The Charmers of the Age*, reducing the dancers Desnoyer and La Barbarina (with a lewd touch) to the toy mannikins called pantins. (A plate *Pantin à la Mode*, September 1748, showed ladies and gentlemen, monkey and cat, playing with the toys. 'I am in doubt when I hear of this polite fashion,' wrote Lady Luxborough, 'whether it is a mark that the world has returned to its infancy (as old people grow childish), or whether it may not be some coquettish invention that Mr. Pantin may say in dumb show what the lady who wears him cannot say for herself.' The distorting fashions for Hogarth represent abstraction and mechanical sex. The pantin dancer in *Taste* is surrounded by flying insects to show further his lack of humanity.)

Late in 1742 his sister Anne gave up her shop and moved into his house, where she lived till her death in 1771. Soon her signature appeared on bills, receipts, and so on. In his will Hogarth relieved her from 'all claims and demands' he might have on her, showing that he had given her moneys; he left her £80 a year from the profits of his engravings and, if Jane had remarried, she would have taken over the most remunerative sets.

This year Fielding published *Joseph Andrews*, which may well have done much to draw Hogarth back to comic history. Fielding, as in all his novels, is deeply indebted to him, not only for particular themes or images, but also for his whole approach, method, and set of values. He himself declared the link in his preface to the novel:

Now what *Caricatura* is in Painting, Burlesque is in Writing; and in the same manner the Comic Writer and Painter correlate to each other. And here I shall observe, that as in the former, the Painter seems to have the Advantage; so it is in the latter infinitely on the side of the Writer: for the *Monstrous* is much easier to paint than describe, and the *Ridiculous* to describe than paint . . . He who should call the Ingenious Hogarth a Burlesque Painter, would, in my Opinion, do him very little Honour: for sure it is much easier, much less the Subject of Admiration, to paint a man with a Nose, or any other

Feature of a preposterous Size, or to expose him in some absurd or mon-
strous Attitude, than to express the Affections of Men on Canvas. It hath
been thought a vast Commendation of a Painter, to say his Figures *seem to
breathe;* but surely, it is a much greater and nobler Applause, *that they appear
to think.*

Behind such a passage must have lain many discussions with Hogarth on the
burlesque and the comic; the points raised were all close to Hogarth's heart.
It is indeed likely that Fielding read parts of the novel to his friend and
discussed its progress; and Hogarth must have been much stirred at finding
that his method, considered a trivial side issue by the art world, was finding
a new birth in the literary sphere. It cannot be chance that now, after a long
absence from narrative pictures, he returns to them with a full novelist's
perspective.

Fielding was further writing in Hogarthian terms in declaring that his
subject would lie between the paragon and the devil. 'The only source of the
true Ridiculous (as it appears to me) is Affectation.' He uses the last word
in a broad sense to cover all discrepancies between reality and pretence,
conscious or unconscious. As well as using a general Hogarthian method,
Joseph Andrews makes many references to the artist or shows direct memories
of his work: for example in the accounts of Lady Booby or Mrs Tow-wouse.
The tale of Wilson is based on the *Rake's Progress* (with Bedlam left out). The
lady in the coach looking at the naked Joseph through the sticks of her fan is
the sister of the girl in Tom's Bedlam, who ogles through her fan a naked
madman. Beau Didapper suggests the mincing beau in *Noon.* Dealing with
caricature, Fielding finds the phrase, 'comic history painter', which Hogarth
had been seeking for himself. Distinguishing comedy and burlesque, he
writes:

But to illustrate all this by another Science, in which, perhaps, we shall see
the distinction more clearly and plainly, let us examine the works of a Comic
History Painter, with those performances which the Italians call *Caricatura;*
where we shall find the true Excellence of the former to consist in the
exactest Copying of Nature; insomuch that a judicious Eye instantly rejects
anything *outré,* any Liberty which the Painter hath taken with the Features
of that *Alma Mater,* – whereas in the *Caricatura* we allow all License. Its aim
is to exhibit Monsters, not Men; and all Distortions and Exaggerations
whatever are within its proper Province.

The *Craftsman* of 1 January 1743 distorted Fielding's position into one of a
contrast between Caricature and Beauty. Hogarth's reaction was to produce
a print, *Characters and Caricaturas.* He draws a mass of heads in profile, facing
in different directions. Below are three heads labelled *Characters,* taken from
Raphael cartoons, and four labelled *Caricaturas* (Ghezzi, A. Caracci, da Vinci),

with a vague head behind. The crowd of heads shows the endless variations that can be made on given types without falling into caricature, and Hogarth adds: 'For a farther Explanation of the Difference betwixt *Character* & *Caricatura* See ye Preface to *Joh Andrews*.' Later he wrote: 'A Face (Foreign) Painter at whose house I was complemented me with saying he admir'd my charactures, looking round at his portraits I returned it by saying I admir'd his.' So, 'plagued for ever with this mistake occationed among the more illiterate by the similitude of the words', he did his print. And he added a couplet from Dryden's Prologue to Etherege's *Man of Mode:* 'We neither this nor that Sr Fopling call he is knight oth shire and represents us all.'

His print seems influenced by *Human Physiognomy Explained*, the work of Dr Parsons, Assistant Secretary of the Royal Society, which found the cause of changing expressions of passion in muscular movements. Parsons illustrated his thesis with drawings of the same face under different emotions. The *Analysis* shows how closely Hogarth observed the relation of the play of muscles to emotion or character.

It is by the natural and unaffected movements of the muscles, caused by the passions of the mind, that every man's character would in some measure be written in his face, by that time he arrives at forty years of age, were it not for certain accidents which often, tho' not always prevent it. For the ill-natur'd man, by frequently frowning, and pouting out the muscles of his mouth, doth in time bring those parts to a constant state of the appearance of ill-nature . . .

This year, 1743, Fielding published *An Essay on the Knowledge of the Characters of Men*, with many shrewd comments on faces and behaviour, all showing his closeness to Hogarth's positions.

On 2 April the latter advertised a set of six prints, to be engraved by the best Masters of Paris, 'representing a variety of Modern Occurences in High-Life, and call'd MARRIAGE A-LA-MODE'. There was to be not 'the least Objection to the Decency or Elegancy of the whole Work', and no character 'shall be personal'. Two days later readers were told: 'the Heads for the better Preservation of the Characters and Expressions to be done by the Author'. *Characters and Caricaturas* was used as subscription ticket. It may seem odd that the champion of English art had turned to French engravers, but no doubt he felt that they were needed to provide the elegance in a set dealing with high life. The return to comic history no doubt came from the unsatisfying response to his portraits and the stimulus of discussions with Fielding. We see that he has turned to the question of the difference between character and caricature with a new vehemence, and is resolved to free his art from the imputation of burlesque crudity and lowness.

In May he set out for Paris 'to cultivate knowledge or improve his Stock of Assur[ance]', says Vertue. No doubt he was interested in seeing more closely what was happening in French art, but he also wanted to find the engravers for his new set. We know no details of his visit, but he made arrangements with several engravers, but, apparently on account of his low pay offers, only one, Ravenet, came to England and he went off after doing two plates. (Later, prospering, he had the satisfaction of refusing to engrave *Sigismunda*.) On 25 August Mary Edwards died. Hogarth may in part have been thinking of her in taking up the theme of a profligate noble marrying a middle-class heiress.

Perhaps this year he made a print of a hoax (probably the work of the Beefsteaks) in which Highmore, a bragger of love conquests, who had been manager at Drury Lane, was inveigled into bed with a woman who at the last moment changed places with a Negress.

In later notes Hogarth, setting out the three things that brought abuse on him, cited first his attempt at portraiture. He says that he was 'so disgusted' that at times he refused to do portraits, and he approvingly cites a fable of Gay about an artist with the gift of catching a likeness so truly that he lost all his clients, but who then copied busts of Venus and Apollo, chattered about Greece, Titian, Guido, and thus became highly successful. Still, this year he again painted Bishop Hoadly. Hoadly, once attacked as a republican, wrote in support of Walpole and gained much preferment. A big eater, he became so crippled that he could hardly preach a sermon; but, as an absentee bishop, he went on living luxuriously in London. Once, as the Queen and Harvey were discussing his *Plain Account of the Lord's Supper*, George II called him 'a canting hypocritical knave crying *My Kingdom is not of this world* at the same time as he, as Christ's ambassador, received £6000 or £7000 a year'. In the painting Hogarth, perhaps recalling a pope's portrait by Maratta, gave Hoadly all the pomp of his robes of state, at the same time suggesting the wretchedness of his fat useless body; the old man appears pathetic, ridiculous, yet not without dignity.

This year Fielding published *The Life of Mr Jonathan Wild the Great*, in which he took up the method of the *Beggar's Opera*, with more serious and savage satirical intention.

On 24 April 1744 Hogarth's new series was stated to be on the way, with subscriptions open till 1 May. But early this year war broke out with France and an invasion was feared. On 8 November the series was still not issued, and Hogarth stated that three of his expected engravers had not come over. Perhaps to fill the gap, he decided to re-issue the *Harlot*, with a small cross under each plate to show its state. His advertisements had roused much

interest, and Orator Henley, always ready to cash in on any popular excitement, intervened with an oration on Hogarth's fight against the printsellers: 'A Consideration of the little Game Cock of Covent Garden,' says Vertue, 'against. 4 Shake-baggs – meaning four print sellers of London.' An advertisement couched in cock-fighting jargon ended with a hope that Hogarth would turn his eyes to the political cockpit, 'against the old Pastry-Cook's Custard-fed Smock-Cocks'. But Hogarth had too much sense to be drawn into the party-politics of the day. This year there were riots over price rises at Drury Lane; and a spokesman for the public was set up.

Hogarth had long since done the paintings for his new series. The title came from a comedy by Dryden (reprinted 1735) in which both husband and wife take lovers. Garrick's *Lethe* (1740) dealt with a marriage of convenience; the pair, having got what they want, agree to part. Hogarth's pair cannot part; and Garrick, with acknowledgements, took up this theme in his *Clandestine Marriage*. As Hogarth was getting his prints made, Richardson attacked the property marriage in *Clarissa*; and in 1753 the issue was to be furiously debated when an Act was brought in to stop Fleet marriages. Hogarth no doubt also had at the back of his mind Defoe's *Conjugal Lewdness, or Matrimonial Whoredom* (1727), called in later edition *The Use and Abuse of the Marriage Bed*. Here too a man sells himself to gain a woman's property; he infects her with venereal disease, saying 'with a kind of laugh, that he thought he had been cured'; then he has her certified and shut up as a lunatic while he buys more women with her money. Ever since 1689 the price of husbands had been rising; the landed gentry were bitter at the way that city men could offer more money to marry into rich or esteemed families. The prints of Hogarth show the marriage being arranged at Lord Squanderfield's house; the young couple, already disillusioned, in their own home at 1.20 a.m.; the husband consulting a quack about VD, and his wife at a dissolute levee, with her lover Silvertongue at her side; the husband surprising the pair at a bagnio and being killed; the countess taking poison after Silvertongue is hanged, her baby girl showing signs of inherited disease.

Hogarth now has full mastery of such scenes, varying compositions in terms of the main effect and relating characters to settings. Thus in plate 2 he epitomizes both the social origin and personal character of each of the newly-weds. The earl sags in damn-all exhaustion, not bothering to hide his mistress's cap which sticks out from his pocket, sniffed at by a dog. The countess, who has held a large card-party, stretches in a vulgar gesture of weariness. The Methodist servant, going out with bills in his hand, registers horror. Between the couple yawns the hole of the fireplace, which with the

mantel has been designed by Kent in the worst taste and serves for an over-done display of art objects. A Cupid, blowing a bagpipe amid ruins, with unstrung bow, and burned-out candles, expresses the state of the marriage. (In plate 1 the guttering candle represents the old earl's wastefulness and failing health.) Hogarth gave the countess a straying lock of hair in the third state, and explains in the *Analysis*:

A lock of hair falling across the temples, and by that means breaking the regularity of the oval, has an effect too alluring to be strictly decent, as is well known to the loose and lowest class of women; but being pair'd in so stiff a manner, as they formerly were, they lost the desired effect, and ill deserv'd the name of favourites.

Throughout, pictures are used as emblems. A burlesque of the French state portrait shows the old earl's concept of his power, while other pictures symbolize the fate awaiting the young couple. The mad power role of the aristocrat is linked with images of violence, cruelty, and the destruction of the innocent. In plate 2 there is a set of echoes between the steward's face, the Roman bust, and the disgusted statue in the next room. In plate 3, set in Dr Misaubin's house or museum at 96 St Martin's Lane, monsters, abor-tions, chemical apparatus are linked with imagery of Tyburn and hanged criminals; the complicated machines provide a criticism of misapplied or trivialized science. Indeed, the whole mess of things builds up a sense of distorted ingenuity, of purposes twisted awry and perverted to serve death instead of life. (Hogarth seems to be drawing on the account of Fossile's house in *Three Hours After Marriage*, by Gay, Pope, and Arbuthnot, pub-lished 1717.)

In the countess's drawing room, among many erotica, are pictures repre-senting lust. Above the countess and Silvertongue hangs the *Embrace of Jove and Io* by Correggio (reminding us that the woman was turned into a cow), and above the singing castrato (Senesino) hangs a *Rape of Ganymede* (again Correggio). On the sofa is Crebillon's *Le Sopha*, indicating what love-use will be made of that piece of furniture. Art junk bought at an auction lies about; Rouquet mentions that auctions, like masquerades, were used for rendezvous. Silvertongue points to a friar and a nun on the screen; he is explaining to the countess how to meet him at a masquerade. The art themes and the actions of the characters come together.

At the bagnio is depicted a whore dressed as shepherdess, the bulky legs of a soldier (on the tapestry behind) sticking out below her skirt. Over the door, where the watch enter with the nemesis of the law, is painted St Luke with his ox, looking down on the scene. The patron of artists, he stands for Hogarth with his relentless eye and hand. (We may recall the voyeur in the

barn roof looking down on the Actresses.) Finally the stricken husband has the pose of a Christ being taken down from the Cross, just as Tom ended in the pose of a *Pietà*. The countess kneels as a Magdalen before her Christ. In France the Magdalen was the great woman saint of the seventeenth century. Charles Le Brun produced the stereotype of repentance: the woman with pathetic expression and dramatic gesture of sorrow. The exploitation of the Magdalen was part of a wide set of devices used by the Church to attract people; the Jesuits especially took her up. More and more ladies from round 1660 were painted in her role: Madame de Chatillon and the Duchesse de Longueville (repentant *frondeuses*) were examples. The retreat of Louise de la Vallière into a convent stimulated the fashion; and many ladies, fallen from favour, liked the image: for example, Béatrice des Custance and Louise de Kerouaille (done by Lely). The Duchess of Cleveland, another mistress of Charles II, was painted as Magdalen, St Catherine, and the Madonna, with one of her royal bastards as Jesus. At last the type became so sentimentalized, as by Nattier, that the Magdalen could not be told from a shepherdess or a fine lady awaiting her lover. Elizabeth Rowe in her *Dialogues* makes Mrs Trifle address a pious lady: 'If your devotions should take a more romantic turn, perhaps you'll retire to some grotto, beautiful in the height of negligence, with your fine flaxen hair falling over your neck, like *Mary Magdalen*, in that picture that hangs by you.'

In the merchant's house, where all is dirty, broken, wretched, we find two Dutch drolls which serve as contrast between the fantasy of cheerful hearty bourgeois life and the usurious reality. At the outset the old earl 'sells' his son to raise money for a big Palladian mansion; he dies and the young couple act out their self-destruction in pretentious rooms decorated by Kent. Their art taste is one with their vices and lies. Indeed, throughout, the rooms, the events, the characters are closely interrelated. Horace Walpole noted: 'It was reserved for Hogarth to write a scene of furniture.' He gives examples and adds that they 'are the history of the manners of the age'.

The subscription ticket was the *Battle of the Pictures*, an idea taken from Swift's *Battle of the Books*. Hogarth's works are attacked by the enemy-forms of art. Plate 2 of the new series stands on an easel as his latest creation; it is set in a studio open to the view of all, open to all the winds of life. On the left is a closed building with a porter and with a portrait in gilt frame on show; a weathercock stands on top. Here is the world of connoisseurs and dealers, with no stable theory or understanding. The weathercock also represents Cock the auctioneer; an auction is being held. The conflict is not merely between old and modern; it is between the idealized and remote art

of the establishment and the art truly revealing men and nature. St Francis at his *Meditations* attacks the Prude of *Morning*; the old ideal of asceticism attacks the exposure of repression. Mary Magdalen attacks the Harlot; the idealized whore attacks the real one. A procession of Bacchus attacks the rake in the Rose Tavern; the Aldobrandini depiction of marriage attacks *Marriage à la Mode*; the *Rake* (3) makes a hole in a *Feast on Olympus*. *Marsyas flayed by Apollo* and *Europa's Rape* stand in reserve. The caption states that the bearer of the print is entitled to attend the auction of Mr Hogarth's picture on 28 February 1745.

He had decided to appeal over the heads of the dealers as he had done with his engravings. On 25 January he issued a set of proposals. Offers for his paintings of the two *Progresses*, the *Four Times*, and the *Actresses*, were to be entered in a book; the pictures would go to the highest bidder, with the closure marked by a clock striking in his room at 10.15. Only persons entered in the book could bid on the last day, and only those with tickets would be admitted. Later he agreed to sell the works singly as well as in sets, and changed the hour to noon.

Confidently he told Reynolds: 'I shall very soon be able to gratify the world with such a sight as they have never seen before.' On the day, Horace Walpole bought *Sarah Malcolm* for five guineas. He noted a 'poor old cripple', Mr Wood, who bid for the *Rake's Progress*, saying, 'I *will* buy my own progress' – though 'he looked as if he had no more title than I have but by limping and sitting up'. (He was doubtless the Wood who about 1730 commissioned pictures of his family, his daughter, and his dog.) William Beckford, who had rich city parents, however, got the *Rake*. Wood bought the *Actresses* for twenty-six guineas. Beckford ended by buying both the *Progresses*, at £88 4s and £186 16s respectively. The Duke of Ancaster bought *Noon*, *Evening*, and *Danae*. Vertue next day summed up the event.

. . . a new manner of sale, which was by Engravd printed tickets his own doing – & delivered to Gentlemen Noblemen & Lovers of Art – only – bidders, (no painters nor Artists to be admitted to his sale) and by his Letter and a day affixd to meet at his house, there the pictures were put up to sale, to bid Gold only by a Clock, set purposely by the minute hand – 5 minutes each lott, so that by this means he could raise them to the most value & no barr of Criticks judgment nor – cost of Auctioneers, and by this subtle means he sold about 20 pictures of his own paintings for near 450 pounds in an hour admit the Temper of the people loves humourous spritely diverting subjects in painting, yet surely, the Foxes tale – was of great use to him. as Hudibrass expresseth

> yet He! that hath but Impudence,
> to all things, has a Fair pretence

Indeed the event was novel; some £500 was brought in. But the significance lay, as with the engravings, in attempting to find a new direct relation to the audience – though with paintings Hogarth was up against much stronger conventions and vested interests. However, though he did not know it, this moment represented the height of his success as a painter. His buyers, though including landowners and men with city connections, were not truly representative of the art collectors. The auction had the chance success of a novelty and attracted a few men who admired his work or who were interested in the odd and the entertaining.

The *Marriage* paintings were not put up till five years later; but the prints were delivered on 31 May (not 25 March as announced). Probably during the 1744–5 season the drawing school run by G. M. Moser, Swiss enameller, combined with the St Martin's Lane academy.

The year 1745 saw Hogarth engrossed in portraits. He secured his most highly placed sitter, Thomas Herring, Archbishop of York (soon of Canterbury), and may have gone to York to paint him. He had the chance to apply some of the lessons learned in Paris, especially from Quentin de la Tour's pastels, though at the same time looking back to Van Dyck and Kneller. He is said to have told Herring that church dignitaries like Laud and Tillotson had had the luck to sit to those artists, and 'the crown of my works will be the representation of your Grace'. In September Herring, gathering the Hanoverian forces of Yorkshire against the invading Jacobites, became a famous figure, and Hogarth is said to have done the drawing engraved for his call-to-arms sermon. Early in November Herring wrote to a London friend that he did not wish to sit for any more artists. 'None of my friends can bear Hogarth's picture.' Influenced by the talk of Hogarth as an irrepressible caricaturist, the Herring circle considered the portrait to show 'features all aggravated and *outrés*', making him look ferocious instead of benevolent; Reynolds was the artist who should have been called on.

These remarks give substance to Hogarth's own claim that what first aroused strong opposition was his work in portraits. No doubt the clue lies in the way Reynolds was set up as the contrasted ideal. The Anglo-Italianate school of Hudson, Ramsay, and Reynolds had continued to make headway; and though it was some time before Reynolds could come out openly against Hogarth, we can be sure that others had been doing their best to ridicule and oppose him. Thus, Vertue, writing on the auction of paintings, admits Hogarth's force and versatility, but adds that he worked 'in opposition to all other professors of Painting'. Thus, he 'by his undaunted spirit, despised under-valud all other present, & precedent painters . . . Such reasonings or envious detractions he not only often or at all times – made

the subject of his conversations & Observations to Gentlemen and Lovers of Art But such like invidious reflections he woud argue & maintain with all sorts of Artists painters sculptors &c.' His theoretical arguments were seen as expressions of envy and malice.

He thus found himself ever more isolated, and the more isolated he was the more he talked sharply. Not that he was ever cut off from the art world, but he was treated more and more as a blindly arrogant egoist who, apart from his humorous ingenuity, was no longer in the main stream. The anti-Hogarthian trends were concentrated in the suave Reynolds with his business capacities. The Herring portrait thus represented Hogarth's highest level of social success as portraitist and the moment when he decisively found himself opposed to the ruling trends in art, Chippendale furniture was coming in, so much linked with French rococo that it was called the French taste; and the passion for collecting antique objects was growing ever greater.

For the moment he could not have realized what was happening. He painted the niece and the nephew of Herring. The niece, Mrs Salter, is done with all the delicacy of paint, all the material solidity, of the *Marriage* paintings; the greens, light and dark, with the pale rose in the centre, the boldly-painted yellow sleeves, the fresh face and brown-reddish hair, beget a lively and subtle harmony. About this time too he did the bustling scene of *Lord George Graham in his Cabin*; but for all the action the members of the group are not truly related. The warm bright colours of the *Marriage* have yielded to the greys and blues of the 1750s. In autumn 1745 he painted *Garrick as Richard III*. Garrick had done much to clear out the popular elements from the theatre; he was soon to get rid of spectators on the stage and bring in footlights. The result was to cut off the stage and produce a new concentration on the actor and his scene as systems operating on their own. Hence the difference of the Garrick pictures from those of the *Beggar's Opera*. No doubt it keeps close to the actual stage properties, but there are also memories of sublime history, of works like Le Brun's *Tent of Darius*. Garrick-Richard starts awake from his guilty sleep and stares at the ghost hovering between him and the spectators. His body makes a long strong diagonal, defined by S-curves, which his clothes and the curtain emphasize. His choice is defined by the armour near his feet and the crucifix near his head. The work is the most successful of Hogarth's attempts at the sublime and it has an important place in art history as having helped to bring English themes, and Shakespearean ones at that, into the genre. But if we consider it in terms of his full creative potentialities, we feel that it hardly matters. He has turned aside to produce a work useful and interesting in terms of the contemporary art situation, but it holds little of his vision of life.

Round this time he did his self-portrait in an oval. He is much older-looking, with strain round the eyes. The colour is in a low key. He is varying a formula of baroque self-portraiture, with an added self-consciousness. We can make out repaintings. First he tried a plain portrait, then put in his dog; a white ruffle and a bonnet were replaced by black waistcoat and fur cap. Thinking of an engraving, he put his scar on the brow so that it would come out on the right side. So we are meant to read from Trump (who had taken Pug's place in 1740) up to the man, then down to the palette, with its line of beauty. Volumes of Shakespeare, Milton, and Swift provide the base; in the engraving the names were omitted. In putting himself into a picture inside a picture, Hogarth gave the effect that he looks out into the space of his own life: his *alter ego* the formidable dog, his inspirations, his art. Only through these he looks out further, at the spectator and the world in general. It is not clear when he published the engraving. The painting has 1745 on the palette; and in the *Analysis* he states that he wanted to make clear his grasp of the line of beauty and

therefore in the year 1745, published a frontispiece to my engraved works, in which I drew a serpentine line lying on the painter's pallet, with these words under it, THE LINE OF BEAUTY. The bait soon took; and no Egyptian hieroglyphic ever amused more than it did for a time, painters and sculptors came to me to know the meaning of, being as much puzzled with it as other people, till it came to have some explanation; then indeed, but not till then, some found it out to be an old acquaintance of theirs, tho' the account they could give of its properties was very near as satisfactory as that which a day-labourer who constantly uses the leaver, could give of that machine as a mechanical power.

Others, as common face painters and copiers of pictures, denied that there could be such a rule either in art or nature, and asserted it was all stuff and madness; but no wonder that these gentlemen should not be ready in comprehending a thing they have little or no business with.

However, an early state of the print has 1749 pencilled in; and in March 1749 the busybody Vertue noted the painting as if it had only just been completed. Hogarth clearly wanted to establish that he was very familiar with the line by 1745; and indeed we have proof that he had made the phrase well-known among his friends, for in 1745 Vertue, discussing Hussey's theory of triangles as providing the true bodily proportions, noted that Hogarth 'much comments on the inimitable curve or beauty of the S undulating motion line, admired and inimitable in the antient great Sculptors & painters'. And in July 1746 Garrick wrote: 'I have been lately allarm'd with some Encroachments of my Belly upon the line of Grace and Beauty, in short I am growing fat.' So it seems that round 1745 Hogarth arrived definitely at his concept,

though with his deep-rooted impulses of curiosity, his need to understand the principles on which he acted, he had doubtless had glimmerings of it from the time he began grappling with rococo curves and undulations.

He had grown friendly with Jean André Rouquet, an enameller, who had been in England some twenty years. Rouquet had been explaining Hogarth's prints to the captured Marshall Belleisle; and Hogarth encouraged him to put his ideas into French for publication. He had perhaps been impressed by the bilingual text with Highmore's illustrations to *Pamela*. About this time he had the idea for another series, *The Happy Marriage*, to offset his depiction of a misalliance. For the *Courtship* we have only Ireland's print; of the *Marriage Procession* some fragments survive, together with the sketch for the *Wedding Banquet*. Then, in Ireland's plates come *Relieving the Indigent* and the *Garden Party*, and, finally, the sketch of the *Dance*. This reconstruction is by no means certain; and another sketch, *The Staymaker*, seems to show the trying-on of the bridal gown. Still, he doubtless had some such series in mind for the representation of a happy marriage, set in the country, where the loving pair tried to live a socially useful life. Ireland's plates are poor, but the oil sketches are among his finest work, with a breadth and ease of treatment all their own. In part this effect comes from the unfinished state which shows the structure of forms, provided by his mnemonic system, in a maximum of simplification that at the same time is rich in its feeling of mass and volume. *The Country Dance* has a vividness of colour treated in terms of movement as well as of mass, and thus gains a new dimension of expressive force. There is a broad handling of reds and salmons, greens and blues, in rapidly defined dancing forms, while other forms are built up in greys and mild greens. Despite the olive ground, the composition glows with a warmth that seems to come as much from the strenuous exertions of the dancers (the complex involving pattern of movement) as from the ochres.

Why did Hogarth drop the project? It is not enough to say that he felt insufficient interest in a story with lyrical moments but no dramatic conflict. True, in the *Analysis* he declares:

It is strange that nature hath afforded us so many lines and shapes to indicate the deficiencies and blemishes of the mind, whilst there are none that point out the perfections of it beyond the appearance of common sense and placidity. Deportment, words, and actions, must speak the good, the witty, the humane, the generous, the merciful, and the brave. Nor are gravity and solemn looks always signs of wisdom: the mind much occupied with trifles will occasion as grave and sagacious an aspect, as if it were charged with matters of the utmost moment; the balance-master's attention to a single point, in order to preserve his balance, may look as wise at that time as the greatest philosopher in the depths of his studies.

But he is not there saying that goodness and intelligence are unfit subjects for art; he is merely raising problems of characterization for both good and false persons. We have only to look at the *Staymaker* and the *Dance* to realize that he enjoyed painting these works with his whole being. He must have halted because he could not see how to interest his public in such works or how to have them effectively engraved. What deterred him was the fact that so much feeling had gone into the paint, which he could not see how to translate interestingly into black and white. His fondness for the *Dance* is shown by his use of it in the *Analysis* to illustrate the line of beauty; but without some such text he lacked faith that his public would appreciate it.

This series then brought him up against an insurmountable barrier, but not the one usually suggested. He had reached the climax of his painting powers, but could not see how to use those powers in a way to affect his period. *Marriage à la Mode* had shown the limit to which he could free his brushwork without moving beyond the sensibility of those around him, and he feared to go further. He could find no satisfaction in painting a work like the *Dance*, then re-doing it in a tamer form. The *Happy Marriage* had to be a lyrical expression of delight in living, in goodness and love, or it would fail. (I do not mean that he thought in quite these terms. To do so, he would have needed to get outside the age's categories of thought and look at the issues from a distance; but he must have arrived intuitively at something like this judgement. He decided to drop the project.)

In February 1746 an anonymous account of *Marriage à la Mode* in verse opened with a discussion of the nature of Hogarth's art. The author used the terms comic poet, history, and dramatic painter. We see that at least a few intelligent persons were trying to define the new kind of history achieved by Hogarth. In April Rouquet published his *Lettres de Monsieur . . . à un de ses Amis à Paris*, explaining his prints. Thereafter Hogarth included a copy of the book when sending sets of prints abroad. Nichols says that he paid Rouquet well. One effect of the translations of his paintings into black and white was that they could be exported in fair quantities; thus he became well known all over the Continent and was able to influence a large number of foreign artists. He says that the explanation of the prints was all the more necessary 'as it seems they are considered there as it were in an Historical light which Idea of them may have proceeded from their being designed in series and having something of that kind of connection which the pages of a book have'. Further, the 'Characters of the faces and figures' belong to the English 'at this age', and 'such Expressions as certain Incidents' in them 'naturally produce are to be more precisely and Intimately given by prints

than can possibly be convead by any other means except that of actualy seeing the things themselves.'

His words are not altogether clear, but he seems to be appealing to history in a new way: not history as an aesthetic category but history as a specific set of events, here English in character, which lack the idealized 'timelessness' of the acclaimed history-painting, and which need to be understood in their precise time and place. Elsewhere he writes of his works as defining 'such characteristicks of this country' and so becoming 'a kind of Historical pictures'. He adds: 'It may be Instructive and amusing in future times when the customs manners fasheons Characters and Humours of the present age in this country may possible be changed or lost to Posterity unless by this or some such means they are preserved to posterity.'

In July he announced the print of Garrick was to be had for 7*s* 6*d* at his house, 'where also may be had, all his other works'. Later in the year two versions were put out at Dublin. The painting was sold to Mr Duncombe for £200, a price that delighted Hogarth, 'more than any portrait painter was ever known to receive for a portrait'. But he then goes on to say how he grew disgusted and at times refused portraits. He had become friendly with Garrick, whose relatively realistic modes of acting would have pleased him. In July they both visited the pluralist John Hoadly in his parsonage at Old Alresford, to whom Garrick had written:

the little-ingenious *Garrick* and the ingenious little Hogarth, will take the opportunity of the *plump Doctor's* being with You, to get upon a Horse-block, mount a pair of Quadrupeds (or one if it carries double) & hie away to the Rev'd Rigdum Funnidos at ye aforesaid Old Alresford, there to be as Merry, facetious Mad & Nonsensical and Liberty, Property & Old October [ale] can make Em! huzza!

The plump Doctor was Messenger Monsey, a witty buffoon of slovenly appearance. Benjamin, brother of John and physician to George II, seems to have been with Garrick and Hogarth. The party was jolly and the group staged a parody (wholly or partly Garrick's work) of the quarrel scene between Brutus and Cassius in *Julius Caesar*. The characters were turned into an English sergeant and corporal, concerned with the death, not of Portia, but a mastiff bitch. John played Brutarse; Garrick, Cassiarse; Hogarth, the Devil's Cook (replacing Caesar's Ghost). We are told that Hogarth couldn't memorize the two lines he had to speak, so they were scrawled on the outside of a paper-lantern which he entered carrying. However, the manuscript shows that he, as Grilliardo, had twenty-three lines. He entered to thunder and lightning, and answered Brutarse: 'I am Old Nick's Cook – & hither am I come To slice some Steaks from off thy Brawny Bum, Make

Sausage of thy Guts, & Candles of thy Fat, And cut thy Cock off to regale the Cat.' He carries on in this vein till he sees hell gaping and walks off with the cry, 'I sink.' We can imagine the high spirits and endless foolery with which the farce was composed, prepared, and acted. Hogarth painted the set: 'A sutling booth, with the Duck of Cumberlands head by way of sign'. And he drew up a playbill with 'the characteristic ornaments'. Not long afterwards Garrick wrote of 'those never to be forgotten or parall[eled] Days that were spent at O. Alresford in the reign of *Raganjaw*', adding, 'I was never in better spirits or more nonsensical'.

In August Hogarth was invited to St Albans by a doctor, who took him to the White Hart to see the Jacobite Lord Lovat on his way to London for trial. (Later Peter Pindar said that Lovat was being shaved and embraced Hogarth, leaving soapsuds on his face.) On the 25th he issued an etching of the wily old Lord, who is ticking off on his hand the clans that fought for the Pretender. The print was very popular and was twice pirated in England as well as issued in Holland and Germany; many copies were made of the head.

In October Hogarth replied to a query from the Club of the Argonauts of Norwich about the effect that the proportions of Garrick and Quinn had on their appearance of height. He could not resist adding a boost about the price he had got for the Garrick painting. In his *Analysis* he was to write a long chapter on proportions and in his summing-up he remarks that under the general idea of form, 'as arising from fitness for movement &c. I have endeavour'd to explain, by every means I could devise, that every particular and minute dimension of the body should conform to such purposes of movement, &c. as have been first properly considered and determined: on which conjunctively, the true proportion of every character must depend; and is found to do so, by our joint-sensation of bulk and motion.' Here, as always, he opposes all static geometrical concepts of form and proportion. Form in nature he saw as always involving a living adaptation to some purpose and as revealing itself truly only dynamically in 'our joint-sensation of bulk and motion'.

Watching the permanent edifice of the Foundling Hospital rise, he could not but feel that here was a public place deserving decoration and at the same time offering help to artists who helped it. He certainly gave his support to the hospitals out of genuine humanitarian motives; but, once involved, he saw that the institutions could serve also as places for demonstrating the social function of art. From December 1744 he had probably begun an alliance with the sculptor Rysbrack, who, though a foreigner, had learned to speak English well (unlike Kneller, Handel, Roubiliac) and who had known

Thornhill. They set about gathering a group of artists, which met at the Foundlings from 1746 on. With a yearly dinner on St Luke's Day, they seem to have taken over from the body with that saint's name of which Rysbrack was an ex-steward. Rysbrack offered to do a marble relief for the new Court Room, and Hogarth proposed that other artists should be invited to decorate the room. An official statement was not made till the last day of 1746, by which date many works had been done. The artists named were Hayman J. Wills, Highmore, Hudson, Ramsay, Lambert, Scott, Monamy, R. Wilson S. Whale, E. Hately, T. Carter, G. Moser, R. Taylor, J. Pine. These men, with Hogarth, Zincke, Rysbrack, and Jacobsen, the hospital's architect, were to form a committee, meeting yearly on 5 November 'to consider of what further Ornaments may be added to the Hospital without any expence to the Charity'.

Hogarth's first idea seems to have been of an angel intervening to stop a desperate mother from strangling her baby; but he dropped it and turned to a normal history subject in the grand style: *Moses brought to Pharaoh's Daughter.* (Coram had used the subject for a design for the Hospital seal, 'Moses being the first Foundling we read of'.) Hayman also chose this theme, depicting the discovery of Moses in the bullrushes. In Hogarth's work the princess is the centre of interest as she stretches languidly across in a diagonal, with the other figures upright. Moses stands in a moment of choice between mother and princess. Hogarth could not resist the sort of realistic touch that annoyed the upholders of the grand style: a Negress whispers to her companion that the child must really be the princess's. He did his best for rich colour, with gold of hair, green or blue of dresses, yellowish white and salmon. Again the importance of the work is primarily historical; we see a movement towards the later classicism of the century, with perhaps even a suggestion of Géricault in the treasurer on the left. But if we compare it with the *Dance*, or indeed any of the paintings of the *Rake* or the *Marriage*, there is not much artistic character about it.

A work of Hogarth's that is hard to date, though it ranks among his masterpieces, is the *Shrimp Girl*, called in the family the *Market Wench*. The size is 20 by 20¾ inches, and the work shows the boldest and broadest brush-strokes of anything he did. Its purpose is hard to make out. It is too big for use in a modern history meant for engraving; it would not have suited any sublime history. We can only assume that he painted it out of sheer joy, struck by the gay charm of the girl and wanting to perpetuate it as vividly as his powers permitted. 'When a subject is trifling or Dull,' he wrote in his ironic way, 'the execution must be excellent or the picture is nothing. If a subject is good, providing such material parts are taken care of as many

convey perfectly the sense, the action and the passion may be more truly and distinctly conveyed by a coarse, bold stroke than the most delicate finishing.' His love for the *Shrimp Girl* is shown by the fact that he kept it and that his wife used to tell visitors: 'They say he could not paint flesh. There's flesh and blood for you — them!' She is clearly echoing what she had heard him repeat. Though the date may be later, it seems best to treat the work as of the *Happy Marriage* period, when he was most consistently developing the full virtues of his brushwork, his capacity to build up form with rich paint and in building it to give an effect of the movement of lines, surfaces, planes, volumes. Here the figure emerges out of the mesh of sweeping and broken tones, reddish-brown and rosy-pink, with greens and greys making the movement of colour subtler and giving an atmospheric quality to the solidity. The rich and fluid impressionism of the colour develops a complex flow and interrelation of forms that go beyond the pictures by Hals, such as his series of merry fisher boys and girls, in which the brushwork is bold and free, but without the liquidity of movement over the whole surface of the picture. Never again did Hogarth bring together so happily all his innovations in a unified image at once solid and dynamic.

10 *The Gathering People (1747–51)*

By February 1747 the paintings by Hogarth, Highmore, and Wills were hung in the Hospital; Ramsay painted Dr Mead and Hudson did Jacobsen; some landscapes also seem to have been ready. At last on 1 April they were all unveiled; the meeting was at noon with dinner at 2 p.m. Vertue records that the works by Hogarth, Highmore, and Wills were 'generally approvd & commended. as works in history painting in a higher degree of merit than has heretofore been done by English painters'. Hogarth's piece gave the 'most striking satisfaction – & approbation'. In the next ten years many more works were added, including pictures by Reynolds, Wilson and Gainsborough. Here was in effect the first public gallery, which did much to raise the prestige of English art. For some time there had been sporadic efforts by artists, such as Salvator Rosa, to reach out past the limited range of patrons; but no one made such a systematic and pertinacious attempt as Hogarth to reach the wider public: through his engravings, the advertisement and distribution of which were organized on an unprecedented system, and through his schemes for using public institutions to mount permanent exhibitions open to all who wanted to see them.

In June he published at 1*s* a print *The Stage-Coach, or the Country Inn Yard*. He seems to have added topical detail to a drawing already made of a morning coach about to set off amid everyday humours: lovers kissing, drunks making a noise, a fat woman being shoved up the stairs, a jolly English sailor jostling a wretched French footman on the coach roof, an old woman with a pipe in the basket, and so on. But in the background is an election parade with a sign 'No Old Baby', referring to the case of John Child who had stood for Essex in 1734 at the age of twenty. Hogarth probably wants

to suggest that the noisy political issues are infantile and meaningless, and that the most unsuitable candidate is liable to be elected if power and money are behind him. In the foreground a passenger, actually an agent, tries to bribe the innkeeper on pretence of paying a bill. A General Election had been announced on 18 June, to be held at the end of the month, and Hogarth has furbished up an old work to gain a topical response.

This year *The London Tradesman* described his academy:

Painting. The present State of this art in Britain does not afford sufficient education to a painter. We have but one Academy meanly supported by the private subscriptions of the students, in all this great metropolis. There they have but two figures, a man and a woman, and consequently there can be but little experience gathered. The subscribers to this lame Academy pay two guineas a season which goes to the expense of the room and lights. The subscribers in their turn set the figure, that is place the man and woman in such an attitude in the middle of the room as suits their fancy. He who sets the figure chooses what seat he likes and all the rest take their place according as they stand in the list and then proceed to drawing, every man according to his prospect of the figure.

For some time Hogarth had been working on a new series, *Industry and Idleness*, and in mid-October it was announced as 'shewing the Advantages attending the former, and the miserable Effects of the latter, in the different Fortunes of two APPRENTICES': twelve plates at 1*s* each, or 14*s* for the complete set on better paper. This time he worked from drawings. No doubt he felt, after the *Happy Marriage*, that there was a dislocation between his paintings and the engravings from them; at the same time he turned from the elegant world of Rake and Earl to a more popular level. A number of factors must have converged to bring about this change of direction. In one sense he went back to positions reached in the early 1720s, but he did so with a vastly matured artistic technique and understanding of his world. Clearly he felt an increasing dismay and unhappiness at the deterioration of the social situation, with increase of crime and gin-drinking. Fielding was not yet a magistrate, but he must have already arrived at the conclusions he was to set out in 1751, and he would have discussed things with Hogarth. From now on Hogarth seeks in his art a much broader social basis of idea and application. The crowd becomes a more and more important element in his work. The new series deals with two individuals, but they are less particularized than were the harlot, the rake, the earl, and the countess; their careers are seen more strongly from a social angle. The art works that portray them are smaller, looking rather to popular broadsheet or chapbook than to art-engraving. There is a direct return to the emblem book, with moral captions and quotations from the Bible, and with admonitory devices:

scourge, manacles, and halter for Idle Tom, and the city mace, the alderman's gold chain, the sword of state for Goodchild. There is an almost total lack of the elaborate art symbolism used in the other series.

There are two almost complete sets of drawings. The first is bold, with loose but expressively placed lines and with washes playing about here and there in masterly economical effect. We are far from the neater drawings of his earlier work in pen, ink, and wash, which had their links with Dutch genre drawings. The nearest thing to them in his previous work are the rapid sketches illustrating the *Peregrination*. There he used a quick bold technique because he wanted to amuse himself and a few friends, seeking to revive in direct vividness his recent memories of their shared experiences. Here he uses the method, since he has behind him all the assurances won by freeing his brushwork. We can see French influences (e.g. of Gillot), but he has transformed them in terms of his strong realistic vision. A drawing such as that of Tom stealing from his mother (not used in the set) or that of the Lord Mayor's Banquet anticipates the rollicking effects of Rowlandson, but with a weight and a force in their finely shifting lines and tones that bring them rather into the great realist tradition running from Géricault to Daumier and on to Rouault. In the second series of drawings, made for the engraver, much of the quick glancing energy goes. He has diverted his vision from the bold free paintings to the level of the popular cult. The energy remains in a leashed form, but tamed in a more simple kind of ordering.

There were many popular and literary sources for his theme. The contrast of two apprentices had been worked out in *Eastward Hoe* by Chapman, Marston, and Jonson – included in Dodsley's *Old Plays* (1744), and revived in 1751 as a result of Hogarth's series – and in Lillo's *The London Merchant; or, the History of George Barnwell* (1731), with an old popular ballad behind it. We must add the whole puritan tradition of contrasted paths in life, one leading to redemption, the other to hell. Hogarth would have known Patience and Passion in *The Pilgrim's Progress*, of whom Bunyan wrote: 'These two Lads are Figures'. But he has secularized the tradition in terms of worldly success and disaster. Sets of his prints seem to have been given by masters to apprentices as Christmas presents; and as part of their impact Lillo's play was done in the Christmas and Easter holidays for apprentices, from 1749 on. Hogarth says that his prints were

calculated for the use & Instruction of youth wherein every thing necessary to be known was to be made as inteligible as possible and fine engraving was not necessary to the main design provided that which is infinitely more material viz the characters and Expressions were well preserved, the pur-

chase of them became within the reach of those for whom they were cheifly intended.

He is well aware of the link between a change of style and a change of audience. The buyers however were the masters, not the apprentices. We hear of a schoolmaster, John Adams of Edmonton, who had the set framed and lectured on it once a month to his pupils, illustrating the lesson by rewarding or caning his boys. Vertue thought the prints 'in a slight poor strong manner. to print many'. Hogarth wanted to save money after the cost of 'good workmen' for the *Marriage*. Still, 'as the View of his Genius seems very strong & Conversant with low life here as heretofore, he has given fresh instance of his skill'.

The anonymous author of *The Effects of Industry and Idleness Illustrated* gives us the feeling of excitement roused by the issue of Hogarth's sets and the way in which they were discussed:

Walking some Weeks ago from *Temple-Bar* to *'Change* in a pensive Humour, I found myself interrupted at every Print-Shop by a Croud of People of all ranks gazing at Mr. *Hogarth*'s Prints of *Industry and Idleness*. Being thus disturbed in my then Train of Thoughts, my Curiosity was awakened to mingle with the Croud, to take a View of what they seemed so much to admire. Mr. *Hogarth*'s Name at bottom was sufficient to fix my Attention on these celebrated Pieces, where I found an excellent and useful Moral discovered by the nicest Strokes of Art to the meanest Understanding. After I had step'd into the Shop to look at such as were not stuck up in the Window, and viewed the Whole more calmly, I purchased a Set, and was proceeding on my way to *'Change*, when a Thought struck me in the Head, I apprehended might divert me more than the Business I had there, which was to take a Tour around all the Print-shops, and listen to the Opinion of the several Spectators concerning this new Performance of the ingenious Mr. *Hogarth*. By this means I expected to find out the Influence which a Representation of this kind might have upon the Manners of the Youth of this great Metropolis, for whose Use they seem chiefly calculated; and at the same time I promised myself an agreeable Amusement from the diversity of Notions and Reflections the Vulgar are apt to make about Things the least removed from their Sphere of Knowledge.

He stops at several shops where some of the prints are displayed in the window; but instead of finding the populace discussing the moral lessons:

the first I heard break Silence was one of the Beadles belonging to the Court-End of the Town, who upon viewing the Print of the idle 'Prentice at play in the Church-yard, breaks out with this Exclamation, addressed to a Companion he had along with him, *G—d Z—ds*, Dick, *I'll be d—n'd if that is not* Bob ——, *Beadle of St.* —— *Parish; its as like him as one Herring is like another: see his Nose, his Chin, and the damn'd sour Look so natural to poor* Bob. *G—d*

suckers, who could have thought Hogarth *could have hit him off so exactly? It's very merry; we shall have pure Fun Tonight with* Ned; *I expect to see him at our Club; I'll buy this Print, if it was only to plague him.*

However, he cannot afford it. The author then walks on to St Paul's Church-yard, loiters before another shop, and listens to beaux who see a bawd of St James's Street in the old woman with pew keys (plate 2). It would indeed suit Hogarth's humour to have the woman who admits to a place in church, in heaven, as the woman who admits to a brothel bed. The beaux also identify other persons. Thus, the woman with the fan is Polly Glass. The observer decides that he must write a pamphlet that truly drives home the moral.

In this set Hogarth for the first time presented the theme of choice in terms of alternative answers. The two lads are apprenticed to a Spitalfields weaver. One works hard, is attentive in church, marries his master's daughter, rises in the world, and becomes Lord Mayor. The other idles, gambles, evades church, is sent to sea, sinks into crime, and is hanged at Tyburn. The paths of the two cross when the law-breaker is brought before his old companion who as alderman, acting as magistrate, condemns him to death. The two characters are thus not merely opposed as examples; the virtuous one kills the one who has erred.

In plate 1 we see the workshop in July. Weaving at the time was the leading industry in London. Tom Idle dozes, a cat playing with his shuttle; his *Prentices Guide* lies trampled, but a ballad *Moll Flanders* hangs on his frame. Goodchild works his loom and holds a flying shuttle. (Kay's invention of 1733 helped the broadcloth weavers of Yorkshire, domestic workers, but made the men on the narrow Norfolk looms work faster without earning more per piece.) Goodchild's *Guide* is well looked after; his ballads are *Wittingdon Ld Mayor* (the hero who rises by marrying his master's daughter) and *The London Prentice* (which in Arbuthnot's *John Bull* is linked with Bunyan as fare given to apprentices for their 'benefit'); the woodcut shows Daniel resisting two Lions, the 'prentice chasing off temptation. Plate 2 shows Goodchild singing unctuously in the church of St Martin-in-the-Fields with his master's daughter. In plate 3 Tom plays at hustle-cap on the slab of an altar-tomb and tried to cheat his friends, while a beadle lifts a stick over the group from behind. Close to the gamblers yawns a newly dug grave.

Plate 4 shows Goodchild risen from the work floor to the counting-house, in a role of authority. Clasped gloves express his bond with the master; in the *London Almanac* Youth (or Industry) seizes Time by the forelock. Plate 5 shows Tom, with his indentures forfeited, being taken off to a ship. A waterman points to a gallows on the shore, while a boy holds a rope sug-

gesting the halter (or cat-o'-nine-tails). Tom makes a defiant horn-gesture, which is linked with the promontory ahead, Cuckold's Points.

Next, Goodchild marries the master's daughter and becomes a partner in firm. His house is near the Monument. Drummers, two butchers with bones and cleavers, and Philip-in-the-Tub, a legless balladist, perform outside. Plate 7 shows Tom, home from sea, in a garret with a whore; he has taken to highway robbery and is scared of arrest. He quails at the noise made by a cat falling down the chimney while the unmoved whore counts the loot. (Goodchild's surrounding noises are jubilatory; Tom's are menacing.) Goodchild becomes Sheriff, and he and his wife are being banqueted. Hogarth introduces a statue of Walworth, holding the dagger with which he killed Wat Tyler; Goodchild now represents the city power that is armed against the people. At the hall door is a crowd of supplicants; a beadle holds up the petition of one of them.

Tom and his whore are in the cellar of the Blood Bowl House near Water-lane, Fleet Street. (The tale went that a rustic, complaining of a picked pocket, was told to shut up or the blood bowl would be fetched and his throat cut.) The keeper had recently been tried for robbing a shop; and the frequenters of his cellar are said to have been the Black Boy Alley gang who terrorized Clerkenwell; they decoyed people into empty tenements, then dropped their bodies into Fleet Ditch. In the print a murdered man is being dropped through a trapdoor while a fight is going on and a rope dangles from a rafter. Tom shares out his loot with a one-eyed man (who was earlier one of the graveyard gamblers). The whore, who seems to have abstracted the earrings that she was admiring in the garret, is at the door, betraying Tom to a magistrate. (As a result of not having reversed the drawing, the entry with the ominous lantern is on the left; usually such an entry, common in Hogarth's stories, occurs on the right – so that after we have explored the scene of crime or vice we come on the shattering intrusion of nemesis.)

Tom is brought before Goodchild. The one-eyed man, turned king's evidence, takes the oath, while a wench bribes the turnkey. Since the late seventeenth century the weakness of the policing system meant that authority, at local or national level, and various associations, offered all sorts of induce-ments to informers. Here the one-eyed man uses his left hand, which would technically make his oath non-binding; but that may be merely the result of failure to reverse the drawing. Goodchild turns from Tom in a falsely theatrical gesture.

With the last two plates we come suddenly to mass scenes; the personal drama is fully enlarged in its social significance. The two protagonists are still there, but swallowed up in the mass of people who as witnesses have

become in some sense a sharer of their fates. Tom, in the cart with his coffin, approaches the place of execution, with the hills of Highgate and Hampstead in the distance. A Methodist preacher prepares him for his end, while the official Newgate Ordinary rides ahead in a coach. All the details of such a scene are given. On the triple gallows climbs the executioner's assistant examining the ropes or the zany Funny Joe who went through his antics on these occasions. A pigeon is let loose to announce the cart's arrival. Tom's mother weeps in the cart that will remove the corpse. Mother Douglas watches, and Tiddly Doll, king of the wandering tradesmen, stands by his cakes. Of his two apprentices one guards his wares, the other picks his pocket. The whole story of Tom and Goodchild is starting over again. But these details have to be sought out. The overwhelming effect is of the surging crowd, disorderly and yet compact. In particular our eyes are caught by the woman, with child in arms, who bawls out *The last dying Speech & Confession of Tho. Idle*, and the back-turned man who balances her, a stick with a wig over his shoulder. The death of Tom on the gallows becomes a minor thing next to the heaving sea of the people who have come to bear witness. They share in the death ritual, but with an energy that speaks only of life.

Then we see the apotheosis of Goodchild who, as Lord Mayor, is driving through the City in his triumph, about to turn into King Street for the Guildhall, with the City Companies marching up. At the coach window is the Marshal of the City, who with his sword of state seems far more important than Goodchild glimpsed in profile. The crowd lacks the rough, tough vitality of the Tyburn mob, but owns a far greater force than is suggested by the emblems of authority. The coach with its packed flunkeys seems a mere cockleshell about the press and push of the spectators. The City Militia, posted across Paternoster Row, have a ridiculous disorganized look. A couple embrace on a scaffold, with a boy peering up the woman's skirts; a chimney-sweep laughs at the better-off spectators whose rickety stand has collapsed. The dignified group in the balcony, which includes the Prince of Wales and his wife, are contrasted with the plebeian variety and coarse vigour of the folk below. More, Tom, though hanged, haunts the scene. A wizened peddlar behind the militia sells *A full and true Account of ye Ghost of Tho: Idle*.

Hogarth, in early crowd scenes like that in *South Sea Scheme*, is thinking rather in terms of artists like Callot or what has been called late-mannerist Dutch genre painters or designers. The groups are made up of not very clearly articulated sections, and there is a lack of rhythm binding the figures within the sections. *Southwark Fair* showed a big advance in a unifying arrange-

ment of the mass of figures, though elements of the old disarticulations persisted. Now he completed the rhythmic compacting. The crowd becomes a living organism; and we feel in it his deep love of life, of everyone who is vigorously himself; his sense of the endless sources of energy in the people. Only half of himself went into the moral lesson of the set. Tom's way may have nothing in it that merits praise or acceptance; and yet in its very waste and perversion of human potentiality it appears as a protest against the Goodchilds with their smug elevation of bourgeois values. Goodchild rises through getting himself into the good graces of his master and marrying his daughter. His achievement of official importance is signalized by the banquet, depicted as an event of shameless gluttony, with the people shut out. When Tom is brought to justice, justice is exposed as corrupt by the turnkey taking bribes. In the last plate Goodchild fades out behind the emblems of state power.

It seems clear then that, whatever were Hogarth's conscious aims in planning the series, his emotions took more and more charge of him as he went on. The banqueting scene in particular cannot be other than a denunciation of the rich and powerful men who ruled the City. In a pamphlet issued in 1751 by someone who seems a personal friend, it is remarked: 'And was one to traverse the Halls of the several Companies at the annual Election of their Chief Magistrate, what Scenes of Gluttony, Drunkenness, and Excesses of all Kinds should we see rampant every where?' Above all, the deliberate introduction of the statue of Walworth, the corrupt mayor who murdered the champion of the people, could not have been done without a wish to link or identify Goodchild with him.

The ambiguity that we then find in the presentation of the two careers is a natural result of the disturbed thought which Hogarth had been giving to the problem of his society's direction in the last few years. He himself had been helped to rise by marrying his 'master's daughter', and he too partook of extravagant feasts. But his notes attest how he felt the need to mix idleness and pleasure with hard work. He repeatedly calls himself Idle, referring to his 'situation and Idle disposition', 'this Idle way of proceeding'. 'It was natural for me to make use of whatever my Idleness would suffer me to become possest of.' He repeats the last phrase in discussing how 'a redundancy of matter constantly occuring a choice for composition was next to be conside[re]d'. We may note how he keeps on using a capital letter for Idle or Idleness, and he can hardly have forgotten his remarks about himself when he chose the name Tom Idle.

Further, despite his struggles for success, he did not at all identify himself with persons who, like Goodchild, prospered by the world's standards.

In later years he contrasted with bitterness and irony the hard life of a devoted artist and the prosperity of the commercial classes: 'The artist who must be a man of (such) uncommon parts (as Shakespear or Swift) to excell in that part of painting', which is carried to the heights of which it is capable, must 'forego the pleasure of youth' and 'waste his life in a laborious (tedious) study for empty fame when his next door neighbour perhaps a brewer (or porter) or an haberdasher of small wears shall accumulate a large fortune become Lord Mayor member of parliament and at length get a title for his heirs.' Here the Goodchild type is directly opposed to the artist. In his rejection of money values, for all his keen business sense, we may compare him to the tradesman Richardson. Thus in *Clarissa* Lovelace, behind the counter in Smith's shop, amuses himself by assuming the role of tradesman. He gives the game away and brings out how money values have permeated society, at the very heart of what people consider pure moral values. He, the aristocrat, has tried to buy Clarissa; he speaks of her as 'goods' and 'property'. The Harlowes too have tried to sell her; the harlots have tried to enhance her price. Ideas of value, cost, purchase, price, run all through the book, concentrated in the shop scene.

We have kept on noting the importance of the theme of choice in Hogarth's work. That theme indeed is central in all expressions that truly depict human development; but no artist before Hogarth had been so directly obsessed by it. The emblematic method had issues of choice at its core, for it implied a continual confrontation with forces of salvation or damnation. Hogarth, we noted, was in one sense a secularized Bunyan. But we must also realize that he grew up in a society where, despite many obstructions and resistances, the question of choice was growing insistent to an extent without parallel. Customary usages were dissolving in the acid of the cash nexus, and the problem of social mobility arose in a quite new way. True, the full effects did not show up till after 1750, but 'the century and a half between 1600 and 1750 was a period of great social mobility, when humble men of merit could aspire to, and attain, riches and social prestige, even a title' (Hartwell). Hogarth registered the deep internal shocks felt by his society and yet was able to treat that society as something like a simple organism, dealing with both upper and lower classes inside a single focus. After him such a position became untenable.

He began with the *South Sea Scheme*, where the choice before men was that of submitting to money mania or becoming victims of injustice. Then he concentrated on the more purely personal aspects: the girl who takes the easy way out and finds it the hard one, the middle-class youth who apes the upper classes, the middle class and upper class in misalliance. Then he

came right up against the matter of basic economic choice. Did one accept the cash nexus and the work disciplines that it was developing as industrialism appeared, or did one rebel and find oneself outcast into the ranks of beggars, criminals, rootless men? No alternative kind of response seemed possible. Yet he could not accept either of the only two apparent choices. The story of his later development is one of his attempts to break through this impasse, and his failure to see the new sphere of choice emerging under Wilkes.

The brisk fellow described in the *Peregrination* seems to have become increasingly absentminded as he grew older. Nichols says that at table he would sometimes turn round in his chair as if he had finished the meal, then as suddenly would turn back and go on eating. In 1776 Benjamin Wilson was discussing him with George III. The King said that he supposed Hogarth could tell a tale very well, and Wilson replied: 'Pretty well, but he was apt sometimes to tell the *wrong story*.' Once, with Garrick and others, he had said that he'd tell a story to make them all laugh; but what he recounted made them all grave. For a moment he appeared a little uncomfortable, then he struck the table with his hand and remarked that he had told the wrong story. They laughed, and then, when he told the story he had meant, they laughed again. Once he addressed a letter to Benjamin Hoadly 'To the Doctor at Chelsea', and somehow the letter did get to Hoadly, who kept it 'as a pleasant memorial to his Friend's extraordinary inattention'. Steevens was told in 1781 by a friend of Hogarth that soon after the latter had set up his equipage he went to call on the Lord Mayor. While he was in the Mansion House a violent rain shower blew up. Leaving by a different door than he'd gone in, he called for a hackney coach; and as there was none at the near stands, he walked all the way home in the rain, quite forgetting about his coach till his surprised wife asked him where he'd left it. Such absentmindedness suggests an inner distraction, which may well have come over him in these years as he felt pulled in different directions.

On 5 November, Guy Fawkes' Day and the day of William III's landing at Torbay, the Foundling artists held their annual dinner and toasted the liberty of the arts out of a punchbowl of blue and white china. An early effect of their union was the commission for Hayman to do an altarpiece for a Yorkshire church. Hogarth heard that Lord Wyndham had left £2,000 to the Society of Lincoln's Inn for a work of history to decorate the west end of the chapel. Approaching the Society, he was asked to submit a design; in December his proposal was accepted.

An important event was the translation of *Letters on the English and French Nations* by the Abbé Jean-Bernard Le Blanc. This work supported the ideas set out by La Font de Saint-Yenne in 1747: that a return to the grand style

of idealizing history was needed to defeat the fashionable rococo forms with their (increasingly light, frivolous, erotic aspects. Le Blanc stated that England, lacking an academy, had produced no great painter. He depreciated Thornhill and saw the burlesque as the opposite of the sublime. The English, tending to the burlesque, were hardly any happier with it than with the grand style. Hogarth was an engraver of genius, but no painter. As for his engravings:

The whole nation has been infected with them, as one of the most happy productions of the age. I have not seen a house of note without those moral prints, which represent the Rake's Progress in all the scenes of ridicule and disgrace, which vice draws after it; sometimes even in those circumstances, the reality of which, if tolerably expressed, raises horror; and the English genius spares nothing that inspire it.

It was some time before the full effect of these derogatory remarks showed itself; but the passage was probably decisive in turning the tide against Hogarth. It chimed in with all the worst prejudices of the patrons and gave the seal to the relegation of Hogarth's talents to a low level of vulgar effec-tiveness. Such a vulgar artist could not possibly succeed in the grand style. Le Blanc further helped, in the sphere of portraits, the semi-idealizing trend of Reynolds and others. (The French attack on trivializing art tendencies thus led to a demand for the idea; Hogarth's attack involved the demand for realism.) Dr Parsons in his *Treatise* had tried to counter Le Blanc's cavils by insisting that there were great works to be seen at St Paul's, St Bartholomew's, the Foundling, and Greenwich Hospital; but he agreed that only 'little Portraits' were encouraged in England and that English art was weakened by the lack of academies of the continental type.

Fielding too turned to old popular forms, opening a puppet theatre in Panton Street close to Hogarth's house on 28 March 1748, carrying on till June and evading the Licensing Act by giving his shows as accompaniment to break-fasts. He stated that he wanted to turn Punch-and-Judy systems into a vehicle for satire. Hogarth was hard at work on his painting for the Benchers: *Paul before Felix*. He was again returning to Raphael and attempting monu-mentality. Bishop Hoadly had argued that Paul established the principle of the law's superiority to the executive power and thus prefigured the 1689 Revolution. Hogarth no doubt felt it was a good idea to paint for lawyers an unjust judge confronted with a higher authority and forced to make a difficult choice. He put in Felix's wife, making her charming in contrast with her harsh and worried husband: perhaps to suggest what the unconstrained human reaction to the situation would be. The other persons are impressed or awed, except for the soldier and the *fasces*-bearer, who do their best to

ignore the whole thing. Vertue, it seems in May, expressed his admiration of the 'grand new designs . . . much bigger than life', and of 'the greatness of his *spirit* (tho' a little) man to out vye. all other painters'.

In June Hogarth seems to have moved the painting from his studio to the Inn, finding that it didn't suit the allotted place. Asking the Benchers for their opinion, he had the unusual honour of an invitation to dine. On the 28th he sent a sketch of what he thought the right kind of frame. He had taken the picture home 'in hopes of making some improvements whilst the Frame is making'. On 8 July he received £200; but he hung on to the picture as long as he could, despite requests for it from the Benchers, and it was not finally hung till 1750.

In July he had felt the need for a break and went to France, with Hayman, Hudson, the sculptor Cheere, and the drapery painter Vanhacken. After visiting Paris, Hayman and Hogarth returned to Calais while the others went off for Flanders and Holland. Hogarth disliked French houses and said that they were 'all gilt and beshit'. At Calais he sketched the drawbridge to the gate. 'I was santering about and observing [people] & the gate which it seems was built by the English when the place was in our possession (there is a fair appearance still of the arms of England upon it).' Vertue says that Hayman too was drawing, but it was Hogarth who was arrested and carried to the governor as a spy. 'I conceild none of the memorandum I had privately taken and they being found to be only those of a painter for [my] own use it was judged necessary only to confine me to my lodging till the wind changed for our coming away to England.' However, the Rev. W. Gostling of Canterbury, with whom Hogarth stayed the first night on his return, told Nichols that there had been 'a very strict examination' and Hogarth was 'committed a prisoner to Grandsire, his landlord, on his promise that Hogarth should not go out of his house till it was to embark for England.' And Walpole, probably reproducing Hogarth's own heightened tale in December, says that 'he was forced to prove his vocation by producing several caricatures of the French; particularly a scene on the shore with an immense piece of beef landing for the Lion d'Argent, the English inn at Calais, and several hungry friars following it. They were much diverted with his drawing, and dismissed him.' He himself later described the great change felt on landing in France: 'A farcical pomp of war, parade of religion, and Bustle with very little bussiness in short poverty slavery and Insolence with an affectation of politeness.' He says that on his return to England he at once set about 'the Picture wherein I introduced a poor highlander fled thither on account of the Rebelion year before brozing on scanty French fair [fare] in sight of a Sirloin of Beef a present from England which is opposed [to] the

Kettle of soup meager'. And we have an account by an English engraver
(R. Strange or T. Major), embroidered by Steevens, who liked to belittle
Hogarth, which describes him as 'often clamourously rude' in the streets,
crying down everything French in 'a torrent of imprudent language'. The
narrator warned him that there were often Scots or Irish about, who would
be happy to get him mobbed; but he 'laughed at all such admonition, and
treated the offerer of it as a pusillanimous wretch, unworthy of residence in
a free country'. At Calais the Commandant told him that 'had not the Peace
been actually signed, he should have been obliged to have him hung up
immediately on the ramparts'. Two guards took him on shipboard and
stayed till they were three miles out, then they 'spun him round like a top,
on the deck', and let him go. 'With the slightest allusion to the ludicrous
particulars of this affair, poor Hogarth was by no means pleased.'

To get his own back he painted the picture of Calais in which the beef
symbolizes British sturdiness and independence, surrounded by the miserable
French and the exiles. Through the gate we see priests carrying the Host
to houses of the ailing; above is the inn-sign of the Dove (the Holy Ghost).
Religion is all that the poor folk have to feed on. The gate gives the effect
of a formalized stage-setting and at the same time gapes like a hungrily open
mouth. Only the friar is fat.

Earlier in 1748 Smollett had published *Roderick Random*, reacting strongly
to both Fielding and Hogarth but without the deep kinship of outlook that
bound those two. Still, he put in his own Harlot's Progress, the history of
Miss Williams. At the year's end came *Tom Jones*. Fielding had now perfected
the method of character drawing and narration which he shared with
Hogarth.

Everything is copied from the book of nature, and scarce a character or
action produced which I have not taken from my own observations and
experience . . . Vanbrugh and Congreve copied nature; but they who copy
them draw as unlike the present age as Hogarth would do if he was to paint
a rout or a drum in the dresses of Titian and of Vandyke.

In the winter of 1748–9 he acted as a Westminster magistrate, growing ever
more concerned with the causes of crime and demoralization among the
people.

In early March 1749 the Calais painting was engraved with the subtitle:
The Roast Beef of Old England, the name of a song in Fielding's *Grub-Street
Opera* of 1731, which contrasted English solid fare with French frothy
syllabubs. The motto of the Sublime Society of Beefsteaks was 'Beef and
Liberty', and groups of workers who felt their status rising were liable to
see it as a right to beef. Thus the Paviours at their annual meeting decided

to substitute roast beef for hogs' faces. Theodosius Forrest, son of Ebenezer, wrote a cantata, *The Roast Beef of Old England* (published sometime before 1752 with a small copy of Hogarth's print on top). The French riposte appears in La Mettrie's *L'Homme Machine* (1749), with its claim that the English contempt for other nations, their animal ferocity, came from their liking for underdone steaks.

On 6 June Hogarth wrote to his wife the only letter between them that we possess:

Dear Jenny I write to you now, not because I think you may expect it only, but because I find a pleasure in it, which is more than I can say of writing to any body else, and I insist on it you don't take it as a mere complement, your last letter pleased more than I'll say, but this I will own if the postman should knock at the door in a weeks time after the receipt of this, I shall think there is more musick in't than the beat of a Kettle Drum, & if the words to the tune are made by you, (to carry on metafor) and brings news of your all coming so soon to town I shall think the words much better than the musick, but dont hasten out of a scene of Pleasure to make me one (I wish I could contribute to it) you'l see by the Enclosed that I shall be glad to make a small contributer to it. I dont know whether or no you knew that Garrick was going to be married to the Violette when you went away. I supt with him last night and had a deal of talk about her. I can't write any more than what this side will contain, you know I wont turn over a new leaf I am so obstinate, but then I am no less obstinate in being your affectionate Husband Wm Hogarth

Along the side he wrote: 'Complement as usual' – for Lady Thornhill, who was with Jane. He sends some money, but does not mention what detains him. His tone is warm and affectionate, with a slight bantering note, especially at the end. We feel that their relations were friendly, even cordial, but with a certain tension. Both he and Jane were strong characters; no doubt his resolve to go his own way, his obstinacy, led to strain, though affection and good sense on both sides prevented any serious conflict or break. There is no sign of infants who died early.

Morell knew them both well after they removed to Chiswick; he lived nearby at Turnham Green. He wrote later of Hogarth that to assert 'he had little or no acquaintance with domestic happiness, is unjust. I cannot say, I have ever seen much fondling between Jenny and Billy (the common appelation of each other); but I have been an almost daily witness of sufficient endearments to conclude them a happy couple.' He was replying to Steevens's innuendoes about their childless marriage. Wilkes in 1762 remarked that Hogarth could picture only the dark side of things: a *Marriage à la Mode* but not a *Happy Marriage*. And he said of *Sigismunda:* 'If the figure

had any resemblance of any thing ever on earth, or had any pretence to meaning or expression, it was what he had seen, or perhaps made, in real life, his own wife in an agony of passion, but of what passion no connoisseur could guess.' He would hardly have made this comment unless there were stories of Hogarth now and then infuriating his wife, no doubt by his thirst for convivial diversions. We may recall the jealous touch in his will, ensuring that no second husband of hers should ever get his hands on the profits of his art.

A glimpse of his home life is given by prints of his *Quadrille Fish*. Ireland says that he never played at cards. 'While his wife and a party of friends were so employed, he occasionally took the quadrille fish, and cut upon them scales, fins, heads, *etc.*, so as to give them some degree of character.' The fish were counters that went to the winner and were kept in a 'pool' in the middle of the table: hence their name. Hogarth carved them to look like fish in fact. A barber who shaved him says that he wore a scarlet roquelaure, a loose buttoned cloak, long after it ceased to be fashionable. We see him as a diner-out in taverns in the tale of his invitation to the Rev. Arnold King, rector of St Michael, Cornhill. He drew a circle (dish) with knife and fork as supporters; inside was a pie with mitre on top; around he wrote: 'Mr Hogarth's Compts to Mr King and desires the Honnor of his Company at dinner on Thursday next to Eta Beta Py' (eat a bit of pie at the Mitre Tavern). Here emblems are used in a joking riddle. He liked unbending among jovial artists like Hayman, Ellys, Lambert, and listening to knowledgeable men of the professions. What he did not like was the literary man with no high spirits or practical experience. Horace Walpole is said to have inveigled him into dining with the poet Thomas Gray. 'What with the reserve of the one and the want of colloquial talent of the other, Walpole never passed a duller time than between these representatives of *Tragedy* and *Comedy*.'

In September 1749 Hogarth bought a country villa in Chiswick, an unspoiled area by the Thames. He may have been already renting a house, perhaps the one he bought; and Jane may have been there when he wrote to her in June. The place was not big enough to suggest the country gentleman, but superior to the 'suburban villas, highway-side retreats' (Cowper), which well-off London tradesmen were building round the city. Assessed at £10 and rated at 5*s*, it was of brick, with a high wall cutting the garden off from outside view. A ground-floor passage led to parlour (or dining room) and stone-flagged kitchen; the staircase led to two bedrooms and the best parlour with hanging bay window; on top were quarters for servants. All windows, save a couple of small ones in the servant's rooms, looked in on the garden. The lane outside went past the parish church to the river. Around were fields.

The nearest Hogarth got to playing the squire was when he gave the village children the mulberries from the tree in his garden. In mid-nineteenth century the studio could still be seen over the stable, with narrow stairway and large window through which paintings could be lowered. John Ireland, who saw the house in the 1780s, says that there were no Hogarth prints on the walls; instead there were those of Thornhill's St Paul's paintings and the Houbraken heads of Shakespeare, Spenser, and Dryden. Over the garden gate was a leaden cast of George II's mask.

This year Hogarth produced his painting *The March to Finchley*. The guards, recalled from the Low Countries in 1745, march off to Finchley where they are to protect the City against the Jacobites. They seem to have spent the night near the Tottenham Court turnpike, since it is there they say goodbye to the whores, with Highgate village in the distance. The theme is the contrast between disciplined or regimented forms and the disorderliness of life outside those forms: the theme of *Industry and Idleness* shown in a compacted image. We see the military march afar, and the confusion of everyone, soldiers and civilians, in the foreground where the word of command has not yet been given. In the march there is no choice, but in the tumult problems of choice keep asserting themselves, stressed by the trio in the centre: a soldier assailed by an old creature and a pretty girl with swollen belly. Roguery and lewdery of all kinds is going on, and the political issue pervades the confusion. The girl carries Hanoverian broadsides; the hag, also pregnant, is a Catholic with Jacobite productions. (There is a joke in making Fielding's *Jacobite Journal*, not published till December 1747, one of her wares; it was really anti-Jacobite.) Two Jacobite spies whisper. The area is one of boxing establishments, and a fight goes on. The signs of Gardener and Nursery, and of Adam and Eve, suggest the theme of the Fall as well as the infantility of the amusements. On the right is the King's Head (Charles II) with nine harlots (one of them the Methodist Mother Douglas) sticking their heads out of the windows to bid farewell to their clients. The Stuart king is patron of whores, but the soldiers with GR on their knapsacks are as lecherous as he.

There is further political irony in the dedication: 'To his Majesty the King of Prussia and Encourager of the Arts and Sciences! This print is most humbly Dedicated.' The loose behaviour of the troops is thus contrasted with Prussian discipline, and at the same time George II's failure to help the arts and sciences is underlined. There may be a side glance at the Duke of Cumberland, who wanted a Prussian sort of army. In 1749–50, on till 1751, a Mutiny Bill was furiously debated in the Commons, supported by followers of the Duke and Henry Fox. As usual there is ambiguity in Hogarth's

picture. The Duke's supporters could have said: Here is the dire result of in-discipline. Those against the Duke could have repeated what Rouquet says (certainly echoing Hogarth): 'If you complain of this choice,' (between orderly column and heaving crowd) 'you will be plainly told that order and subordination suit only slaves; for what is called license by everyone else-where assumes here the august name of liberty.' George II is said to have been infuriated: '*What, a painter burlesque a soldier?*' The work could indeed be taken as a parody of the heroic battle theme. Rouquet comments ironically, it 'has the fault of being still all glittering with that ignoble freshness which one discovers in nature and never sees in highly celebrated Cabinets'. The key is determined by the red, white, and blue of the national flag behind the central figures, though the working-out is in cool tones; and the variegated nature of the scene is stressed by the shifting focus of light and shadow, which gives a labyrinthine depth to the patterns of the serpentine line. We see Hogarth achieving the full expression of what he calls Intricacy:

The active mind is ever bent to be employ'd. Pursuing is the business of our lives; and even abstracted from any other view, gives pleasure. Every arising difficulty, that for a while attends and interrupts the pursuit, gives a sort of spring to the mind, enhances the pleasure, and makes what would else be toil and labour, become sport and recreation.

Wherein would consist the joys of hunting, shooting, fishing, and many other favourite diversions, without the frequent turns and difficulties, and disappointments, that are daily met with in pursuit? – how joyless does the sportsman return when the hare has not had fair play? how lively, and in spirits, even when a cunning old one has baffled, and out-run the dogs!

The love of pursuit, merely as pursuit, is implanted in our natures, and design'd, no doubt, for necessary, and useful purposes. Animals have it evidently by instinct. The hound dislikes the game he so eagerly pursues; and even cats will risk the losing of their prey to chase it over again. It is a pleasing labour of the mind to solve the most difficult problems; allegories and riddles, trifling as they are, afford the mind amusement: and with what delight does it follow the well-connected thread of a play, or novel, which ever increases as the plot thickens, and ends most pleas'd, when that is most distinctly unravell'd?

The eye hath this sort of enjoyment in winding walks, and serpentine rivers. and all sorts of objects, whose forms, as we shall see hereafter, are composed principally of what I call, the *waving* and *serpentine* lines.

Intricacy in form, therefore, I shall define to be that peculiarity in the lines, which compose it, that *leads the eye a wanton kind of chace*, and from the pleasure that gives the mind, intitles it to the name of beautiful . . .

We see how complex is his idea of Intricacy. The formative process in the artwork is felt to involve the whole impetus of purposive activity in life, which drives man forward. It is merged thus with sexual desire and the quest

for pleasurable release. In turn it is inseparable from the intellectual urge to understand life, to unravel its secrets and to discover the hidden connections. Hence the importance of symbolism, allegories, emblems in art, in which the artist discovers some of the hidden connection and puts them together in a form which, though involving difficulties, makes a solution possible by the spectator. Intricacy thus holds a sensory or aesthetic element as well as an intellectual or moral element; and all the elements come together indivisibly in the art work. We see here in a complex way the unity of pleasures and studies that Hogarth spoke about in explaining the evolution of his power as an artist. In the concept of Intricacy, form and structure are seen as essentially dynamic. Though the concept did not necessarily imply mass scenes, clearly in such scenes the artist had one of his best chances to show how he had mastered it. The ostensible theme of the *March* is the 1745 Rebellion, but what Hogarth depicts is the growing confusion and discontent of the times. Such order as the state imposes seems unreal and distant; the reality is the tumult close at hand.

To get fully inside his works from *Industry and Idleness* onwards, we need to grasp the function of the mob in these years. Men prided themselves on being freeborn Englishmen ready at all moments to assert their independence. The century was characterized by tumults and riots finding their highest point in the defence of Wilkes and then confusedly in the Gordon Riots. The French could not understand why the English failed to keep the lower classes in their place. We may take from this year 1749 an example of the way violence was liable to irrupt. On 1 July three seamen from the man-of-war *Grafton* were robbed in a brothel in the Strand, then thrown out by the bullies. They gathered companions from round Wapping, broke into the house, turned the women almost naked into the streets, wrecked the furniture, and made a bonfire. They then smashed up another brothel, but were dispersed by a detachment of guards. Next day, Sunday, a huge crowd assembled to see the wreckage, and demolished another brothel. Only one man was hanged despite attempts of the people in the parish of St Clement Danes and others to get his pardon. He became a popular hero and his supporters set up a monument to him with a long inscription worth citing for its fellow-feeling and anti-government tone:

He was hurried, by a ZEAL for his countrymen, and an honest detestation of PUBLIC STEWS, (The most certain BANE OF YOUTH, and the DISGRACE OF GOVERNMENT,) to engage in an undertaking, which the most partial cannot defend, and yet the least candid must excuse. For thus indeliberately mixing with rioters, whom he accidentally met with, he was condemned to die; and of four hundred persons concerned in the same

attempt, he only suffered, though neither principal nor contriver. How well he deserved life appears from his generous contempt of it, in forbidding a rescue of himself . . .

Throughout Hogarth's period, till near his end, there was nothing clearly political in the riots, though food scarcities often caused them. Only in the strikes do we find a definite social protest able to link large numbers of people in a common aim, though they were mostly isolated events that did not lead yet to forms of lasting organization. The masters however were very afraid of such consequences. In George I's reign all workmen's associations were forbidden; under George III the masters were authorized to form bodies to proceed against machine breakers. But it was some time before working-class protests and resistances could develop coherent or effective policies. For Hogarth and others of his world the mob was a dangerous spontaneous force with no system about it. Many of its actions might evoke their sympathy; others seemed blind manifestations of energies without any serious purpose, childlike explosions of rage, resentment, hatred of controls, irrational defences of traditions that were often reactionary and dehumanizing, such as the many baitings and tormentings of animals. Still, difficult as it was to see anything consistently making for social betterment in the moods and furies of the populace, Hogarth had come in the later 1740s to realize in a new way that the people constituted a force which had to be reckoned with. He had moved beyond the level at which he had created his vision of society through the Harlot, the Rake, the Noble and the Merchant's Daughter in uneasy union, the contrasted Idle and Industrious Apprentices. Now he wanted images that expressed the movement of society in a fuller and more panoramic way.

11 *A Time out of Joint (1750–53)*

*E*arly in 1750 London was hit by two earthquakes; a mad lifeguard ran round prophesying a third quake and large numbers of people left London, gathering on the commons to await the end of the world. The *General Advertiser* on 30 April remarked that Hogarth would find the flight a good theme; he did not take up the idea but must have been strengthened in his feeling against superstition. During February James Townley, an undermaster at the Merchant Taylors' School, wrote an admiring letter to him, speaking throughout of him as a great author, and added: 'I wish I were as intimate with you, and as well qualified for the purpose' of drawing an adequate portrait of Hogarth, 'as your friend Fielding.' On 16 March the print of the *March* was advertised, with its ticket showing a trophy-heap of old-fashioned weapons of the Scots contrasted with the modern ones of the English. On 23 April he announced that persons subscribing 3s over the 7s 6d for the print would have a chance of winning the painting in a lottery. 1,843 chances were subscribed for, and the remaining numbers up to two thousand were allotted to the Foundling Hospital. The number 1,941 was drawn on 30 April and the hospital gained the painting. Vertue remarked on the 'cunning artful contrivances, which men of much greater merritt, could never Get or expect'.

On 3 January 1751 the print, done by Luke Sullivan, with heads probably by Hogarth, was issued. Mid-month came Fielding's *Enquiry into the Cause of the late Increase of Robbers*. Emulation of the upper classes is seen as a main demoralizing force. The poor are forced to turn beggars or starve; 'Those of more art and courage become thieves, sharpers and robbers.' That Fielding and Hogarth had been discussing the problem with passionate concern is

shown by the advertisement on 13 February of six prints, *Beer Street* and *Gin Lane,* and four 'on the Subject of Cruelty'. In the hopes of reaching the lower classes and of reforming 'some reigning Vices peculiar' to them, 'the Author has published them in the cheapest Manner possible'. They appeared on the 15th. Again, Hogarth made no paintings; he wanted a stark popular style. His later statement dealt only with the social aspects:

Bear St and Gin Lane were done when the dredfull consequences of gin drinking was at its height In gin lane every circumstance of its horrid effects are brought in view, in terorem nothing but (Itleness) Poverty misery and ruin are to be seen Distress even to madness and death, and not a house in tolerable condition but Pawnbrokers and the Gin shop.

Bear Street its companion was given as a contrast, were the invigorating liquor is recommend in order to drive the other out of vogue. here all is joyous and thriveing Industry and Jollity go hand in hand the Pawnbroker in this happy place is the only house going to ruin where even the smallest qantity of the linquer flows around it is taken in at a wicket for fear of farther distress.

The problem of choice was posed by contrasted ways of living. In the first state of *Beer Street* he put a miserable Frenchman (lifted up by the brawny blacksmith), but he then erased him and inserted a pair of lovers instead. We see that he was drawing on the *Calais* print with its contrast of starveling French and the beef of England. In the second state, the blacksmith swings up a leg of mutton. (Behind both plates are Brueghel's paintings, *La Cuisine Grasse* and *La Cuisine Maigre.*) *Beer Street* shows stalwart workers, with paviours and tailors at their tasks. The day is 30 October, the King's Birthday (shown by a flag), and there is a reference to the king's speech of 29 November 1748 on 'the Advancement of Our Commerce and cultivating the Arts of Peace'. The fisherwomen read a ballad by John Lockman, secretary of the Society of the Free British Fishery; and a pile of useless books, such as that of Turnbull advocating ancient art, are going off for waste paper. But even here Hogarth cannot help inserting a certain ambiguity. The drawing shows the painter at work on a sign as a jolly part of the beer-drinking scene below; the print shows him elongated and lean, high up his ladder in a detached pose, concerned only with his painting. More, the bottle he paints is a gin bottle; he studied an actual bottle but produces a conventional shape that needs no model. The artist does not really identify himself with the scene. (Even if the figure jestingly depicts Francis Hayman, its significance in the composition is not affected.)

Hogarth was always interested in signboards; and about this time he was paying particular attention to them. Philip Dawes, his assistant and perhaps

pupil, says that he more than once went with him to the Fleet Market and adjacent Harp-alley,

which were in those times the great marts, and indeed exhibitions, of signs, of various descriptions, barbers'-blocks, poles. etc. etc. which were then more in request than they have been of late years. In these places it was the delight of Hogarth to contemplate those specimens of genius emanating from a school which he used to observe emphatically was truly English, and frequently to compare with, and prefer to the more expensive productions of those Geniuses whom he used to term the *Black Masters*; and it was his delight to consider the blocks, which used to be ranged in those shops in great order one row above another, like the spectators in the galleries of a Theatre, in different points of view, and to remark upon the different characters which the workman had bestowed upon their countenances, to endeavour to guess from their appearance at their dates, and thence deduce the effect which they would have if decorated with the various wigs which the fashion of their different periods might have clapped upon them . . .

This is a valuable account, showing Hogarth returning to his roots in popular art and deeply enjoying what he found. We see also his historical sense at work as well as his feeling for variations in character and formal pattern brought about by dress changes. Here was an exhibition, also a theatre; he must have found much fun and stimulus in noting the collocations and contrasts brought about by the arrangements of the signs. He had grown friendly with Joshua Kirby, nineteen years his junior, who had been apprenticed as a painter of houses and signs. He came to know him, it is said, through admiring his sign of a rose, and Kirby became agent for his prints at Ipswich. Hogarth's regard for sign painters is further shown by his comment on Correggio: 'The common proportions of his figures might be corrected by an ordinary sign painter.'

He is said to have painted a sign himself, *Man loaded with Mischief*, for an alehouse in Oxford Street. It showed a man carrying a magpie, a monkey, a woman with a glass of gin, while a woman enters a pub with horns as gable finial, the Cuckold's Fortune of the *South Sea Scheme*, and a sow sleeps in a pothouse. Notice: She is drunk as a sow. Two cats make love on the roof and a carpenter pawns his tools in Gripe's pawnshop. It seems that someone else made up this signpost out of Hogarthian motifs; but the tale brings out how many of his emblems would have suited elaborate signposts. Later Churchill described *Sigismunda* as 'so rare a pattern for the sign-post trade'. The signposts as a form of popular art often used emblematic or allegorical motifs, and Hogarth used them in his art as emblems related to the activities going on below them.

In *Gin Lane* only distiller, undertaker, and pawnbroker do well; the barber

has hanged himself. Gripe takes in the carpenter's tool and a woman waits to pawn her kettle, saucepan, tongs. The central figure, a woman on the steps down to the gin cellar, is dead drunk and drops her baby to its death as she takes snuff; she has syphilitic sores. (The third state showed the baby as dead before it falls.) All around are scenes depicting the acute demoralization of the gin drinkers. The area is that called the Ruins of St Giles. In the rear rises the steeple of St George, Bloomsbury, topped with the king's statue and symbolizing the union of state and Church. Above it hangs the cross of the pawnbroker, darkly banishing the Cross of Christ. (Of the 17,000 houses in Westminster at least 1,300 sold liquor; of the 16,000 in the City, at least 1,050.)

In 1736 heavy taxes and licence-charges had been imposed on retailers of gin. The enraged mob held funeral processions of Madam Geneva (also called Cuckold's Comfort, Ladies' Delight, Strip-me-naked). Soon the law was ignored; in 1743 an attempt was made to turn the trade respectable and raise the price of spirits. 1747 saw a setback, compound-distillers being allowed to retail. In 1751 came a return to the 1743 system; with better enforcement of penalties and carrying out of the law.

Townley wrote cautionary verses for the two prints, as also for the four *Stages of Cruelty*. The latter showed the progress of Tom Nero from torturing animals as a boy to beating a disabled horse; he then murders a girl and, hanged, has his corpse dissected by the Barbers-Surgeons' Company. The law provided the bodies of criminals and the public were let in to the advertised dissections. Hogarth does not directly attack the customs of baiting badgers, bulls, bears, of 'drawing up a dog with fireworks', and of bull-baiting; but in plates 1 and 2 he links the depicted cruelties with such customs, which had official support. In 1694, when William III entertained Prince Lewis of Baden, 'there was bears' baitings, bull sport, and cock-fighting instituted for his diversion and recreation'. Frederick Prince of Wales loved the bull-baitings at Hockley-in-the-Hole, which Tom Brown under Anne refers to as 'her Majesty's bear-garden'. An early attack on the baitings had been printed in the *Craftsman* of 1 July 1738. 'I am a profess'd Enemy to Perscution of all Kinds, whether against Man or Beast.'

Two points need notice. In print 1 the boy offering a tart to save the dog seems certainly meant for the Prince, later George III. In print 4 a surprising turn is made and the callousness of the lower classes is related back to the attitudes of the rich, the great, the learned. The onlookers are fascinated by the cutting-up of Tom's body, and the president with royal arms signifies official approval. Tom is now the victim, a point stressed by the dog's licking of his heart. The two grinning skeletons aloft become heraldic supporters

with warning fingers: *vanitas*-emblems but also threats to the smug spectators and surgeons. The dead malefactors, stripped to the bone, yet dominate the busy scene of their betters, who set the values of their society; they menace it. The raising-tackle repeats the gallows rope that killed Tom; he is twice killed. More, there is a religious symbolism. A print aimed at Pelham and the Duke of Newcastle, and based on Poussin's *Martyrdom of St Erasmus*, shows Britannia martyred; her intestines are being drawn out.

A few years later, 1754, in *Admonitions from the Dead to the Living*, we meet a dead girl recounting to her mother the horrors of her corpse on the dissecting table. The surgeons are identified with executioners, hangmen, torturers, butchers. 'The living would not escape, could they come at them. Nay, let it be lawful to tell you what I heard, I was a witness to their wishes on several occasions, that this had been a living subject.' The author seems to have been recalling Hogarth's print.

Hogarth gives his own account of the set in his notes:

The four stages of cruelty, were done in hopes of preventing in some degree that cruel treatment of poor Animals which makes the streets of London more disagreable to the human mind, than any thing what ever, the very describing of which gives pain but it could not be done in to strong a manner as the most stony heart were ment to be effected by them the french among other mistakes of the like kind as particularly w[h]ere they speak of our tragidies Imagine these things done by cruel dispositions.

Then he explains why he used a direct popular method:

The circumstances of this set as the two former were made so obvious for the reason before mentioned that any farther explanation would be neadless we may only [say] this more that neither great correctness of drawing or fine Engraving were at all necessary but on the contrary would set the price of them out of the reach of those for whome they were cheifly intended however whatever was more material, and indeed what is most material even in the very best prints viz the Characters and Expressions are in these prints taken the utmost care of.

In other notes he states 'that I had rather if cruelty has been prevented by the four print[s] be maker of them than of the Raphael cartoons unless I lived in a roman Catholic country, the prentices bought at Christmas'. And elsewhere in repeating this statement he adds that he is speaking 'as a man not as an artist'. He means that a Protestant country needs an art of history which is based, not on superstitious tales, but on direct social themes inculcating the virtue of good works. This comment adds point especially to the fourth print where Tom's tortured body, as we saw, has taken the place of some mangled and martyred saint whose bowels have been torn open. Hogarth's theme is the martyrdom of man by man. The 'prentices buy his prints at

Christmas instead of religious images. The anonymous *Dissertation* on his sets paints a horrific picture of the effects of this infernal combustible, *Gin*. It speaks of the 'merciless Surgeons', and makes a valuable commentary by relating Hogarth's whole indictment back to the acute property-sense in England.

As there is a vast Disproportion in the Guilt, it seems not a little strange, that our Lawgivers, in all Ages, never set a greater Price upon the Blood of Man, than they did upon so small a Part of his Property; and this, perhaps, may be the Reason why more Murders are committed in *England* than in any other Country; and more aggravated with Circumstances of Cruelty than they are generally known to be any where else.

On 26 February 1751 the Benchers allowed Hogarth to take back Paul for retouching. Vertue saw the work at the Inn and thought it 'great and noble', raising 'the character of that little man – tho not his person'. By 'additional cunning & skill, and a good stock of assurance evey way of the acutest kind possible' he had managed 'to be well paid beyond others of the same profession'. This month appeared Smollett's *Peregrine Pickle*. Trunnion's grin of rage was so complex we are told that 'it would be a difficult task for the inimitable Hogarth himself' to depict it. But there is also a satirical picture of Hogarth himself as Pallet, who is visiting Paris. Pallet is extremely talkative, pronounces 'judgment upon every picture in the palace', but shows himself a dunce in art, French, and Latin. When a Swiss connoisseur exclaims *magnifique*, Pallet talks him down:

Manufac, you mean, and a very indifferent piece of manufacture it is; pray gentlemen take notice, there is no keeping in those heads upon the back ground, nor no relief in the principal figure; then you'll observe the shadows are harsh to the last degree; and come a little closer this way – don't you perceive that the fore-shortening of that arm is monstrous – agad, sir! there is an absolute fracture in the limb – doctor, you understand anatomy, don't you think that muscle obviously misplaced?

He struts about 'in a gay summer dress of the Parisian cut, with a bag to his own grey hair, and a red feather in his hat'. (James Barry recalled him strolling in a skyblue coat. Others spoke of 'his hat cocked on one side, very much in the manner of the great Frederick of Prussia', though John Ireland says that he wore no hat so as to show the scar on his forehead which he had go as a child; Benjamin West thought him 'a strutting, consequential little man'.) Smollett tries to degrade Pallet's art by linking with Dutch low-life genre; he shows 'the image of a certain object so like to nature, that the bare sight of it set a whole hogstye in an uproar'. Pallet jeers at the hungry French and

gets into trouble by disguising as a woman, so that he is sent to the Bastille. At Antwerp he mocks at Raphael and sketches an Old Capuchin preaching, so that he is nearly mobbed. In London he arranges a lottery for his *Cleopatra*, 'a begging shift to dispose of a paultry piece'. This kind of denigration, fitting in with the criticism of Le Blanc, was just what was calculated to raise yet more prejudice against Hogarth among artists and connoisseurs. Since the Peace of Aix-la-Chapelle the taste for Italian art had gained new strength.

Hogarth had been thinking about Rembrandt, as was shown by two events in May. Hudson, a collector of the etchings, declared that any imitation could be at once detected. Benjamin Wilson, who had had a brush with Hudson at an auction, decided to get his revenge. He found out how to imitate the paper used by Rembrandt, and made a fake print, on which he wrote in Dutch, 'The Companion to the Coach'. He sent the fake in a portfolio of genuine etchings to Hudson, who bought it as the best example of Rembrandt he knew. Hogarth had been in the trick: 'Damn it, let us expose the fat-headed fellow.' He encouraged Wilson to repeat the hoax on a printseller. Wilson then spent the proceeds on a supper for twenty-three artists, Hudson among them. A sirloin of beef was served, decorated with the prints. Hogarth stuck his fork into one of them and passed it on to Hudson. West asked what Hogarth had said. 'He! an impudent dog! he did nothing but laugh with Kirby the whole evening.'

Two days later, 9 May, he advertised engravings of *Moses* and *Paul*, ten shillings the pair. The receipt was 'a new Print (in the true Dutch Taste) of *Paul before Felix*'. This etching was done on a mezzotint ground and early impressions were stained (probably with coffee) to give a dirty faded effect. It burlesqued Rembrandt's style of drawing, but with no grasp of his essential character. Justice is a fat old woman with moneybags at waist, butcher's knife in hand, and bandage leaving one eye free. A small devil saws at a leg of the stool on which Paul stands while his sprawling angel dozes; Felix, quaking, empties his bowels to the distress of those around. Hogarth at this date had probably seen very little of Rembrandt's work apart from some etchings and accepted him as an exponent of Dark Art contaminated by Dutch drolls. But he soon seems to have realized that Rembrandt in his day was attacked by the idealizers, and to have discovered a kinship with him. In 1755 he painted John Pine in a Rembrandtesque style.

He had decided to sell the paintings of *Marriage à la Mode* by auction. Each bidder was to sign a note, which was put in a glass case with only the sum offered visible; at noon on 6 June the case would be opened. No dealers

were to bid: scarcity was the standard of judgement, 'so righteously and laudable establish'd by Picture-Dealers, Picture-Cleaners, Picture-Framers, and other Connoisseurs'. His revulsion from sets of engravings based on paintings is shown by the statement that he was unlikely to do another group of paintings 'because of the Difficulty of vending such a Number at once to any tolerable Advantage'. He adds:

So that whoever has a Taste of his own to rely on, not too squeamish for the Production of a Modern, and Courage enough to avow it, by daring to give them a Place in his Collection (till Time, the suppos'd Finisher, but real Destroyer of Paintings, has render'd them fit for those more sacred Repositories, where Schools, Names, Hands, Masters, &c. attain their last Stage of Preferment), may from hence be convinced, that Multiplicity of his (Mr. Hogarth's) Pieces, will be no Diminution of their Value.

He mentions that he has shown not more than fifty of 'this historical or humourous kind'. To dealers and connoisseurs, 'humourous' and 'historical' would have seemed antithetical terms. We see how he has turned advertisements into manifestos, the first of their kind in art history.

This time the auction was a fiasco. The buyer was John Lane of Hillingdon, who paid twenty-one guineas per picture, a sum which included four guineas for each of the 'elegant Carlo Muratt frames'. His account states that Hogarth had asked friends not to come along and overcrowd the room, dressed early, put on his tie-wig, 'strutted away one hour, and fretted away two more'. About eleven Lane dropped in and found no one there but the artist and Dr Parsons. When the box was opened, only one bid was found: from Charles Perry for £120. Lane offered to make it guineas. Noon came. Parsons tried to ease things by saying the sale had been fixed too early, 'when the people at that part of the town were hardly up. Hogarth, in a tone that could not but be observed, said, Perhaps it might be so. Mr Lane, after some little time, said he was of the Doctor's mind, adding that he was of opinion he was very ill paid for his labour.' He offered to give Hogarth till 3 p.m. before the bids were closed. Hogarth warmly accepted and Parsons proposed to make Lane's generosity known, 'which was peremptorily forbid by Mr. Lane, but which was ever remembered and acknowledged by Hogarth till the time of his death'. At 2 p.m. no one had come in, so Hogarth told Lane that he accepted his bid, only asking to be informed if he wanted to sell the works – and never to 'let any person, by way of cleaning, meddle with them, as he always desired to take care of them himself'.

The episode was a sore blow to Hogarth. Lane says: 'This *nouvelle* method of sale probably disobliged the Town, and there seemed to be at that time a combination against poor Hogarth, who, perhaps from the extraordinary

and frequent approbation of his works, might have imbibed some degree of vanity, which the Town in general, friends and foes, seemed determined to mortify.' Vertue records:

he puffed this in news papers for a long time before hand. but alass when the time came – to open this mighty secret he found himself neglected. for instead of 500. or 600 pounds he expected. there was but one person had got to bid. without any advance, the only sum of 120 pounds. by which he saw the publick regard they had for his works – but this so mortified his high spirits & ambition that threw him into a rage cursd and damned the publick. and swore that they had all combind together to oppose him . . . by this his haughty carriage or contempt of other artists may now be his mortification – (and that day following in a pet. he took down the Golden head that staid over his door).

It was not the auction's novelty that caused the fiasco; he had not done so badly in 1745, even if he had left the solid body of dealers and collectors untouched. Now however the opposition had cohered in a more definite way, for which he was unprepared. This summer the Gin Act was passed and the consumption of gin fell off. Fielding and Hogarth had helped to strengthen public opinion in favour of such a step; but it would be an exaggeration to claim that they brought it about. The burlesque *Paul* must have been liked; for in December Hogarth sold it separately and used as ticket a revised *Boys Peeping at Nature*. He removed the quotations, gave Nature a more classical headgear, took out the peeping fawn, and put in a *putto* with a panel that blocked Nature out but for head and shoulders, which he defined as an oval with a few curving lines. Was he renouncing his old defiant curiosity and accepting an idealized abstraction as Nature's face? More likely he was ironically telling the public that he offered them the idealized forms they cherished.

While the failure of the auction shows how deep was the breach between Hogarth and the connoisseurs, we have evidence that he was ever more popular with ordinary folk. Steevens says that Purce, a merchant, left him £100 in his will as a return for the 'pleasure and information' that his work had given. Shops selling comic prints took his name: Hogarth's Head in Cheapside and Hogarth's Head and Dial in Fleet Street.

This year one Thynne called on him to see if he would take the son of a rich Cumbrian landowner, Senhouse, as apprentice. (Thynne had reported that Hogarth was thought by several gentlemen to be the fittest man 'tho' he deals much in the Grotesque way'.) Hogarth told him lads went 'as Pupils by the year', and advised Senhouse to try the portraitist Knapton. Somewhat later the author John Brown called on various painters for Senhouse and breakfasted with Hogarth, who said he took no pupils. He advised engraving

for the lad, as it ensured a weekly guinea and a half, 'besides his Entertain-
ment, as soon as he is out of his Apprenticeship', also, if he wanted to paint
history, he could then engrave his own work. (The lad in fact was put with
the painter Devis; in June he visited the Foundling Hospital and was 'very
agreeably entertain'd by the histories'; he died of smallpox in 1753.)

In February 1752 Hogarth issued the engraving of *Moses* and two versions
of *Paul*, one by himself and one by Sullivan (which did not reverse the
painting); he seems to have wanted to revise various aspects of the com-
position. Whether both prints were sold to subscribers is not clear. He was
elected a governor of Bethlehem Hospital. At the end of the month he
announced *The Analysis of Beauty*, 'Wherein Objects are considered in a new
Light, both as to Colour and Form. (Written with a View to fix the fluctuating
Ideas of Taste).' The ticket for the book showed Columbus and the Egg.
The explorer's enemies had suggested that anyone could have thought of his
project; he in reply asked them to set an egg upright on a table. When they
failed, he knocked the egg smartly on the table and flattened its end, then
stood it up. The inference was that Hogarth had discovered a new world and
could solve problems baffling everyone else: an idea not likely to placate his
enemies and ridiculers.

On 22 March Rouquet returned from Paris. By summer or early autumn he
was living near Hogarth, and for two years worked on an account of English
culture, *The State of the Arts*. Hogarth must have helped and encouraged. He
was hoping that his *Analysis* would turn the tide of artistic opinion, and
Rouquet could be expected then to contribute to the effect.

Kirby had become interested in problems of perspective, set about com-
piling a book on the subject, and asked Hogarth for a frontispiece. In 1751
and again in November and December of 1753 he advertised *Dr Brook
Taylor's Method of Perspective Made Easy*. On 3 May 1753 he thanked Hogarth
for the frontispiece, a *Satire on False Perspective*, engraved by Sullivan, which
shows a multiple series of ludicrous effects produced by errors of perspective:
exaggerations of the sort of thing that Hogarth at times used for humorous
or symbolic effect – the cow horns over the cuckold, the lover's sword seem-
ing to strike at the Jew. Kirby asked Hogarth to contribute also an essay to
end the book:

then I shall have you both in my Front, & Rear, & shall not be afraid even
of ye D—l himself when I am so Guarded: If the little Witlings despise ye
Study of Perspective, I'll give 'em a Thrust with my Frontispiece, which
they cannot parry; & if there be any that are too tenacious of Mathematical
Rules, I'll give them a Cross-Buttock with ye Dissertation, & crush 'em into

as ill-shaped Figures as those they would Draw by adhering too strictly to ye Rules of Perspective.

The passage suggests the way that he and Hogarth talked together about those who disagreed with them on the need at times to dispense with mathematical rules if a true effect was to be preserved. Hogarth did not provide the essay; no doubt he was too busy with his own writings.

Late in June Hogarth again advertised the *Analysis*, explaining what the two accompanying prints would be like; he tried to widen the range of interested persons by saying that it would be useful to 'the Curious and Polite of both Sexes, by laying down the Principles of personal Beauty and Deportment, as also of Taste in general, in the plainest, most familiar, and entertaining Manner'. He is trying to appeal once again over the head of the connoisseurs. We meet his deep interest in popular art in a tale told by Morell. Returning from a visit to John Rich at Cowley, he saw a large drawing of St George and the Dragon in coal on an alehouse-door, all in straight lines; he stopped the carriage and made a copy.

Several public matters this year must have interested him. There was the Marriage Act, against which it could be argued that the existing loose methods enabled young folk to marry for love and escape the toils of parents concerned only with property. On the other hand there were the 'drunken swearing parsons with their myrmidons that wear black coats and pretend to be Clerks and Registers to the Fleet, plying about Ludgate Hill, pulling and forcing people to come peddling Alehouse or Brandyshop to be married', as complained a Lady signing herself Virtuous in the *Gentleman's Magazine* in 1735; Ministers of the Church of Scotland, called Buckle-the-Beggars, married poor folk in pubs in the Canongate. Still, in the Act Hogarth must have seen the advance of the regimenting forces. This year too there was an attempt to bring in a Census. William Thornton, a Yorkshire country gentleman, typified the resistance. The Bill, he said, would only help enemies abroad and at home, 'place-men and tax-masters', and would be 'totally subversive of the last remains of English liberty'. Throw census officials in the horsepond! The Bill was rejected. In 1753 the government had to repeat an Act for the Naturalization of the Jews, so furious were the country gentlemen. The Duke of Cumberland, representing Hanoverian militarism and suspected of aiming to usurp the throne, was caricatured as lining up to be circumcised and remarking that it made little difference: he was rumoured to be impotent.

Meanwhile Hogarth was having trouble with his fellow artists. He had tried hard to open up new roads for himself and them; but except for Hayman at Vauxhall, none of them showed much initiative, content to jog along

with what patronage they could gain. Hogarth certainly at times made unwise comments, setting himself before them as an example. The question of a public academy had been coming up for some time; and many arguments must have been going on behind his back. On 24 March the subscribers to his academy met to settle accounts and make arrangements for the next year. On 23 October a group used the academy's funds to print a circular calling for a meeting to deal with a scheme for a public academy. Hayman apparently chaired the meeting on 13 November. As there was no debate on the merits of the proposal, we can assume that the meeting was called by artists already agreed on the scheme. Presumably there were elections and Hogarth was not present. All his life he was totally opposed to any kind of State Academy. In his *Apology* he wrote in rough notes:

We hear much of the academies (of painting) abroad rooms were naked men stand in certain posture to be drawn after with these places many are made to believe painting (will) can never be attain to any degree of perfection, Lewis the 14 got more honr by establishing a pompous parading one at paris than the academician advantage by their admition into it Voltaire observes after that establishment no work of genious appeard for says he they all became imitators and mannerists all painting it is true is but Imitation if we go no further than copying what we see done without entering in[to] the causes of (the) effects (that are produced) if vary from our original we fall off from it and can have no hopes [of] getting beyond it. to this purpose and his reasons giving but supposing an academy were all it is imagind to be that monarch purchased same at an easy rate, for we have (had) in St martins lane (supported by a trifling subscription of young) near these thirty years one to all intents and purposes as usefully serving (about) by paultry salarys tho not more as I have been informed than 50 pounds a year and a farcical parade would be laughd at here were it to be set on foot.

His own academy, says Rouquet, was getting along quite well, 'admirably adapted to the genius of the English: each man pays alike; each is his own master; there is no dependance; even the youngest pupils with reluctance pay a regard to the lessons of the masters of the art, who assist there continually with an amazing assiduity'. He adds that some members tried to find ways of establishing an academy; but they failed, forgetting that such a body cannot exist 'without some subordination, either voluntary or forced; and that every true born Englishman is a sworn enemy to all such subordination, except he find it strongly his interest'. Strange later described the situation in other terms. The failure came through 'the intrigues of several among the artists themselves; who, satisfied with their own performances, and the moderate degree of abilities they possessed, wished, I believe, for nothing more than to remain, as they then were, masters of the field'. He is clearly hinting at Hogarth as the main enemy of a public academy.

12 *The Analysis of Beauty*

In the midst of the arguments about an academy, on 1 December 1753 Hogarth published his *Analysis of Beauty*, which throughout denies the validity of an academic type of art teaching, attacks copying and the cult of idealized form, and exalts nature in all her complex variety:

Now, as every one has a right to conjecture what this discover of the ancients might be, it shall be my business to shew it was a key to the thorough knowledge of variety both in form, and movement. Shakespear, who had the deepest penetration into nature, has sum'd up all the charms of beauty in two words, INFINITE VARIETY; where, speaking of Cleopatra's power over Anthony, he say,

> – Nor custom stale
> Her infinite variety: –

It was no accident that he turned to Shakespeare, and to the most powerfully sensuous of his plays, for the stressing of this point.

Many aspects of the book have already come up, and we may summarize them here. First, form is always conceived in terms of organic wholeness, not as a putting together of parts on some imposed principle of proportions and harmonies. Variety is the result of a fusion of intricacy and simplification, and is an active principle, compared to a kind of chase or pursuit in which the artist is himself involved. Form is thus inseparable from movement. Nature and art are not concerned with forms which are *put into* movement; the movement is integral. The ability to feel and express organic wholeness is linked with the impulse of mimicry or empathy in which the artist feels himself *into* the object, feels himself *as* the object. So the organic sense is in turn one with the ability to realize the form as movement, as existing in a

chase or activity that involves the artist as well as the object. And so, further, the impulse of study (the struggle to know and master the forms of the world) is one with the impulse of pleasure (the desire to enjoy the world, to unite vitally with it). Form thus ceases to be a matter of linearity, of abstract constructions; it involves, at every point, mass, volume, lines, surfaces, colours, tones, all the qualities that make up the living totality. There is a joint sensation of bulk and motion.

Hogarth stressed the analogy of labour process and organic process, and the analogy of both with art activity. As a child he discovered the mystery of form movement through the vanishing spiral of the turning kitchen-jack. The line twists and curves away in order to be reborn at the point where it began; and because the line is spiral it involves bulk, volume, spatial depth. Weaving processes teased Hogarth with intuitions of both physiological and artistic processes. In the body, both in its external aspects and in its inner anatomy, he felt deeply the 'continued waving of winding forms from one into the other'. What he calls the line of beauty represents the tensional force operated by these winding forms on one another. In a sense all movement aspires to the level of the dance. In the *Analysis* he sets out and expounds these ideas.

From the outset he was argumentatively in search of a theory of art. Not a theory in the abstract, but one that would illuminate his practice and help him to develop it. He had originally approached art as a minor craftsman, with certain attitudes of mind derived from his father, which he sought to apply in his own way. An outsider, he brought a critical viewpoint to bear on all aspects of the art world he was entering. His independent outlook and his strong sense of life as something to be lived, not something to be judged by ready-made criteria, artistic, moral, or social, ensured that he would keep on reconsidering his positions thoroughly at each phase of his development. We have seen him in many disputes. Here is yet one more passage showing how his arguments led on to the *Analysis*.

. . . if I have acquired anything in my way it has been wholy obtain'd by Observation by which method be where I would with my Eyes open I could have been at my studys so that even my Pleasures became a part of them, and sweetned the pursuit. As this was the Doctrin I preach'd as well as practis'd an arch Brother of the pencil gave it this turn That the only way to learn to draw well was never to draw at all. in short these notions as they clash'd with most of the commonly receiv'd ones of the school drew me into frequent disputes with my brethren in which as the torrent was against me I seldom got the better of the argument yet observing that several availd themselves of the very doctrins they so warmly opposed and also as these sentiments got ground, espoused them as their own, I began to think if I

were but able to publish my thoughts in writing I might have fairer play and if there should be any merit in what I could suggest I should probably reap the credit and advantage of it, instead of labouring as I then did under the imputation of a vain and obstinate opposer of establishd opinions. But as all the times of setting down to business have been necessarily appropriated either to the Graver or the pencil the Pen grew an Impliment I was affraid to take up.

He speaks of one friend encouraging him to write. In another passage, repeating what he says of his arguments, he speaks of applying to several friends, as he states again in his preface. He turned to friends

whom I thought capable of taking up the pen for me, offering to furnish them with materials by word of mouth: but finding this method not practicable, from the difficulty of one man's expressing the ideas of another, especially on a subject which he was either unacquainted with, or was new in its kind, I was therefore reduced to an attempt of finding such words as would best answer my own ideas, being now too far engaged to drop the design.

He had shown himself able to set down his ideas in the Britophil essay or the journalistic oddments that he seems to have fed to the press, though a work of the compass of the *Analysis* may well have daunted him. He had used men like Rouquet or Bonnell Thornton to publicize some of his ideas; and Fielding had done his best, especially in *Joseph Andrews*, to support him, but even if he had now had the time, he lacked Hogarth's theoretical capacities. So Hogarth was forced back on himself and discussed the project of a book with friends like B. Hoadly, Ralph, Kirby, Townley, and no doubt others like B. Wilson, Dr John Kennedy, Roubiliac, and various scientist friends.

Wilson experimented and wrote on electricity as well as painting portraits: in 1754 he told Hogarth that he meant to show 'further advantages which I have gained from your excellent Analysis'. In 1746 he had published his *Essay on Electricity;* in 1750, 1752, 1755, 1788 came further treatises, with many papers in the *Philosophical Transactions* of the Royal Society between 1753 and 1779. He must have often talked about electricity in Hogarth's presence; and if we recall the contemporary view of forces as fluids, we can see how his ideas helped Hogarth to a sense of the dynamic and fluid movement of the line of beauty, energy, life. During 1753 there was widespread interest in electricity through Franklin's linking of electricity and lightning. Wilson was one of those who verified the thesis. On 12 August 1752 he wrote a letter from Chelmsford where he had got 'electrical snaps' from an iron rod at the end of a thunderstorm. He would have discussed with Hogarth the whole question of attraction and repulsion as revealed in electrical

phenomena. (He was considered enough of an expert to be put on the committee with Franklin, Cavendish, and W. Watson, to investigate the use of pointed conductors for protecting the powder magazine at Purfleet in 1772.)

Kennedy, numismatist, provided the quotation from Lomazzo on the serpentine line; and Roubiliac, returned from Italy, gave information about things like the Apollo Belvedere. Among scientist friends were men like Parsons, John Ellis, botanist, Dr Freke, surgeon who wrote on the philosophy of the natural sciences, Thomas Birch, to whom a copy of the *Analysis* was sent before publication for the Royal Society's library, Sanderson, who is mentioned in the *Analysis* and at whose college (Corpus Christi, Cambridge) Hoadly taught mathematics:

Hence I would infer, that the eye generally gives its assent to such spaces and distances as have been first measured by the feeling, or otherwise calculated in the mind: which measurements and calculations are equally, if not more, in the power of a blind man, as was fully experienced by that incomparable mathematician and wonder of his age, the late professor Sanderson.

No doubt to ensure himself against the accusation, which in fact did come that he had not written his own book, he kept three drafts, which survive. Only in the third, transcribed by an amanuensis, do we find corrections by another hand (that of Morell). A fourth draft, sent to the printer, has not come down. Hogarth's account runs:

Hereupon, having digested the matter as well as I could, and thrown it into the form of a book, I submitted it to the judgment of such friends whose sincerity and abilities I could best rely on, determining on their approbation or dislike to publish or destroy it: but their favourable opinion of the manuscript being publicly know, it gave such a credit to the undertaking, as soon changed the countenances of those, who had a better opinion of my pencil, than my pen, and turn'd their sneers into expectation: especially when the same friends had kindly made me an offer of conducting the work through the press: And here I must acknowledge myself particularly indebted to one gentleman for his corrections and amendment of at least a third part of the wording. Through his absence and avocations, several sheets went to the press, without any assistance, and the rest had the occasional inspection of one or two other friends.

A poem of his, printed by John Ireland, expresses the fears and hopes he felt during composition:

> 'What! – a book, and by Hogarth! – then twenty to ten,
> All he gain'd by the pencil, he'll lose by the pen.'
> 'Perhaps it may be so, – howe'er, miss or hit,
> He will publish, – here goes – it's double or quit.'

Hoadly was the main helper. He became ill and Hogarth turned to Ralph, but they argued together too much; so Morell took over. Townley dealt with the Preface. The first draft there was stronger in its attack on 'the Power of habit and custom'. He used Plato's image of the Cave, giving it his own homely turn:

It is easy to conceive, how one brought up from Infancy in a coal Pit, may find such pleasure and amusement there, as to disrelish, day light, and open air; and being Ignorant of the beautys above ground, grow uneasy, and disatisfied, till he descends again into his Gloomy cavern; so I have known the brilliant beauties of nature, disreguarded, for even the imperfections of art, occationd by running into too great an attention to, and imbibing false oppinions, in favour of pictures, and statues, and thus by losing sight of nature, those who take things upon trust they blindly descend by such kind of prejudices, into the coal pit of conoiseiurship; where the cunning dealers in obscure works, lie in wait, to make dupes of those, who thus turn their backs on the perfections of Nature.

The imagery well suited his attack on dark pictures, but he must have been advised by his friends that the comments were too sharp.

The *Analysis* owed very little to previous books. In the Preface Hogarth attempted a rapid glance at art in Egyptian and Graeco-Roman times, at the development of painting in Italy, France, and the Lowlands. He cited Leonardo, Lomazzo, Ten Kate, Du Fresnay, De Piles and other well-known critics. But he seems to have known little of their writings apart from some points picked up in conversation and argument, though he may have skimmed through a few of their books. There is not much of interest in this section of his work. As he was keen to find support in ancient or Renaissance theory, he would certainly have liked to cite other authors than Lomazzo in defence of his line of beauty. If he had read John Elsum's *The Art of Painting after the Italian Manner* of 1703, he would have found the serpentine line there. He could further have cited Testelin, Dupuy de Grez, De Lairesse, and Jonathan Richardson. The last named had written: 'The contours must be large, square, to produce greatness; and delicate and finely waved, to be gracious.' However, Hogarth had in effect covered himself:

Many writers since Lomazzo have in the same words recommended the observing this rule also; without comprehending the true meaning of it; for unless it were known systematically, the whole business of grace could not be understood.

It was indeed true that he had worked out and applied the idea of the serpentine line in a new way, with a fullness and subtlety of range, that quite transformed it from being a mere ingredient, however important, in baroque

and rococo theory and practice. In De Lairesse he could have read an exposition which, beginning with straight and then simple curved lines, goes on to more complicated ones such as straight-curved-undulating lines. This system, which goes back to Dürer's *Unter-weysung*, is set out by Hogarth himself; but he deals with it, not because it involves a series of forms increasingly difficult to draw, but because it leads to an increasing beauty and grace in the forms. It is clear that he was correct in claiming that he was setting out an essentially original concept of form and its meaning.

It is true that he was picking up certain ideas that were common currency in the art discussions of the epoch: for example that of *concordia discors*, a mixture of harmony and disharmony which produces a complex unity, not a confusion. This idea lies behind his whole concept of variety:

All the senses delight in it, and equally are averse to sameness. The ear is as much offended with one even continued note, as the eye is with being fix'd to a point, or to the view of a dead wall.
Yet when the eye is glutted with a succession of variety, it finds relief in a certain degree of sameness; and even plain space becomes agreeable, and properly introduced, and contrasted with variety, adds to it more variety.
I mean here, and every where indeed, a composed variety; for variety uncomposed, and without design is confusion and deformity.

For the contrast of variety and plain space we might look at the *March to Finchley*, where the human tumult is opposed, first to the flat surfaces on either side (especially on the right), and then to the open sky above.

Hogarth's concept here is a dialectical one. He is not speaking merely of a mixture of uniformity and variety, but of their *fusion* – a fusion which does not blur out the distinction between them, yet resolves the conflict in a higher unity. So he goes quite beyond the other thinkers or poets who use the idea of *concordia discors*. At times indeed he writes as if he were describing a balance of variety and regularity, in which one controls the other. Thus he says of St Paul's:

There you may see the utmost variety without confusion, simplicity without nakedness, richness without taudriness, distinctness without hardness, and quantity without excess. Whence the eye is entertain'd throughout with the charming variety of all its parts together.

The test he applies is the consideration of the building at different distances. As one gets further away, the basic structure becomes clearer as 'bold and distinct parts'. He applies the same test to Westminster Abbey, with the same result. He also uses the concept of the mean or the middle as a sort of balancing-point between two extremes, e.g. Alcinous as the mid-point

between a series of forms on either side of him ending in Atlas (massive) and Mercury (slim and sinewy).

But he also sees the operation of his principle as the union or fusion of opposites. 'Any two opposite colours in the *rainbow*, form a third between them, by thus imparting to each other their peculiar qualities.' And beyond any particular formulation there is his whole concept of form as something dynamic, always involving movement and tension. The serpentine line thus becomes the resolution of entangled tensions, pulls, conflicting and inter-acting forms. Hogarth stresses that the waving line has its utmost variety when 'composed of two curves contrasted' – that is, opposed.

His originality becomes yet clearer when we consider his relation to the whole English tradition of thought, to which he belongs and which he yet transforms, lifting the key concepts to a new level and giving them decisive reorientations. The tradition is that of Hutcheson and Shaftesbury, of Addison and Spence. On the one hand among these thinkers there is high praise of Nature, but their nature is a thing of order and symmetry. The positions are set out with special eloquence by Anthony Ashley, third Earl of Shaftesbury, whose *Characteristicks of Men, Manners, Opinions, Times* of 1711 deeply affected poets like Thomson and Akenside, not to mention Pope, and European thinkers like Leibniz, Voltaire, Diderot, Lessing, Herder. It exalts nature: 'O glorious Nature! supremely Fair, and sovereignly Good! All-loving and All-lovely, All-divine! . . . Thee I invoke, and Thee alone adore. To thee this Solitude, this Place, these Rural Meditations are sacred; whilst thus inspir'd with Harmony of Thought, tho' unconfin'd by Words, and in loose Number, I sing of Nature's Order in Created Beings, and celebrate the Beautys which resolve in Thee, the Source and Principle of all Beauty and Perfection.' This nature is the source of order and harmony; hence the con-templation of it is supposed to instil a sense of virtue, of moral unity with Providence.

This too is certain; That the Admiration and Love of Order, Harmony and Proportion, in whatever kind, is naturally improving to the temper, advan-tageous to social Affection, and highly assistant to *Virtue*; which is it-self no other than the Love of Order and Beauty in Society. In the meanest Subjects of the World, the Appearance of *Order* gains upon the Mind, and draws the Affection towards it. But if *the Order of The World* itself appears just and beautiful; the Admiration and Esteem of *Order* must run higher, and the elegant Passion or Love of Beauty, which is so advantageous to Virtue, must be the more improv'd by its Exercise in so ample and magnificent a Subject. For 'tis impossible that such *Divine Order* should be contemplated without Extasy and Rapture; since in the common Subjects of Science, and the liberal Arts, whatever is according to just Harmony and Proportion,

is so transporting to those who have any Knowledge or Practice in the kind.

These passages are important; for without grasping what were the positions of the moral philosophers, dominant in Hogarth's world, which he totally rejected, we cannot understand what he is saying. Those positions led to the attitude summed up by Pope:

> *All discord, harmony not understood,*
> *All partial evil, universal good.*

Which in turn led to the attitude: 'Whatever is, is best.' Here we have the Augustan doctrine of order, an aristocratic conception, which justifies all existing inequalities and discords in the name of a higher balance. Even the couplet-form of Pope, self-contained and continually reasserting symmetry after a momentary wavering or unbalance, is the perfect aesthetic expression of such a view of life. Behind it lies Newtonian mechanism with the axiom that all action and reaction are equal and opposite. Against this world of order and symmetry Hogarth defiantly sets his world of dynamic variety and fused opposites.

In denying that the principle lies in uniformity underlying variety, where the main emphasis is on uniformity, he also denied all theories of art form which looked to mathematical systems or theories of proportion. Thus he condemned all such thinkers as Shaftesbury or Hutcheson:

The cheif steps that have hitherto been taken by writers, to dispell these clouds of uncertainty, and error, with design to fix some true Ideas of taste, upon a surer basis; have been first, those set forth by the natural philosophers, who by their extended contemplations, on universal beauty, as to the harmony and order of things, were naturally led, into the wide Roads, or uniformity, and regularity; which they unexpectedly found cros'd, and interupted, by many other openings Relating to a kind of Beauty, differing, from those they were so well acquainted with, they then, for a while travers'd these, seeming to them, contradictory paths, till they found themselves bewilder'd in the Labarinth of variety; not considering it necessary first to go through the province of painting; before it was possible, to get into the right Road, of Natures more superficial beautys, of sportiveness, and Fancy, if they may be so term'd, & which differ so greatly from her other beauties, of order, and usefulness. Thus wandering a while in the maze of uncertainty, without gaining ground; they then to extricate themselves out of these difficultys; suddenly ascend the mound of moral Beauty, contiguous with the open field of Divinity, where ranging at large, they seem to lose all remembrance of their first pursuit.

It is worth noting, as a proof of Hogarth's consistently materialist position, that he never once in all his writings or comments invokes the name of God,

Divinity, moral beauty (as an abstraction). The passage just cited above comes from the discarded Preface.

Here further is a passage in which he condemns all theories of form based on static geometrical or mathematical principles:

Whilst Albert Durer, who work'd by rules which he asures you in his book of proportions, were calculated Geametrically, to correct the most beautiful nature; never so much as once deviated into grace, which he must have done, had he not been fetter'd with his own almost impracticable rules.

He goes on to compare 'Tedious Mathematical manner of finding the proportions of the human body (which is of a peice with the Isopleuros Triangle Scheme in Lomazzo)' with Swift's Laputan tailor, and ends: 'From hence I infer, that the Mathematical road is quite out of the way of this Enquiry.' We can now begin to realize the full basis of his position in rejection of all Palladian ideas and his continual mockery of theories of proportion in architecture. The notion of harmonious proportions had been restated by Robert Morris in his *Lectures on Architecture.*

The thinker who came closest to Hogarth was Antoine Parent, with his essay *On the Nature of Bodily Beauty* in the *Journal des Scavants,* 22 November 1700. Though he found that beauty to consist 'in a word in the harmony found between the different parts of a figure', he laid his main stress on smoothness or roundness. Lessing summed up his position:

Right at the beginning, *Parent* proves that beauty could not consist in that type of relationship between elements which *Hogarth* also singles out for criticism in *Dürer* and *Lamozzo* [*sic*]. He then proves that beauty does not depend on mere variety of elements, though this is frequently pleasing. This is indeed also maintained by Mr. *Hogarth*. But this similarity would still have no significance if it did not extend to the main point. *Parent* goes further and examines the forms which possess no beauty and he finds that these are composed of many far-protruding or far-intruding angles together with many straight lines. Beautiful figures on the other hand, he maintains, exactly as does Mr. *Hogarth*, consist of beautiful curves which are created from soft convexities, concavities and flexions.

But though the links between Parent and Hogarth are many, Parent's theory is much more a direct abstraction from baroque art than is Hogarth's. It lacks the far wider range of applications in the latter, which we shall later examine. There can be no doubt that Hogarth did not know of Parent's contribution. If he had known of it, he would not have dared to make his confident claims to a fundamentally new theory.

Parent, we may note, had developed in 1704 the theory of the working

of water-wheels, making, it seems, the first application of the differential calculus to engineering machines and the first statement of a machine's mechanical efficiency. A teacher of mathematics, he was drawn into seeking the unity of theory and practice through having to expound his ideas to pupils interested in architecture and (mostly military) engineering. Just at the time that Hogarth was getting down his ideas on to paper for the *Analysis*, Parent's work on water-wheels was having important effects in England through the research and applications by John Smeaton. We touch here some of the hidden relations that existed between such an aesthetic as that of Parent or Hogarth and the whole movement of thought in their period, a movement which included the advances being made in both abstract and applied science. In all sorts of ways, some clear, others subterranean, Hogarth was affected with a new dynamic sense of a world in ceaseless movement, yet resisted the mechanistic reduction.

One propounder of a geometrical theory whom Hogarth knew well was Giles Hussey; we cited Vertue as saying in 1745 that Hogarth opposed him. He had a scheme of triangles, which looked forward to what may be called romantic-classical attitudes. He argues that 'every face is in harmony with itself' and that the drawing of the human form should be corrected by the musical scale. After the keynote had been attained, Hussey said, the proportions of the face could be determined by it. He detested the physiognomical precepts of Le Brun as 'caricatures of passions', and laid down that 'if we have not a just idea of virtue and of the bounds which it prescribes to all passions we shall easily fall into theatrical affectation'. (He may have been hitting at Hogarth in that comment.) Hogarth however refers to Le Brun's series as providing 'a compendious view of all the common expressions at once', even though they are imperfect copies. He does not refer to Hussey in the *Analysis*, though he must have had him in mind in attacking theories of musical proportion:

. . . as all mathematical schemes are foreign to our purpose, we will endeavour to root them quite out of our way: therefore I must not omit taking notice, that Albert Durer, Lomazzo (see two tasteless figures taken from their books of proportion) and some others, have not only puzzled mankind with a heap of minute unnecessary divisions, but also with a strange *notion* that those divisions are govern'd by the laws of music; which mistake they seem to have been led into, by having seen certain uniform and consonant divisions upon one thing produce harmony to the ear, and by persuading themselves, that similar distances in lines belonging to form, would in like manner, delight the eye. The very reverse of which has been shown to be true, in chap. 3, on Uniformity. 'The length of the foot, say they, in respect to the breadth, makes a *double suprabipartient*, a *diapason*, and a *diatesseron*:' which, in

my opinion, would have been full as applicable to the ear, or to a plant, or to a tree, or any other form whatsoever; yet these sort of *notions* have so far prevail'd by time, that the words, *harmony of parts*, seem as applicable to form, as to music.

What he objects to is a mechanical application of the ideas of harmony and proportion. He himself uses musical comparisons in discussing colour, tone, and aerial perspective. Indeed he stresses the connections or analogies.

There is so strict an analogy between shade and sound, that they may well serve to illustrate each other's qualities: for as sounds gradually decreasing and increasing give the idea of progression from, or to the ear, just so do retiring shades shew progression, by figuring in the eye. Thus, as by objects growing still fainter, we judge of distances in prospects, so by the decreasing noise of thunder, we form the idea of its moving further from us. And, with regard to their similitude in beauty, like as the gradating shade pleases the eye, so the increasing, or swelling note, delights the ear.

In architecture he sees the theories of proportion as limiting men's minds and preventing them from recognizing all sorts of new possibilities. In one of his plates he shows a design for a capital based on periwigs and three-cornered hats.

Yet were we but to hint, that the proceeding upon the foregoing Principles in search of a new order, would not be a vain attempt, we fear some biggoted Architect, or Builder, who holds the five orders as sacred as the Jews do their Penteteuch or five books of Moses, and dares not strike a stroke without book, would be much offended at so presumptuous a suggestion, altho he were not able to give any other reason why it is not practicable, but because attempts, have hitherto been in vain, and therefore he would conclude it must be an Impossibility; which conclusion might have had as good a foundation, if ye Anciants had left us no more than two orders. However see two new orders attempted. the violet or Larkspur order from which flowers the hints were taken and the [*illegible*] or Hat and Peruke order.

Wren himself had put this sort of position, though less provocatively. 'Modern authors who have treated on Architecture, seem generally to have little more in view, but to set down the proportions of Columns, Architraves, and Cornices, in the several Orders, as they are distinguished', and as these proportions are found in ancient buildings, 'they have reduced them into Rules, too strickt and pedantick, and so as not to be transgressed, without the Crime of Barbarity; though, in their own Nature, they are but the Modes and Fashions of those Ages wherein they were used'. But since we admire the ancient ruins 'we think ourselves strictly obliged still to follow the Fashion'.

Hogarth's rejection of the order or uniformity of the moral philosophers

is in turn linked with his rejection or sharp criticism of the state's imposition of order on the variety of mankind. This attitude of his reaches its climax in *The March to Finchley*, but pervades the other works in varying degrees of emphasis.

Joseph Spence, whom Hogarth would have classified as a moral philosopher, published his *Crito: or, a Dialogue on Beauty*, early in 1752, when Hogarth was thinking about the same subject and can hardly have missed reading the book. Though Spence considered that the moderns (from the Renaissance on) had lapsed in allegorical pictures from the style of the ancients, he was much concerned with the human body as it was in nature, in reality, looking to 'visible Beauty; and of that, to such only as may be called personal, or human Beauty; and that again, to such as is natural or real, and not such as is only national or customary . . .' In dealing with the beauty of the various parts of the body he uses a fourfold system (colour, shape, expression, grace) in an ascending series of value; and he has much to say of the blending of red and white in the human face, which reminds him of sunset. But despite his interest in the 'natural or real', he moves into idealizations.

We see then that, while Hogarth drew on many strands of the thought of his period, he made a radically new contribution; for the central point from which all his ideas proceeded was not shared by the other thinkers about art. He could rightly announce 'a work with a face so entirely new' that it would 'naturally encounter with, and perhaps may overthrow, several long received and thoroughly establish'd opinions'. But this claim of his to have found a quite new 'great principle' did much to stir up resistance among the artists and collectors. He had no effect at all on the dominant theory of harmonious proportions, which was soon to be authoritatively restated by Reynolds; he was opposed by all the idealizing tendencies which were gaining new strength through thinkers like Winkelmann. The antique mania was fast increasing. The rough and often crude acceptance of the hurly-burly of life, which had been normal in Hogarth's younger days and which we see expressed in Fielding's plays, had given way to an extreme sentimentality and fear of anything that could be labelled 'low'. The middle class was extending, separating itself out, and finding its own ideal of decorum opposed to aristocratic vice and plebeian coarseness.

Hogarth's concept of form and beauty had a strong functional aspect. Wren had worked out an aesthetic which also had many functional viewpoints in his *Tracts*, published by his grandson in *Parentalia* (1750). We would expect Hogarth to have read these, though he makes no reference to them.

Instead he cited different sources, such as Xenophon's account of Socrates in a statuary's yard, which Morell translated for him; he may have read, or have had pointed out to him, Berkeley's use of the passage in *Alciphron* (1732). Socrates argues that the character of men shows itself both in their looks and gestures, whether they stand or move. He asks the sculptor: 'Do you make your statues appear more lifelike by assimilating them to the figures of the living?' and 'by imitating the parts of the body that are drawn up or down, compressed or spread out, stretched or relaxed by the gesture?' Further, 'does the representation of the passions of men engaged in any act excite a certain pleasure in the spectators?' He concludes: 'A sculptor must express the workings of the mind by the form.' Similar ideas come up in the talk with the artist, Parrhasios. Hogarth would have liked the sentence: 'At least you represent substance, imitating them by means of colour, hollow and high (concave and convex), dark and light, hard and soft, rough and smooth, fresh and old.' Also this piece of dialogue: 'Can a dungbasket then, said Aristippos, be a beautiful thing? Undoubtedly, answered Socrates, and a shield of gold may be a vile thing, considered as a shield; the former being adapted to its proper use, and this not.'

The idea of functional use is strongly present in Hogarth's concept of form. He seems to have borrowed from Hume's section: 'Why Utility pleases' in his *Enquiry concerning the Principles of Morals* (1751). Hume writes:

A ship appears infinitely more beautiful to an artist, or one moderately skilled in navigation, where its prow is wide and swelling beyond its poop, than if it were framed with a precise geometrical regularity, in contradiction to all the laws of mechanics. A building, whose doors and windows were exact squares, would hurt the eye by that very proportion; as ill adapted to the human figure, for whose service the fabric was intended.

Hogarth uses the same illustrations:

Thus though a building were ever so large, the steps of the stairs, the seats of the windows, must be continued of their usual heights, or they would lose their beauty and their fitness; and in shipbuilding the dimensions of every part are confin'd and regulated by fitness for sailing. When a vessel sails well, the sailors always call her a beauty, the two ideas have such a connection.

But Hogarth's ideas about fitness and function go much further than merely involving an adaptation for some particular purpose. They are essentially organic and are concerned with the deep formative processes which involve a highly complex and living relationship between organism and environment. The state of biology in his day prevented him from working this aspect out; he is forced to rest himself on an intuitive sense of organic form, its connections, its vital energies and systems of self-expression.

In plate 1 of the *Analysis* he produces a parody or inversion of Clion's yard in Xenophon's *Memorabilia*. Here everything is as unfit as possible. His picture is based on the yard of his friend Cheere at Hyde Park Corner, but he is thinking of all the other yards roundabout which are turning out copies of copies in lead or stone, mostly for decorating gardens. Two persons are present. A dancing master wants to correct the lounging (curving) posture of an Antinous; a man holds a book of geometricized anatomies while looking up at the Venus de Medici. Everything is incongruous. A Roman general is being dressed by a tailor and periwig-maker, or is he Caesar being stabbed by an English actor made up as Brutus? Anyway, he seems tilting with a rope round his neck as if he were being hanged: he is in fact caught in some tackle for moving the statues. Apollo seems to be knocking the Brutus in turn on the head or ogling the Venus. The Farnese Hercules turns his back while a judge ignores the scene, though a *putto* or cherub at his foot weeps with a symbol of rectitude that can also be taken as another gallows. The judge has a flame (the Holy Ghost) on his head; he is the connoisseur of art who ignores its living content and wants only the dead copy. (From another angle he is God the Father, aloof from the world though he records its events.) All around the main picture are small designs (115 of them), which show schematic forms in various aspects of fitness or unfitness. We see the connoisseur again guyed as the dog or bear led by a tutor (from a Ghezzi print), wax torsos through which wires run to establish 'opposite points on the surface', a capital of hats and pyramids, a series of heads growing more mechanized till they turn into a barber's block, a row of women's stays, and so on, with the ideal as the serpentine line round a cone. By the introduction of the gallows motif and the scene of muffled violence round Caesar, Hogarth suggests that false views on art are linked with the cruelties and treacheries inside the society that holds them.

The variety and range of Hogarth's interest in forms are to be seen in the objects treated, which range from a curling worm and wormwheel, with a stick-and-ribbon ornament, bells, candlesticks, the sides of old-fashioned stoves, chair-legs, to lily, fleur-de-lys, parsley, chalcedonian iris, autumn cyclamen, a leaf from an ash tree 'growing like an excrescence'. A glance at the text of the *Analysis* shows his loving scrutiny of plants, flowers, leaves, egg, pineapple, shells, butterfly-wings, stay-whalebone, rainbows, horns, hair, and so on. In all forms he is seeking a common principle of growth, of vital and functional organization.

We have often noted earlier that he sees form as always involving movement. He discourses on 'the use of thinking of form and motion altogether'. Though he is in part dealing with the problem of showing forms in move-

ment, he is developing a much deeper concept of motion. He is again think-
ing, in organic terms, of the force of life manifested in the most tranquil
form, in the surface of the human skin. The joyous sense evoked in him by
the very existence of living form is

neither 'optical' nor 'tactile', neither linear nor painterly, but a sort of empathy
which is the beauty of the biological. His admiration for 'motion' . . . has
not much in common with the well-known observations on 'motion' by
Lomazzo and his followers in England up to Hogarth's time. Whereas they
thought of the dynamism of Michelangelo and the motion of the elements
in landscape in the sense of Leonardo, Hogarth seems to be trying to formu-
late something different, which is nevertheless rooted in the Renaissance
tradition. To communicate his enthusiasm to the reader, he speaks in his em-
pathetic way of the beauty of bones, and tries to show their analogy with
something equally living, the beauty of foliage. (Dobai)

That is well said, though we might add that his sense of form is also optical,
tactile, linear, and painterly. Though he talks about lines of beauty, his line
is also a surface. He knew that the line was an abstraction. 'The constant use
made of lines by mathematicians, as well as painters, in describing things
upon papers, hath establish'd a conception of them, as if actually existing on
the real forms themselves.' And as we saw earlier, he talks of the *joint-
sensation* of bulk and motion'. What moves is both form and mass. He is
thinking all the while of line, surface, and form (volume). He speaks of
'retiring shade, adequate to the serpentine line', and is concerned with the
complex transitions as the source of beauty in tone and colour. His serpentine
line is thus a concept that embraces a variety of rhythmic movements which
come together to make up the total organic object. Sterne was a good pupil
when he wrote: 'Attitudes are nothing, madam, – 'tis the transitions from
one attitude to an other – like the preparation and resolution of the discord
into harmony, which is all in all.'

The passage which most fully illuminates Hogarth's subtle concept of form
is that in which he sets out his scheme of the shell. He begins by saying that
his design is to consider 'the variety of lines, which serve to raise the ideas
of bodies in the mind, and which are undoubtedly to be consider'd as drawn
on the surface only of solid or opake bodies'. But it will be useful 'to conceive,
as accurate an idea as is possible, of the *inside* of those surfaces, if I may be
allow'd the expression'. So he asks us to imagine the object being con-
sidered as to 'its inward contents scoop'd out so nicely, as to have nothing
left but a thin shell, exactly corresponding both in its inner and outer surface,
to the shape of the object itself'. This shell we are to imagine as made up of

very fine threads, 'closely connected together, and equally perceptible, whether the eye is supposed to observe them from without, or within; and we shall find the ideas of the two surfaces of this shell will naturally coincide. The very word, shell, makes us see both surfaces alike.' Thus 'we shall facilitate and strengthen our conception of any particular part of the surface of an object we are viewing, by acquiring thereby a more perfect knowledge of the whole, to which it belongs: because the imagination will naturally enter into the vacant space within this shell, and there at once, as from a center, view the whole form within, and mark the opposite corresponding parts so strongly, as to retain the object, as we walk round it, and view it from without.'

The last thing Hogarth wants to suggest is that one views the object as an empty shell; he wants us to fill it out with our own sensory qualities, so that we simultaneously view or realize it from the centre as a whole and from the outside in every possible angle. And this total and comprehensive grasp does not exclude movement. On the contrary. What he wants to do is get us away from the habit of looking at, or drawing, an object from one angle only. 'By these means we obtain the true or full idea of what is call'd the *outlines* of a figure, which has been confin'd within too narrow limits, by taking it only from drawings on paper.' He has suggested a way of regarding a sphere as made up of 'an infinite number of straight rays of equal lengths issuing from the center, as from the eye, spreading every way alike; and circumscribed or wound about at their other extremities with close connected circular threads, or lines, forming a true spherical shell'. Now he says that each of the imaginary circular threads 'has a right to be consider'd as an out-line of the sphere, as well as those which divide the half, that is to be seen, from that which is not seen; and if the eye be supposed to move regularly round it, these threads will each of them as regularly succeed one another in the office of out-lines (in the narrow and limited sense of the word:) and the instant one of these threads, during this motion of the eye, comes into sight on one side, its opposite thread is lost, and disappears on the other.' The essential thing is this movement of the eye round the total form; and Hogarth insists that while the concept of the whole three-dimensional form is easy in the case of a sphere, it can be built up in terms of any figure whatever.

He who will thus take the pains of acquiring perfect ideas of the distances, bearings, and oppositions of several material points and lines in the surface of even the most irregular figures, will gradually arrive at the knack of recalling them into his mind when the objects themselves are not before him: and they will be as strong and perfect as those of the most plain and regular forms, such as cubes and spheres; and will be of infinite service to

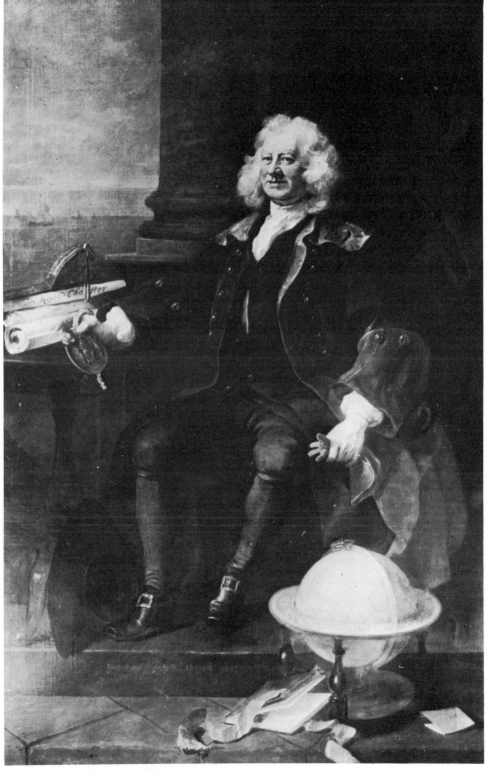

Captain Thomas Coram, 1740

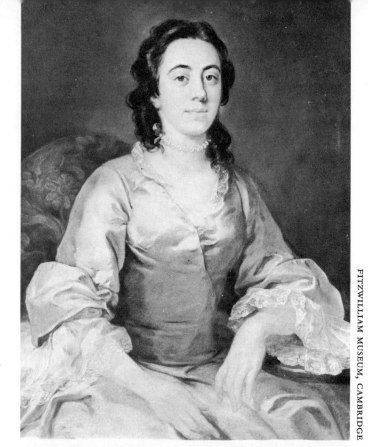

Miss Frances Arnold,
c. 1740

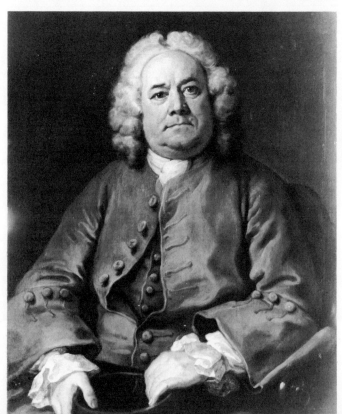

George Arnold, c. 1740

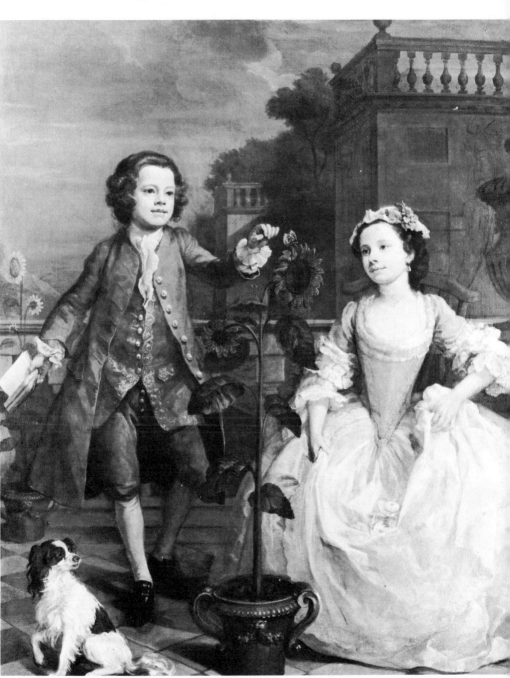

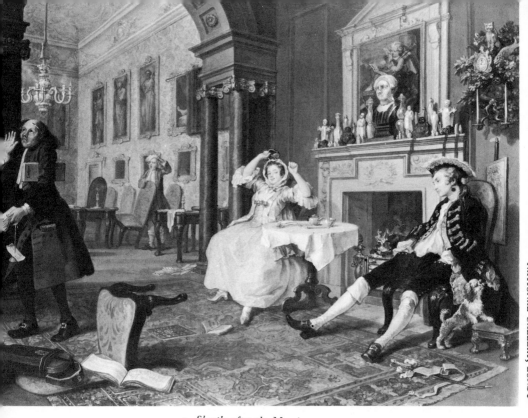

2. Shortly after the Marriage

MARRIAGE A LA MODE, C. 1743

4. The Countess's Morning Levée

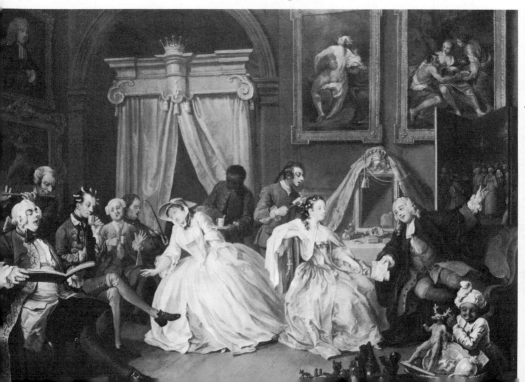

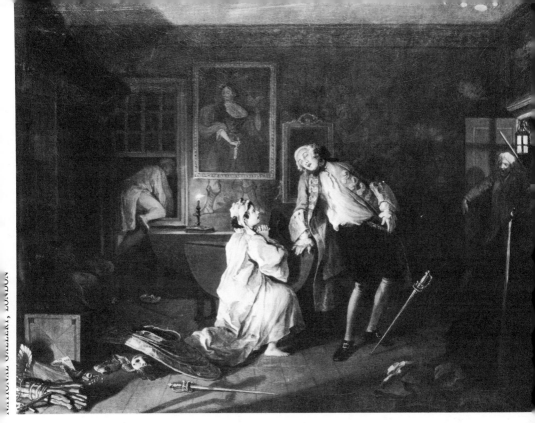

5. *The Killing of the Earl*

The Staymaker, c. 1745

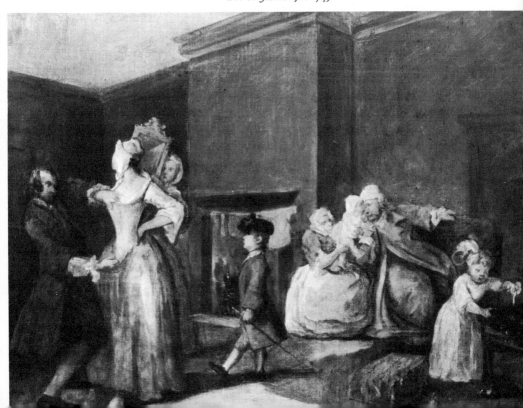

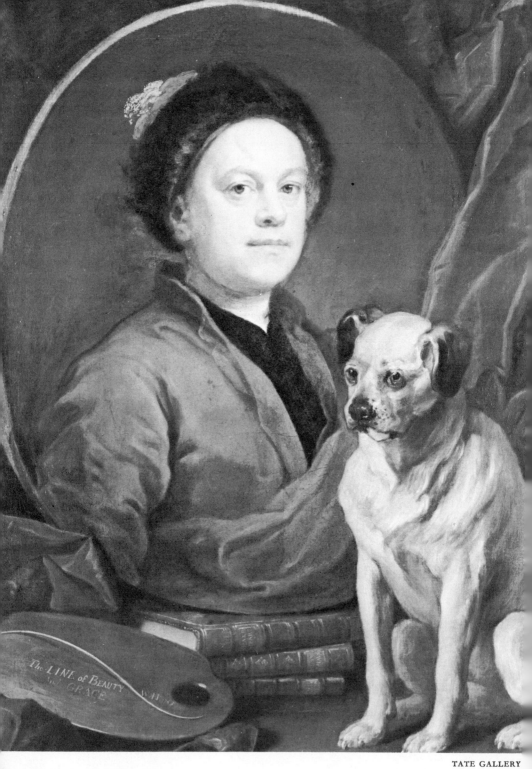

Self-portrait with Pug, c. 1745

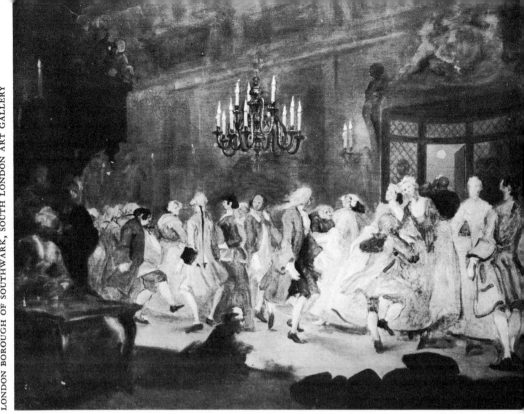

THE HAPPY MARRIAGE, C. *1745* *6. The Dance*

The March to Finchley, published 1751

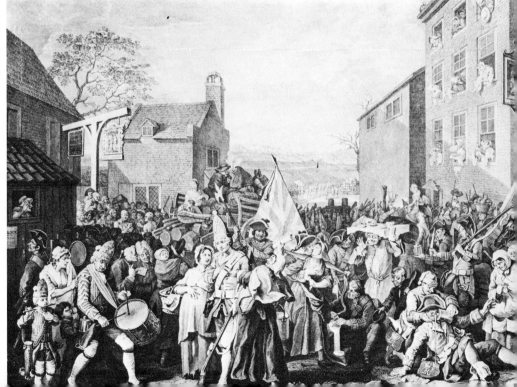

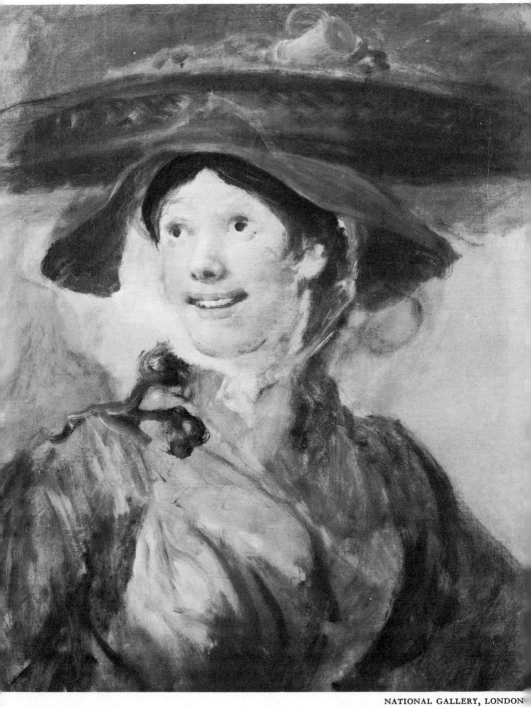

The Shrimp Girl, c. 1745

those who invent and draw from fancy, as well an enable those to be more correct who draw from the life.

In this manner, therefore, I would desire the reader to assist his imagination as much as possible, in considering every object, as if his eye were placed within it.

We might say that Hogarth has here anticipated the cubist idea of seeing all round an object and defining it in a series of planes all in effect given along the same picture surface. But he makes a diametrically opposite use of the idea than did the cubists. He wants to use the idea of grasping the inner centre of the object and the succession of outlines which appear as it turns around on its axis, to bring about a fuller sense of the volume and mass of the object, its total sensory content, so as to give the outline a dynamic quality – as if an invisible spin of the object rotated it round 360 degrees, leaving us only with a vastly enriched sense of all the other aspects of the object which in the last resort give the one fixed aspect its meaning. He would have known through Wilson of Franklin's discussion of the electrical shell or atmosphere surrounding a sphere (set out in 1749), and this thesis may well have stimulated his idea of a fluid moving surface.

He goes on to discuss ways of finding a system, or 'mechanical way', for settling on the point opposite to any given point in the human body. But more important is the relation of the movement-round-a-form to his serpentine line in its spiral aspect. Thus, in dealing with stays, he observes that 'the whole stay, when put close together behind, is truly a shell of well-varied contents, and its surface of course a fine form; so that if a line, or the lace were to be drawn, or brought from the top of the lacing of the stay behind, round the body, and down to the bottom peak of the stomacher; it would form such a perfect, precise, serpentine-line, as has been shewn, round the cone' in plate 1. The spiral, then, in his system, represents the essential lines or surfaces defining the volume of the body seen or felt as a whole.

He may well have been helped towards his idea by a passage in Addison dealing with the Concave and the Convex in architecture:

There are indeed Figures of Bodies where the Eye may take in two thirds of the Surface; but as in such Bodies the Sight must split upon several Angles, it does not take in one uniform Idea, but several Ideas of the same kind. Look upon the Outside of a *Dome*, your Eye half surrounds it; look up into the Inside, and at one Glance you have all the Prospect of it; the entire Concavity falls into your Eye at once, the Sight being as the Centre that collects and gathers into it the Lines of the whole Circumference.

Addison also remarks that with a square concave the eye has to move up and down the different sides before it is master of all the inward surface; with a curved opening the eye can gain a more quickly unified impression.

For this Reason the Fancy is infinitely more struck with the view of the open Arch and Sky that passes thro' an Arch, than what comes thro' a Square, or any other Figure. The Figure of the *Rainbow* does not contribute less to its Magnificence, than the Colours to its Beauty.

Plate 2 is the painting Hogarth had done some time back, of the *Country Dance*. We have seen how finely he there achieved fluidity of brushwork and interrelation of dancing forms in rapid movement. Opposed to the living forms are the stylized forms in the portraits on the wall, based on works by Holbein, Van Dyck, Kneller. On the left are set a pair who are intended to be more genteel in his poise of grace; but in fact the line of beauty, as the line of life, is far more vigorously and variously expressed in the other dancers. Round the main picture are again a series of drawings and diagrams which are far bolder than those in plate 1 in the way they show the breaking-down of vital forms into abstractions. Indeed here we may say are the first conscious abstractions in art, but done in order to show the forms taken by the death of art. Two of the diagrams express the paths traversed by the dancers in the minuet and the country dance. Extremely simple patterns depict the postures of the dancers, looking like primitive ideograms. Three crosses represent different ideas of human proportions. One study (no. 89) shows a well-worked-out abstract pattern of form, tone, shade. Thus Hogarth not only defines the way in which art achieves an ever greater enrichment of its organic content, but also prophetically realizes the lines on which alienation, the disintegration of the human content, can disembowel art and reduce it to abstraction.

So far we have been considering the strengths of the *Analysis*. What are its weaknesses? We have pointed to them in observing that the genteel couple in the *Country Dance* are taken to represent the line of beauty in some particular sense, compared with the more hearty and entangled other dancers. That is, Hogarth is to some extent divided in his aim and definitions; essentially his line is that of the formative life process, but it is continually involved with rococo formulations of grace and elegance. This ambiguity or confusion in turn leads to difficulties and makes it possible for opponents to accuse him, in the midst of his attacks on dogmatism and preconceptions, of being a dogmatist himself. He seems at times to be offering a strict formula to which everyone must conform, whereas at root he is trying to free himself and others to see truly and without any set spheres of reference. In this way he laid himself open to misrepresentation and ridicule, as if his line was an eternal and self-sufficient system that had validity everywhere and in all cases. Satirists were able to ask why the camel with its S-back was not the

most beautiful of animals, or why all peoples had not the same notion of beauty. He himself had remarked on the power of custom. 'The Negro who finds beauty in the black Females of his own country, may find as much deformity in the european Beauty as we see in theirs.' But he did not face the problem there raised. On his weak side the Line of Beauty is something that is merely there, in the object itself; on his creative side, the line results from the tension of man and man, man and object, from the formative process in man merging with that process in objects outside himself. The relation is thus both dynamic and dialectical; and the realization of it is ultimately brought about by labour process and the whole human activity of objectification.

When the worst is said, the *Analysis* is a remarkable book, probably the most original work of art theory composed by an artist. Once we can ignore or discount the rococo aspects (with baroque behind them), we see that by 'beauty' he means, at the deepest levels of his inquiry, the organic structures developed by the formative process in its evolutionary adaptations. The artist's problem is to grasp these structures with true understanding of their nature and functioning. Social or personal associations and interpretations will have their effect on his choice of subject, certain of his lines of approach, and so on; but in the last resort beauty resides in living process, in the forms realized in their vital tensions, movements, oppositions, and harmonies, with sensuous fulness. In this system indeed the curve has an important role, since it expresses living tensions, while the straight line expresses uninterrupted mechanical motion; the spiral represents the curve as it develops through prolonged and complex tensions. Intuitively, then, Hogarth is protesting against post-Galilean mechanism in terms of the living nexus of forces that involve a ceaseless conflict and fusion of symmetries and asymmetries.

13 The Election (1754–7)

The reviews of the *Analysis* were favourable. In the *Gentleman's Magazine* John Hawkesworth ended his respectful notice: 'A book, by which the author has discovered such superiority, could scarce fail of creating many enemies; those who admit his analysis to be just, are disposed to deny that it is new.' The January issue, in a prefatory poem claiming that Westminster Bridge now made 'haughty Tyber' yield, devoted an eighth of the space to praise of the *Analysis* which in fact revealed one of its weaknesses: 'The *Proteus* BEAUTY that illusive pow'r, Who changeth still, was all things in an hour, Now, fix'd and bound, is just what Reason wills, Nor wayward Fancy's wild decrees fulfills.' Hogarth, in attempting to free art from all imposed rules, wrote at times as if he had found the complete formula; he had meant to make beauty more Protean, not to fix and bind it. But though the patrons and dealers did not get their opinions into print, they were stirred to a much deepened hatred of Hogarth, his art and opinions. *Gray's Inn Journal* stated the wits had been much exercised over the book; hence the verses:

> *Hogarth, thy Fate is fix'd; the Critic Crew,*
> *The Connoisseurs and Dablers in* Vertù,
> *Club their united Wit, in ev'ry Look,*
> *Hint, shrug, and whisper, they condemn thy Book;*
> *Their guiltless Minds will ne'er forgive the Deed;*
> *What Devil prompted thee to write and read?*

In the *Evening Post* a poet wrote that the book would live, 'tho' Scriblers, Witlings, Connoisseurs revile', and called on Hogarth to write a second work

that would 'delineate Envy, Ignorance, and Hate'. The ironically named *Connoisseur*, edited by Colman and Thornton, wrote: 'How should I rise in the esteem of my countrymen, by chastising the arrogance of an *Englishman* in presuming to determine the *Analysis of Beauty*.' The friendly critics thus at once recognized what a hornet's nest Hogarth had stirred up; and it was to an artist, Paul Sandby, that the connoisseurs turned for champion. Starting promptly in December he soon produced eight bitterly satirical etchings. Hogarth is shown as a humped and heavy man, ageing, slouching, strutting, big-jowled, with eyelids falling over his liverish eyes. All the prejudices against him are brought out. He wants to be a sublime painter, but makes his themes ridiculous and contemptible. In a picture of Abraham and Isaac, supposed to be his, the angel saves Isaac by pissing into the firing-pan of the old man's musket. He shuts out the light of the Old Masters from his studio and turns himself into a magic lantern; he abuses copyists but steals from Dutch prints; he ends in Bedlam, scribbling images on the walls. He is the 'Low Refracting Mirror of the Age', and the *Painter's March to Finchley* is dedicated to the King of the Gypsies. He is Herostratus burning down the temple of Artemis at Ephesus, 'a self Conceited arrogant Dauber groveling in vain to undermine every Sacred Monument'. He is Painter Pugg, and Deformity 'spreads an Ugliness in every Face'. He is 'the senseless, tasteless, Impudent, Hum Bugg'. In *The Analysist Besh [itte]n* he fatly rants with five disciples while copies of his book are 'Thrown into the Cave of Dulness and Oblivion'. A Palladian edifice rears up in the rear, 'A Public Academy erecting in spight of his Endeavours to prevent it'. In *Pugg's Graces* we also find 'Reasons against a Publick Academy 1753'; the only argument he is shown to bring against the scheme is 'No Salary'. The references to the Foundling Hospital suggest that his sole interest is to advance himself.

The *Analysis* is mocked as a work of folly, which is anyhow a plagiarism and written by his friends. The line of beauty results in forms like hunchbacks, and Hogarth has to distort shapes to make them conform to it. Disciples or toadies include B. Hoadly, shown in almost every print, as friend and corrector, or trumpeter; Morell, thin and hollow-cheeked, is the disciple 'unable to find out the Meaning of ye Book'. A slight young man seems to be Kirby; he drops palette and brushes 'thro' Concern for his Masters forlorn State' or is 'the Fidler standing in ye Line of Beauty'. Morell tries to stop Hogarth 'sinking to his *Natural Lowness*'. The artist is accompanied by his dog and in one case is half a dog himself. He is depicted as a fanatic with a band of disciples who accept his delusions of grandeur, and at the same time an astute business man, who thinks up schemes like lotteries and auctions. Nothing that could hurt or belittle Hogarth is forgotten. In

the *Finchley* parody he is shown with a shrewish wife chasing and belabouring him, while cow's horns behind his head (as in *Evening*) suggest that he is a cuckold. 'The principal Humour of this Composition is left to the fertill Imagination of the Public. I will shew in my next Print how Poor Pugg was treated with Rump Stakes, at a great Man's Palace, by Presenting the silly Analysis.' All eight prints were announced as available in sets as *The New Dunciad, done with a view to fixing the fluctuating ideas of taste.*

A print in defence of Hogarth showed a group of connoisseurs round a table; one of them tramples the *Analysis*, Milton and Shakespeare, while all examine with delight Sandby's *Burlesque sur le Burlesque*. Even weaker was another print, *A Club of Artists*. Hogarth himself made no reply. His first reaction was a sketch of himself, ass-eared, stripped and tied to a cart's tail while a long-wigged connoisseur whips him; 'You'll write books, will ye?' Above his head we read: 'Twere better a millstone had been tied about thy neck, and (THOU) cast into the sea.' The inscription dates the sketch: 'A Christmas Gambol from Leicester Square to Westminster Hall'. He added a mock advertisement:

N.B. Speedily will be published an Apology in Quarto Calld Beauty's Defiance to Charicature? with a very extraordinary Frontispiece, a just portraiture, (printed on Fools cap paper) and discription of the Punishment that ought to be inflicted on Him that dare give false and unnatural descriptions of Beauty or Charicature great personages, it being illegal as well as mean practice, at the same time flying in the Face of all regular bred Gentlemen Painters, Sculptures, Architects, in fine Arts and Sciences.

In his notes he admits how much he suffered: 'It is a trite observation that as life is checquer'd ever success or advantage in this world is attended with a reverse of one kind or other. So this work however well receiv'd both at home and abroad by the generality yet I suffered more (uneasiness) from the abuse it occasions me than satisfaction from its success altho it was nothing less than I expected as may be seen by my preface to that work.' In his final notes he pointed out he had been honoured by the approbation of men who had shown 'their (great) abilities in optics and otherwise of the clearest understanding', while 'those who adhere to that old notions' and who cannot or will not understand a word of it 'tell you it is but a heap of nonsense or that there is nothing new in the whole book'. These detractors were chiefly of his own profession. Indeed the situation was odd. The work, generally welcomed by the reviewers and soon well known on the Continent, where it was praised by men like Lessing, aroused implacable antagonism among the leaders of the art world in England. The extent to which the abuse affected Hogarth is shown by the way in which he henceforth carefully kept

all testimonials, letters, manuscripts, which might help him in setting out his case. The way in which the gentlemen sneered behind his back is brought out by an anecdote later recorded by Uvedale Price. Price's father told him that once Hogarth was talking 'with great earnestness on his favourite subject', and asserted that 'no man thoroughly possessed with the true idea of the line of beauty, could do anything in an ungraceful manner', adding that 'I myself, from my perfect knowledge of it, should not hesitate in wha manner I should present any thing to the greatest monarch'. Yet at that moment he happened to be sitting 'in the most ridiculously awkward posture'. (It is unlikely that Hogarth claimed personal grace; he was probably speaking of art work and Price's memory distorted the conversation.)

During the winter of 1753–4 he and his supporters kept control of the St Martin's Lane academy. Kirby gave three lectures based on his perspective work, and on 3 February his book, dedicated to Hogarth, appeared. The group opposed to Hogarth's policy had divided, some staying on in the academy, others withdrawing. On 22 March the Society of Arts was founded with William Shipley, as moving spirit, a Northampton drawing master, who had come to London in 1753. The first premiums were offered for the discovery of cobalt and madder in England for use in dyes, but an attempt was also made to encourage young artists. During the year support seemed to be fading out, but Shipley persisted.

Highmore had replied to Kirby, arguing for 'strict mathematical Perspective Rules'. Kirby drafted a reply and sent it to Hogarth, who answered on 7 June. He advised against taking Highmore too seriously, and appealed to optical effect against mathematical rigidity.

Let him be asked if any historical painter ever did or ever will widen or distort his figures as they are removed from the centre of his picture – or would draw a file of musqueteer so, when the last man in the rank would be broader than high. Then why should he serve poor columns or pedestals so when poor dumb things, they can't help themselves. & are all objects exempt from the rule of perspective except Buildings; – Did he himself ever so much as dream of an intervening plane, when he has been drawing a family piece with four or five people in a row, so as to distort the bodies and faces of those who have the misfortune to be placed nearest to the side of the frame . . .

Kirby took his advice and shortened his draft in the reply printed in his second edition, 1755. Hogarth was not concerned with mere optical effect taken in isolation. With his view that eye-movements were involved in the construction or reading of a picture, he was looking for a principle of unification, which combined variety, intricacy, and simplification. Purely mathematical calculations destroyed this principle by the omission of living

tensions. In March he had issued a ticket for a print to be called *An Election Entertainment*, relying on the Oxfordshire election to provide topicality. The seat had not been contested since 1710; the great men of the county had found it easier and cheaper to arrange things among themselves. The division of parliamentary spoils without elections was characteristic of the era. Northamptonshire saw elections only three times in the century; in the General Election of 1761 only three counties held contests. Such was the level of corruption to which the Whig regime, with its virtual one-party system, had brought the country. Oxfordshire was a Tory, even Jacobite, centre, and now the Duke of Marlborough decided to challenge the Whigs; the result was a series of riots that at times reached the level of pitched battles, with men killed or taken prisoner. The Tory gentry, who planted Scots firs, revived every reactionary slogan to decry the Whigs; they agitated afresh against the Gregorian calendar, raised the anti-Semitic issue, attacked the Marriage Act of last year, and abused the Duke of Cumberland. For two years the tumults went on, with parades, feasts, clashes. Hogarth could not have chosen a theme going deeper into the conflicts of his world. The battles of Oxfordshire were blind alleys, but they pointed to the breakdown of the Walpole system that was to lead to truly significant conflicts in the 1760s.

On 24 February 1755 the print was announced as ready and subscriptions were opened for three more. For the first time Hogarth was developing an important political and social theme on the level of history painting. Previously, as with *South Sea Scheme*, he had treated such themes at the level of the emblematic print. In the new compositions there is an increased breadth and concentration; details are articulated with the basic pattern in a clearer way. The architectural backgrounds are not just frames or limits for the tide of human energy; they are solidly and coherently a part of the design. The shifting focus which reached its climax in the *March* is gone. Instead Hogarth relies on the dynamic balance inherent in the composition itself, in which colour plays a key part, both liberating the movement and holding it in large bold patches. Reds, cool blues, grey, and creamy light shades dominate. Canaletto's influence can perhaps be detected, as well as a renewed interest in signboards; a Raphaelesque clarity of design is brought alive with a baroque vivacity.

Hogarth had trouble with the engraving; hence at least in part his delays. Plate 1 is overworked. He called in another engraver, who brought down the stronger contrasts; then, dissatisfied, he tried to get the plate back to its first state. Here he did not reverse the painting, though he did so in the following three plates. The theme was a Whig dinner in a parody of da

Vinci's *Last Supper*, with the text: 'He that dippeth his hand with me in the dish, the same shall betray me.' The dying Mayor, who is being bled (giving his blood), is Christ; and there are thirteen persons at the table. The Judas motif appears in the groups round the candidates, who deceive and betray them, and in the tailor who is being bribed. In the foreground we see the Biblical motif of feet-washing. The slogans of the election are prominent and bricks are hurtling through the window.

Hogarth dedicated the print to Henry Fox, his first subscriber; he also makes a political point. Fox, who had opposed the Marriage Act, was a leading member of the Duke of Cumberland's coterie. In these years Hogarth seems vacillating between support of the Duke and of the Prince of Wales. This interest of his in the Royal Family is different in kind from the vague efforts for patronage made in the early 1730s. Some remarks in Rouquet's book (published this year in France) seem certainly inspired by him: 'For no lucrative post is given away in England but with either a direct or indirect view of gaining or preserving a plurality of votes at parliamentary elections. According to this ministerial economy, founded on such wide and prudent principles, let the artist have never so great abilities, yet if he has no right to vote at elections, or no protector possessed of such a right, it is in vain for him to think of any place or preferment.' With his restless drive to find some way of breaking through the barriers against which he kept on beating, he seems to hope that after all he might invoke some power higher than the magnate-patron and connoisseur. But any such hope was in turn bound up with changes in his attitude to his society as it emerged from the Walpole epoch. He was sick and tired of a system in which one great man might edge another out of positions of power and privilege, but with no effects beyond various re-allocations of the spoils of office and of profitable places. The Oxfordshire elections had shown no challenge to the system, only an unruly effort of one faction to dislodge another. That kind of strife seemed to offer only a worsening of things. And so Hogarth became susceptible to the ideas set out by Bolingbroke in *Letters on the Spirit of Patriotism and on the Idea of a Patriot King* in 1749. 'Party is a political evil, and faction is the worst of all parties.' Bolingbroke argued that corruption was the result of party politics, and saw the only solution in the domination of society by a great man, who, above all considerations of party and faction, would rule in the interest of all. The Old Tories like Swift had wanted a 'mixed government', with the King holding together the discordant elements; the Whigs, looking on Parliament as the key factor, argued that political forces held in an imposed balance would only obstruct and destroy one another. The new bourgeois world growing up, though in alliance with certain sections of the nobility,

seemed to the majority of the country gentry to threaten all they held most dear; the idea of the patriot king appealed strongly to them as a formula for arresting the movement of the new forces.

Early in 1755 another plan for a Royal Academy was drafted and presented to the Dilettantis. Hogarth notes that nobles and popes had wanted to be as famed as the artists they employed. 'No wonder they should dislike those who deprive them [of] so much honour by daring to make themselves without their assistance.' The Dilettantis wanted to use the artists, so that 'when the schemers pretended to bear a part in the school', the proposals were dropped. But Hogarth was no longer dominant in his own academy; he was being supplanted by Reynolds, who could mix with the fashionable world and fit in with the new imperial trends developed under Pitt in the late 1750s. However in May Hogarth got his second and last commission for a sublime history. The vestry of St Mary Redcliffe, Bristol, wanted to replace their altarpiece and applied to Hogarth, who was asked to come down from London at their expense. He found that he had to fill a large space brought about by bad remodelling of the Gothic structure; but he was keen to accept any such offer, and a fee of £525 was agreed upon. The size of the painting made it necessary for him to work on the spot, and it was some time before he could begin.

In October Rouquet's *State of the Arts* appeared in English. It described the English as a commercial people only interested in pictures that reproduced their faces; fashionable works from the Continent were bought for social prestige. It was surprising that the arts survived at all. The book dealt even with cooking, but mainly discussed the economic position of artists, portraits, and history. Rouquet praised the French Academy, of which he was a member; but otherwise what he says is mostly in Hogarth's vein. The *Analysis* is acclaimed. Hogarth's 'new kind of pictures' are classified under history; but nothing is said that was likely to disturb the dominant role of Le Blanc's ideas. Returning to France, Rouquet went mad and died in 1758 or 1759.

In November a mob attacked and wrecked Garrick's theatre, and also damaged his house; he was thought to be using some French dancers. The Militia Act was being pressed in Parliament, as part of the Duke's hope of a highly trained regular army, but it failed this session. At the end of December Hogarth joined the Society of Arts, which had picked up. Shipley's main interest was the training of young people in the industrial arts. Hogarth in his note, perhaps unfairly, attributes the Society's success in part to a snobbish wish of lesser folk to take part in a venture in which 'a great man or two put themselves at the head'. He adds: 'Happy was he who had courage enough

to speak tho ever so little to the purpose the intention of this great society no doubt is very laudable their success in subscription amazing but how far their expectation (in general) has been answered in proportion to their endeavours is no business of mine.' He himself had taken part in the discussions. 'I shall beg leave to give to the reader my opinion as then ventured to give it to the society.' He objected to the idea that English manufactures were 'much inferior to our neighbours'. He was put on the committee of judges and on committees for dealing with accounts and new rules. On 28 January 1756 a paper was read on the improving of paper manufacture and referred to a committee of four, on which he served. 'Order'd, that the above Paper be deliver'd to Mr Hogarth for his private perusal.' He himself gave a paper dealing with the premiums for drawings. He probably wanted to widen the range of the competitions. We are told that at one meeting he declared: 'Genius was Diligence and Attention.' His companion said that he was surprised to hear such a comment from 'a person so copiously gifted by nature, and possessing such peculiar talents'. Hogarth replied: 'Thank you for your Compliment, Sir, but I am still of my first Opinion.'

In his notes he repeats that a trading nation like England could maintain only a few fine artists, and says of the youngsters trained to draw, 'how often have they wished they had been brought up cobblers'. Rewards for 'improvements in kettles etc.' were more sensible than premiums for drawing. What was needed were plans for helping poverty-stricken artists. Anyway, 'there is something so bewitching in these arts there will always be too many Poets and Painters'. He was repelled by the attitude of the merchants who wanted to use the Society for their own profit: 'cruelty on endeavouring to augment the numbers the plans for so doing viz the Improving our manufactures groundless and absurd the cruel speech of member of the society [that] the number of poor would [make] good thing cheap labourers in the coal mines.' Meanwhile the scheme for a Public Academy went on. The Hogarths were actively interested in the Foundling Hospital, which had had to put out young children to wet nurses. Hogarth was one of the inspectors superintending the nurses in their districts. Jane too seems to have been a supervisor and Anne Hogarth signed at least one account.

In March Hogarth announced that inability to get able engravers had held up his other *Election* prints. Early this year the war with France that was to last seven years had begun. Hogarth turned out two prints, *The Invasion*, in strongly popular style; they hit the mood of the moment so well they were used as recruiting posters. One shows the starveling coast of France with troops boarding a ship, while a monk has torture instruments and a plan for a monastery at Blackfriars. The other shows a corresponding English scene

outside the Duke of Cumberland Inn. A recruit stands on tiptoe to increase his height and be eligible for service; two girls measure a grenadier's stalwart shoulders and the keenness of his blade (laid across beef). A sailor waves his hat; a second grenadier caricatures the French king on the wall. Under the Duke's name on the sign are the words: 'Roast & Boil'd every Day' – the Butcher of Culloden is thus oddly assimilated to the beef that the French covet. Garrick's lines for the print declare: 'The Hungry Slaves have smelt our Food, They long to taste our Flesh and Blood, Old England's Beef and Beer.' (We are reminded of the good eating associated with the Baptist's Head in *Noon*, and the rite attributed earlier in the century to the Republican Calves Head Club, when the head was eaten in 'a Diabolical Sacrament'.)

But the English did badly in the war; 1756 saw many riots and uprisings, attacks on mills, through the food shortage. The gloom of the Old Tories deepened and the dogma of man's corrupt nature was invoked; the suggestions of franchise extensions made by some City periodicals was seen as the devil's counsel. The most important statement of such views was made by Dr John Brown in *Estimate of the Manners and Principles of the Times*, which went through seven editions in a year. 'Neither the comic Pencil, nor the serious Pen of our ingenious Countryman, have been able to keep alive the Taste of Nature, or of Beauty.' Brown discoursed on national disunity and attacked mercantile power (Pitt's basis) as undermining the old ideals and corrupting taste in the arts. Such arguments must have strongly appealed to Hogarth, especially as Brown put much blame on the 'vain, luxurious, and selfish effeminacy in the higher ranks of life'. A second volume of the *Estimate* came out in 1758; in 1766 Brown committed suicide while insane. The Tory pessimism is expressed by Smollett's Ferret (1760), who declares of the English that they are 'a pack of such profligate, corrupted, pusillanimous rascals, as deserve no salvation'.

After attending a meeting of the Society of Arts on 28 April, Hogarth seems to have gone to Bristol for over three months. On 14 August he received payment for the altarpiece. He had been helped by John Simmons, a sign painter who had risen to church decoration and who was now paid for gilding frames and painting four niches. Hogarth is said to have been impressed by Simmons's sign of the Angel in Redclyffe Street and to have remarked, 'Then you need not have sent for me.' Another tale says that as the two men walked down a Bristol street, Hogarth halted before a sign: 'I am sure you painted it, for there is no one else here that could.'

Hogarth's three panels dealt with the Ascension (influenced by Raphael) in the middle, and with the tomb-sealing and the visit of the Three Marys

at the sides. The compositions are rather loose and empty; the transfigured Christ is so far aloft that he has no connection with the disciples agitated below. Only the colour has a unifying life. The setting Hogarth had to fill was indeed a difficult one, but he made no attempt to grapple with it. Later in noting that he only had two history commissions, he remarks rather casually that he 'did them and as well as I could recollected some of these ideas I had pickt up when I vainly imagind history painting might be brought into fasheon'. This year the accepted idea that he could not keep Lownses out of even his most serious works was set out by Joseph Warton in his Essay on Pope. He takes Pope's line: 'One science only will one genius fit', and argues that Shakespeare and Garrick alone have excelled at tragedy and comedy. Hogarth when deviating from 'the natural bias of his genius', could not help 'some strokes of the Ridiculous'. In *Paul* a dog snarls at a cat, and the figure of Moses 'expresses rather archness than timidity'. He only excepted *Garrick as Richard III* as showing an unmixed strength. In fact there is no dog in *Paul* (Warton thinks of plate 2 of *Industry*), and Moses reveals a genuinely childish uncertainty between the two women. Hogarth was certainly much hurt by Warton's book.

On 8 January 1757 Garrick wrote to Hogarth to say that he heard from Wilson that the latter had been pained by his neglect of him. In a cheerful chaffing letter he pleaded bad health and 'many froward Children'. However he did soon call and arrangements were made for a portrait of him and his wife. In February Hogarth published an apology for the delays over the *Election* prints and added that he did not want to 'trespass any further on the Indulgence of the Publick, by increasing a Collection already grown sufficiently large' – so 'he intends to employ the rest of his Time in POR-TRAIT PAINTING chiefly'. He complained also of spurious prints issued in his name, and offered a copy of Ramsay's *Dialogue on Taste* with each copy of the *Analysis* bought. He no doubt felt that Ramsay's criticisms showed how others might demur without becoming abusive, and he must have liked such statements as that he, Hogarth, is 'convinced by a thousand experiments that the leading principle in poetry and painting . . . is known to the lowest and most illiterate of the people'. He now resigned from the Society of Arts; but after he left the policy he had advocated was taken up. The age limit in contests was raised to twenty-four; drawings of the human figure and landscapes were accepted; and it was no longer necessary to do the works at the Society's premises.

No doubt he had found it difficult to find suitable engravers for his prints but he seems also to have lost heart. He had announced that he was turning to portraits, perhaps because they were the least contentious of the art forms

he practised, though he had previously condemned them as a kind of manufacture. His picture of Garrick and his wife was nearly done when John Hoadly called on 20 April; Hogarth 'has got again into Portraits; and has his hands full of business, and at a high price'. He was also painting Dr Hay. But the background of the Garrick remained uncompleted. We hear of Hogarth being put off for a while by Garrick using all his powers of changing his face; also Garrick is said to have made jokes about the likeness till Hogarth slashed his brush over the painted eyes. (The left eye shows signs of of revision.) Some conflict seems to have come up, for the picture stayed in the studio till Hogarth's death, when Jane gave it to Garrick. But we do not hear of any impairing of their friendship. The picture was not a set portrait, but a version of French domestic scenes where a man, opening a letter, is surprised by his wife; Hogarth also thinks of Vanloo's picture of Colley Cibber with his wife stealing his pen. Garrick in fact is writing a prologue for Foote's *Taste*, a lively satire on dealers as cheats and dupers; the wife thus takes on the pose of an inspiring Muse turned mischievous.

In March a letter from one Reiffenstein of Cassel praised the *Analysis* and asked Hogarth to be an honorary member of the Imperial Academy of Augsburg. He accepted. Reiffenstein's motive is not clear and the Academy was in effect fraudulent, devised to help the founder's publishing house and using lotteries. In dealing with the benighted continent Hogarth seems ready to put aside his dislike of official academies. John Hoadly had acted as an intermediary to make Warton admit his errors over Hogarth's works; Warton said that he would revise the passage and Hogarth sent him copies of the two criticized prints.

On 6 June Hogarth at last received direct political patronage. He was appointed Serjeant Painter to the King by the Duke of Devonshire, Lord Chamberlain since 16 May. He thus stepped at last into the shoes of Thornhill. Thornhill had resigned the post in favour of his son John, who, in the spring, had had to resign through a disabling disease. The *London Chronicle* reported that he had recommended Hogarth; but there must have been more to it than that. The Duke, who had sat to Hogarth in 1740, was a friend of Garrick and a supporter of the Fox–Cumberland group. That group must have approved of the appointment. The office brought in a salary of a mere £10 a year, but gave its holder a monopoly of the painting and gilding of all royal palaces and conveyances, all banners and tents of royal troops and ships. Hogarth later said that 'in five years I have had at least one way or another £200 with this competency of my own ra ing as independent as may be'. We know he drew payments from September 1757 and that his gross earnings for the year were £400. He drew up a mock patent.

Punch by his order Grace and Deportment of all theaters in the world Nabob know ye that I for divers good causes and considerations as hereunto especial moving of our especial grace and our certain knowledge and meer motion have given and granted and by these presents do give and grant to my trusty and well beloved W H gentleman the office of scene painter and corporal Painter to all my whatsoever as well as in any wise belonging to my . . .

Here we have 'the true form of his Lownesses Patent'. It fitted in with his sense of the world as theatre that he should make Punch the granter and see the decoration of the royal palaces as scene painting.

This year John Ellis sent him a botanic engraving, which he found 'accurately executed, and very satisfactory, too'. We see his deep interest in natural forms. 'As for your pretty little seed cups or vases, they are a sweet confirmation of the pleasure Nature seems to take in superadding an Elegance of form to most of her works, where ever you find em, how poor and Bungleing are all the Imitations of Art! When I have the pleasure of seeing you next we will set down nay kneel down if you will and admire these things.'

In late April appeared Burke's *Philosophical Enquiry into . . . The Sublime and the Beautiful*. Hogarth must have read it with mingled feelings, though the comments on the *Analysis* were not added till 1759. He would have been pleased that some of his ideas had penetrated the contemporary consciousness, but irritated at the way they tended to lose their vital content in the process. The serpentine line was accepted, but robbed of its functional and organic virtues, in place of which was put a sensualistic and romantic attitude. In place of his concept of variety and dynamic form, as exemplified in the analysis of the sphere, Burke introduced the concept of the artificial infinite, created by succession and uniformity, a constant agitation of the impressions by something monotonous. The book would then have generally depressed Hogarth as showing how his ideas could be diverted, lose their original content, and be applied in what he could consider the wrong directions. (Burke dealt with Miltonic Sin, Death, and the Devil, though mainly concerned with death and the failure of painters in dealing with 'these fanciful and terrible ideas'. It is barely possible that Hogarth was stirred by these passages to tackle the theme, though an earlier date for his painting seems more likely. It is also barely possible that Burke had that painting in mind.)

Hogarth was certainly serious in his statement that he was turning mainly to portraits. He tried to draw Benjamin Wilson into a sort of partnership with him; but Wilson declined and was soon making £1,500 a year on his own. Perhaps about this time Hogarth tried to work out a scheme for doing

a portrait in four sittings, each of a quarter of an hour. Walpole sets out the position at the time: Ramsay 'and Reynolds are our favourite painters, and two of the very best we ever had. Indeed the number of good has been very small, considering the number there are. A very few years so there were computed two thousand portrait painters in London; I do not exaggerate the computation, but diminish it; though I think it must have been exaggerated.' No word of Hogarth. Later, in the preface to his *Anecdotes of Painting* he commented on the total neglect of 'historic Compositions'. 'Reynolds and Ramsay have wanted subjects, not genius.' Again Hogarth is not worth mentioning.

The latter had given in to a vogue for portraits in historical costumes, in painting Mary Lewis, Jane's cousin and companion, and Mary Cholmondeley, sister of Peff Woffington; he also made a commissioned copy of Van Dyke's Inigo Jones. The family portraits were the more interesting ones. At Chiswick, beside Hogarth and Jane, his sister and mother-in-law, were Mary Lewis, six servants, and Miss Julien Bere, a relative or boarder visited now and then by a cousin from Yorkshire, who in his records gives us a few glimpses of the household. When Hogarth had painted the cheerful plump Mary, he said: 'I have put you in a ruff to disguise you, for you are too handsome. Now, I have been offered twenty guineas for it. Therefore, if you like, I can let you have that instead of the picture.' She replied 'No, Sir! I thank you for the pains you have taken to oblige me, and I shall keep the painting for your sake.'

About this time he painted Lady Thornton, stern, erect, forbidding. Here is his only portrait with a whitish face; no doubt she was particularly pallid. (There is no link with Reynolds's pale faces, which result from his use of fugitive carmines in his early work.) But the most striking of the family works is the picture of his servants, painted for his own pleasure in loose lively brushwork. The system derives from the prints of accumulated heads, but there is here an interplay of age and character, In the *Analysis* he discussed how faces change with age, from 'a sort of settled firmness . . . aided by an air of acquired sensibility' (showing at the age of thirty) to the 'further havoc time contrives to make after the age of fifty . . . leaving at the last a comely piece of ruins'. This development is finely illustrated here in the movement from the lad at the top to the man in the centre and then up to the old man, Ben Ives, at top right.

In March 1758 the three further plates of the *Election* were issued. *Canvassing for Votes* is centred on a farmer being offered bribes by two innkeepers, one of the Royal Oak (Tory) and another of the Crown (Whig). The candidate

Tim Partitool buys favours from a Jewish pedlar for two girls in a balcony; the hostess, sitting on the British lion, counts her gains. At the back a Tory mob attacks the Crown, which has a notice 'The Excise Office' under its sign; a man saws through the signpost, disregarding the fact that when it breaks he will crash to the ground. (The Tories never forgot Walpole's scheme of an excise tax, which they viewed as a threat to liberty.) The sign of the Stuart Royal Oak has a large double board with anti-government images. Punch, candidate for Guzzledown, hands out bribes from a wheelbarrow, while his wife Joan menaces takers with her stick. (Punch looks like the Duke of Newcastle, who was however usually depicted as an old woman. In the puppet *Punch's Opera* of October 1756 he was Joan while Fox was Punch.) Money pours out of the Treasury buildings into an ammunition waggon while the royal coach goes through the arch in the Horse Guards, Whitehall, where the General Staff was located. (Both buildings were by Kent.) Like the *March*, *Canvassing* has as central motif a parody of Hercules at the Crossroads.

The Polling shows election day, with reserve voters being fetched: an old soldier who has lost a leg and both arms, and who starts a debate among the lawyers by taking the oath with his hook; a blind man, a crippled man, a dying man, an imbecile helped by a manacled man, Dr John Shebbeare. The latter had been gaoled for attacks on the Marriage Act in a novel, which drew on *Marriage à la Mode*, in 1754. After his Sixth Letter to the People of England, attacking the House of Hanover, he was arrested on a general warrant in January 1758, fined, pilloried, and again gaoled in December. Just what his role is in the print is hard to make out, but his presence shows Hogarth's nose for topicality. In the print a woman sells a gallows-ballad and at the back Britannia rides in a coach about to overturn. The parties have no interest in her fate.

Chairing the Members shows the climax in violence. One member, toppling as he is elevated, is in the centre; the other is only a shadow at the back. A lawyer has done well, with a line of servants carrying food dishes. The house behind is wrecked by riots or has withered in the shadow of the law. At the front furious fights go on at the head of the procession, over a covered stream or sewer. A blind beggar, fiddling, leads the way, with skull and bones overhead on the cemetery gate. The bestiality of the scene is expressed by several animal parallels. A large pig with litter (the Gadarene swine) dashes in panic over culvert-edge, prophesying disaster. Overhead there flies, not the eagle of apotheosis, but a goose that resembles the candidate below, Bubb Doddington, a rich eccentric not above turning his coat.

Hogarth had now reached his last stage of vigour. Though we cannot say

that the work to come was of no value, he had substantially said all he had to say. In the *Election* plates he had summed up his political vision of a hope-lessly corrupted England and had done his best to say: A plague on both your parties. This viewpoint had enabled him to escape partial attachments or illusions; but from this date on it showed its negative aspects and made him incline to something like the idea of a patriot king. His royal appoint-ment, however he made fun of it, certainly inclined him to the view that the king represented a level above both the parties.

The position of the member, simultaneously elevated to his height and sent toppling, brings out clearly much of Hogarth's attitude to time in his work. He likes to depict the moment of extreme tension, when a situation is about to turn into its opposite. The height of the Harlot's day-dreaming with the stolen watch on the tumbled bed is the moment of retribution as the door opens, and so on. Hazlitt describes excellently Hogarth's love for the moment of tension, of transition, of decisive change.

Everything in his pictures has life and motion of it. Not only does the business of scene never stand still, but every feature and muscle is put into full play; the exact feeling of the moment is brought out, and carried to its utmost height, and this instantly seized and stamped on the canvas for ever. The expression is always taken *en passant*, in a state of progress or change, and, as it were, at the salient point.

Time is thus in a sense for Hogarth the moment of crisis, of change that includes powerfully both the before and the after. In plate 2 of the *Harlot* we see the tea-things suspended in the air, with the Jew desperately striving to rescue them. We can already hear the crash, see the flying splinters. The moment includes both the Harlot's reckless sense of security and her disas-trous lapse from security. Space is included in this sense of movement. The sphere, for Hogarth, we saw, was made up of a sort of explosion of 'straight rays of equal lengths, issuing from the center, as from the eye, spreading every way alike'. Space too is an enclosing sphere, a complex of spreading rays, not a matter of mathematical measurement.

. . . the eye generally gives its assent to such space and distances as have been first measured by the feeling, or otherwise calculated in the mind: which measurements and calculations are equally, if not more, in the power of a blind man, as was fully experienced by that incomparable mathematician and wonder of his age, the late professor Sanderson.

He goes on to discuss 'the means by which we attain to the perception or appearance of an immense space surrounding us; which cavity, being subject to divisions and subdivisions of the mind, is afterwards fashioned by the

limited power of the eye, first into a hemisphere, and then into the appearance of different distances, which are pictured to it by means of such dispositions of light and shade as shall next be described'. The lights and shades are 'types of distinction, they become, as it were, our materials, of which prime tints are the principal; by these I mean the fixed and permanent colours of each object, as the green of trees, &c. which serve the purposes of separating and relieving the objects by the different strengths or shades of them being opposed to each other'. The other shades in the work 'help to the like purposes when properly opposed; but as in nature they are continually fleeting and changing their appearances, either by our or their situations, they sometimes oppose and relieve, and sometimes not, as for instance; I once observed the tower-part of a steeple so exactly the colour of a light cloud behind it, that, at the distance I stood, there was not the least distinction to be made, so that the spire (of a lead-colour) seemed suspended in the air; but had a cloud of the like tint with the steeple, supplied the place of the white one, the tower would have then been relieved and distinct, when the spire would have been lost to view.'

Thus form cannot be considered apart from space, or space apart from the light and shadow filling it. More, light and shade are 'continually fleeting', so that the relations of space, form, and colour are functions of time. Time and space are seen as unified in a dynamic concept of process. Hogarth rejects the positions of Galilean and Newtonian thought in which time and space are abstract coordinates in a system of quantitative measurements. He of course does not work out the philosophic consequences of his attitudes, which are akin to those developing in the first romantic poets, Thomson and Savage. (Thomson's *Seasons* had come out as Hogarth was moving to his *Beggar's Opera* works.) His position is none the less striking and significant. What is important is the way in which his ideas link with his art treatment of the crucial moment when the tensions of form need to coincide with the most expressive light-shade focus inside the concave of space. The forms turn in the turning sphere of light-shade or space; the problem is to catch them so that the 'before' and the 'after' are dynamically present in the immediate moment. It is noteworthy that he likes to depict time as opportunity with a forelock that men can grasp. Time is not just something that flits past; it is a force with which man is actively involved. He sees life as made up of critical moments of change involving asymmetry as well as symmetry and thus as always precipitating a new set of dynamic interrelations.

Throughout his career Hogarth shows almost no awareness of the new romantic forces beginning to show themselves in poetry and new attitudes to nature, unless *Fairies by Moonlight* is his work. No doubt the main reason

lay in the fact that he was an artist of city life. Apart from the glimpses of a spacious country world in *Southwark Fair* and the *March*, he uses as his symbol of a different or 'natural' way of life the pretty girl who seems unaffected by the squalor round her. Yet his whole anti-Augustan position, with its rejection of symmetry, harmonious proportions, and all mechanistic concepts of form or organization, makes him closely akin to the romantics. Already with Thomson and Savage, for all their overt acceptance of the Newtonian universe, we see the quest for forces, fluids, energies that do not fit easily into that universe; and the growing importance given to colour contradicts a world view in which colour is a mere subjective and secondary quality of things. Hogarth sets out, and works from, positions deeply akin to those of the romantics, so we see him in the line leading to Turner and Delacroix as well as to Géricault and Courbet.

14 *The Last Stake (1758–61)*

*I*n March he issued the print of himself painting the Comic Muse. He could not help boasting: 'Wm Hogarth SERJEANT PAINTER *to His Majesty*'. He sits in a chair of serpentine lines, about to apply paint to the figure in white chalk on the canvas. We can make out the coarsened elements which Sandby mercilessly exaggerated. Against the easel leans a copy of the *Analysis*, its line thesis exemplified in the chalk drawing. The tension between the artist, who concentrates as he prepares for his attack on the canvas, and the geometrical forms of canvas and easel, is admirably rendered. But it is odd that he depicts himself as the devotee of the Comic Muse at the period when he renounces modern history. How deeply he felt himself embedded in the work is shown by the fact that between this date and his death in 1764 he kept on altering the face for the worse; by the fourth state he removed the smile; in the fifth the mouth hardened. He also darkened the general effect. A growing lack of grip seems to appear in a letter of 19 May, telling Sir Edward Littleton that he had had the *Inigo Jones* ready for a year, but had expected him to drop in and so had not notified him. True, he liked to hold on to his paintings, but here the motive seems inertia. In September he issued a print *The Bench* showing the judges in action, with a powerful effect of their malevolence and indifference. The royal arms have the motto *Semper Eadem*: Nothing Changes. In a long text he tries to establish the distinction between character and caricature, which are 'usually confounded'.

It has ever been allow'd that, when a *Character* is strongly mark'd in the living Face, it may be consider'd as an Index of the mind, to express which with any degree of justness in Painting, requires the utmost Efforts of a great Master. Now that which has, of late Years, got the name of *Caracatura*, is, or

ought to be totally divested of every Stroke that hath a tendency to good Drawing; it may be said to be a Species of Lines that are produc'd rather by the hand of chance than of Skill; for the early Scrawlings of a Child which do but barely hint an Idea of an Human Face, will always be found to be like some Person or other, and will often form such a Comical Resemblance as in all probability the most eminent Caracaturers of these times will not be able to equal with Design, because their Ideas of Objects are so much more perfect than Childrens, that they unavoidably introduce some kind of Drawing: for all the humorous Effects of the fashionable manner of *Caracaturing* chiefly depend on the surprise we are under at finding ourselves caught with any kind of Similitude in objects absolutely remote in their kind. Let it be observ'd the more remote in their Nature the greater is the Excellence of these Pieces; as a proof of this, I remember a famous *Caracatura* of a certain Italian Singer, that Struck at first sight, which consisted only of a Streight perpendicular Stroke with a Dot over it.

Outré he defines as 'nothing more than the exaggerated outline of a figure'. Thus 'a giant may be call'd a common man *Outré*'. Why he feels so strongly on these matters is that he is convinced the confusion he attacks lies behind the denigrations of his modern histories as low. At the same time he is much agitated by the general problem of confusion or chaos as against order, the true order of nature. Townshend, with his caricatures of the Duke and his group, appeared as an encourager of both artistic and political disorder. Hogarth has for the moment forgotten his own interest in simplified designs as a type of popular art and as a mnemonic aid to character and movement. That aspect of simplification, he feels, is lost in the hit-or-miss nature of caricature, its reduction of a man in his fullness to some exaggerated or incidental aspect. In notes written soon after, he states that he had made the print because of 'the Injury I have for this twenty years sustained by the wilful mistake of my enemies and the innocent mistake of my Friends, many of whom when I have set them to rights have blushed at [the] offense it would have been and thank[d] he for my explanation'.

In depicting judges he wanted to stress the point that true character could not be hidden by the weight of external oddments. In the *Analysis* he had written of the awful dignity of the judge's robes, the sagacity and dignity of the wig: effects produced by 'the quantity of their contents'. But against this impressive quantity stands the quality of the wearer. He defines 'character as it relates to form' as based on some remarkable aspect of a figure as a whole or in some part. But that aspect will have no meaning unless it is combined 'with some remarkable circumstance or cause'. Thus, 'a fat bloted person doth not call to mind the character of Silenus, till we have joined the idea of voluptousness with it; so likewise strength to support, and clumsiness of figure, are united, as well in the character of Atlas as in a porter'. That is,

character in form cannot be separated from the way of life of the person represented; social and psychological insights cannot be separated from the grasp of purely formal aspects. In the *Bench* the individualities of the judges are fused with their social function. The malevolently awake big-bodied judge and the thin dozing judge are both realized as judges; and their persona characters are set against the robes and wigs, the social insignia, which in one sense dominate them. The result is artistic character in its full meaning.

A prompt reply was made by B. in the *Monthly Review* of 20 September, claiming that Hogarth's distinction was wrong. The differentiations he set out were too familiar to need repetition; caricature could reveal as excellent drawing and genius as did character, exemplified in the work of Clarendon, Shakespeare, Hogarth. The latter began scribbling notes to vindicate his position, but soon flagged into incomplete flurries of comment. After the attacks on the *Analysis* he found it increasingly difficult to write down his ideas, as if he at once heard the jeering voices and was disconcerted. His health may have been failing, but there was certainly a psychological factor upsetting him as soon as he tried to use words polemically. Townley mentions a discussion in his kitchen in Christ's Hospital, which he dates 1758. He had revived the vexed question. 'I'll shew you, master Townley,' said Hogarth. He took up a dirty old pen from the kitchen inkbottle and made a sketch in which a face started as character and by stages was distorted into caricature. It came to look rather like William Pitt.

In November William Huggins who had taken over Headley Park, Hampshire, after his father's death in 1745, wrote asking Hogarth to do a portrait of him as a companion piece to that of his father. Hogarth agreed, but excused himself from a visit to Hampshire. Huggins sent him part of a translation of Dante, on which he'd worked since his version of *Orlando Furioso* (1754); he hoped that Hogarth would illustrate it. Hogarth's reply reveals the state into which he had drifted;

What you propose would be a Noble undertaking which I believe ten or a dozen years agoe I should have Embraced with joy, and would have pleased the Public, if I could have done the Author any degree of Justice, but consider now my dear Friend Sixty is too late in the day to begin so arduous a Task a work that could not be compleated in less than four or five years. The Bubble glory you hint I have no antipathy to, weighs less and less with me every day, even the profit attending it. I grow indolent, & strive to be contented with what are commonly call'd Trifles, for I think otherwise of what best produces the Tranquility of the mind. if I can but read on to the end of the Chapter I desire no more. this is so truly the case with me, that I have lately (tho I enjoy and love this world as much as ever) hardly been able to muster up spirits enough to go on with two Pictures I have now in hand

because they require much exertion, if I would succeed in any tolerable degree in them. notwithstanding the terms they are done upon are the most agreeable that can be wish'd for, I am desir'd to choose my subject, am alow'd my own time, and what mony I shall think proper to ask: one is for my Lord Charlemont the other for Sr Richard Grosvenor, one should not conceal the names of such as behave so nobly. tho this is troubling you with my stuff and I am at the bottom of my bit of paper so just have room to say how much [I] am your oblig'd humble Servt Wm Hogarth

His excuse for giving the names is a thin one; he wanted to boast. He was in a weakened sceptical state, in which he took refuge in cynicism, telling Ralph that 'till Fame appears to be worth more than Money he will always prefer Money to Fame'. In notes he declared himself 'fully determined to leave off Painting, partly on account of Ease and retirement, but more particularly because he has found by thirty years experience that his Pictures had not produced him one quarter of the profit that arose from his Engravings', apart from the Bristol altarpiece and a work commissioned by Charlemont. He seems to have forgotten that a while back he renounced engravings in favour of portraits. The fact is that he had lost his nerve, his impetus. Business calculations had never been absent from his mind, but the motive driving him on had been the desire to develop his art, though that development had always been linked with the quest for audience. Now, with money worries actually banished by his official post, he concentrates on them as he never did in days of genuine financial stress. In his failing nerve we indeed see his ageing condition; but in the last resort what got him down was the shock of the treatment of the *Analysis*, which had brought home inescapably his isolated and vulnerable position, and his growing malaise over the national situation, for which his previous ideas seemed inadequate.

James Caulfeild, Lord Charlemont, of Anglo-Irish family, had been mostly abroad since 1746; in 1756 he made a definite return, but was still restless. A love potion seems to have debilitated him. He was one of the first art patrons in England to get something of a sense of Greek art as well as Roman. The picture Hogarth painted for him was *The Lady's Last Stake* (or *Picquet*). 'A virtuous married lady that had lost all at cards to a young officer wavering at his suit whether she should part with her Honr. or no to regain the Loss which offered her.' So Hogarth explained. The painting was brilliant, the general effect more French than any other of his works, though far more solid than a painting by, say, Lancret or Subleyras. The flowing lines of the young couple are caught between the Venetian window and the fireplace where the flames carry on the motif of passion. Here, in another scene of choice, Hogarth reverts to the use of art emblems: a Penitent Magdalen in the Desert, Harpies holding up the grate, a Cupid with Scythe

(like Time) on the clock, the inscription NUNC NUNC ? (Now Now ?). Now is the moment of choice, the moment of living. Sunset is coming and the moon is rising.

Sir Richard Grosvenor had seen *The Lady's Last Stake* in the studio and made Hogarth a proposition. Clearly he expected another erotic canvas; but Hogarth craftily felt that here was a chance to venture again into sublime history, planting the result on a connoisseur. He must have known what Grosvenor meant, and his later complaints have a disingenuous note. What he painted was *Sigismunda*, a heroine mourning over her murdered lover's heart. He had been stimulated by the auction sale of a work on this theme being sold as a Correggio for £400, though he correctly realized that it was by some later artist – in fact Furini, a Florentine of the seventeenth century. His notes tell what happened.

A gentlm now a noble man seeing this Picture (for Charlemont) being infinitly Rich Prest me with more vehimence to do what subject I would, upon the same terms much against my inclination. I began on a subject I once wish[ed] to paint. I had been ever flattrd as to expression my whole aim was to fetch Tear from the Spectator my figure was the actor that was to do it.

Note the stage conception. He says there are 'many living ladies especially that shed involuntary tears' at his work. He was in part inspired by Thomson's play, considered a masterpiece and done into French and German; but he also knew Dryden's version in his *Fables*. His distracted state is shown by the fact that he still had not sent Littleton his picture; in September we find him blaming a bad frame. His unease was increased by the fact that Reynolds now felt himself in a strong enough position to begin attacks. At first Reynolds composed a direct depreciation. Hogarth accused others, he said, of using his line without understanding; but he himself provided no philosophic basis, merely saying that the line gave pleasure because it did; in fact the line attracted merely because people were more used to it than any other. But on considering his draft, he decided that a more devious and ironic tone would be more effective in deflation. In Johnson's *Idler* of 29 September he depicted a connoisseur remarking before Raphael's *Paul at Athens* how much nobler it would have been 'had the art of Contrast been known in his time; but above all, the flowing line, which constitutes Grace and Beauty! You would not have seen an upright figure standing equally on both legs, and both arms stretched forward in the same direction, and his drapery, to all appearance, without the least art of disposition.' Thus he derided Hogarth's ideas and at the same time suggested that he did not apply them. Then, having put Hogarth in his place in a fitting tone of ridicule, in two more

essays he elaborates his counter-thesis of true beauty as the idealization of nature in the Italian manner. To join the Dutch and Italian schools was to mix 'contraries which cannot subsist together'. He called for more sublimity or enthusiasm.

Hogarth, smarting under such attacks and the long delay of Warton's retraction, engraved the latter's offending passages on the reissued *Paul* and *Moses*, unconcerned at overburdening the plates. We catch an amiable glimpse of him about this time in the memories of Hester Lynch Salusbury (later Mrs Thrale and Mrs Piozzi). The families were good friends and Hogarth often dined with the Salusburys. One day

my aunt and a group of young cousins came in the afternoon – evenings were much earlier things than they are now, and 3 o'clock the common dinner-hour. I had got then a new thing I suppose, which was called Game of the Goose, and felt earnest that we children might be allowed a round table to play at it, but was half afraid of my uncle's and my father's grave looks. Hogarth said, good-humouredly, 'I will come, my dears, and play at it with you.' Our joy was great, and the sport began under my management and direction. The pool rose to five shillings, a fortune to us monkeys, and when I won it, I capered for delight.

She was writing some forty years later and seems to have telescoped the years together. Her story sounds as if she were quite young, but she goes on to say that when next the family were at Leicester Fields, Hogarth asked her to sit for the lady in Charlemont's picture. In 1758 she was about seventeen years. 'And now look here,' said he, 'I am doing this for you. You are not fourteen years old yet. 'Tis the lady's last stake; see how she hesitates between her money and her honour. Take you care; I see an ardour for play in your eyes and in your heart; don't indulge it. I shall give you this picture as a warning, because I love you now, you are so good a girl.' And she makes him die almost at once afterwards. No doubt he had delivered to her some such homily against gambling. Other memories, some set down in the 1770s, seem to catch the tone of his voice. He told her to get to know Dr Johnson, 'whose conversation was to the talk of other men, like Titian's painting compared to Hudson's; but don't you tell people now, that I say so, for the connoisseurs and I are at war, you know; and because I hate *them*, they think I hate *Titian* – and let them!'

Under 4 February 1759 a barrister John Baker mentions a dinner at which Hogarth, Miss Bere, and Samuel Martin were present. In April Goldsmith supported in his *Enquiry into the Present State of Polite Learning* Hogarth's appeal to the public over the heads of experts and collectors. 'The ingenious

Mr. Hogarth used to assert, that everyone, except the connoisseur, was a judge of painting. The same may be asserted of writing.'

Hogarth worked hard at the painting of *Sigismunda*, hoping to make it tragic and pathetic, and at last to rout the sneerers at his Sublime Painting. In his subscription book for the engraving he stated that though he had been 'fully determined to leave off painting', he had been prevailed on by 'the flattering compliments as well as generous offer' by Grosvenor, 'who was immensely Rich'. He was working in the melodramatic tradition of Reni and his successors, though seeking to avoid overdone effects of upturned eyes, tears, and the like; he may have been recalling Coypel's *Cornelia* (engraved 1730), where the heroine holds Pompey's ashes and bares much of her breast. His sketch was of a vertical figure like Furini's and Coypel's, but in the painting he turned to horizontal forms, with the girl at a table. He couldn't resist some elaborate details: a gaudy box with panel on which we see a church or castle and a Palladian domed villa (perhaps suggested by Chiswick House that lay obtrusively near his home). *Sigismunda* seems based on Jane. We saw that Wilkes later jeered at the connection, and a housemaid stated that Hogarth used his wife as she mourned her dead mother. Lady Thornhill died in November 1752, but Hogarth may have taken up sketches that he then made. The doomed lovers had done their wooing under a father's jealous eyes; so Hogarth may indeed have seen Jane and himself in them. The heart would then be his; and the picture which he hoped to use in a final triumph over the connoisseurs in fact provoked his final defeat and crucifixion. This suggestion may seem far-fetched, but it is supported by the passionate emotion he felt towards the painting.

At first the heart was shown bloody, smearing Sigismunda's hands; Hogarth is said to have used as model a heart supplied by the surgeon Sir Caesar Hawkins. But disapproval was expressed and he repainted the hands, though still leaving the heart too real-looking for sublime sensibilities. In the *Analysis* he had remarked that the intestines lacked beauty of form, 'except the *heart*; which noble part, and indeed kind of first mover, is a simple and well-varied figure; conformable to which, some of the most elegant Roman urns and vases have been fashion'd'. As we would expect of a work on which he pinned such hopes, it was worked over a great deal. Morell says: 'It was so altered, upon the criticism of one Connoisseur or another; and especially when, relying no more upon strength of genius, he had recourse to the *feigned* tears of *fictitious* woe of a female friend.' He hardly knew the work when it was shown in 1761. 'In my opinion, I never saw a finer representation of flesh and blood, while the canvas was warm, I mean wet.' He suggests that reworking weakened it.

When in June Grosvenor saw the picture in the studio, beside the *Lady's Last Stake*, he seems to have been aghast, but must have been evasive; for on the 13th Hogarth wrote an uneasy letter, a copy of which he pasted in the subscription book with other documents. This unusual care shows both his extreme regard for the work and his fears of failure.

I have done all I can to the Picture of Sigismunda, you may remember you was pleased to say you would give me what price I should think fit set upon any Subject I would Paint for you, and at the same time you made this generous offer, I, in return, made it my request that you would use no ceremony of refusing the Picture when done, if you should not be thoroughly satisfied with it. This you promis'd should be as I pleased which I beg you will now comply with without the least hesitation, if you think four hundred guineas too much money for it. One more favour I have to beg, which is that you will determine on this matter as soon as you can conveniently, that I may resolve whether I shall go about another Picture for Mr Hoar the banker on the same Conditions or stop here.

In this crucial document he does not claim that Grosvenor had seen the picture before or that he knew what the subject was to be. Further, he wrecks his case by admitting that all along Grosvenor had had the right to refuse the work, and by suggesting that Hoare might be ready to take it. (We hear nothing more of Hoare, who had an art gallery at Stourhead.) Later Hogarth declared that while he was doing *Sigismunda*, Grosvenor fell 'into the clutches of the dealers in old pictures'. As he knew only too well 'what a living artist was to expect when those gentry once get footing, [it] alarmed our author so that he thought it best to set his Lordship at Liberty to take the Picture or leave'. This account has all the marks of being developed after the event. A rich man like Grosvenor would have been infested by dealers as soon as he came into his money.

On the 17th he replied that if Hoare had a fancy for the work: 'I have no sort of objection to your letting him have it; for I really think the Performance so striking, & inimitable, that the constantly having it before one's Eyes, wou'd be too often occasioning melancholy ideas to arise in one's mind: which a Curtain's being drawn before it wou'd not diminish in the least.' Grosvenor thus politely extricated himself, with a compliment that he could say was ironic if the wits twitted him with it; indeed it may have been fear of ridicule, rather than meanness, which stopped him buying the work and then putting it aside. Hogarth did his best to use Grosvenor's urbanity against him. 'As your obliging answer to my Letter in regard to the Picture of Sigismunda, did not seem to me to be quite positive, I beg leave to conclude you intend to comply with my Request, if I do not hear from you within a week.' There was no answer but Hogarth did not feel brave enough to

deliver the picture with a bill. (Grosvenor later bought the *Distressed Poet*, perhaps to show that he had a high opinion of Hogarth in modern history.)

Hogarth's many enemies made the most of the episode. Reynolds painted the courtesan Kitty Fisher as Cleopatra, making his composition just enough like that of *Sigismunda* to provoke sniggers; he had probably heard that Jane was Hogarth's model and wanted to equate her with a prostitute. Hogarth wrote of 'many falsehoods'. He adds: 'I kept my Picture he kept his mony . . . Ill nature spreads so fast now was the time for every little dog to bark in there profession and revive the old splene which appeard at the time my analysis came out.' He had always had his streak of vanity, but in the past it had had an accompanying good humour and sense of proportion; it had seemed offensive only to those radically opposed to his positions. Now however he showed himself childishly greedy for praise, not so much for his truly great work as for his *Sigismunda*. Any remark in its favour, we are told, 'commanded a proof print or forced an original sketch' out of him. It was his own irresistible impulse to publicize the episode which more than anything else blew up into a defeat of the first magnitude.

In August Dr Hay paid him some compliment about *Sigismunda*, and on the 7th Hogarth wrote to him: 'Notwithstanding I was sensible that what you said to me at Mr Perrys, proceeded from friendship only, I could not help being more affected by it than by Sr Richards refusal of the Picture, as you may see by my setting down to scribble the following foolish verses which you have on the other side turn'd into English by my friend Paul Whitehead.'

> *To Risque, I own was most absurd,*
> *Such labour on a Rich mans word,*
> *Tis true a pittiful demand,*
> *Must oft content a modern hand,*
> *For living Artists ne'er were paid,*
> *But he agreed to grant me dead,*
> *As Raphael, Rubens, Guido Rene,*
> *Twas this indeed that drew me in,*
> *To lose two Hundred quiet days,*
> *Of certain gain for doubtful praise.*
> *When a new piece is ventured forth,*
> *Tis hard to fix upon its worth.*
> *Because you find no copied line,*
> *Or colours from the masters shine,*
> *The picture cant be right your sure,*
> *But say my Friend, or connoisseur,*
> *Why doth it touch the heart much more,*
> *Than Picture ever did before,*

Confest by even Sr himself,
But used as Plea to save his Pelf,
I have his letter on my shelf,
Which Plea if 'twas sincerely given,
Is a most curious one by heaven,
Howe'er I wish you'd understand
On this I ground my whole demand.

The fact that he could take Grosvenor's comments at all seriously shows how obsessed and blinkered he was. By August he had put his last touch to the *Lady's Last Stake*, and he wrote to Charlemont, whose portrait he was painting. Charlemont replied in an affably flattering letter, apologizing that 'ten thousand troublesome Affairs' had interfered with his sittings for the portrait and that he must leave for Ireland till late January or early February. 'I am still your Debtor, more so indeed than I shall ever be able to pay, and did intend to have sent you before my Departure what trifling Recompence my Abilities permit me to make you. But the Truth is, having wrongly calculated my expenses, I find myself unable for the present to attempt paying you – However, if you be in any present need of Money, let me know it, and as soon as I get to Ireland, I will send you, not the Price of your Picture, for that is inestimable, but as much as I can afford to give you for it.' Hogarth, in his wounded state, was only too pleased to accept delays from a noble who wrote in such an amiably reassuring way.

The English were still not doing well in the war, and the *Invasion* prints were reissued: 'Proper to be stuck up in publick Places, both in Town and Country, at this juncture.' The Militia Act was put into action, however imperfectly. But Hawke's victory at Quiberon ended the threat. On 21 November we glimpse Hogarth in his social activities. Baker records: 'Mr Banisher and I sat and chatted Hogarth,' at a revival of the *Beggar's Opera*. Earlier in the month, after the Society of Artists moved to new premises in the Strand, Hayman proposed a 'public receptacle' for the work of artists; and soon after it was agreed to hold a yearly show in April, with a shilling entry fee. The aims were to help and encourage artists and to build up a fund for those aged or infirm and for their widows. Hogarth took no part in the proceedings and was not on the committee elected to carry out the proposals. His presence at the theatre shows that he was not ill about this time.

This month he issued one of his finest single prints. Again he based himself on Leonardo's *Last Supper*, but now the setting was a Cockpit conceived in terms of the Circles of Hell, about which he must have learned through Huggins's version of Dante. The central figure of Christ has become Lord Bertie who had been shown with the boxers in the *March*; a blind devotee of

gambling, he is invested with a strange note of calm, of total obsession, among the unruly plebeians. His withdrawn intensity gives a dream quality to the scene of demented cruelty. The shadow of a man hung up in a basket for failing to meet his debts gives an eerie effect as of some unearthly watchman; his efforts to stay in the game by offering his watch seem to make him hold a miniature gallows. Someone has chalked a gallows on another man. Thieving goes on all round. The royal arms are balanced by a portrait of a well-known cock trainer. In no other work by Hogarth are the emotional, moral, and aesthetic elements so powerfully unified. This year there was a financial crisis, but his gross official earnings were £947. Out of such sums he had to pay a deputy, who did the actual work.

On 29 January Charlemont wrote from Dublin, enclosing a note for £100 in another very affably self-deprecating letter. 'Imagine you have made me a Present of the Picture . . .' Hogarth was in no mood to query any payment made in such laudatory terms; he cherished Charlemont's letters and liked to show them to visitors. Jane told Charlemont that her husband always used to mention, 'with the greatest pleasure and gratitude, the honour of that friendship your lordship conferred on him, with that ease and politeness, peculiar to yourself; and I can say with the greatest truth, that, the kind manner you always behaved to him, was the highest pleasure he felt, in the close of his life'. Charlemont clearly had much charm and he provided just the balm that Hogarth needed at this phase for his hurt feelings.

The first two volumes of *Tristram Shandy* had appeared in 1759; now in the spring of 1760 Sterne came to London. He had begun sketching as a child and carried on all his life, always interested in art problems; his first ideal had been Hogarth. He called on the *Analysis* in his account of Dr Slop and Corporal Trim; but beyond such matters there was a deep affinity between the minds of the two men. Sterne too had his deep rejection of rules, his reliance on life itself for the essentials of form and meaning. In both men was a stress on transitions, on dynamic involvement and fluid movement of character, on complexity of interrelationships which imply more than one time level. Sterne grew aware of his position through an opposition to Lockean rationalism; Hogarth, through an opposition to theories of proportion and order. Playing about with words, Sterne was able to bring out, as Hogarth could not do, the full philosophical implication of such positions. He now got in touch with Hogarth, who agreed to do an etching for the second edition of *Tristram Shandy*. In the first draft of his letter he had written: 'I would give both my Ears (if I were not to lose my Credit by it), for not more than ten Strokes of *Howgarth's* witty Chissel to clap at the front

of my next edition.' But on second thoughts he modified the effusiveness: 'What would I not give . . .'

On 21 April the first specially organized art show, the work of the Society of Artists, opened and met with much success. Hogarth, who sent nothing n, had the chagrin of seeing Reynolds increase his reputation. Next day the committee decided to use the profits (some £165) for 'the advancement of the Academy'. Hogarth must have felt that his suspicions had been justified. In June he excused himself from engraving his portrait of Huggins, who had completed his Dante. 'The copying my own works is the devil. I am sure the poorest engraver would do it better than I should.' He failed to engrave the *Lady's Last Stake*, though he hung on to the painting for a year. Charlemont says that he could not do the woman's head to his satisfaction and broke up the plate. He did another drawing for Sterne and a sketch for Kirby's *Perspective of Architecture;* but he did not complete the portrait of Charlemont.

His self-confidence seemed impaired; and he fell ill. Pyne says he caught inflammation by standing at a window to watch the proclamation of the new king at Charing Cross; he had meant to sketch the scene for a picture. But he seems to have been already in poor health. In notes he says that the anxiety which attended the Grosvenor affair, 'coming at a time when perhaps nature rather wants a more quiet life and something to chere it as well as exercise after long sedentary proceeding for so many year brought on an Illness which continue[d] a year'. A pet bullfinch died; he buried it in his Chiswick garden and inscribed on a rough stone: ALAS, POOR DICK! OB. 1760 AGED ELEVEN. He was well enough, however, to attend a meeting of the Foundling Hospital in December. Windows had been broken and disorderly persons, soldiers, porters, had caused trouble at the artists' exhibition; on 8 December the committee approved plans for 1761. They wanted their show to be in June, so that their work would not be confused with that of the premium winners. On the 31st the Society rejected the requests. The crowning of the new king had revived hopes of royal patronage. Hogarth began round this time making many notes, often hard to interpret, on academies. His gross earnings for 1760 as serjeant painter were £645.

In the spring Sterne had come to know Reynolds and succumbed to his fashionable charm. From now on he did not refer to Hogarth in his work, but twice drew on Reynolds, calling him son of Apollo. After his earlier reliance on Hogarthian theory and method, this surrender to Reynolds's ideas was in effect an insulting rejection of Hogarth, but how aware the latter was of it we do not know.

The Society of Artists lost no time in making a formal address to George III,

which was printed in January 1761; it hopefully cited his 'early Patronage of the politer Arts'. Hogarth too had his hopes. Sometime in the late fifties he redrew the elegant couple in the *Dance*, making them the Prince and his wife, who were thus shown as setting the correct tone. Now he drafted a Letter to a Nobleman, who cannot be other than Lord Bute, the king's favourite, whom he approached through his friend, Samuel Martin, Treasury secretary and head of the civil service. He says that he is sending only a rough sketch, as he first needs the Lord's 'opinion of a singular point or two on which the whole will be made to turn and which cannot with propriety be put into writing. the particular points I mean will not take up more than half an hour of your lordships time.' If the Lord doesn't agree, 'I shall immediately desist from urging, and be proud to obey your lordships commands in any other proposed scheme.' He writes throughout in this humble tone and confesses that the *Sigismunda* affair has somehow damaged his whole position. 'I am now upward of sixty years of age and have made mankind as much my study as the things relative to the arts. In the latter speculative part rather than the Practic. now my lord in all I shall here only boldly assert for honesty sake I give positive pruff (as to every particular) whenever I shall be called upon to do it. the intention I confess calculated to wipe off certain prejudices which I am perfectly assured stick to my character & must consequently so long as they remain prevent the undertaking I have in [mind] from tak[ing] effect.'

Why he should consider his proposals so startling is not clear. Presumably he wanted to put the case for a system of self-government among the artists while urging the extension of royal patronage. We do not know if he saw Lord Bute; probably he did not. He adds: 'My lord I am almost af[r]aid there is a scheme on foot already the author of it will naturally defend his own in opposition to mine which will breed a controversy a thing [I] must possitively avoid for my healths sake for as I am circumstanced I had rather lose the most favourite point than break one nights rest.' Elsewhere he notes: 'If the prince upon the throne who beneficent compass and lode of arts was to set the example and furnish any part of his Palace of each of his most eminent subject[s] work,' there might be a fashion for a time, 'but it is still to be apprehended there never could be a market [for] the number of things that would be produced.' It does not look as if he had a very hopeful scheme to set before Lord Bute.

The artists had delegated Reynolds and an architect Price to find a place of their own; by 4 March they rented Cock's auction-room in Spring Gardens. (All this while it seems that the academy in St Martin's Lane was carrying on.) Now at last Hogarth decided to exhibit with the other artists;

he had decided to have *Sigismunda* engraved and thus perhaps win the support of a wider public. As ticket he issued *Time Smoking a Picture* with captions: 'As Statues moulder into Worth' (Paul Whitehead), 'To Nature and your Self appeal, Nor learn of others, what to feel', and a quotation from Crates saying that Time was no good artist but weakened all he touched: with a reference to a *Spectator* essay in which Addison described Time with a forelock (as in the ticket) moving about a gallery, perfecting the pictures with a beautiful brown. Hogarth, in the *Analysis*, had already attacked the view that Time improved pictures. 'How is it possible that such different materials, ever variously changing (visibly after a certain time) should accidentally coincide with the artist's intention, and bring about the greater harmony of the piece, when it is manifestly contrary to their nature, for do we not see in most collections that much time disunites, untunes, blackens, and by degrees destroys even the best preserved pictures', and so on. Now by attacking the virtues of dark pictures he was setting the tone for the coming show of modern art.

But bad luck attended his attempt to get *Sigismunda* engraved. He had shown it in February at some auction rooms. 'If this Piece meets with the Approbation of the Publick, it will be engraved in the manner of Drevet.' But by 16 March only forty-four persons, mostly friends, had subscribed, and he returned the advances and declared he could not find a suitable engraver. His writing grew shakier. On the back of the page with the subscribers' names he pasted the passage from *Othello* about the man who filches one's good name. (He tore the paper off but a fragment adhered.) But he still had not given up hopes of restating his views on art. On 4 April in a letter dealing with the line of beauty in music he wrote: 'I intend, as soon as possible to publish a Supplement to my Analysis.' And there is a draft of what seems an advertisement for a Supplement on the Orders of Architecture, in which he would expound 'the doctrine of varying lines'. Perhaps discussions with Kirby lay behind this project.

At a meeting on 7 April he proposed that the artists should call themselves 'The Free Professors of Painting, Sculpture & Architecture'. Their aims should be to advance the arts 'on a right Footing suitable to the Genius and this Country'. Further: 'as absolutely necessary thereto, Means proper to be put into practice he resolved on as may tend to explore those Errors & Prejudices which have hitherto misguided the Judgments of true Lovers of Art as well as discouraged the Living Artists in the Progress of their Studies'. He was making a last effort to unite the artists in the task of tackling reality instead of following formulas. He did not mean to lay down the law as to the ways in which individual artists should approach the problem; but the

sections of the *Analysis* where he speaks as if he had discovered the definitive laws of taste would inevitably make them suspect that he wanted to impose his own ideas on the art world. And though it was hard to oppose him when he made proposals like the above, in fact no one wanted to turn the aims into realities. The adjective 'Free' was quickly dropped, and the group became the Society of Artists.

For the catalogue, Hogarth did two designs using the motif of Watering the Arts. In one the water pours out from under a statue of the king and is caught in a can by Britannia, who then showers it on the three trees of Painting, Sculpture, and Architecture. In the other a monkey-connoisseur tries vainly to revive the dead stumps of antiquated art. In April, Foote's farce *Taste* was re-staged with its satire on the crafty art auctioneer Puff. This month also a long letter in the *St James's Chronicle* (which Garrick had helped to found) praised Hogarth as 'the great Original of Dramatic Painting', and his link with the comic stage was stressed. The writer, John Oakly (John the Oak-hearted Englishman), who seems to have been a friend of Hogarth, claimed that 'union among the Artists is now happily brought about, and that all little private Parties, Caballings, Suspicions, and Animosities, are laid aside for more general and generous Considerations'. The newspaper said that the letter had been a subject of much Conversation in coffee-houses. John declared that the artists were being 'cordially assisted by the Author of the Analysis of Beauty'.

The Society of Arts opened its show on 27 April; the Society of Artists followed on 9 May. A few days earlier Horace Walpole had called on Hogarth in his studio. Vertue had died in 1756 and Walpole had bought some forty of his notebooks on English art, which he was using for his *Anecdotes on Painting* in England. Hogarth was working on his portrait of Henry Fox, with *Sigismunda* near by. Walpole wrote an account of his visit soon after to George Montagu; it vividly evokes the artist at this phase:

– but the true frantic oestrus resides at present with Mr Hogarth; I went t'other morning to see a portrait he is painting of Mr Fox – Hogarth told me he had promised, if Mr Fox would sit as he liked, to make as good a picture as Vandyke or Rubens could. I was silent – 'Why now,' said he, 'You think this very vain, but why should not one speak truth?' This *truth* was uttered in the face of his own Sigismunda, which is exactly a maudlin whore tearing off the trinkets that her keeper had given her, to fling at his head. She has her father's picture in a bracelet on her arm, and her fingers are bloody with the heart, as if she had just bought a sheep's pluck in St. James's market. As I was going, Hogarth put on a very grave face, and said, 'Mr Walpole, I want to speak to you.' I sat down, and said, I was ready to receive his commands. For shortness, I will mark this wonderful dialogue by initial letters.

H. I am told you are going to entertain the town with something in our way. *W.* Not very soon, Mr Hogarth. *H.* I wish you would let me have it, to correct; I should be sorry to have you expose yourself to censure. We painters must know more of those things than other people. *W.* Do you think nobody understands painting but painters? *H.* Oh! so far from it, there's Reynolds, who certainly has genius; why, but t'other day he offered £100 for a picture that I would not hang in my cellar; and indeed, to say truth, I have generally found that persons who had studied painting least, were the best judges of it – but what I particularly wanted to say to you was about Sir James Thornhill (you know he married Sir James's daughter) I would not have you say anything against him; there was a book published some time ago, abusing him, and it gave great offence – he was the first that attempted history in England, and I assure you some Germans have said he was a very great painter. *W.* My work will go no lower than the year 1700, and I really have not considered whether Sir J. Thornhill will come within my plan or not; if he does, I fear you and I shall not agree upon his merits. *H.* I wish you would let me correct it – besides, I am writing something of the same kind myself, I should be sorry we should clash. *W.* I believe it is not much known what my work is; very few persons have seen it. *H.* Why, it is a critical history of painting, is it not? *W.* No, it is an antiquarian history of it in England: I bought Mr Vertue's MSS, and I believe the work will not give much offence. Besid', if it does, I cannot help it; when I publish anything, I give it to the world to think of it as they please. *H.* Oh! if it is an anti-quarian work, we shall not clash. Mine is a critical work; I don't know whether I shall ever publish it – it is rather an apology for painters – I think it owing to the good sense of the English, that they have not painted better. *W.* My dear Mr Hogarth, I must take my leave of you, you now grow too wild – and I left him – if I had stayed, there remained nothing but for him to bite me. I give you my honour this conversation is literal, and perhaps, as long as you have known Englishmen and painters, you never met with any-thing so distracted. I had consecrated a line to his genius (I mean for wit) in my preface; I shall not erase, but I hope nobody will ask me if he was not mad.

We see how strongly he still felt about Thornhill, but behind his remarks was the wish to probe and find out how Walpole meant to treat him, Hogarth. He was certainly serious at this time about writing his *Apology*. He drafted a title page: 'On the arts of Painting and Sculpture particularly in England To which is added Some observations A Short Account (explanation) of (all) Mr Hogarths prints (Works) written by himself.' Three main themes run through the notes: the problems posed for artists by living in a mercantile society obsessed with foreign art; the whole question of judgement in art; the blind alley of copying other art works or even of working from nature without understanding. At the same time Hogarth's deep feeling of isolation, of being the centre of abuse, make him want to turn all the time to self-justifications.

The *Chronicle* strongly supported the exhibition, and among its items was a second letter from Oakley on the way that dealers conditioned young men interested in art; while 'Admirer' argued with a connoisseur friend, lavishly praised Hogarth, and was astounded before *Sigismunda*, while the connoisseur called Hogarth 'an absolute Bartholomew Droll'. Reynolds's *Idler* essays were reprinted in the *London Chronicle*. Hogarth contributed to the show *Sigismunda, Calais Gate, Election Entertainment, The Last Stake*, and three portraits. But ten days after the opening he took *Sigismunda* out. A later story says that he posted a man to write down any observations made against the work. 'Of these were a hundred at least, but Hogarth told the writer of this [T. Birch], that he attended but to one, and that was made by a madman! and perceiving the objection was well founded, he altered it. The madman after looking steadfastly at the picture suddenly turned away saying *D—n it, I hate those white roses*. Hogarth then and not till then, observed that the foldings of Sigismunda's shift-sleeves were too regular and had more the appearance of roses than of linen.' But there must have been many insulting comments to make him take the drastic step of removing the picture, which could not have but stimulated all sorts of hostile rumours and deductions. His appeal to the public at the show had been his last desperate resort. Birch, not long after, referred to the contempt shown to the painting at the exhibition.

An odd side-product of the show was a project for a collection of sign paintings, which seems to have been conceived at Thornton's Nonsense Club, but which had a strong link with Hogarth, as is shown in the names of works said to have been received: Adam and Eve, an Historical Sign; The Salutation, a Conversation Piece; a Half-length Portrait, designed for the Duke of Cumberland, but converted into the King of Prussia. Thornton, in a piece in the *Adventurer* of 2 December 1752, had written as 'a humble journey-man sign-painter', saying that his parents had hoped to see him emulate Raphael and Titian, but the prejudice against native-born artists and English lack of taste, had brought him down 'to the miserable necessity, as Shaftesbury says, "of illustrating prodigies in fairs, and of adorning heroic sign posts" '. The idea caught on or Thornton decided to push it. More items were printed in the *St James's Chronicle*, with a list of works by 'true British Artists in the SIGN Way'. Again Hogarth was at the centre of the account. There were works After his Manner, A Crooked Billet formed exactly in the Line of Beauty, and so on. A date was given for the show; but after the two real shows closed, the joke was dropped.

Hogarth's illness now seems to have passed. He himself says it lasted a year. Then a horse, when he was well enough to ride, helped him to recover.

In November he issued his print *The Five Orders of Periwigs*, ridiculing the idea of classical proportions. He may have been stimulated by an emblematic triumphal arch painted by Oram for the Coronation and set up at the northern end of Westminster Hall, opposite the throne. He had attended the ceremony on 12 September as Serjeant Painter. Taking up the idea that Orders could be devised out of all sorts of things, he uses Periwigs as affording a monstrous shape that distorts the wearer and fitly symbolizes a pompous event of state power. He depicts the Five Orders 'as they were worn at the late Coronation, measured Architectonically'. They are Episcopal, Old Peerian or Aldermanic, Lexiconic (for Lawyers), Composite or Half Natural, Queerintian or Queue de Renard (for Beaux). Each wig is divided up as capitals were. Hogarth may well have had in mind the stories told of the origins of the Greek Orders. This in 1738 John Boswell wrote in *A Method of Study*:

And accordingly they work'd the Pillars more tapering, the better to represent the Shape of the Goddess, adding such Ornaments as were thought agreeable to the Delicacy of her Dress. Thus they adorn'd the Pillars with *Bases* in Imitation of the Buskind Ornaments of the Legs and Feet worn by the Ladies in those Days, and made the *Channellings* deeper, intending thereby to represent the Foldings and Plaits of a fine light Garment. *Volutes* or *Scrowles* likewise were put upon the *Capital*, in Imitation of a young Lady's Head-Dress, whose Hair beautifully descending from the Top of her Head, was wont in those Days to be curl'd up in airy Ringlets under each Ear. This is the Account that is given of the Origin and Meaning of the *Ionic Order*.

If the ancients built their systems out of their clothes and coiffures, Hogarth says, why not the moderns? Indeed, the latter should do it if they wanted an architecture relevant to their way of life.

In 1760–61 there was growing unrest among the workers, leading to strikes and combinations for higher wages with a direct relation to the cost of living; in 1761 a Bill was brought in against rebellious journeymen. Hogarth ignored such events or viewed them merely in terms of a general malaise. On 10 December the king renewed his patent for the Serjeant Paintership. On the 15th he was elected on to an enlarged artist's committee, which seems to have taken steps to extend its power over shows, to claim the right to elect president and secretary from its own numbers, and to co-opt an artist to fill any vacancy in its ranks. Hogarth would have protested at this anti-democratic system, or he may have merely dropped out. He did not show with the Society again. His gross earnings from his patent this year were £982.

Perhaps this year he executed the plate *Enthusiasm Delineated*, though he may have worked on it earlier. He expresses strongly his darkened mood

about people's behaviour, which seems ever more irrational. We are inside a Methodist meeting place (probably Whitfield's Tabernacle). The raging preacher throws off his wig, revealing a Jesuit tonsure; under his gown is a harlequin costume. He holds a puppet in each hand: God, blind and hoary with a trivet (Trinity), and the Devil with gridiron. Round the pulpit are six more puppets: Adam and Eve, Peter with Key pulling Paul's hair, Moses crowned with a legged pot (horns), priestly Aaron. The puppets also represent art that Hogarth scorns: Dürer's diagrammatic figures or Dutch burlesque naturalism. His plate is a reply to Reynolds's call for enthusiasm or sublimity; religious mania is merged with fanatical idealization of the Old Masters.

Thermometers record the degree of rant, which reaches its height in *Chroist Blood Blood Blood!* and the excitement of the congregation rising from Luke Warm and Lust Hot, to Extacy, Convulsion Fits, Madness and Revelation, and then on to Wrathful, Angry, Changeable, Pleased, Joyful (with the Dove of the Holy Ghost). Below Luke Warm we sink to Despair, Madness again, Prophecy. Round the suffering Clerk flit two cherubs made of heads, wings, duckfeet. A girl, with a noble's hand inside her dress, registers Lust Hot. A Christ image gathers the tears from a penitent branded thief. A Mouse Trap takes the place of the Poor Box. A woman (Mother Douglas) lies in a fit. Behind her a converted Jew opens the Bible at the ruthless Old Testament stories; he looks like a Prophet, but is cracking a louse. The Chandelier is a gaping Face of Hell, a Map of Damnation. Some worshippers (Irish, says Ireland) gnaw or chew Christ images. A bewildered Mohammedan stares in at the window, in the vein of the books that tried to put Europe in a critical focus by describing the reactions of a visiting Chinaman or Persian. Behind the whole conception lies a memory of Swift on 'The Mechanical Operation of the Spirit' (1710) which stresses the hypnotic relation built up between preacher and congregation.

Friends are said to have persuaded Hogarth from publishing the print; and he may well have quailed at putting out such a savage work, which, ostensibly an attack on Methodism, gives rather the effect of repudiating Christianity altogether. In his ironic way he dedicated the work to the Archbishop of Canterbury, who had Methodist learnings; on the surface appealing to the official Church, he implicates it in the demoralization of people. More than any other work the print reveals his tormented and outraged sensibility at this time, which he had vainly tried to channel into the image of the bloody heart in Sigismunda's loving hand. The *Cockpit* has as deep a conviction of human brutality and perversion, but there the image is controlled and concentrated. Here Hogarth returns to the method of

complicated emblematic imagery which cannot have the same immediate effect. Still, the elements of the composition are well held together. The eye moves from the convulsed woman round to the lecherous pair and up to the preacher. The swing of the puppets takes the eye out to God, and we are momentarily suspended over the turmoil of demented humanity below. The hell globe balances God, and the windows of the outside world (with the light that holds a hope of sanity) balance the puppets of fall and redemption. If we compare the work with the early *Sleeping Congregation* we feel the demonic element that has entered into the depiction of people. Religion, which was an opiate, working with state power to stupefy people, is now seen as a force that stirs up all their worst qualities. The static composition of the early work, broken up, has been given a new variety and depth.

Here, with Hogarth near his end, we may pause and try to sum up. We can justly call him the first modern artist in that he consciously discards the whole Renaissance tradition and its ideals, and, though taking over elements from baroque and rococo, sets up unmediated nature as his criterion. He wants to depict life just as he sees and feels it, seeking out its inherent patterns, forgetting set forms and established systems. He has some antecedents in painters like Brueghel with his medieval popular elements, and in a sense he has as predecessors Caravaggio and Rembrandt. But rebels as those two painters were, they could not make his decisive break. That sort of break was not indeed possible before his era, when the modern bourgeois state was definitely cohering and society moving confusedly yet powerfully into the first stages of industrialism. The alienation of the individual in the city desert found its first expression in his work. The concept of the self-made man (Robinson Crusoe) expressed one side of the new possibilities: the entrepreneur with his initiatives and decisions. Merged with the forces driving the individual back in on himself and making him feel a cut-off self-motive system of energies, it begot for good and bad the new sense of individualism, which found expression in literature and art with deep effects. The romantic enhancement of the self could be linked with a realistic sense of the distance between the self and society, of the give-and-take between the two – the feeling of a lost unity playing tantalizingly over the whole new outlook.

First in European art the concept of the self-made man appears in Hogarth; he constructs his art world through a direct relation to the object, repudiating all the existing aristocratic appropriations of it as false, as cheating. However, if that were all, the result would be cold and mechanical. The need to find an unmediated relation to the object is in turn part of a wider need, a consuming

hunger for life. Hogarth wants to enter into the immediate scene around him as a participant and enjoy its good things; his attitude is always an active one and involves a sense of other people. He recognizes the hunger for life in these others, and in this way achieves a sense of fellowship with them. In seeing the object as it truly is (in an active relation to men), in thus enjoying its essence, he feels, not competition with the others, but his common humanity. His vision of life is of a mass of leashed and unleashed energies, which should work harmoniously in the shared aim, but which do not. Discord and conflict keep on threatening his keen sense of all the possible enjoyments present in the scene, in the human moment, and so he needs to understand and define them as the first necessary step to keeping his sense of the object intact, his hunger for life unlessened. He needs to fuse a dynamic sense of participation with a detached scrutiny of what is happening and what it all amounts to. He both reflects the social forces at work all round and inside him, and opposes himself critically to them, noting without palliation all their dehumanizing effects. He is the middle-class critic of the aristocracy and its falsifying obsolete ideals, which it imposes on society; he is also the plebeian critic of the middle class and its subservience, its money ethic, its greeds and oppressions. So in his depths he becomes simply the human critic of the whole situation.

But he could not arrive at this position without creating his own artistic method, since he has rejected the dominant tradition maintained by aristocratic patrons. At one level, the plebeian, he carries on a popular tradition, which shows itself in methods of drawing and in emblematic systems, in a view of life as embodying a ceaseless succession of choices that impregnate every object with a symbolic significance and give each scene its particular depth of pervasive meaning, its typicality. To develop the possibilities in this tradition, he has to move beyond its previous limitations and find ways of unifying his art and of extending its technical powers, so that he can challenge the aristocratic art of the grand style: not by using its methods and ideals, but by creating an art which is serious in a different way, as capable of drawing on all the technical resources of the painting craft. While rejecting the idea that Renaissance or baroque art provides a ready-made system he had yet to draw on the tradition of high art to enrich his craft powers and make them adequate to his needs.

He thus discovers and develops in his own way the baroque concept of the cosmic theatre (behind which lies the struggle to humanize the post-Galilean concepts of time and space). He brings the baroque imagery down to earth by finding his direct relation to the theatre through the *Beggar's Opera* and by developing a dramatic concept of life itself as a series of

conflicts and crises, set on the stage of the new self-consciousness and moving towards the fulfilment or destruction of self. At the same time his deep joy in life, his impulse of active participation, make him seek new methods of brushwork, new colour harmonies or contrasts capable of expressing his rich and entangled sense of the various things before him, of which he is excitingly a part. Thus he achieves his kind of realism, which is above all dynamic, concerned with the movement of interrelated forms and with the inner tensions of character in dramatic involvement. By its nature it had a far larger scope and depth than could be found in Dutch drolls. By entering into the full and complex drama of life it challengingly set itself on the same level as the history painting which the age looked on as the sole serious and meaningful form of art. But despite all his restless attempts to bring about the confrontation, Hogarth was never able to extract, except in very limited ways, the admission from his contemporaries that his modern or comic history was to be judged on the same level as the works in the grand style.

The rejection of what we may call the art establishment (the patrons, connoisseurs, the art dealers, and the critics who set out the virtues of the grand style), meant that he had to find a new kind of audience. Otherwise he would have painted solely for himself in a poverty-stricken corner and would have been ignored. And secondly he had to fight for new forms of permanent exhibitions of art works, outside the collections in the great houses. Protestant England had no use for church decoration and thus closed the one avenue through which artists in Roman Catholic countries could reach the broad mass of the people, even if the latter were still excluded from any active relation to the works thus provided, except in a religious sense.

So Hogarth had to turn to engravings as the one form of art expression which could reach a wide public and defy the connoisseurs. By doing so he created a new public for art. There were affinities with what had happened in Holland in the seventeenth century; but there was a new element as well. The satirical and socially critical aspects of the engravings meant that a far more active and strenuous relation was built up between artist and people; the art was no longer merely entertaining or illustrative. Secondly, Hogarth began his efforts to use public institutions like Spring Gardens or the hospitals as centres for art galleries freed from the domination of the aristocratic patron and his needs.

One result, however, was that, lacking any possible audience for large-scale modern history, he was compelled to paint such works on a small scale which made them suitable for engraving. He geared them to his engraving system and his new public, and had no basis for developing them into life-

size representations that would fully and finally have challenged the grand style on its own ground. Worse, as he could see no way through his *Modern History* of bringing that challenge about, he felt driven from time to time to attempt to prove that he could do the sublime and ideal works which were held, as an axiom of the art principles of the day, to belong to a far higher branch of art than the things he did, however well, 'in his own way'. As a result, he ended in a series of false confrontations and never fully developed his powers of brushwork and colour, though he was essentially a painter and not a black-and-white draughtsman.

Hence the number of contradictions in his career. He keeps on succeeding in ways that partially frustrate him, and then in attempting to overcome those frustrations he finds himself out of his depth in waters not his own, so that his many enemies in the art world are able to jeer at him and argue, with more apparent effect, about the limitations of his powers, his jealous and embittered nature, and so on. In his efforts to prove himself a painter of high quality, he turned to a genre in which he could not possibly use his characteristic powers. His obstinate attempts to wring acceptance from the art establishment led him at last to the impasse of *Sigismunda*. The tragedy lay in the fact that he had accepted the values of his enemies and so was defeated before he started; he was hoping for the wrong kind of acceptance.

But these remarks must not be taken as stressing too strongly the element of frustration and misdirection of his work. He did develop his powers over pigment and colour to a remarkable degree even in his small conversation pieces and the works made for engravings, and in his best portraits. He showed himself the finest and truest painter of the rococo era even when thus restricted. But there was a point beyond which he could not go. He reached it in the *Happy Marriage*, where he felt impelled lyrically to express himself in terms that transcended the needs of the engraving market. In the *Shrimp Girl* he showed how far he could have gone if he had found a viable art form which combined his expressive mastery of character with his powers of using paint to express movement of shapes, surfaces, volumes. In works like the *Shrimp Girl* and the *Country Dance* he had indeed driven far beyond anything that his contemporaries could conceive as a feasible art genre. But while he might make this breakthrough in a work or two painted for himself, he could not imagine any basis on which to sustain an extended art expression embodying all the dynamic qualities of which he was capable as painter.

He showed himself, however, the most experimental painter of his age in Europe, deeply aware of the lines along which sensibility was to develop. Early he took up the still indeterminate conversation piece and made out of

it a new genre, the vital depiction of an interrelated group. In his small paintings he went on experimenting with brushwork and with ways of using colour: in bold broad patterns or inside a shifting focus of light and shade. He proved that he could paint life-size figures in portrait or in history of the accepted kind, and in portraiture he went further and broke new ground, discarding aristocratic conventions and achieving a new directness: defining a dignity of character which was in no ways idealized or reliant on externals.

His very versatility told against him in the eyes of the connoisseurs. Tormented by his inability to make people realize what he was putting into his art, he wrote *The Analysis of Beauty*, in which he set out a new concept of organic form, of form in total movement – that is, form involving movement not only of lines, but also of surfaces and volumes. While he was deeply interested in the emotional relationships of people as revealed by the rhythm and interrelation of forms, his concept of moving surfaces applied in the last resort as much to a person in repose as in action. But the *Analysis*, instead of clarifying what was at issue, was taken by the art establishment as the final exposure of his heresies, his inability to understand serious art. Its reception was a heavy blow to him, and led on in time to his effort to extort from the connoisseurs the recognition of his powers by an invasion of their special territory, an effort foredoomed to failure. The 1760s were to see him making yet another fundamental misjudgement, in the social and political spheres.

But though he might seem to his contemporaries an outsider in the art world, brilliant or overweening according to one's point of view, the 'ingenious Mr Hogarth' who did effective things in his own odd way, he had in fact breached the old ideas and preconceptions at a thousand points. One great virtue of his need to work in engravings was that at least certain aspects of his art became quickly and widely known all over Europe, affecting artists and art theoreticians of all kinds. Rouquet's work had helped to spread his name, and the *Analysis*, soon translated into German and French, had multiple effects, in part through thinkers like Lessing, Winckelmann, Diderot. His ideas and his art works merged with kindred tendencies to help artists as diverse as Greuze and Goya; and found something like a stabilization of their influences in what we may call the revolutionary classical realism of David and Géricault. Many other forces and influences had come into play to bring about that final result; but it is a token of Hogarth's forward-looking ideas and methods that we may indeed claim they anticipate in varying degrees many of the most substantial achievements in European art during the following century. When Courbet painted his *Stone-Breakers* more than life size, claiming for them full heroic stature, the vindication of modern history as against idealizing art was finally made.

There is yet one more aspect of Hogarth's work that needs to be noted. By his profound impact on Fielding, Richardson, Sterne, and to a lesser degree Smollett, he may be said to have played a vital part in the development of the English eighteenth-century novel. Here is an odd by-product of his art; and we can at least say that no other artist has had anything like so strong or important an effect on the growth of a kindred literary form. The reason for this impact of his lies in part in the nature of his period, when the novel was in its infancy and the novelists could not but feel they had much to learn from an artist so illustrative of the social scene; but more deeply in the nature of his art; which is the first in history to combine narrative, deep-going social inquiry and criticism, and internalization of typical social experience by means of a subtle symbolizing system. We may add that Hogarth, followed in various ways by Fielding, Richardson, and Sterne, achieves a true sense of form in his works. The Augustans, for all their talk of order and proportion, could not achieve unifying form; they concentrated on the symmetry of the couplet, the sentence, and so on, and made up the whole work out of such units set side by side. With Hogarth alone there comes in a dynamic and unifying sense of form, which he does much to teach the novelists.

15 *Finis (1762–4)*

*T*o get inside Hogarth's mind we must glance again at the social crisis. We noted the start of a new militancy among workmen. The war, which ended in 1763, brought Britain vast new colonial territories and improved her mercantile role; but with the heaped-up debt the Tory gentry could argue that the country had been bankrupted to build up Whig politicians, merchants, financiers. The mercantile interests, fighting back, did much to stir up the London crowds. By autumn 1763 the king complained: 'We hear of insurrections and tumults in every part of the country; there is no government, no law.' Corruption and inefficiency were extreme. 'You may rest assured,' said Admiral Lord St Vincent, 'that the civil branch of the navy is rotten to the core.' Looking back at the Romans, many men decided that Britain was at its last gasp, 'in public poverty and private opulence, the fatal disease which has put a period to all the greatest and most flourishing empires of the world'. Hogarth was much affected by such attitudes.

Yet among his friends at the time was Wilkes, energetic and witty, with his strong radical views. Hard up, he linked himself with Pitt, and when Pitt resigned in October 1761, he turned to journalism, showing that he could write as vivaciously and cuttingly as he talked. His writing also developed his radical ideas and drew him further away from the cold astute Pitt. His closest friend was the poet Churchill, also a loose-liver, but less capable of looking after himself, running into debt and wrecking himself with VD. Wilkes and Churchill enjoyed chatting and drinking with Hogarth, admiring the long fight he had put up, and probably thinking he shared more of their outlook than he did. He had grown ever more verbosely vain, liable to talk on and on about his enemies and their detraction of his great achieve-

ments. As they drank, it all seemed amusing and harmless, a weakness on the part of a great man who was growing old and obsessed.

Hogarth, Wilkes, and Churchill had many qualities in common: abundant high spirits, a capacity for deep enjoyment, a ceaseless interest in people and events. Their honesty and breadth of sympathy, their feeling that joy in life implied the acceptance of others' right to the same sources of self-fulfilment, gave them a richly democratic outlook; not in merely political terms, but in an instinctive response to all the direct calls of humanity, an instinctive rejection of social status and power as providing a superior set of rights. Each man in his own way was self-absorbed, yet without losing his warm-hearted and out-turned responsiveness. In Churchill these attitudes led to his magnificent poem *Gotham*, a fantasy of greatness that is lifted above all pettiness by the concepts of justice and brotherhood that pervade its world view. In Wilkes it led to his dauntless development as the first great popular leader since Cromwellian days, straddling the gap between the old feudal and the new industrial world. Hogarth's achievement lay substantially behind him, but it had its kinship with Wilkes's fighting spirit and Churchill's vision in *Gotham*: an art deeply and truly popular, and at the same time drawing on the great achievements of the past, an art that in all essentials looked forward into the new possibilities which were to emerge in the next century and a half. The break between Hogarth and Wilkes, viewed in his perspective, has a truly tragic aspect.

In 1762 came out Warton's second edition with its belated apology, which mollified Hogarth. Garrick teased him by pretending that Warton had made a retaliatory attack over the remarks on the plates. Then, when the truth was told, 'he, thoroughly disconcerted, offered to destroy the plate in which your name is mentioned, for he declared that he would not be overcome in kindness'. Meanwhile Thornton and his friends were preparing for a real show of signposts, perhaps roused by the Acts making them illegal. By November the London signs were coming down. The Society of Sign Painters was advertised as getting together a magnificent and varied collection. 'The Vertuosi will have a new Opportunity to display their Taste on this Occasion, by discovering the different *Stile* of the several Masters employed.'

On 5 April Hogarth issued his *Credulity, Superstition, and Fanaticism.* Here was *Enthusiasm* with the elements liable to give wide offence cleared away; now the print could be taken as wholly an attack on Methodist excesses. The doves, the images of Christ, the puppet of God, the puppets round that pulpit, were all removed. All stress was put on the recent scandal of the Cock Lane Ghost in which an eleven-year-old girl was thought to be the

medium of a murdered young woman; the fraud was exposed on 12 February after having excited enormous interest. Hogarth puts a witch in place of God, figures connected with ghost stories are set round the pulpit, the sweep hugging a statue becomes the boy of Bilston (who spat out hobnails and iron staples), the woman in convulsions becomes rabbit-bearing Mrs Toft. Hogarth identifies Methodism with Witchcraft and Spiritualism on account of Wesley's repeated statements of belief in witches, his claim that to discredit witchcraft was to discredit the Bible. In the bowdlerized print the art symbolism goes.

Hogarth did a frontispiece for Garrick's play, *The Farmer's Return* (dedicated to him), which also drew on the Cock Lane story. In March Churchill had published his interminable poem on the same theme, which is generally close to Hogarth, even in the use of an Hudibrastic medium. He too brought in Mrs Toft, attacked the Society ot Arts, and went on to defend the signpost show. Connoisseurs are those

> *Who, humble artists to out-do,*
> *A far more liberal plan pursue,*
> *And let their well-judged premiums fall*
> *On those who have no worth at all;*
> *Of sign-post exhibitions, raised*
> *For laughter more than to be praised,*
> *(Though by the way we cannot see*
> *Why praise and laughter mayn't agree)*
> *Where genuine humour runs to waste,*
> *And justly chides our want of taste,*
> *Censured, like other things, though good,*
> *Because they are not understood.*

Hogarth, we are told, decided to raffle his *Election* paintings. Garrick called to subscribe, felt the project unworthy of so great an artist, came back and bought them for 200 guineas. On 20 April the Signboard Show opened in Thornton's rooms in New Street. Several works were given to Hagarty (Hogarth). Among these were: *Nobody, alias Somebody*, and *Somebody, alias Nobody; Welcome Cuckolds to Horn Fair; The Spirit of Contradiction; A Conversation; A Man (nine tailors); View of the Road to Paddington, with a Presentation of the Deadly Never-Green that bears Fruit all the Year round* (Tyburn with three hanged felons). The show seems to have had much success, carrying on till 17 May like that of the Society of Arts. Hogarth must have thoroughly enjoyed the whole thing, which vindicated something popular and English against the empty and the pretentious. He could hardly have worked out in his mind any clear notion of his relation to popular art, but he certainly felt

a kinship. There was something remarkably fitting in this symbolic link of his work with the signboards in the last days of his life.

His opposition to the artists was begetting satirical prints against him. In one he appears as the English knight errant, 'descending in a waving Line from Don Quixote'; he is urged on by Thornton and confronts the host of artists led by Hayman. A less pleasant print, *A Brush for Sign-Painters*, shows him at work, seated on a close-stool. One of Envy's snakes guides his brush as he paints *Sigismunda*. Below is a representation of Aesop's fable about the frog who bursts in trying to swell out to bull size.

In April his head of Fielding appeared in the first volume of Murphy's edition of the *Works*. This, the only record of Fielding's features, was done from memory. We may disregard the stories of him using a scissor-cut silhouette by Margaret Collier (who had gone with Fielding to Lisbon) or of Garrick making himself up as the dead man and mimicking him to serve as model. In April too Churchill published his *Apology*, an attack on the critics. (His *Rosciad* on the stage and its actors had appeared in March 1761.) Again we find positions that Hogarth would have heartily approved. The critics 'lurk enshrouded in the veil of night; Safe from detection, seize the unwary prey, And stab, like bravoes, all who come that way'. A long passage on strolling players clearly looks to Hogarth's print. 'The mighty monarch, in theatric sack, Carries his whole regalia on his back . . . In shabby state they strut, and tatter'd robe, The scene a blanket, and a barn the globe.'

Now, carried away by the feeling that factions were ruining Britain, Hogarth determined to do two prints on *The Times*, which in effect involved an attack on Wilkes and Churchill. Wilkes, still carrying on his periodical, the *North Briton*, was stationed at Winchester as colonel of the Buckingham-shire Militia. A friend wrote warning him of Hogarth's intentions; and he got two common friends to remonstrate with the artist 'that such a pro-ceeding would not only be unfriendly in the highest degree, but extremely injudicious, for such a pencil ought to be universal and moral, to speak to all ages, and to all nations, not to be dipt in the dirt of the faction of a day, or an insignificant part of the country, when it might command the admiration of the whole'. Wilkes was only asking Hogarth to abide by the principles which had so far strictly governed his art. But Hogarth was not to be deterred; he replied that neither Wilkes nor Churchill were attacked in his print, which was soon to appear, though Temple and Pitt indeed were attacked.

'A second message soon after told Mr. Hogarth, that Mr. Wilkes would never believe it worth his while to take notice of any reflections on himself, but if his friends were attacked, he would then think he was wounded in the

most sensible part, and would, as well as he was able, revenge their cause; adding, that if he thought the *North Briton* would insert what he sent, he would make an appeal to the public on the very Saturday following the publication of the print.' The message may have gone by word of mouth; no copy of it survives in Hogarth's collections. But the gist of the story is confirmed by Ralph Griffiths, who said that he heard it from Hogarth shortly before his death.

To understand just what Hogarth was doing in attacking Wilkes, and what was the 'unanimity' he wanted to preserve, we must glance at the sort of exposure that Wilkes had been making. When Fox was taken into the cabinet to organize bribery on a huge scale, loans were jobbed so as to provide profits for the men supporting the new combination. On 19 March 1763 the *North Briton* published details of the floating of a £3,500,000 loan in such a way as to make a clear present of a tenth of the sum to 'ministers' friends', to whom stock was issued at a low rate. Personal government by the king through Bute seemed on a fair way to consolidation. Wilkes exposed one of the main distributors of the bribes, Samuel Martin MP, who had left Pitt for Bute, 'the most treacherous, base, selfish, mean, abject, low-lived, and dirty fellow that ever *wriggled* himself into a secretaryship', a close and trusted friend of Hogarth. An example of Martin's methods was given. John Ghest, army inspector at Bremen, rejected large amounts of rotten mildewed oats on the way up the river for the soldiers; the contractors thus lost large profits (on which they had no doubt paid the usual bribes); at their complaint one Pownal was dispatched to supervise Ghest; he sent the oats on and took away the detachment of soldiers through which Ghest secured respect for his orders. Ghest reported the matter to Martin, who ignored his letter but told Pownal to dismiss him. After exposing the agent, Wilkes went on to attack the principal, Bute, in the form of a satirical introduction to Ben Jonson's play, *The Fall of Mortimer*, ostensibly contrasting the Mortimer of Edward III with the Bute of George III, but in fact comparing them. Edward 'was held in the most absolute slavery by his mother and his minister . . . and the minion disposed of all places of profit and trust'. Horace Walpole cried in glee, 'It's all wormwood,' but George is said to have been upset, not by the revelations of corruption or the comments on his own imbecility, but by the suggestion of a liaison between his mother and the handsome Bute, who was so unpopular that he dared not venture in the streets without a bodyguard. No one before Wilkes had set himself systematically to expose corruption, not for personal reasons, but as a matter of political principle. Now Hogarth attacked him as a disturber of national unity. There seems little doubt that Martin played an essential role in working him up to this position.

The Times appeared in early September, a defence of the Bute ministry. A few days before, *John Bull's House set in Flames* had used the same symbolism, but against Bute. Clearly it had been hastily produced as a riposte by Pitt supporters who had learned of Hogarth's print. In *The Times* the fire is the Seven Years' War. Two houses, France and Germany, are engulfed; a third, Spain, has been drawn in. Now the fire spreads to England and the Globe. (The world-end fire which in Plate 2 of the *Rake* represented the moral or physical death of the debauched individual has become an actual conflagration of universal war and bankruptcy.) Round the king on the fire engine a small band tries to put the flames out, opposed by the Pitt faction and unaided by the indifferent Londoners. A Pittite with the *North Briton* in a wheelbarrow goes to add fuel to the fire, tripping up the loyal Scot who has a bucket of water. The Whigs in the Temple coffee-house shoot their extinguishers at the fire fighter, not at the fire. From the garret the water is sent on to the king by men who can only be meant for Wilkes and Churchill.

The house of England has the notice, The Post Office, cracked across: Pitt used the Post Office for much patronage. The sign, The Newcastle Inn, is collapsing: Newcastle resigned in May 1762. Other signs make further political points. Thus we see an Indian chief with money-bags and casks: he represents the conquests in America and the West Indies, their loot and trade benefits; more specifically he is one of the three Cherokees brought to London in June 1762, who drank a lot and earned money for their sponsors by being exhibited in gardens. Beckford, rich trader in tobacco and sugar, points to a sign with the chief; by him there emerges from its kennel a fox – Henry Fox who had done well as Paymaster-General of the Armed Forces. A Dutchman sits on a bale of goods; Frederick of Prussia plays his violin gaily amid the scene of destruction and the common folk who suffered from his wars.

There is much here that we cannot but sympathize with: the attack on war and colonialism. With justification Hogarth has grown suspicious of the London merchants who wanted profits at home and abroad without concern for human misery. But he makes his valid points as a partisan of Bute and George III without a grasp of the wider issues of which Wilkes was deeply aware. The question facing Englishmen was not whether or not they supported a patriot king who crushed all political parties not rallying to his call. It was rather whether they ended the cruel farce of government by corruption, extended the franchise, and brought into action more and more the broad masses who were quite excluded from any voice in politics. Wilkes was not a Pittite in the way in which Hogarth saw him; his concern was for radical reform. Not that he was a man of strong theory. Rather he was one

who learned from the direct struggle how to formulate his ideas and find the crucial issue. His great days were yet to come; but if Hogarth had not closed his mind over the last decade, he could have learned much from him. Then, with his genuinely deep sense of the energies and powers of transformation in the people, he would have been able to bring his faith out into the open. He would have linked his art with the new forces that were steadily to change the England he knew. Probably what above all held him back was the deep sufferings he had gone through after the attacks on the *Analysis* and *Sigismunda*. He had been driven back on himself, as had not previously happened, and had come to pin his hopes on an intervention arriving from outside the vicious circles in which he seemed enclosed. When he became Serjeant Painter and deluded himself that in the new king would arise a patron above the connoisseurs and the factions, he finally lost touch with his own deepest instincts and impulses. Certainly part of the blame for his confusions must be laid on *Sigismunda* itself. In concentrating so much hope on a work in which he could not possibly express his true self as an artist, he fell into a futile struggle with the established art world in which he could only exhaust himself. His earlier attempts at the sublime had not unduly distracted him, and they had had the virtue of enlarging the sphere of English art and putting him at the head of the artists united for the advance of their craft. In *Sigismunda* he moved away from the vital centre of his art activity and thus from the principles that had activated him throughout his modern history. Wilkes warned him with full clarity that he was betraying himself; but the warning had no effect. We see that Hogarth's own personal struggles and the historical crisis merged in driving him to produce *The Times*.

Once more we see his affinity with Defoe. The latter, in his *Hymn to the Mob* (1708), had expressed a strong conviction that the spirit of society, the moving force, resided in the mob, which had produced the Reformation. But now, in the interests of bourgeois society, the mob must be controlled and forced to labour. 'Since that, to every reformation true, Our mobs the reformation still pursue, And seldom have been in the wrong till now.' For *now* history has 'made two mobs of what was one before', and the populace are unstable. Paternal authority, expressed in the king and state, must be reasserted. These contradictions did not rend Defoe as they rent Hogarth at the end, for he was never faced with such a choice as the latter was with Wilkes. Hogarth's attitudes at this time are shown by alterations he made in plate 4 of the *Rake*. He introduced lightning jagging down out of the sky at White's gambling house: an apocalyptic world-end effect. The date of the addition is proved by the paper stuck in the hat of a gaming bootblack: 'Your Vote & Interest – Liberty', referring to the popular slogan of

Wilkes and Liberty. A parody of *The Times* in September showed buildings destroyed by thunderbolts. Perhaps at this time Hogarth redid plate 2 of the *Election*, making the lion toothless.

It seems that he at first hoped to patch things up with Wilkes; we are told that he called to see him in Salisbury, but Wilkes was away. However J. Ireland, who tells the story, confused the date of the *North Briton* no. 17 and may have got the visit wrong. According to Reynolds, he and Wilkes dined on the 13th at the Beefsteak; Hogarth was there but avoided Wilkes. Three prints attacked *The Times*, two by Sandby. One, *The Butifyer*, showed him whitewashing a huge jackboot labelled the Line of Booty (Beauty, Bute), suggesting that he was out for money. Churchill told Garrick: 'Speedily to be published, An Epistle to W. Hogarth, by C. Churchill.' Garrick pleaded for mercy on Hogarth. 'He is a great & original Genius. I love him as a Man & reverence him as an Artist – I would not for all ye Politicians in ye Universe that you two should have the least Cause of Ill will to Each other.' Then on 25 September Wilkes published a *North Briton* wholly devoted to Hogarth. He praised his past work highly: Hogarth 'possesses the rare talent of gibbeting in colours, and in most of his work has been a good moral satirist'. But now in his decline he has sunk to 'entering into the poor policies of the faction of the day, and descending to low personal abuse, instead of instructing the world, as he could once do, by manly satire'. Further, he argues that he has deviated from his true line into sublime history, *Sigismunda;* he makes attacks on the Old Masters that are dictated by self-interest; he can depict *Marriage à la Mode*, but not a *Happy Marriage;* he is personally vain and jealous; his powers have badly declined; he has accepted a sinecure from the king so that 'he is not suffered to caricature the royal family'. As for the role of Serjeant Painter: 'I think the term means what is vulgarly called house-painter.'

Some of these criticisms are unfair or unduly pressed. Wilkes goes much too far in saying that 'gain and vanity have steered his light bark quite thro' life. He has never been consistent, but to these two principles.' He was no doubt drawing on his memories of Hogarth's talk in recent years and attributing to his whole career the effects there given of meandering self-obsession. Hogarth could be very generous, and Wilkes was unfair in saying: 'He has been remarked to droop at the fair and honest applause given to a friend, tho' he had particular obligations to the very same gentleman.' He seems to be misinterpreting and incorrectly generalizing some of the touches of persecution mania that Hogarth had undoubtedly been showing. Wilkes adds that both the Society of Arts and that of Artists have 'experienced the most ungenteel and offensive behaviour from him'. Hogarth may have acted

too bluntly and rigidly in connection with the societies, but his positions were based on strong and consistent principles with which Wilkes should have sympathized.

Hogarth's own account of the episode is unsatisfactory. Ignoring the sums gained over these years through his patent, he states that he was driven to do *The Times* through lack of money. He had lost much time and prints were doing badly through the wars, so he had to do 'some timed thing' that would 'stop a gap in my income'. His print 'tended to Peace and unanimity and so put the opposers of this humane purpose in a light that gave offence to the Fomentors of distruction in the minds of the people'. One of the most notorious of these fomentors, 'till now rather my friend a flatterer', attacked him 'in so infamous a manner that he himself when pushed by even his best friends', was driven to 'so poor an excuse as to say he was drunck when he wrote', and Hogarth himself being at his work 'in a kind of slow feaver', found that 'it could not but hurt a feeling mind'. Indeed, rumours went round that he was dying; the artists began considering who would succeed to his patent. Wilkes wrote that 'Mr. Hogarth is said to be dying, and of a broken heart. It grieves me much. He says that he believes I wrote that paper, but he forgives me, for he must own I am a thoroughly good-humoured fellow, only *Pitt-bitten.*' The comment is heartless if he really thought Hogarth to be in a bad way; but on 16 December Baker met Garrick and Hogarth at a public execution in Golden Square, hardly the sort of event one would expect a sick man to attend on a wintry day.

Some time later Hogarth completed a companion piece to his print. That he intended to do two or more from the start is shown by *The Times* being described as *Plate 1*. But we have no clue as to whether the second print was designed about the same time as the first, or whether Hogarth worked it out some time afterwards, inserting details to make Wilkes's accusation of supporting a faction seem untrue. His notes are confused, but show a disillusioned outlook:

Plate 2 the two patriots who let what party will prevail can be no gainer yet spend their Blood and time which is there fortunes for what they think is Right a glass of gin perhaps to sperits and resolution ever to die in the Cause which after hapens in these contentious (times) what did the greatest Roman Patriots more.

Who the patriots are, is not clear, but the term suggests Wilkes and Churchill. In the background London is being rebuilt; in the centre is the king's isolated statue; on the right is Parliament where most of the members seem asleep, while the others shoot at the dove of peace in the sky; on the left is the dis-

orderly populace, with Conspiracy (Fanny of the Cock Lane Ghost) and Defamation (Wilkes) hung up in the pillory.

So far from aiding art, the king seems badly worsening things. The fine tower of St Mary-le-Strand is soon to be blotted out by the Premium-sign of the Society of Arts; the Bute-ifying of London goes on, with a distant Chinese pagoda to represent the tasteless taste that inspires it. The royal statue, repudiating the line of beauty, follows Ramsay's straight line, as is stressed by the notice: A *Ramsey delt*, and the plumbing board and deadline at its side. The statue's function is to pour water (money) from the lion-mouth on the pedestal to enrich the potted trees (placemen); 'James III' crossed out on the rose trees shows the Scots trying to hide their Jacobite connections. The chief gardener, Bute, controls the flow of bounty so that none reaches the laurel, Culloden (Duke of Cumberland). But heaven intervenes on the duke's behalf; Aquarius sends down a special jet for the tree. Only a feeble stream sprays out to the struggling crowd made up of war veterans. The people are barricaded and moated off from the royal enclosure, where the second gardener Fox, now Bute's leader in the Commons, is obstructed by a roller (the National Debt) as he drops clipped GRs (discarded placemen) into the moat. He had done much to complete the 1763 peace, in charge of the bribery and the expulsion of recalcitrant office-holders.

This print then differs from the first in aiming blows all round. Perhaps Hogarth did it to assert his independence and rebut Wilkes's charges. But he never issued it. Perhaps he felt too unnerved by the reactions to the first; perhaps he feared that he would seriously annoy Bute and the king. Then the political situation took a new turn. On 23 April the *North Briton* ended, a general warrant being issued for the arrest of Wilkes for failing to make the conventional distinction between the king and his ministers with regard to the speech closing Parliament. Arrested, he was lodged in the Tower. His long struggle with the oligarchic system of government, with the absolutist tendencies fostered by George III, had begun. This struggle was in effect to break up the system that Hogarth had come to accept as an ineradicable feature of society, and to lead, slowly, erratically, but surely, into a quite different political world. On 3 May Wilkes was brought before the Court of Common Pleas. Remanded to the Tower, on the 6th he was again brought to Westminster, before Chief Justice Pratt. He at once clarified the fundamental issue. 'The liberty of all peers and gentlemen, and, what touches me more sensibly, that of the middling and inferior set of people, who stand most in need of protection, is in my case this day to be finally decided upon: a question at once of such importance as to determine at once whether English liberty should be a reality or a shadow.' He briefly recapitulated the

violences to which he had been subjected. Pratt, evading the question of general warrants, found that a Secretary of State had the power of commitment to prison which an ordinary magistrate had, but declared that Wilkes had done nothing to justify the suspension of his parliamentary privileges. The crowd, inside and outside the building, shouted: *Wilkes and Liberty.*

Hogarth played an ignoble part. Wilkes noted: 'Mr Hogarth skulked behind in a corner of the gallery . . . and while every breast from him (Pratt) caught the holy flame of liberty, the painter was wholly employed in *caricaturing* the *person* of the man, while all the rest of his fellow citizens were animated in his cause, for they knew it to be their own cause, that of their country, and of its laws.' For all its rhetoric, that was a true judgement. Hogarth was too enclosed in a personal vendetta to grasp the significance of the event. He made a drawing of Wilkes with porte-crayon, later marked it with pen and brown ink, then incised it as he transferred it to the copper plate. His hand was shaky.

My best was to return the complement & turn it to some advantage his Portrait done as like as I could as to feature at the same time some indication of his mind fully answerd my purpose the ridiculous was apparent to every Eye a Brutus a saviour of his country with such an aspect was so arrant a Joke it set every body else a laughing gauld him and his adherents to death this was seen by the papers being every day stufft with evectives till the town grew sick of seeing my (drawing) always at length.

That Wilkes was galled was a pathetic illusion on Hogarth's part. He laughed: 'No! they shall never have a delineation of *my face*, that will carry to posterity so damning a proof of what it was', and so on.

When the High Sheriff, an MP, tried to burn the *North Briton* before the Royal Exchange, the crowd rescued the copies and burned a big Jackboot (Bute) instead. On the 12th, as an address of congratulation, wrung from the City, was being borne to the Palace, the people hooted it along Fleet Street; the bell of St Bride's and then Bow Bells were tolled. Hogarth's print, announced for 21 May, was a companion piece to that of the Jacobite traitor Lovat; Wilkes's wig was drawn so as to give an effect of devil-horns; he holds his staff of maintenance topped with a vessel suggesting the cap of liberty. (That cap had come into cartoons during the struggle against the Excise, 1733, and Pitt was shown by friendly artists as holding staff and cap.) The sketch, making the most of Wilkes's squint, was very effective. It drew both support and attack, but most commentators opposed Hogarth. Prints showed him with cloven hooves trampling the cap of liberty, while his paint pot is labelled 'Colour to blaken fair Charachters'. Or he paints Wilkes with *Sigismunda* at his side, producing two works of equal caricature. In the latter

print Bute leans approvingly on his chair; in the first is a moneybag, '£300 per Ann. for distorting features.'

Churchill's poem, after many delays, at last appeared late in June; the delays were due to bad health, not to a wish to work on Hogarth's nerves. A work of 654 lines, it showed considerable moderation; 308 lines are used up in a prefatory discussion on Satire. Hogarth is accused of envy; Churchill describes at length his self-obsessed talk and his endless boasting of *Sigismunda*, then praises him strongly for his earlier work, while stressing his physical and intellectual decline. Apart from the passages on envy and detraction, we cannot say that the poet is letting himself go with the usual virulence of the age's satire. Thus he deals with the caricature of Wilkes:

> *When Wilkes, our countryman, our common friend,*
> *Arose, his king, his country to defend;*
> *When tools of power he bared to public view,*
> *And from their holes the sneaking cowards drew;*
> *When Rancour found it far beyond her reach*
> *To soil his honour, and his truth impeach;*
> *What could induce thee, at a time and place,*
> *When manly foes had blush'd to shew their face,*
> *To make that effort which must damn thy name,*
> *And sink thee deep, deep in thy grave with shame?*
> *Did virtue move thee? No; 'twas pride, rank pride,*
> *And if thou hadst not done it, thou hadst died.*

Thus he describes Hogarth in his monologues of self-praise:

> *Oft have I known thee, Hogarth, weak and vain,*
> *Thyself the idol of thy awkward strain,*
> *Through the dull measure of a summer's day,*
> *In phrase most vile, prate long, long hours away,*
> *Whilst friends with friends all gaping sit, and gaze*
> *To hear a Hogarth babble Hogarth's praise.*

He may exaggerate in saying that Hogarth kept claiming 'to challenge, in one single piece, The united forces of Italy and Greece', then made nonsense of his words by producing *Sigismunda;* but it is clear that he grew quite unbalanced in his estimate of that painting. When we look at it, we may now well wonder what all the uproar was about. It certainly stood high in the rather meagre achievements of English sublime history at this date; and later, bought by Boydell and engraved, it found its place in that genre. We can only understand the controversy around it when we relate it to the whole complex of Hogarth's struggles. Wilkes was quite right in seeing the

work as a dereliction from Hogarth's true role as an artist; but the argument about it was largely provoked by Hogarth's own propaganda on its behalf, which gave his many opponents a secure basis for ridiculing him. What they really wanted to undermine was his genuine creative achievement, and it was he that gave them their chance by confusing the issues. Thus his claims for *Sigismunda* and his attacks on Wilkes have their roots alike in his failing grip on reality.

Churchill ended his poem with the counsel that alone could have put him back on the road native to his genius.

> *Blush, thou vain man! and if desire of fame,*
> *Founded on real art, thy thoughts inflame,*
> *To quick destruction Sigismunda give,*
> *And let her memory die, that thine may live. . . .*
> *In walks of humour, in that cast of style*
> *Which, probing to the quick, yet makes us smile,*
> *In comedy, thy natural road to fame,*
> *Nor let me call it by a meaner name,*
> *Where a beginning, middle, and an end,*
> *Are aptly joined; where parts on parts depend,*
> *Each made for each, as bodies for their soul,*
> *So as to form one true and perfect whole;*
> *Here a plain story to the eye is told,*
> *Which we conceive the moment we behold,*
> *Hogarth unrivall'd stands, and shall engage*
> *Unrivall'd praise to the most distant age.*

The account there of the living unity of conception and execution in the modern histories is perhaps the finest praise that Hogarth got in his own period. On 25 June Birch had written that he was 'extremely unhappy' through Wilkes's attack and 'his apprehension of the threatened poem of Churchill, wch, it is imagined, will be almost a Death's wound to him. His Vanity with his Success always made him impatient of any mortification.' But when the poem appeared, Morell, who took a copy to him, stated that 'he seemed quite insensible to the most sarcastic parts of it. He was so thoroughly wounded before by the North Briton, that he lay no where open to a fresh stroke.' Hogarth himself writes: 'Churchill W—— toadeater put the North Briton into verse in an Epistle to me, but as the abuse was the same except a little poetical heighting which alway goes for nothing, it not only made no impression but in some measure effaced the Black stroke of the N.B.' However, one of the Chiswick housemaids said that he never smiled again after the *Epistle*. Garrick thought it 'ye most bloody perform-

ance that has been publish'd in my time', and singled out the account of Hogarth's infirmities as 'shocking & barbarous'.

Certainly Hogarth could not hold himself back from replying. He took the old plate of Guglielmus Hogarth, erased his own face and the palette, and substituted a clerical bear with club and beerpot, the bruiser, a Modern Hercules 'Regaling himself after having Kill'd the Monster Caricatura'. Churchill was large and clumsy, with heavy face, thick arms and legs and lumbering body, so that the bear image was not inept; later he used it of himself. In the sixth state Hogarth added a small inset with complicated emblematic points. He himself whips the bear and the monkey (Wilkes); there is a tomb for Pitt (now as good as dead) with Gog and Magog from the Guildhall crowning him and holding a shield; Pitt uses a match from the giants' pipes to fire a cannon ball at the royal standard and its doves of peace. This addition suggests that Hogarth felt the lack of content in merely depicting Churchill as a boozy bear.

Churchill declared that he would reply. 'He has broke into my pale of private Life, and set that example of illiberality . . . I intend an Elegy on him, supposing him dead.' He had forgotten Wilkes's unkind reference to Jane Hogarth in the *North Briton*. Birch, on 6 August, wrote that Hogarth 'seem'd to me much more in Spirits when I met him a fortnight ago, than he had been for some time past'. Hogarth in his notes claims that 'the satisfaction (and pecuniary advantage) I received from these two prints together with constant Riding on horse back restored me to as much health as can be expected at my time of life. What may follow god knows Finis.'

Wilkes was carrying on his fight inside the Commons and outside. In November Martin, who had bided his time several months since the exposure of him in the *North Briton*, launched an attack on its author in the House as 'a cowardly rascal, a villain, and a scoundrel' (repeated twice). Next morning he got the expected letter from Wilkes challenging him to a duel. Martin accepted and hurried in with a proposal for the use of pistols immediately in Hyde Park, though Wilkes as the aggrieved party had the right to name weapons. In the duel Wilkes was shot in the groin and, in the belief that he was dying, he told Martin to flee to France. However, he recovered. At the time he had no suspicion of foul play. But it came out that Martin had been practising with pistols all the summer till he was a dead shot; that was why he had delayed his insult and tricked Wilkes into accepting pistols. Horace Walpole commented: 'I shall not be thought to have used too hard an expression when I called this a plot against the life of Wilkes.' And later Wilkes found that Martin had been paid by the government to kill him. 'Under the head of *secret and special service* I find that between October 1762 and

October 1763, a most *memorable year*, there was issued to Samuel Martin, Esq., £40,000.' Hogarth continued to be a friend of Martin. On 24 December Wilkes got away to France and on 2 January 1764 was expelled from the Commons.

By the end of 1763 Hogarth must have felt very alone. Most of the men who had been close friends were dead or had gone abroad like Garrick and Martin. Huggins had died in July 1761; Ralph and Roubiliac in 1762. There was no longer any group with which he could feel fellowship. Oddly, to attack Churchill, he had obliterated his own face and put the enemy looming up out of the oval of observation that had once been his. Probably it was in 1763 he promised Charlemont a written account of his plates, 'which he said the public had most ignorantly misconceived; and it was his intention, at one time, to have given a breakfast lecture upon them in the presence of his Lordship, Horace Walpole, Topham Beauclerc and others', but never did. He declared of his prints: 'It becomes at this time still more necessary than ever as not only imperfect but wilful misrepresentation of some of them have been published with an intent to render them either ridiculous or immoral the effects of which tend not only to the injuring me in my property but sully my character as a man the latter of which to an honest mind is far more painful that either his Interest or his reputation as an artist.' What he meant to write of the prints was 'not only a description but also what ever occur'd to me as relative to them'.

He insisted: 'The three things that have brought abuse upon me are 1st the attempting portrait painting 2nd the analysis 3rly the Print of the times.' He goes on: 'Story of Coram', but switches from portraits to art in general. 'Painting & Sculpture considered in a new manner differing from every author that has as yet wrote upon the subjects the reason for this hardy attempt is ye *Injury* which I humbly conceive the arts have labour'd under by the Prejudices imbibed from the Books hitherto written on this subject.' For a while he returns to his personal story, ending with the account of *The Times* and the word 'Finis' cited above. He seems next to make various remarks on the moral aim of his work and his own experiences. Throughout there recurs a sense of persecution: 'When a man is cruelly and unjustly treated he naturally looks round and appeals to the standersby.' In his account of Rouquet's book on the prints he breaks out: 'Their Malice is so great as they could not (illegible) it that they endeavoured to wound the peace of my family.' He feels so strongly about this point that he puts a circle round the words. In an incoherent passage on 'envious attacks' he remembers Le Blanc: '. . . by lowest le blanc prejudices against me what cultivated by who and for what ends'.

This year 1763, revising plate 8 of the *Rake*, he stuck an overlarge coin on the wall of Bedlam, with a wild-looking Britannia. Bedlam now includes the whole of the realm. (Smollett used Jail as a microcosm of society in *Peregrine Pickle* or, less effectively, in *Sir Launcelot Greaves*.) He had been hardening his own face in the painting of the Comic Muse; now he changed the face and mask of the Muse from white to black, and scored her face with lines, giving it a tragic look, while the mask grew horns and looked like a satyr. He ruled out his title and finally allowed only the words: 'William Hogarth – 1764'. A more cheerful note is struck in a glimpse of him in his last days by the dissident history painter James Barry. Barry was walking with the sculptor Nollekens through Cranbourn Alley, when the latter cried: 'There, that's Hogarth.' 'What!' said Barry, 'that little man in a sky-blue coat?'

Off I ran, though I lost sight of him only for a moment or two, when I turned the corner into Castle-Street, he was patting one of two quarreling boys on the back, and looking steadfastly at the expression in the coward's face, cried, 'Damn him! If I would take it of him; at him again!'

The Society of Artists was doing better every year. Now on 24 January they agreed to beg the king to incorporate them by royal charter, which was granted the next January. By 1768 the Royal Academy was born, with Reynolds playing a leading part. Hogarth meanwhile had stubbornly returned to the project of engraving *Sigismunda*. On 2 January 1764, with script now tremulous, he reopened his subscription book. 'All efforts to this time to get this Picture Finely Engraved proving in vain Mr Hogarth humbly hopes his best indeavours to Engrave it himself will be acceptable to his friends.' He speaks of friends, not of the public. Till the end he worked at his plates, revising, aided by craftsmen whom he took along to Chiswick.

On 1 April the sun was totally eclipsed. Mid-April came the print, *Tail-piece, or the Bathos*. A story tells how one day while 'the convivial glass was circulating', he said: 'My next undertaking will be the End of all Things'. A friend replied: 'If that is the case, your business will be finished; for there will be an end of the painter.' Hogarth sighed heavily. 'There will so; and therefore, the sooner my work is done, the better.' He started on the print next day and worked hard at it. However that may be, the theme had been in his mind as we have seen from his comment: 'What may follow god knows Finis'. He heaps together emblems of breakdown and world end, failure and death: gallows, unstrung bow, broken crown, tombstone, worn broom stump, rope end, dead trees, smashed bottle, sinking ship, empty purse, cracked palette, snapped musket, split bell, guttering candle, setting sun, clock without hands, death's-head, a shoemaker's waxed-end twisted round a wooden last, statute of bankruptcy with seal (pale horse with pale

rider, Death), and label: *H. Nature Bankrupt*. The Inn of the World's End falls down; the sun chariot crashes in the sky; the moon wanes; the print of *The Times* will soon be burned by a candle. Amid all the litter of death lies Time, his scythe and hourglass broken, his will made. The text he has been reading concludes with *Exeunt Omnes*; the play is over. With his last breath he exhales FINIS. The broken bow is by the defeated line of beauty.

The theme is the death of the artist who had hoped to embrace all life and to realize the line of beauty and energy in all things. And yet, even in his desperate acceptance of death, he cannot help propagating his ideas. The picture is also a satire on Dark Art and the Sublime from which the connoisseurs have excluded him. 'The Bathos, or Manner of Sinking, in Sublime Paintings,' runs the caption, 'inscribed to the Dealers in Dark Pictures.' A footnote adds: 'See the manner of disgracing ye most Serious Subjects, in many celebrated Old Pictures; by introducing Low, absurd, obscene & often prophane Circumstances into them.' He is satirizing the art taste that found sublimity in vastness, deserts, rocky depths, Addison, no doubt with Milton in mind, had opposed greatness to beauty in such terms; but Hogarth was probably thinking of Burke, who found sublimity in the apprehension of pain, obscurity, power, privation, vastness, infinity. The death image becomes a taunt thrown back at his opponents. Churchill wrote under a copy:

> *All must old Hogarth's gratitude declare,*
> *Since he has nam'd old Chaos as his heir;*
> *And while his works hang round that anarch's throne,*
> *The connoisseur will take them for his own.*

That is ambiguous. It could mean that Hogarth's works have here reached their proper destination; but it could also mean that only when their meaning is distorted in terms of a false sublimity will the connoisseurs accept them. Further, we are reminded that behind *The Bathos* lies the end of Pope's *Dunciad*, which describes the same sort of death scene, though without its heap of emblems. In both cases world-end comes about through bad art, through the Goddess of Dullness or the Muse of Sublimity.

To stress his point, Hogarth cannot resist intruding in his text a pyramidal shell: 'The Conic Form in wch the Goddess of Beauty was worshipd by the Ancients at Paphos in ye Island of Cyprus. See the Medals struck when a Roman Emperor visited the Temple.' He has been excited at discovering, or having brought to his notice, two ancient texts on the Cone (Tacitus and Maximus Tyrius), which he cites. On the other side of the print he shows a cone round which twines the Line of Beauty: 'A Copy of the precise Line of Beauty, as it is represented on the 1st explanatory Plate of the Analysis of

Beauty. Note, the Similarity of these two Conic Figures, did not occur to the Author, till two or three Years after the publication of the Analysis, in 1754.' So, at the moment when he seems to be giving up the ghost, he is full of combative delight at what he feels to be a verification of his *Analysis*.

Before June he was weakening and had to call in E. Edwards to make the drawing of *Sigismunda* from which an engraver could work. On 12 June, apparently for a friend, he copied out the account of how he came to do the picture, which he had put in the subscription book, adding that the work had been 'after much time and the utmost efforts finished, BUT HOW! the Authors death as usual can only positively determine'. Basire (later the artist to whom Blake was apprenticed) was to do the engraving, though 'I shall take care of the head myself'. To the materials assembled in the subscription book he added: 'Things having been represented in favour of his Lordp (Grosvenor) much to Mr Hs dishonour, the foregoing plain tale is therefore submitted to Such as may at any time think it worth while to see the whole truth, of what has been so publicly talked of.' The question of his relations with Grosvenor was in fact of little importance; the main thing was that the patrons and so many others had laughed at the picture itself.

On 16 August he made his will. His chief property was the plates, which were not to be 'sold or Disposed of without the consent of my Said Sister and my Executrix', Jane. They were to stay in Jane's possession while she lived, 'if she continues Sole and Unmarried and from and immediately after her Marriage my will is that the three Sets of Copper Plates', the *Progresses* and *Marriage*, 'shall be Delivered to my said Sister'. If Jane died, they all went to Anne. He also left to Jane unspecified moneys and securities, and his properties in London and Chiswick. Anne got an annuity of £80; Mary Lewis, £100 for 'her faithful Service'; Miss Bere, a ring valued at five guineas; Samuel Martin, his own portrait; Sir Isaac Schomberg, a ring valued at ten guineas. That he included Martin here among his close intimates shows how highly he estimated this unscrupulous politician and foe of Wilkes.

By September he was too ill to attend to his affairs as Serjeant Painter. His deputy, S. Cobb, appears in the records. Through this and the next month he seems to have been at Chiswick, working when he could on revising old plates. He was still much concerned to explain his idea of character, turning afresh to the *Bench*. He erased the strip across the top and introduced faces in varying degrees of caricature; only the sharp-nosed judge was taken from the main part of the print, the other heads being drawn from Raphael's cartoons. (He no doubt used Thornhill's sketches.) The plate was unfinished at his death. An assistant added: 'This plate would have been better explain'd had the Author lived a week longer.'

On Friday 25 October he was taken to Leicester Fields 'in a weak condition, yet remarkably cheerful'. Jane stayed on at Chiswick, so it seems he was not thought to be in danger. He found awaiting him a letter from Benjamin Franklin about an order for a complete set of proofs, He

drew up a rough draught of an answer to it; but going to bed, he was seized with a vomiting, upon which he rang the bell with such violence that he broke it, and expired about two hours afterwards in the arms of Mrs Mary Lewis, who was called up on his having been taken suddenly ill . . . Before our artist went to bed, he boasted of having eaten a pound of beefsteaks for his dinner, and was to all appearance heartier than he had been for a long time before. His disorder was an aneurism. (Nichols)

He died only a few days before his sixty-seventh birthday. His body was carried to Chiswick and a cast taken of his right hand. On Friday 2 November, a week later, he was buried in a plot in St Nicholas's churchyard, where already lay the body of Lady Thornhill. Not far off was James Ralph, and inside the church, in the Burlington vault, were his old opponents Lord Burlington and Kent. In 1771 Anne was buried beside him and a monument was set up by Garrick. In 1789, after some twenty-five years of selling his prints, Jane joined him. Mary Lewis was the last of the household to be buried there, in 1808.

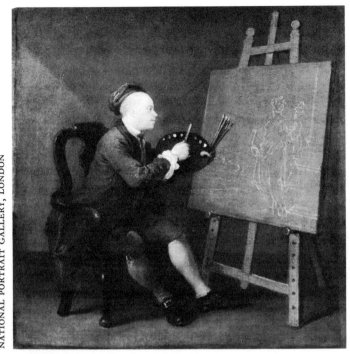

*Self-portrait: Painting
the Comic Muse, c. 1758*

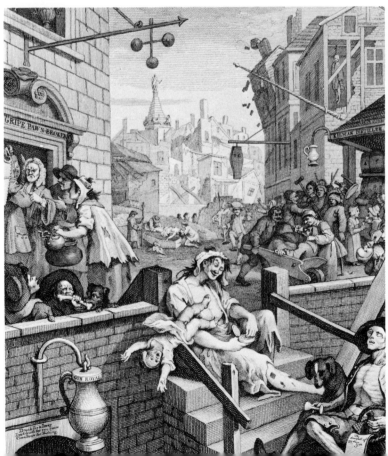

Gin Lane, 1751

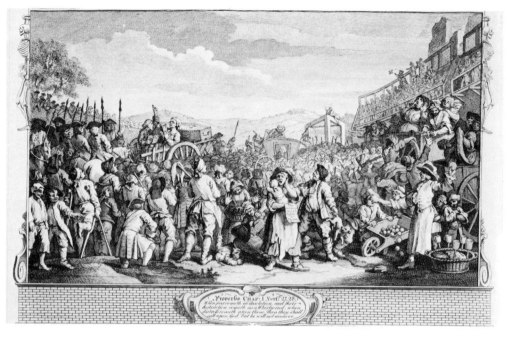

11. The Idle Prentice Executed at Tyburn

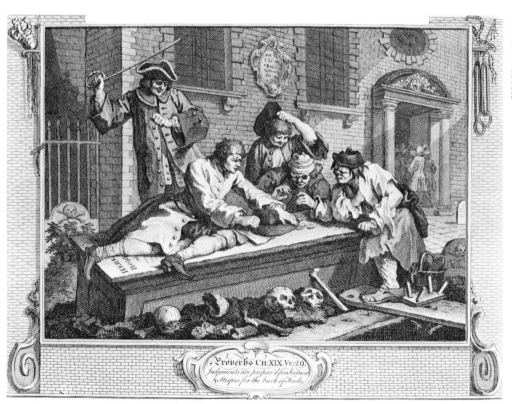

3. The Idle Prentice at Play

INDUSTRY AND IDLENESS, 1747

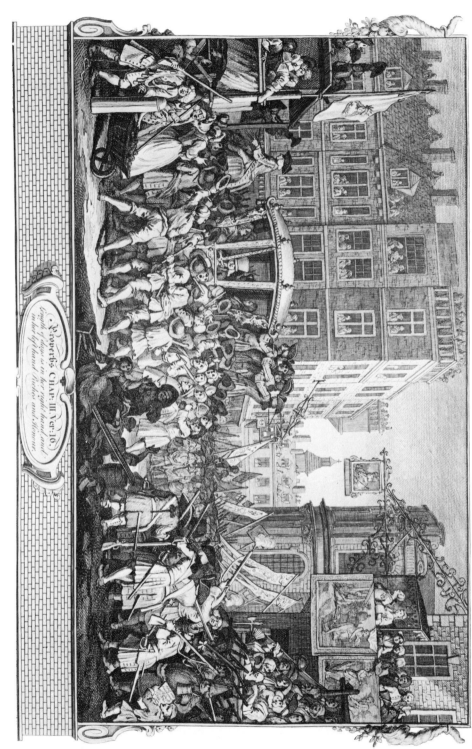

Proverbs Chap. III Ver. 16.
length of dayes is in her right hand, and
in her left hand Riches and Honour.

Hogarth's House at Chiswick

Hogarth's Servants, c. 1750–55

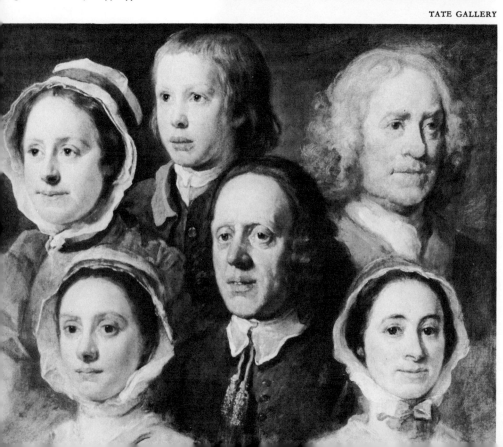

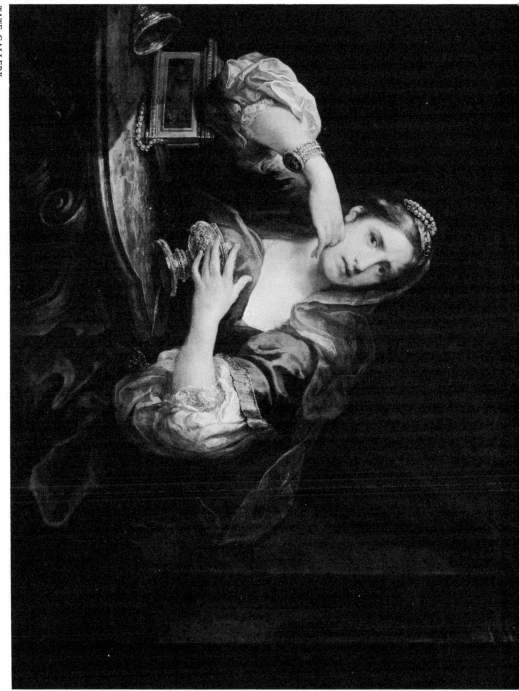

Sigismunda, 1759

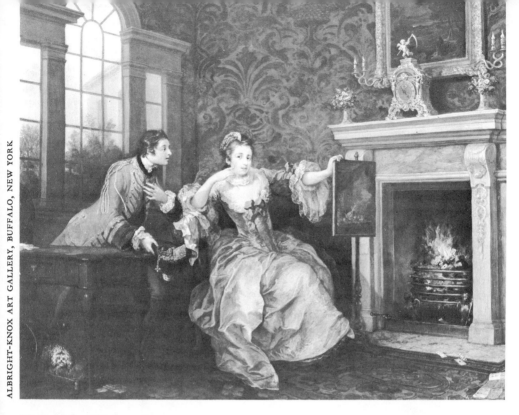

The Lady's Last Stake, 1758–9

The Times 1, 1762

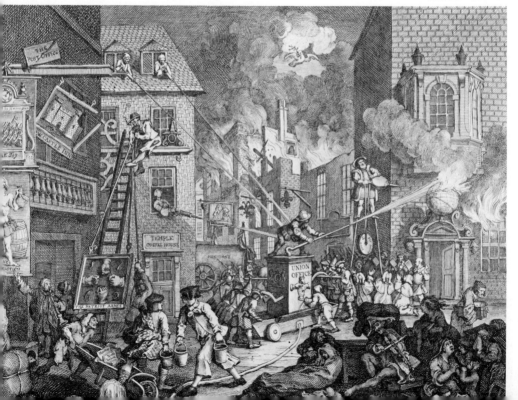

Sigismunda, 1759

The Lady's Last Stake, 1758–9

The Times 1, 1762

Simon, Lord Lovat, 1747

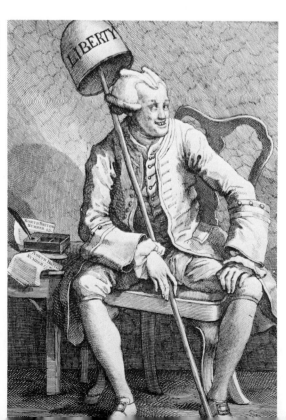

John Wilkes, 1763

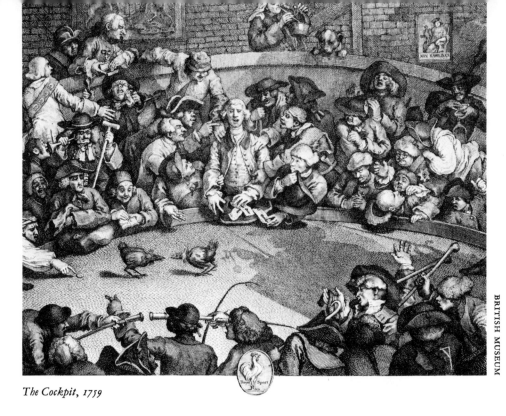

The Cockpit, 1759

Tailpiece, or the Bathos, 1764

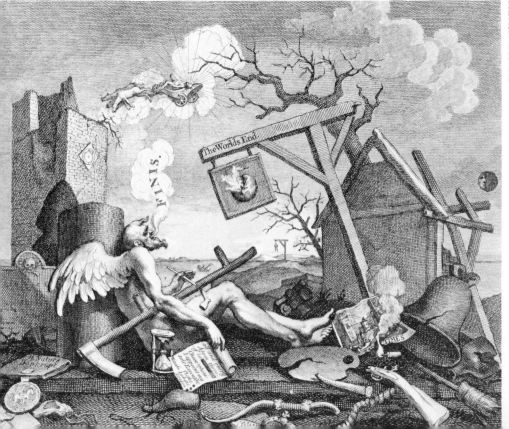

Notes

I must repeat here the debt to R. Paulson's exhaustive researches into all details of Hogarth's life and into the themes of the pictures. Since his vast apparatus of notes and references is readily available, I have kept my own notes to a mimimum. I should like also to express my debt to Burke's edition of the *Analysis* as well as to draw attention to Kitson's text of the *Apology* and Mitchell's of the *Peregrination*. The following abbreviations are used: A for Antal (1); AB for Burke's *Analysis;* Ap. for Kitson's edition of the *Apology;* D for Dobson (1); GW for Paulson's *Graphic Works* i; H for Hogarth; P for Paulson (2) i, and P ii for the second volume; Q for Quennell.

Chapter 1 Early Years

For refs. P ch. 1; D and P; appendices ABC. *Remnants of Rhyme*, Thomas Hoggart, of Troutbeck (Kendal, 1853). We can ignore the tradition of a Yorkshire origin, Smithfield: Ned Ward ch. v; *Oliver Twist* ch. xxi; Wheatley, Phillips, Roquet, T. Brown iii, 33. Fair: Morley, Ward, T. Brown i, 191. St Bartholomew's turned Palladian by Gibbs in 1730s. Citations: AB 204, 48, 184f, 43–5 (jack); Ap. 106. Artist: P suggests John Dalton, Rogers, Woolaston, Egbert van Heemskirk, who depicted Quakers' meetings; his son, singer and painter of drolls, published 1734, *Nothing Irregular in Nature*: P 310 n28, also Antal, Index, Heemskirk. *Grammatica:* JWCI ii, 82–4, with Latin citations and basis of the image in Plutarch, Petronius, Theodulf of Orleans, Melancthon. Tom Brown i, 190.

Chapter 2 Gaol and Apprenticeship

P ch. 3; AB 204f, 201. Gamble lager: P 45. Adcock 39. Edmund Hogarth died early 1719, cutting Anne H. off with a shilling; the family must have pestered him. Dec. 1711 Richard published *Disputationes Grammaticae*. Caricatures: Paston 1f; Gray to Chute in Florence, May 1742; P 472f, 266 (de Hooghe); A 139f; Gombrich (1) 134, also for relation to modern cartoon. Pleasure: AB 201f, 207. Mnemonics,

ib. 202, 206; monsters, 50; also 210f, 106, 210. Vertue i, 1; iii, 146f. For full background of mnemonic systems with pictorial elements, see the works of Frances A. Yates. It is possible H. knew something of Renaissance systems through his father. Work of de Hooghe, 1670, for *Tab. Ceb.* shows scenes close to *Rake's Progress.* After Peace of Utrecht, Dutch and French engravers came in; large projects appeared (Marlborough's Battles, Thornhill's St Paul paintings).

Chapter 3 Masquerades

Callot: Tate no. 2; A 82–4; La Mottraye, A 85–7; Bosse, P 515 n29. Pattern-books: P 514 n22. Watteau in England 1720–1, no sign that H. was yet aware of him. *Scheme:* Picart and A. Ramsay, P 73f. General: Carswell, Erleigh, Paston 88ff; A 80f. Directors operate the wheel; note parody of the Monument; GW 95f. Enigma: Montagu. Still-life: Gombrich (1) 103f. Hercules: GW 93f. Curiosity: AB 171. La Fontaine: McGowan; see also Whitney, Green, Praz(3), Tuve, Levéque, Clements, Freeman, De Vries, Volkmann, R. Klein. For dissenters on 'ocular language', Toplady in 1888 (Edinburgh) ed. of Quarles. Allegory: GW 96f; A 81–3; Addison on Allegory, *Spectator* 1711. Early allegorical design by H of Hercules killing Hydra as Hanoverian defeat of Jacobites, the Graces as Trade, Arts, Royal Power. See Hunter for Defoe's Emblematic Method and puritan structure of experience; *Crusoe* 'portrays, through the struggle of one man, the rebellion and punishment, repentance and deliverance, of all men, as they sojourn in a hostile world', 126. Stubbe: Brodsley, D. George. Clarissa: vi, 108–10; Doody 222; A 80f. History: AB 215, 230; P 144f, citing Steele; Defoe, *The Lay Monastery* (1714), 188; AB 171. Congreve, *Love for Love*, I, ii. Thornhill: Mayhew; A 39, 32f; P 521. Vertue thought he learned much from Laguerre. Kneller: Raines 49, 63. Academy: P 93, 98f; AB 284f, 198. History: Elsum and Richardson, P 97–9; A 142. Anatomy: AB 72f, 126f. Kent: Lees-Milne, M. Jourdain, Croft-Murray, H. E. Stuckeley, Wittkower (1–3); P 518. Moyle: *Two English Republican Tracts*, ed. C. Roberts 1969; *Works* i, 1726, reprinted 1728, 1750, 1796. Gothic: P 103f. Ellys got keepership of King's Beasts in Tower for forming Walpole's Houghton Collection. Gibson: P 116, Sykes. Books on way to trunk maker: Fielding, *Covent G. J.* vi; Moore 91. Invasion of West End by popular shows: P 114–16; L. Hughes 96–104; James Thomson, *Letters and Docs.*, ed. A. D. McKillop, 55; Power 257, preface of *The English Stage Italianiz'd*, 1727: A 64; AB 49. Gusto: P 520 n19. Morley 224 (Southwark). *Tale of a Tub*: cf. Carlyle *Sartor Resartus.* AB 205, P 119 n22. The debasement of the stage recurs as theme in *A Just View.* Obituary. *Public Advertiser* 8 Dec. 1764.

Chapter 4 Hudibras and Macheath

Eclipse: cf. Brueghel's *Combat of Strong Boxes and Little Saving Boxes;* Florentine Bracelli broke humans into kitchen utensils etc.; A 131. Also Rosso with his mask-like faces; Archimboldo making forms from plants, animals etc. T. Stimmer 1577 shows the Pope made up of clocks, candles, bells. Freemasons: AB 148; Eric Ward; P 134, 521 n37. Repression: Plumb ii, 40–9; Beattie (2) 71–3. Coypel's print is described in *Analysis.* Gildon: GW 105f, also other early works: P 147, 155 etc. Academy: Vertue vi 170; Ap. 93; A 36; P 93, 108. Thornhill's Coll.: *Burl. Mag.* June 1943 133; A 76. Theory: Du Fresnoy (verse-transl. by Dryden), Du Bos,

Richardson. With Winckelmann the baroque is rejected; only the ancients matter. West: O. Sitwell 5. Butler: Wilding 97; Butler (2) 278, 469. Frontispieces: Hammelman. Engravings: A 87–9, GW 115–27. Temple Bar: cf. *Night*, also Restoration Day. April 1725, agreement with P. Overton for set of large illustrations; H. had no doubt noted success of Coypel's *Don Q.* and had his mind turned again to Butler, to 'the Don Quixote of this Nation' as the advertisements said. Overton seems to have felt the attraction lay in the poem and was not keen to mention H. *Hudibras* and pop. prints: L. Brodsley. See AB 136, ref. to Hudibras' beard, 'the inimitable Butler, Sheppard: Wind. JWCI ii, 121–4; Thornhill drew the highwayman at Newgate. Paviors: Welch, note figure in *Beer Street*. St Paul's: GW 136f, P 140–5, Raphael. Milton: A 143f, GW 112f. Dedication of *Hudibras* prints to Alan Ramsay. W. Ward, co-dedicatee, barrister: P 156. Covent Garden: Raines 6. Defoe in *Compleat London Tradesman* describes movement of mercers into and out of C.G.; T. Brown i, 110. Early painting: Tate nos 9f, A 79, 90f, 93. H. cited: AB 192, 84f, Defoe: A. F. J. Brown 16. J. Stow, ed. J. Strype, *A Survey* etc. (1720) Bk vi, 87ff. Greenwich: AB 132. Cherubs: AB 50, Ap. 86f, GW no. 22; note Lovelace's jokes on cupid-cherubs: *Clarissa* vii, 331f. Gay: P 161; Burgess 53f. D (5) 5; signpost, P 90 n13. For suspicions as to Papistry in art, cf. the trouble over Burlington's design for Mansion House, Laver 104; Reynolds and West foiled by Bishop of London in scheme of painting St Paul's. *Don Q.:* A 148–51; P 161f, 165–7; H. Overton kept the print, then pub. it separately. Play: *Sancho at Court*, 1742. Toft: note figures at opened door, right. *Gulliver:* 1725–6, III, v and ii, experiments with ordure; the flapper said to relate to Newton. AB 91, 26. Ticket: A. 74, Callot. Fielding has much on Heidegger: *The Author's Farce* 1730 (Count Ugly), *Tom Jones, Increase of Robberies, Amelia*. P 111–18 with refs. *Henry VIII:* related to Coronation, not a scene from Shakespeare, A 144f, GW 127f, Tate no 21, P 326, Hughes 113f (long run). Vertue vi, 190. Theft: A 90, Steen. Tapestry: Based on his *Tellus* (P. pl. 7) or Le Brun's cycle used in Soho factory. P 178–80. May 1728 saw the *Dunciad*. Dancing: AB 15, 162, 156f. Laroon and stage: Raines 53, 68. Richardson opposes stage and art: P 18. Betterton advised actors study History, 'because the knowledge of the Figure and Lineaments of the Persons represented will teach the actor to vary and change his Figure.' Both actors and artists were told to study ancient statues: P ii, 26; Tate no. 43. Dance again: AB 147–9, 156–61, 183, 188. Arthos: 55, 80 etc.; H. Tatiya, *Aedes Barberinae ... Descriptio* (Rome) (1642) 124. Bernini, Dramatist, profiteer, artist, built the Cornaro chapel earlier on theatrical lines. *Tale of a Tub*. Intro. *Beggar's Opera:* A 297–9, 59–62 (Watteau, Gillot, Ricci); W. S. Lewis (2); Schultz. Crime: Beattie (2) 72f; Hitchin 2; Defoe, *Effectual Scheme;* Howson 317–24; Plumb (2); Speck. The elder Ramsay and *Beggar's Opera:* Smart 10. *Burlesqued:* accepted by Antal, 61f, and Moore, 87; GW 297–9; Oppé pl. 3 no. 12. *Hudibras* was drawn into the ballad-opera vogue that lasted till about 1733; in May 1727 at Lincoln's Inn Fields was staged *The Wedding ... with a Hudibrastic Skimmington. Ut Pictura:* Dobai 346; Shaftesbury (2) 167; R. W. Lee; Leonardo on expressive movements of dumb, *Trattato* ed. Du Fresne 1651 cap. L; A 238 n24. H takes over, transforms a rather academic tradition, the official Félibien–Lebrun theory stressing importance for artist of the stage with three classical unities. Antoine Coypel, 1721, stressed the value for painting of the actor's gestures (thinking mainly of grand over-life-size ones). Diderot, 1751,

tried to merge the new realism in France with the classical tradition in the Academy of *ut pictura poesis*, arguing it was the dramatic poets that were most relevant. Shaftesbury said the same thing. But H was looking for realist and popular elements in the theatre. Thornhill: P 194f; Mayhew. Garrick: P 194; AB 210. Only sketches for subject paintings are for stage-scenes from same notebook.

Chapter 5 The Harlot's Progress

Bainbridge: A 91; P 198–200, 328 n7. Huggins and Thornhill: P 90. Tothall: Mitchell. Engravers: A 78f, P 206, GW. *Denunciation:* A 94f (van Heemskirk). De Veil soon after took house in Leicester Fields; P 550 n57; *Biog. Anecd.* (1782) 211. Christening: A 94 (Picart); Simpson etc., P 234f. *Midnight Conversation;* 7th c. print, Ashton A 41f; engraving more compact; Boswell 1778, leads into ghost-story; D. 46; Bourne, *Poematia* (1734) 146; *Gent. mag.* (1755) 85. Shand: P229, 530 n62. Portraits: AB 202, P 530. Conversations: Edwards, 63; Praz (1) 68f; Raines 64, 76; A 34, 2 n1; Williamson; S. Sitwell attributes too much to H; P 213, 203 Vertue iii, 40f. In 1730 H and Thornhill worked together on painting a session of the Commons. Wedding: Raines 78; A 42f; Tate no. 28. Cock: Tate no. 49. Mitchell: on good terms with Pope; H did frontispiece to his ballad-opera, *The Highland Fair,* pub. March 1731; P 235–7. Fielding: Moore, ch. 3. Pendarvis: Llanover i, 283; P 224-6. *Before–After:* A 95, Tate nos. 50–3; Raines 65f; P 229f. William, son of John Huggins, got Thomson's version of the Bainbridge painting and the version of the *Beggar's Opera* meant for Grant (also incriminated). *Taste of Town:* GW 299f. *Man of Taste:* A 29, P ii 375. Masons: P 342f. *Harlot:* Vertue iii, 58 (732); Steele, *Spectator* 266 (4 Jan. 1712); Kurz 150; cf. in general, Richardson's *Pamela* (1740), trials of virgin. Italy: Kunze for further details; clash of jealous lovers in *Specchio* vii; no prison scene in Italians. For two children, cf. *Enraged Musician.* The set: P 240–50; Kurz 149; GW 141–52; A 99–101, 105. *Lo Specchio* uses pictures in a simple way as comment. Comic Strip: Kunzle (2). Bawd later taken as Mother Bentley; Gonson, Q 81. City life: A. Smith ii, 280; Fielding, *Enquiry* 2; Beattie (2) 92f; Wrigley; D. Davis. Jew: GW 145 (David), 245; pl. 5, Jew's Bread (fly-trap) by door; Abrahams; T. W. Perry; T. Brown ii, 282. Gibson had petitioned the king to suppress masquerades. Lillo: A 11f; E. Bernbaum; Hughes 150–3. The play was done 22 June 1731, that is for summer audience of citizens; then taken up by Goodman's Fields; then as Christmas play. In 1751 a real life George B. in audience so affected he fell into violent fever and terrible remorse, was attended by Dr Barrowby of St Bart's. Pictures: P 236f, 534 n48 (Laguerre); symbols, P 266 n9. Obscene words: GW ii 147. Plate 6: Cust 40. Politics: P 539 n30, 533 n2, 290. Gombrich (1) ii 122 and *JWCI* v (1942), 100, 128. Rossetti: W. E. Fredeman, *Prelude to the Last Decade (Bull. J. Rylands Lib.)* 52. Caravaggio was accused of treating history as genre, H. genre as history. Ralph in *Weekly Register,* 3 June 1732, on painters afraid of new stories, praises H. *Robin's Progress:* Walpole (1) iv, 144. Hogarth: P 470, ii, 408; AB 212, 215f; Houghton Lib. MSS, Hogarth. Audience: A 57. Painting and engraving: GW 53ff; Burke xlii; Lippmann; A 52. Left–right: P 262f; Reading, cf. Lamb etc., Lord Gardenstone, 'I can read his works over and over . . .', *Gent. Mag.* (May 1735) 344; D 54. Audience: *Epistle from T. Cibber to D. Garrick* (1755) 2; Hughes 7–10; Loftis (1) and (2); Watson

Nicholson, *The Struggle for a Free Stage in London;* Colman, Epilogue H. Kelly's *Clementina* 25 Feb. 1773. Audiences could be up to 1500, Hughes 182f. Musicians: Young, ch. v. In 1731 H was in the distinguished Lodge of Freemasons at the Bear and Barrow, Butcher Row.

Chapter 6 A Jaunt and Southwark Fair

Sub. ticket: P 259f, 535 n2 (Lairesse, Hudibras, Nature); sales P 281. *Lottery:* Moore 95f. Charteris, in *Don Franciso's Descent* meets Mother Needham in hell; Chancellor iii, 153–8; note to *Dunciad* on Mother Needham. Death of Charteris (anodyne necklace) P 285f; tale of Board of Treasury rushing off to see H's prints. Parodies: P 289–91, Fielding 191f, Ralph 293, 536. Shamandra: Moore 96–100. *Rich's Glory*, not by H, GW 300f, Moore 85f accepts. Jaunt: Mitchell, Anon. (1). Nobody; Mitchell, Kitson 49. For Billingsgate and Watermen: T. Brown iii, 136–43. *Indian Emperor:* P 301–5; Boydell in print 1791 puts acting 1731. A 65f; Tate no. 41. Royalty: Tate nos. 38–40; P 423f, 312–15; portraits, P 426. Etched ticket: Singers rehearsing an oratorio by W. Huggins – high-sounding words and distorted faces. Sarah Malcolm: P 310–12; GW 152f. Vauxhall: P 347f. Leicester Fields: P 337f; Hoadly later jokes at H for calling it L. Square. Van Dyke: AB 169. Royal Marriage: A 38; P 318, 541. Vertue iii, 68. *Man of Taste*, often taken as H's: D 24, A 39, 92, etc. Mary Edwards: P 333–7. Audience: A 65, Jarrett 192–4, P 323f. Macklin stresses propriety, character, humour, rather than wit. *Southwark Fair:* H may have been spending summers on south side of Thames. GW 154–8, P 318–20; Jarrett 182; A 71f, 83 etc. Southwark: D. J. Johnson. Macklin's play based on controversial *Suspicious Husband* by B. Hoadly. Laguerre was scene-painter for Rich. A 72, Picart; 83, Callot. *The Stage Meeting* was put on by Rich in July. Mary Edwards: her picture half-way between small crowding groups and more monumental treatment, e.g. *Lord Hervey* 1738.

Chapter 7 The Rake's Progress

Masons: P 344f, 521, 544 n6; Gould; E. Ward. Gravelot left England 1745; Diumetti and first rococo pattern book 1736. H. did figures in Lambert's land-scapes of 1730s. Ellys had painted Polly and Macheath, P 546, 550. At Slaughters: Gravelot who brought in ways of using C and S rococo curves; Ellys, who had been Thornhill's apprentice, was interested in the theatre and bought the Vander-bank tapestry works; Hayman learned from Gravelot decorative methods he used at Vauxhall. Clubs: Raines 52f; Vertue iii, 24; P 207 (H and Lord Boyne). St Luke's, Vertue vi, 120, 31–7; P 347, ii, 43; Raines 52f; BM Add. MSS 39167; Slaughter's and Watteau, Raines 53, 64. Patronage: P 350f. Music, Raines 54; J. Hawkins, *Gen. Hist. of Music* 1776 (1936 ed.) ii, 806; H. Walpole (4) 330, app. 3. Ralph: P 352f, Ellys to Reynolds 354f, Thornhill 355, Mayhew 10, Croft-Murray (2), Osmun. Mitchell, p. xiv, suggests H wrote the *G.M.* obituary. Poem in *Bee* (Mrs F—): 18–25 May 1734, 551f, *G.M.* iv (1734) 269; Bourne, P 390f *Rake's Progress:* GW 160–70; A 195f, pl. 4 and Gillot, pl. 5 and Picart. Bill: D 43. Oil sketch: Kunzle. Desire to rise: Jarrett 192f, 210f; *G.M.* (1755) 43; C. de Saussure 157f; Cheyne, *Natural Method* (1742) 276. Bedlam: 'Behold Death grappling with Despair.' In 1763 H changed warden to parson: A 162. Dress: AB p. xxix, 47–9, 51–3, 173–5.

Tale of Tub: section 2, see also there the tale of Shoulder-knots; poem, P 325-32, 543. Riot: Kunzle 324-6. Palette: P 544 n64; GW 37f (Steen). Colours: AB 125-33; J. Gage, Colour in Turner. (1969) 62-4 for refs. Beefsteaks: P 356-9; Act, 360-6, AB 216. Lodge: P 343; Fire, P 368, A 43. Piracies: Kunzle, Moore. Academy: Kitson 92-5, P 390, 375 (H known). Highmore: A 47-9. For St Luke's Academy, Edinburgh, 1729; Smart 11f. Ramsay and Hysing at St Martin's Lane, ib. 13. Self-portrait: H holds roughly indicated palette, p. 450. Early 1735 Thornhill's paintings from his own collection were auctioned; the set of small copies of Raphael's cartoons went for 75 guineas; the Duke of Bedford bought the larger ones for £200. Vertue noted: 'He was 2 or three years making these Coppies at Hampton. - it was sold for less than cloth and colours cost.' Hogarth must have been angered at such depreciation. (1734-5 the sketch of Richardson with telescope up his son's anus, cf. the picture in a pirated Rake print of doctor peering up woman's bottom.)

Chapter 8 Which Turn?

Hogarth: AB 215f, 202f. In 1736 he took out a fire-policy for self and sisters. Fielding: GW 316, Moore 103f, P 298; in Pasquin a Jew carries off a Maid-of-Honour. Tumble-down Dick (with J. P. based on De Veil) has parodies of gods (sun with lantern etc.), cf. H's Actresses. Vauxhall: Gowing (3); Beckett (1) and (22) 33 wrongly sees the prints as the primary interest. Fairies: Gowing and Tate no. 126. Possibly H made full-length portraits of Prince and Princess of Wales about this time; the works are forced and hard. Richardson: Doody 216-19, 224f, 59f. Scholars: pun on Vacuum. Sleeping Congregation: GW 170, P 390, Raines 82, fig. 38, A 93, Beckett 73. Thornhill: P 553 n51; Swift, Baucis and Philimena 1709. Before-After. Lover ? John Willes, later Chief Justice, GW 172. Scholars: Fisher, Biog. Anecd. (1782) 207. Undertakers: A 130, GW 173f. For attacks on Quacks: T. Brown ii, 132-53; print, Quackery Unmask'd 1748, Arrangement with Bakewell about 1740: D 45. Poet: GW 174-6; Grub-street J. 2 May 1734; R. H. Griffith, F. D. Leach. Britophil: A 141f, D 56, P 373. Bad Taste: O. Sitwell 12-17; J. T. Smith i 251; Leslie and Taylor i, 51. Pool: A 145-8, P 383-7 (Highmore), 426f (Vanloo); nude, Oppé pl. 22 no. 25. Tempest: Tate no. 88 (1730-5), P 388f (1735), Beckett (1728); probably 1737-8. Ariel and Thornhill's Sabine room at Chatsworth. Danae: P 388-90; JWCI xxix (1966), 188, Richardson, Description de divers fameux tableaux iii, 285. Samson attrib. to H, P 390. Red Sea: P 379, 550: noble wanted staircase cheaply painted with Red Sea overwhelming the Egyptians; H said to have merely daubed it with red. Man complained he had only laid on ground. 'Ground! there is no ground in the case, my lord. The red you perceive is the Red Sea. Pharaoh and his host are drowned as you desired, and cannot be made the subject of sight, for the ocean covers them.' Satan: A 155f (Rosa), P 388, ii, 281-3 (Burke), Tate no. 91. Vails: Knapp ii, 109f; Swift, Directions ch. i, ii; to Stella, 13 Oct. 1710. Round this time desperate efforts by servants to conserve the custom. Vanloo (AB 216f) arrived in Dec. and won great patrons, including the Prince. Mrs Mapp died, given a parish funeral. Actresses: GW 182f, P 394f; Addison, Spectator 6 March 1711; Fielding, Champion 10 May 1740. Players: T. S. Graves and E. Colby. See Swift's Directions for servants pissing in all sorts of utensils. Riots:

Victor i, 55ff; Hughes 17–20, 26–30, 41, 51; Pedicord 29, 42, 51–4. Riot in Haymarket against French players: it was laid down magisterially that the public had the right to express their feelings in theatre matters, through the 'judicature of the pit'. *Four Times:* GW 178ff; Richardson (2) 134; Doody 203–5. Advertised, 23 Jan. 1738. *Morning:* G. A. Stevens, *Distress upon Distress*, printed 1752, has scene in Bedlam and line: 'Let pimpled Prudes on Citron waters dote' (I, iv, 101). *Noon,* crying boy from Poussin, *Rape of Sabines;* Kite, blown-out refugees or church spoiling play? *Evening:* girl said to be put in to explain boy howling; Johnson, *Idler* 22 July 1758; De Veil, GW 181 (Fielding), Anon. (2), Wheatley 140. De Veil and theatre riots: *London Mag.* (Feb. 1737) 107, 163; Hughes 19f. *Night:* P. 493 (Gay's *Trivia*), 399, 405. H uses an episode (Aug. 1737) when De Veil drank a bottle of supposed gin into which (unknown to the informer) piss had been put; De Veil fought hard to suppress the gin traffic; in Jan. 1738 big crowds raged at his door. Colour, Size: P 405–15. Portraits: AB 213f; Ramsay, P 434f, Vanloo etc. P 459–62. Ramsay's underpaint: Smart 39; *Walpole Soc.* xxv, 45; Vertue iii, 85, 96. Strodes: A 51 (Chardin). Hospital: P 387; Freke, P 436 n38; Florentine hospital: A 15. Winter: Jarrett 158; Mrs Pendarvis, P 386. Coram: A 45f, P 441f, AB 212f, Omberg. Subticket: P ii, 55. Frankland: A 46. Arnold: A 43f, P 445–8, 468 (Mrs Edwards); more portraits, P 448, ii, 250–3. Roubiliac makes first English statue (Handel) with informal pose. P points out that Aertsen and Snyders did still-life on grand scale, but this was an accepted though lesser genre. 7 Nov., Lady Cust on H's portrait prices; 20 Nov. his sister Mary dies. *Alfred* ticket with Cleveden House in distance; GW 183f; McKillop; A 69; Mallet and the Scot circle. 25 June, H. subscribes £21 to the F. H. Governors of St B.'s, 19 Dec. 1738, decide to ask him, with Gibbs, to see to hanging of picture of Henry III and arrange for making of bust of Rahere, jester-founder of the hospital.

Chapter 9 Marriage à la Mode

Children: A 46, P 458f. *Taste:* A 135–7 (Fuseli), P 466–8. *Charmers:* GW 186; Panton 13, AB 86f (machines of motion), Pantins in *S. Fair*. Attacks were made on Mlle Roland, lifted by Poitiers, 1735–6, 'her only endeavour is to shew above her knees as often as she can', Hughes 144f. Folkes engraved: GW 183 (1742). Vanloo: P 462f; Vertue iii, 117; Smart 130f; Réau. Fielding: Moore 109f; Cross i, 323. Moore 122f. Townley: P ii, 84. *Jonathan Wild.* Moore 125–7 (? written before *Joseph A.*). Notice on Slaughter, *Evening Post* 21–3 Oct., taken by Vertue as H's work; H probably used the press for such squibs. *Characters:* GW 188f; P 472f (Le Brun); A 132–4. Quotation: P 472, H MS Fitzwilliam Mus. *c.* 1775. Paris: Vertue iii, 116. Abuse: AB 213, Gay's *Fable* xviii, 1st s. Hoax GW 187, P 357 (drawings), based in part on Lancret illustrating La Fontaine fable about a trick on a love-braggart. Hoadly: Fielding, *J.A.* i, ch. 17; *Tom J.* xi, ch. 7; A 40; Ellis 352–6, 359, 406, 418. Print: P 444. Isaac Watts replied to Hoadly with *The Redeemer . . . The Operations of the Spirit Vindicated*, W. Wilson 145f. *Marriage:* GW 267–75. Pl. 1, Steen, Cochin; ? Hayman model for Earl. Room is drawing-room 14 Arlington St. where H. Walpole once lived. Earl and mirror, cf. *Baptism.* Furniture: D6, Walpole *Anecdotes* (1771) 74. Hair: AB 52. Marriages: Speck in Holmes 146. Pl. 2: Negro and statue of Actaeon. Misaubin: cf. *Tom J.* xiii, 2, T. Brown ii, 134. Pl. 4:

A 106, Coypel and J. F. de Troy; note baby-rattle. Magdalen: Rousel 47. Lovers' duel in Italian prints. Pictures in *George Barnwell*: P 483. Oil-sketch: Beckett pl. 141. *Battle of Pictures:* Ramsay satirized, Smart 87. Auction: P 490–6; Vertue iii, 123; Walpole to Mann, 25 July 1750. Moser favoured continental type of academy. Dec. 1744, sculptor Rysbach a F.H. governor. July 1745: Highmore *Pamela* prints. Herring: A 40, P ii, 8. Self: A 118. Graham: probably celebrating his action off Ostend, June 1745. H and Nazari: A 239 n41; F. J. B. Watson. Mercier: A 239 nn45f; Raines (2). Chippendale: Kimbal. Garrick: 23 Oct. to friend in London, has had 'a great account' of H's picture. From Dublin, 1 Dec., asks how H gets on, 'and does he intend a print from it?' Hayman also paints him as Richard, in different scene. P ii, 27–9, A 67–9, 178f. Self: AB 10; Dobai 340; P ii, 3–5; Vertue iii, 126; AB 143; Bourne: P ii, 5. Rouquet: AB 228–30, nothing on H's theories; says H depicts low life etc. to make it repellent. *Happy Marriage:* A 113–15, 49f; AB 141f; P ii, 15, 18f. Vauxhall: Gowing 12. Pamphlet: P ii, 21f. Rouquet: AB 228, 208; P ii, 19–21. *Taste:* P ii, 468; Panton 12. Garrick: AB 213. Grignion states he tried the face several times till he got it right, in engraving. Proportions: P ii, 31; Oppé 6, cat. 39; AB 103. Old Alresford: P ii, 31–4. Lovat: GW 192f; A 129. David Lock: P ii, 56. Foundling Hospital: Smart 50f; Court Minutes. *Moses:* GW 218 (Poussin), crocodile under chair, pseudo-Egyptian scene. A 200f (Vien); Rosenblum 1–7; A 151f (Guéricault). Wills's *Suffer the Little Children* anticipates Victorian sentimental works. Highmore did *Hagar and Ishmael*. *Shrimp Girl:* Tate no 129 (? 1745); A 116f (back to Titian's latest works, on to Manet); P suggests mid-1750s.

Chapter 10 The Gathering People

Paintings: P ii, 44, 49f. Shows: *ib.* 42; Vertue iii, 134f, 90. *Arms:* GW Cat. 236. Lovat executed 9 April, last public beheading. 13 May H brought up at F.H. the matter of engraving rights. *Coach:* GW 192. Trembling Beggar (*St James's E. Post* 8–10 Sept. 1747) in L. Fields fights with man who called him a Pickpocket; perhaps man in AB 141, 187, with head clouted up 'very artfully' and 'what he intended for a grin of pain and misery, as rather a joyful laugh', P ii, 96f. *Industry and Idleness:* GW 194ff; 12 was usual number in continental cycles. Drawings: A 119. Effects: P ii, 431, 71; AB 225; P 43. *Westward Hoe:* Pedicord 216f. Pl. 1: A. 12; Barnwell on drawing. Pl. 3: A 122, Rosa. Pl. 8: Portrait of William III over Goodchild. Pl. 10: Raines 55, 59, Laroon's Bow St drawings. Informers: Radzinawicz ii pt. 1. Pl. 11: usual time, 8 a.m., Monday; Bruegel, GW 201. Pl. 12: stands for city guilds, tapestry from royal gallery only fine-art object in series. Note Tom and cats: pls 1, 3, 7. H liked praises of his high moral aim: 'A Sermon wonce preach[d] on my print . . .' Pamphlet: Anon. (3) 4f. Idle: AB 208f, 195, 211 etc. Effects: Moore 13f, P ii, 61f. Hartwell 32–4. Absent-minded: P ii, 82. Whitehead praises his satirical power; anon., *Gent. Mag.*, calls on him to use image of Cockpit: A 17 n79. Le Blanc: P ii, 135f, 437 n12; Leith 8f. Parsons: *Human Physiognomy explained in the Crounian lecture on muscular motion*, 1747. Puppets: cf. Signboard, *Election* pl. 2. *Paul:* P. ii, 51–4, line of beauty in scroll leading up to Paul. Sources in Hoadly or Richardson: Omberg, P (6). France: P ii, 75–7, Armistice, May, peace 18 Oct.; AB 227f; Vertue iii, 141f; Walpole *Corr.* xx, 13 (cf. Vanbrugh in 1690); P ii, 431 n20. Gostling

made a verse version of *Peregrination*. Vertue vi, 200 on the Beef; GW 203. August this year, recent statue of George I in L.F. was ordered by householders to be gilt 'with all Expedition'. Kalm, 1748, on coal-smoke in London: Jarrett 221. Pantin prints: Paston 13. In 1748-9 the Dilettantis considered an academy-plan. Chinoiserie coming on; at Vauxhall a painting of Venus and Mars 'in the Chinese taste'. Paviours: Welch 51; Renard 95. La Mettrie: P ii, 423 n23. Vauxhall: Gowing 12. *Coram* engraved by McArdill. *Taste:* Paston 12-14. Jane letter: Houghton Lib., P ii, 85. *March:* Coley; GW 277-80, Oppé for drawing. Boxers: Jack Broughton set up own theatre 1742, Oppé cat. 105. Vertue vi, 163-5; king, P 433 n42. Size of painting: 40 by 52½ inches. Wilkes tried to suggest the print was Jacobite in *NB* no 17. Watteau: A 120, *Le Départ du Garnison* lies behind the *March*, though the effects are quite different. Morell: Gen. Works i, 127. Guglielmus H., GW 204f; Ranby's House, GW 205, Cards: GW 205 (Steevens sets before marriage), Riot: Knapp ii, 60-2; Independence, Jarrett chs. 1-2, Renard, etc. W. Faucett published *Regulations form the Prussian Infantry. From the German*, 1754. Chase: AB 39-41, cf. *Tom Jones*, P ii, 177. Crowd: for significance of realizing the city crowd, see Benjamin, *Baudelaire*. More debate on academies, 1749, eg. J. Gwyn's *An Essay on Design*.

Chapter 11 *A Time out of Joint*

Townley: had gift of impromptu epigram, P ii, 158, GW 207. *Stand at Arms* ? from captured arms shown in Tower 1746. First case under H's Act won by plaintiff, 24 July 1750. Walpole wrote, 25 July, asking H. depict King Theodore of Corsica in the King's Bench. *Herring:* engraved by Baron, P ii, 448. *Scandalizade* (P ii, 133): this poem shows pugnacious H identified with his Dog; also jeers at Trotplaid (Fielding) as hanger-on of H. See *Gen. Works* i, 416-19; P ii, 341, 459, for Dawes, Gardelle, Richards. Fielding (P ii, 98) recommended the public bear expense of prosecutions and witnesses: not done generally till 1778. *Beer Street* etc., A 164-7 (Breugel, Jordaens), GW 206-11 (the books). Houses: Besant 297f. Gin: D. George 27-42, etc. Baitings: *Diary of Abraham de la Prynne* 33 (Surtees liv, 187); Malcolmson 119; Besant 400. Martyrdom: Atherton; A 166; Mitchel p. xxvi; T. Brown i, 145. Dissection: *Gent. Mag.* 1754, 152, fear of dissection 506. Correggio: AB 169 and 9; 226, 222. *Dissertation:* 24, 9, 56; it gives statistics of fall in births, 28. Attack on man in L.F., 24 May, P ii, 97. English historical engravings start, *ib.* 30. Coram dies 29 March. Rembrandt: P ii, 113-15, 120f; A 154. Sandby in 1753 assumed H disliked Rembrandt. *Paul burlesqued:* his hand placed so as to seem to grab at Lucilla's loins. Scale: P ii, 122-6. Rouquet gives a glimpse behind the scenes. The Artists' Committee of the Hospital, gaining English art a wider audience, yet led to factions. 'And indeed, the artists have themselves contributed to this injustice, by running one another down, as they usually do.' Then he goes on to H's new kind of picture. He sees them drawing on H's talk. This year H cleaned the staircase paintings at his own cost; asked that no varnish should ever be used. Case before Lord Hardwicke; caricature using Fox's image of Spider. Brothel-keepers and prints: P ii, 128. Thynne: *ib.* 126. C. Smart in *Hilliad* praised H and Garrick for similar talents. *Moses:* GW 218f. In June H met Dr Johnson and tried to excuse George II for executing a Jacobite long after the rebellions; but we only have Reynolds's account. Fleet Marriages: *Gent. Mag.* (1735) 93; W. E. Tate,

The Parish Chest, 3rd ed. (1969), 82, 49; Jarrett 131; Knapp ii, 43f. Census: Jarrett 36f. Academy: Ap. 92f; P ii, 141–5; Rouquet *ib.* 144 n38, Strange in n39. Strange had been a Jacobite; his suspicious irritability, Smart 112–16; J. Denistoun, *Memoirs of Sir R. Strange and A. Lumsden* 1885. For H. and Smollett see Giddings, and M. Praz, *The Hero in Eclipse* (1956) 14f; Smollett and reduction of society to money-values: Giddings 118.

Chapter 12 Analysis of Beauty

Analysis: AB 15, 185f, 192, 19. Note Eels (line of beauty) on Columbus's plate. Townley's joke on Oracle: Burke p. xxxiv. Morell knew works of Locke, Berkeley, Hume; annotated Locke's *Essay on Human Understanding*. Sanderson: AB 119f, Dobai 361, Burke pp. xxxi–vii, AB 19f. Poem: P ii, 157. Preface AB 190. Macklin: P ii, 439. Note similarity of H's ideas and Rodin's: Rodin insisted the eye must not be taken from eye in drawing and discussed the endlessly changing profile of the living object. Wilson: *Gent. Mag.* 1788, 564, 656; I. B. Cohen 242, 264, 134–6. Scope: Burke p. xxxv; Elsum, p ii, 440 n29, Dobai 343f; Richardson (3) ed. 1792, 81; AB 6. *Analysis* ch. vii, Dobai 340. Concordia: P ii, 180; AB 55; Burke p. lvi; AB 35. Parent: Dobai; Pacey *s.v.* Index. Parent wrote an exposition of Descartes's ideas. Balance: AB 63f, rainbow 97f. Shaftesbury, Addison etc.: P ii, 168, 174–6, 178, 166–8; *The Moralists* III, 3 etc.; B. Willey ch. xiv. H. could not have known Cudworth and his 'plastic Nature', active energy. Against proportion: AB 190, 169, cf. 9 and 38; also Bacon in *Essays*, Dobai 353. Hussey: Whitley i, 128; O. Sitwell 15; J. Barry, *Works* (1809) ii, 566; Dobai 342; S. E. Read; AB 138 (Le Brun) cf. 10f. Music: AB 90f, 182f, 187, 203; shade, AB 110; architecture, AB 182. Wren: *Parentalia* Tract II; Dobai 337. Spence: P ii, 165; Dobai 360. Cf. Félibien, *Entretiens* 1685, red and white blended; Burke p. xxxvii. Xenophon: *Mem.* III, x; II, i; III, vi; Burke (3) and (5) 139f; AB p. xxxv. Hume: Burke p. lvi, AB 32f; Smart 86. Watermen and boxers AB 99, 94. Organic: Dobai is the one that sees this. Yard: AB 34; M. Webb (1); GW 220–3; P ii, 170f. Apollo: AB 100. Movement: AB 99, Dobai 399, 363. Change: P ii, 182f (note link with skeleton-men leaf-decked in allegorical works with greenery-covered skulls). Line: AB 54. Sterne: *T.S.* IV, 6. Skin: AB ch. xiv. Shell: AB 27–9, Dobai 378. Spiral: AB 75, 65, 80f, 83, 95. Integrated form from varying views: Dobai 358, AB 37; contrast with Burke's artificial infinity, Dobai 364. Stay: AB 65f, cf. 19, 83, 95. John Boswell i, 381. Dimplings: AB 81. Pl. 2: GW 223–5. Negress: AB 189.

Chapter 13 The Election

Reactions to *Analysis:* P App. G, ii, 493ff, 144–52, 298, 186f. AB 203, Ap. 109; Burke p. xxiv. James Moor in March 1754 read his *Essay on the Composition of the Pictures described in the Dialogue of Cebes* to a literary society; dealt with two ways of showing a variety of motions: by a series 'each representing some one of these actions: and, the whole together, as ONE set, exhibiting the ONE final tendency of all'. Examples of the first way, the *Progresses, Industry;* of the second, *Southwark Fair*, where 'all the various scenes, of clamorous riot. dissolute diversions, and ludicrous accidents' were brought together simultaneously, 'tho' just EXACTLY

according to nature'. Published 1759; P ii, 95, 434. Sub. ticket (*Crowns* etc.) in March; odd alteration of Prince's crown to that of Duke of Cumberland. Ramsay in *Essay on Ridicule* praised H as incomparable; in July he left for Italy. New standards of genteel elegance; Chippendale's *Directory* enabled gentry to show just what they wanted. Art-imitations of Graeco-Roman art in household, even in wallpaper (J. B. Jackson's book). Society of Arts: P ii, 141, 196, 214–19, 307–10, 318–20, 331–4, 345, 352, 363. D. G. C. Allan. Ap. 87–9. *Election: Gent. Mag.* (1754), 289, 338, 377–9; Jarrett 27; GW 226ff; R. J. Robson; A 249; P ii, 191ff. Fielding's play (1736) *The Humours of a Country Election;* E. Wind (3). Pl. 4: Bowen 212; A 170. Pl. 1: Porto Bello and the men reminiscing: in 1740 the anon. author of a poem on Vernon's action had called on H to paint the event. Note the election in Smollett's *Sir Launcelot Greaves,* followed by Ferret's rhetorical sale to the crown of his rostrum. Smollett and Shebbeare: J. R. Foster. In H's use of the term 'history' there is something of the puritan insistence on history as reality. Richard Baxter: 'Nature is delighted in History. And the world is dolefully abused by false History', S. Clarke, *The Lives of Sundry Eminent Persons* (1683), fol. A3v. Fox: Beckett pls 95,200, at the time Sec. of War, joined Duke of Newcastle's cabinet, Dec. 1754, P ii, 203f. Kirby: P App. H. Price: *Essays on the Picturesque* 1798 ii, 169f. *Stir in City:* A 17. Canaletto: P ii, 197. Academy: Ap. 105, P ii, 207. Bristol: Vicar was nephew of horse-painter Wootton; H stayed with prebendary of the Cathedral, who was married to daughter of London merchant who proposed the School to the Dilettantis. Cooking: AB 176f, Rouquet, *State* ch. 29. Manufactures: Ap. 98, 79f. Portraits: Pine, Dashwood. Townshend: use of *Beggar's Opera*, GW 239. Bardwell: P ii, 214. *Invasion:* GW 236f; A 54; Jarrett 40f. Club: Ellis 348ff. Brown: his 1750 sermon at Bath made magistrates close the public gambling tables; he turned later to defend Pitt, 1766. Riots: *Gent. Mag.* (1756) 608, cf. 1740, 3550. Bristol: P ii, 228–31, A 154f. Garrick etc.: P ii, 294, 234f, 344, 242f; A 69f. Militia Bill got royal assent, 28 June 1757; provoked riots. Spurious prints: ? reissue of *Gulliver* as attack on Newcastle–Hardwicke interest. Serjeant-Painter: AB 219, P ii, 249–52, Smart 104. On 5 Nov. F. H. artists' dinner; Boyce's *Ode* set by Arne, H is 'the Cervantes of the art'. Burke: Dobai 366, P ii, 281. Foundlings, *ib.* 306f, 339. Turks Head: Tate no. 196. *Election:* pl. 2, rcf. to Porto Bello victory, 1739, as contrast to Byng and Majorca. Print dates 20 Feb. 1757, but issued year later. Pl. 4 ded. to Hay, a Whig. Portraits: P ii, 244. Martin: 366, 245 (Mary); A 173f; Tate no. 197, see also 190, 198. Costumes: Vanhacken earlier tried a Rubens costume used by Ramsay and others: Smart 41, Steegmann (2). Lion: E. Wind (4) on Leonardo. Shebbeare: later turned on Wilkes and was penalized by Bute, 1762. Movement: AB 119–21 (Hampstead effects); Dobai 364f.

Chapter 14 The Last Stake

Comic Muse: P ii, 251, 259: Vermeer, Metsu as artists painting Muses. Under H's work is fragmentary large composition. *Bench,* ded. ironically to caricaturist Townshend. Caricature: *Monthly Rev.* xix (Sept. 1758) 318–20 (? Barwell); GW 239; P ii, 287; wigs, AB ch. 6 and 11; AB 99; *Outré,* AB ch. on Excess. Huggins: P ii, 262–6, 284, Ralph xx *ib.* 251; BM Addl. MS 22394 f42. Charlemont: P ii, 267f, AB 219, A 171f, P ii, 279. Ramsay early championed Greek art v. Roman,

Gothic v. Renaissance: *Dialogue on Taste*, Smart 91. Grosvenor: AB 220; BM. MS *l.c.;* C. J. Smith pl. 45; P ii, 280. H makes pessimistic reply about Norfolk lad who wanted to enter art. His picture of Schutz vomiting abed (bowdlerized later). Warton: Huggins did not like him, may have worked H up, P ii, 295. Hester: Piozzi (2) ii, 28, 308f; Clifford 23; P ii, 454 nn13–15. Her father was only subscriber to *Sig.* who refused to have money refunded. *Sigismunda:* A 156–8, AB 89, P ii, 22, 37, 270, 275–8, 323, GW 243. H was at Murphy dinner, with Foote and Berenger, 23 April 1759. Letter: P ii, 372 n45. *Cockpit:* A 183, copied on jugs; GW 240. Letter comparing his work to Fire Engine. Sterne: P ii, 286, 302–6, 441, 456; Holtz; A 164. Moore ignores the relation. Ill: AB 220f, P ii, 286. Bird: D 144. Hayman at Vauxhall: war-themes, Gowing. Bute: AB 223f, P ii, 311–18, 457, Ap. 97. Wilkes on Ramsay: Smart 104. *Time Smoking:* GW 241–3, AB 130–2, *Gen. Works* i 324, F. D. Leach (2), G. Klotz. Mayo: P ii, 327, AB 191f, the Nobody dedication. Soc. of Artists: L. H. Cust, *Hist of Soc. of Dilletanti* 1898; Wood, *Royal Soc. of Arts;* J. Brownlow, *Memoranda of the F.H.; Minute Books of the Governors of the F.H.;* Waterhouse, *Three Decades of British Art; Conduct of the Royal Academicians,* 1771; Walpole Soc. vi, 116ff etc; P ii, 456, 319f, 214–16, 333f; A Shirley ii, 250; Protest on 4 April at H alone mentioned in advertisements. Fox: A 44. Ill: AB 221. *Periwigs:* P ii, 339f. 359; Boswell i, 371f, cf. Turner's poem on the Orders in terms of people. *Enthusiasm:* GW 244–6; A 54, 116f, 21; Steele's Ecclesiastical Thermometer; lust-metres in early attack on Masquerades. *Credulity:* GW 247–9, P ii, 354–7, 301. Irreligion: H. Coleridge, *Essays* (1851) ii, 237. *Farmer's Return:* A70, P ii, 344. Augustan form: Battestin (2) and review by P. Fussell, *TLS,* 7 Feb. 1975. For orders, see *Spectator* nos. 98, 127, 145 (Dissection, 275, 281).

Chapter 15 Finis

Situation: New industrial inventions had been coming in (Kay's flying shuttle, 1733; Newcomen's steam-engine installed in coal-mine near Wolverhampton in 1712; coke substituted for charcoal in smelting 1735); 1719 saw the first textile factory proper, under J. and T. Lombe. Colonial expansion led to demands for all sorts of objects that stimulated production at home (nails, axes, firearms, buckets, coaches, clocks, saddles, buttons, handkerchiefs, cordage, etc., etc.): R. Davis. Internal markets grew. Darbys of Coalbrookdale began, about 1710, selling iron-ware in small amounts at fairs; by mid-century they employed agents in Cornwall and Northumberland, then later had big warehouses in London, Bristol, Liverpool. A great network of merchant houses or agencies abroad had developed 1635–1725: Davis (2). The slave-trade was of central importance. London had grown more and more a complex financial centre, with a well-organized insurance sector: P.G.M. Bickson, *The Sun Insurance Office, 1710–1960.* Population grew rapidly in areas of industrial mercantile activity, e.g. that of Lancashire trebled during the century. Manchester had 10,000 inhabitants in 1730, 27,000 in 1770, and so on. Between round 1650 and 1750 'English agriculture underwent a transformation of its techniques out of all proportion to the rather limited widening of its market', L. Jones. These are only a few selected aspects to give some idea of the changes accumulating during Hogarth's life, which ended just on the verge of the advent of the full use of water and steam-power. State: Jarrett 29, 46; Strikes: D. George

(3) 163, 206, 368. Thornton: P ii, 345–7 (Letter in *Chronicle* on meeting the Devil). 347–53. (Silly story about *Ethos* by Steevens or Warton.) 19 April: J. Courtney, tea with Hogarth and Miss Bere, H explained the *Election* pictures, 'talks much against the French'. *The Times:* GW 249–52; A 167; P 372–5. Wilkes–Churchill: P 374ff; Laver, Intro. and Postgate, Bleackley, Treloar, Williamson; Anon. (4) ii 376. *Garrick Corr*, Forster coll. V. and A. AB221, 219, P ii, 252; GW 256. A 129f. BM Add. MS 30, 878; P ii, 467 n88–9. *The Times* 2: GW 252–4, P ii, 390–3; AB 231; Bruegel's *Le Printemps*. For *Jack in Office*, see GW 255. Riots at Drury Lane over stopping of half rate after start of their act; Garrick goes abroad. Poem: Pii 391. *Bruiser:* GW 157f; *Clarissa* vii, 140; BM Satires 4085g; J. Ireland 2,260. Churchill: P ii, 395–7; AB 221f. This autumn he ran off with daughter of H's old friend, Sir Henry Cheere; in June 1763 Smollett went off. Martin: Postgate 91. Charlemont: J. T. Smith ii, 114; P ii, 279 and 401 (MS in coll. Dr James Browne); AB 228f. Money: AB 219. Barry: Nollekens. By this time Ramsay is thought to have been worth some £40,000; he was rich even before his court-appointment: Smart 125. *Finis:* A 167f; P ii, 411–13; GW 259f; D 139f, Coach; AB 55, 35. Excited at ancient grotesque bronze that Basiri was engraving. Nichols says H first tried Grignion. Raffle, will: P ii, 419 nn31f; 420. *The Weighing Horse:* A. 137; GW 287. H's connection with the print seems slight, but Clubbe's book would have interested him, with its fantasy about a magnet, gravity, etc. *Bench:* GW 238. Jane as churchgoer: D 142; Sir R. Phillips, *Morning Walk* (1817) 213. Note the early Hogarth Club to which the Pre-Raphaelites belonged; William Morris grew a vine in his conservatory, Hammersmith House, from a cutting taken from H's Chiswick house.

Wilke's carried on H.'s traditon with his call for a National Gallery, 1777 (also for the development of the British Museum into a great free public library).

Bibliography

(Where no publication is mentioned, London is to be understood)

Abrahams, Beth-Zion, *The Jews in England*, 1869.

Adcock, A. St John, *Famous Houses and Lit. Shrines of London*, 1912.

Alderman, W. E., (1) *Trans. Wisconsin Acad. Sciences, Arts and Letters*, xxvi, 1931 (Shaftesbury); (2) *Pubs MLA of America*, xlvi, 1931.

Allan, D. G. C., *William Shipley*, 1968.

Anon., (1) *The Times*, 12 Nov. 1962; (2) *Memoirs of the Life and Times of Sir Thomas de Veil*, 1748; (3) *A Dissertation on Mr Hogarth's Six Prints*, 1757; (4) *English Liberty*, 1768, 1770.

Antal, F., (1) *H and his Place in European Art* 1962; (2) *Art. Bull*, March 1747; (3) *JWCI* xv, 1952; (4) *Classicisms and Romanticism*, 1966.

Arthos, J., *Milton and the Italian Cities*, 1968.

Ashton, *Humour, Wit and Satire in the 17th century*, 1883.

Atherton, H. M., *Political Prints in the Age of H*, Oxford, 1974.

Babington, A., *A House in Bow Street*, 1969.

Baldwin, E. C., *PMLA* xxi (1911), 528–48.

Balston, T., *History Today*, Aug. 1952 (Boydell).

Bardon, F., *JWCI* xxxi (1968), 274–306.

Barker, T., *The Listener*, 29 June 1967.

Bartley, J. O., *Four Comedies by C. Macklin*, 1968.

Bateson, F. W., *English Comic Drama* 1800–50, Oxford, 1929.

Battestin, M., (1) *Philol. Q*. xlv (1966), 191–208; (2) *The Providence of Wit*, Oxford, 1974.

Baum, R. H., *Art. Bull*. xvi, 1934.

Beattie, J. M., (1) *The English Court in the Reign of George I*; (2) 'Pattern of Crime', *Past and Present*, 62, Feb. 1974.

Beckett, R. B., (1) *The Listener* 16 Feb. 1950; (2) *Hogarth* 1949.

Bernbaum, E., *The Drama of Sensibility*, Camb. USA, 1925.

Bleackley, H. W., *Life of John Wilkes*, 1917.

Bond, D. F., ed. *Spectator*, 1965.

Boswell, John, *A Method of Study*, 1738.

Bowen, M., *W.H. The Cockney's Mirror*, 1936.

Bready, J. W., *England before and after Wesley*, 1938.

Brett, R. L., *The Third Earl of Shaftesbury*, 1951.

Brodsley, L., *JWCI* xxxv (1972), 401–4.

Brown, A. F. J., *Essex at Work 1700–1815* (Chelmsford), 1969.

Brown, G. B., *W.H.* 1905.

Brown, Thomas, *Works*, 1744 (4 vols).

Burgess, C. F., ed., *Letters of J. Gay*, Oxford, 1966.

Burke, Edmund, (1) *Philosophical Enquiry*, 1757; (2) 1759; (3) ed. J. T. Boulton, 1958.

Burke, J., (1) with C. Caldwell, *Complete Engravings*, 1968; (2) ed. *Analysis of Beauty*, 1955; (3) *JWCI* vi (1943), 151–80; (4) *Hogarth and Reynolds*, O.U.P., 1943; (5) *England and the Mediterranean Tradition*, Oxford, 1945.

Butler, Samuel, (1) *Hudibras*, ed. J. Willers, Oxford, 1967; (2) *Characters and Passages from Note-Books*, ed. A. R. Waller, Cambridge, 1908; (3) *Hudibras* ed. Z. Grey, Cambridge, 1744; (4) *Poetical Works*, ed. G. Gilfillan, Edinburgh, 1854; (5) *Notes to Hudibras*, Z. Grey, 1752.

Carswell, J., *The South Sea Bubble*, 1960.

Chaloner, W. H., *People and Industries*, 1963.

Chancellor, E. B., *The Lives of the Rakes*, 1925.

Chapman, R. W. in Turberville ii, 310–30.

Clements, R. J., (1) *Michelangelo's Theory of Art* 1963; (2) *Pictura Poesis*, Rome, 1960.

Clifford, Gay, *The Transformations of Allegory*, 1974.

Clifford, J. L., *Hester Lynch Piozzi*, Oxford, 1941.

Coley, W. B., (1) *JWCI* xxx (1967), 317–26; (2) *Mod. Lang. Q.* xxiv (1963), 386–91.

Croft, Murray, E., *Decorative Painting in England, 1537–1837*, 1962.

Cust, *The Master E.S. and the Ars Moriandi.*

Davies, R., (1) *Eng. Society of 18th c. in Contemporary Art*, 1907; (2) *Chats on Old English Drawings*, 1923.

Davis, D., *Fairs, Shops and Supermarkets* (London, Toronto), 1966.

Davis, R., (1) *Econ. Hist. Rev.* 2nd s., xv (1962), 281–303; (2) *The Rise of the Eng. Shipping Industry*, 1962.

Deane, P., *The English Industrial Revolution*, Cambridge, 1965.

Defoe, D., *An Effectual Scheme for the Immediate Prevention of Street Robberies and Suppressing all other Disorders of the Night*, 1730.

Dézallier d'Argenville, A., *Abrégé de la vie des plus fameux peintres*, Paris, 1745.

Dobai, J., *JWCI* xxxi (1968).

Dobson, A., (1) *W.H.* 1907; (2) 1891; (3) *Eighteenth-Century Vignettes* 3rd s.; (4) *ib.* 1st s.; (5) *Fielding*.

Donoghue, E. G., *Story of Bethlehem Hospital*, 1913.

Doody, M. A., *A Natural Passion* (Richardson), Oxford, 1964.

Edwards, E., *Anecdotes of Painters*, 1868.

Edwards, R., (1) *Early Conversation Pieces* 1954; (2) *Apollo* (Oct. 1935), 193–8; (3) *Country Life*, 27 Nov. 1937; (4) *Burl. Mag.* xcv (1953), 142.

Eicholz, J. P., *Bull. NY Pub. Lib.* lxx (1966), 620–46 (Gay).

Ellis, F. H., ed., *Poems on Affairs of State* vii.

Elsum, J., *The Art of Painting after the Italian Manner*, 1703.

Erleigh, Viscount, *The South Sea Bubble*, 1933.

Esdaile, A. J. K., in Turberville ii, 72–92.

Faithorne, W., *The Art of Graveing, and Etching*, 1662.

Feiling, K. G., *The Second Tory Party 1714–1832*, 1938.

Ferrers, E., (1) *Illustrations of H.* 1816; (2) *Clavis Hogarthiana*, 2nd ed., 1817.

Feuillet de Conches, M. F., *GBA* xxv (1868), 209.

Flower, N., *Handel*, 1923.

Forester, A., *Connoisseur* clii (1963), 113–16 (silver).

Foster, J. R., *PMLA* lvii, (1942).

Fowler, T. H., *Shaftesbury and Hutcheson*, 1882.

Freeman, R., *Eng. Emblem Books*, 1948.

Fry, R., *Reflections on British Painting*, 1934.

Garrick, D., *Letters*, ed. D. M. Little and G. M. Kahrl, Cambridge (Mass.), 1963.

Gaunt, W., *Hogarth*, 1947.

Gay, J., *Letters*, Oxford, 1966.

George, D., (1) *H. to Cruickshank: Social Change in Graphic Satire*, 1967; (2) *England in Transition*, 1931; (3) *London Life in the 18th c.*, 1930.

Gerber, H. E., *Mod. Lang. Notes* lxxii (1957), 267–71.

Giddings, R., *The Tradition of Smollett*, 1967.

Gilboy, E., *Wages in 18th C. England*, Cambridge (Mass.), 1934.

Gilpin, W., *Essay on Prints*, 2nd ed., 1765.

Gombrich, E. H. (1) *Meditations on a Hobby Horse*, 1965; (2) *Procs. Brit. Acad.* xliii (1957), 133–86 (Lessing); (3) *JWCI* xi, 1948.

Gordon, S., with T. G. B. Cocks, *A People's Conscience*, 1952.

Gould, R. F., *Concise Hist. of Freemasonry*, 1903.

Gowing, L., (1) see Tate; (2) *TLS* (9 Feb. 1967), 99; (3) *Burl. Mag.* xcv (1953), 4–19.

Graves, T. S., *Notes and Q.* 7 July 1923 (strollers).

Gray, A. K., *Hist. of Eng. Philanthropy*, 1905.

Green, F. M., *H and his House*, 1958.

Green, H., (1) *Shakespeare and the Emblem Writers* 1870; (2) *Andrea Alciati*, 1872.

Green, John (G. H. Townsend), *Evans Music and Supper Rooms, Covent Garden* etc., c. 1858.

Griffith, R. H., *Manly Anniv. Studies in Lang. and Lit.* Chicago (1925), 190–6.

Guerinot, J. V., *Pamphlet Attacks on A. Pope*, 1969.

Gwynn, J., *An Essay on Design, including Proposals for creating a Public Academy*, 1749.

Hale, J. R., *England and the Italian Renaissance*, 1954.

Hammelmann, H. A., *JWCI* xxxi (1968), 448f.

Hardy, C., *Burl. Mag.* xvi, 1909–10.

Harris, James, *Dialogue Concerning Art*, 1744.

Hartwell, R. M., ed. *The Industrial Revolution* (Blackwell), 1970.

Hayward, J. F., *Huguenot Silver in England 1628–1727*, 1952.

Hervey, Lord, *Memoirs*, ed. R. Sedgwick, 1952.

Hindley, C. L., *A History of the Cries of London*, 1881.

Hitchin, C., *A True Discovery of the Conduct of Receivers and Thief-Takers in and about the City of London*, 1718.

Hoffmann, L., *George Lillo*, Marburg, 1888.

Holmes, G., ed., *Britain after the Glorious Revolution*, 1969.

Holtz, W. V., *Art Bull.* xlviii (1966), 82–4 (Sterne).

Hone, *Table Book*, 1828 (Peregrination).

Honour, H., *Connoisseur* (Aug. 1954), 3–7.

Hotten, J. C., *H's Frolic*, 1871.

Howson, G., *Thief-Taker General: The Rise and Fall of Jonathan Wild*, 1970.

Hudson, W. H., *George Lillo and the London Merchant*, Chicago, 1915.

Hughes, Leo, *The Drama's Patrons*, Texas Univ., 1971.

Hunter, J. P., *The Reluctant Pilgrim*, Baltimore, 1966.

Hyams, F., *Capability Brown and H. Repton*, 1971.

Ilchester, Lord (G. H. S. Strangways), *Lord Hervey and his Friends*, 1959.

Ireland, John, *Memoranda*, 1798.

Ireland, S., (1) *Graphic Illustrations of H.*, 2 vols 1794, 1799. (2) *Picturesque Views of the Inns of Court*, 1800.

Irwin, O., *Eng. Neoclassical Art*.

Isaacs, J. *The Listener*, 4 May 1950.

Jaffé, M., *JWCI* xxxiv (1971), 362–6.

Jarrett, D., (1) *England in the Age of Hogarth*, 1974; (2) *The Begetters of Revolution: English involvement with France 1759–89*, 1973; (3) *Ingenious Mr H.*, 1976.

Johnston, E, intro. *Paintings by Joseph Highmore* (Kenwood House), 1963.

Jones, B. M., *H. Fielding, Novelist and Magistrate*, 1933.

Jourdain, M., *The Works of W. Kent* (intro. C. Hussey), 1948.

Kimbal, F., and E. Donnell, *Metrop. Mus. Studies* i (1929).

Kitson, M., *Walpole Society* xli (1966–8).

Klein, R., *Bibliothèque d'humanisme et de Renaissance* xix (1957).

Klingender, F. D., *H and Eng. Caricatures*, 1944.

Klotz, G., *Zeitschrift f. Kunstgeschichte* xxii (1959), 102–7.

Knapp, A., and W. Baldwin, *Criminal Chronology; or the New Newgate Calendar* ii, 1809.

Krieger, L., *Kings and Philosophers 1689–1789*, 1970.

Kris, E. and E. H. Gombrich, in E. Kris, *Psychoanalytic Explorations in Art*, NY (1952), 189–203.

Kunzle, D., (1) *JWCI* xxix (1966), 311–48; (2) *The Early Comic Strip*, Berkeley, 1974.

Kurz, H., *JWCI* xv, 1952.

Lairesse, G. de, *The Art of Painting*, transl. J. F. Fritsch, 1738.

Larwood, J. (H. D. J. van Scherichaven) and J. C. Hotten, *The Hist. of Signboards*, 1866.

Laver, J., *Poems of C. Churchill*, 1770 ed.

Lawrence, W. J., in Turberville ii, 160–89.

Leach, F. D., *Ohio Univ. Rev.* ii (1960), 5–20.

Le Blanc, Abbé, *Letters on the English and French Nations*, 1749.

Le Blon, J. C., preface to Eng. transl. L. H. Ten Kate's *Le Beau Idéal*, 1732.

Lee, R. W., (Ut pictura) *Art Bull.* xxii (1940), 197–269.

Lees-Milne, J., *Earls of Creation*, 1962.

Leith, J. A., *The Idea of Art as Propaganda in France 1750–99*, Toronto, 1965.

Leslie, C. R. and T. Taylor, *Life and Times of Sir Joshua Reynolds*, 1865.

Leslie-Mitchell, R., *The Life and Work of Sir John Fielding*, 1934.

Levêque, F., *Iconographie des Fables*, 1893.

Levey, H. V., (1) *Marriage à la Mode* 1970; (2) *Painting in XVIII c. Venice*, 1959.

Levey, M., *Rococo to Revolution*, 1966.

Lewis, W. S., and R. M. Williams, *Private Charity in England 1747–57*, New Haven, 1938; (2) with P. Hofer, *Beggar's Opera by Hogarth and Blake*, New Haven, 1965.

Lichtenberg, G. C., (1) *Schriften und Briefe*, 1972; (2) *W. H.'s Zeichnungen*, 1873; (3) *Commentary on H's Engravings*, 1960.

Lippmann, F., *Engraving and Etching*, 1906.

Llanover, Lady, *Autobiography and Corr. of Mary Granville, Mrs. Delaney*, 1861.

Lockman, J., *A Sketch of Spring-Gardens, Vauxhall*, n.d. (1751).

Loftus, J., (1) ed. Steele, *The Theatre*, Oxford, 1962; (2) *Steele at Drury Lane*, Berkeley, 1952.

MacGowan, M. M., *JWCI* xxix (1966), 264–81.

McKillop, A. D., *Philol. Q.* xli (1962), 311–24.

Macklin, C., *Four Comedies*, ed. J. O. Bartley, 1968.

Maclean, K., *J. Locke and Eng. Lit. of the 18th c.*, New Haven, 1936.

Malcolmson, R. W., *Popular Recreations in Eng. Society 1700–1850*, Cambridge, 1973.

Marshall, D., *The Eng. Poor in the 18th c.*, 1926.

Martin, Burns, *Allan Ramsay*, Cambridge, 1931.

Mathews, W., ed., *Diary of Dudley Ryder 1715–16*, 1939.

Mayhew, Edgar de N., *Sketches by Thornhill in the V. & A. Mus.*, 1967.

Middeldorf, U., *Burl. Mag.* xcix, 1957 (Kent).

Millar, A., *Burl. Mag.* ciii (1961), 383f.

Mingay, G. E., *Eng. Landed Society in the 18th c.* 1963.

Mitchell, C., *H's Peregrination*, Oxford, 1952.

Monk, S. H., *J. of Hist. of Ideas* v (1944), 131–50 (grace beyond reach of art).

Montagu, J., *JWCI* xxxi (1968), 307–335.

Moore, C. A., *Pubs MLA* xxxi, 1916 (Shaftesbury).

Moore, N., *The Hist. of St Bartholomew's Hospital*, 1918.

Moore, R. E., *H's Literary Relationships*, 1948.

Morley, H., *Memoirs of Bartholomew Fair*, 1892.

Morris, Robert, *Lectures on Architecture*, 1734.

Nichol Smith, D., in Turberville ii, 331–67.

Nicholl, Allardyce, (1) *The Development of the Theatre* 1949; (2) *Early 18th c. Drama* 1952; (3) *Later 18th c. Drama,* 1952.

Nichols, J., (1) *Biographical Anecdotes of H,* 1781, 1782, 1785; (2) *Genuine Works of W. H.,* with G. Steevens, 3 vols, 1808–17.

Nichols, J. B., *Anecdotes of W.H.,* 1833.

Nichols, R. H., and F. A. Wray, *A Hist. of the Foundling Hospital,* 1935.

Nolte, F. O., *The Early Middle-Class Drama,* New York, 1935.

Ogden, H. V. S., *J. Hist. of Ideas* x (1949), 159–82 (Variety, Milton).

Omberg, H., W. H.'s *Portrait of Captain Coram,* Uppsala, 1974.

Oppé, A. P., (1) *Drawings of W.H.* 1948; (2) *Eng. Drawings, Stuart and Georgian Periods, at Windsor Castle,* 1950.

Osmun, W. R., 'A Study of the Works of Sir J. Thornhill' (unpub. diss., Univ. London), 1950.

Overy, P., *New Society,* 16 Dec. 1971.

Pacey, A., *The Maze of Ingenuity,* 1975.

Parent, A., (1) *Essais et recherches de math. et de physique* (2nd ed. 3 vols), 1713; (2) *Hist. et mémoires de l'Acad. Roy. des Sciences,* 1704.

Paston, G., *Social Caricature in the 18th c.,* 1905.

Paulson, R., (1) *Graphic Works,* New Haven, 1965; (2) *H: His Life, Art and Times,* New Haven, 1971; (3) Intro. Tate Cat.; (4) *Burl. Mag.* cix (1967); 284f; (5) *Studies of Burke and his Times* ix (1967), 815–20; (6) *Art. Bull.* (June 1975), 293.

Pedicord, H. W., *The Theatrical Public in the Time of Garrick,* Columbia, 1954.

Perry, T. W., *Public Opinion, propaganda and politics in 18th c. England: a study of the Jew Bill of 1753,* Harvard, 1962.

Pevsner, N., (1) *Acadamies of Art, Past and Present,* Cambridge, 1940; (2) *The Englishness of English Art,* 1956.

Phillips, H., *Mid-Georgian London,* 1964.

Piozzi, Hester L., (1) *Anecdotes of Samuel Johnson,* ed. S. C. Roberts, 1932; (2) *Autobiography,* etc., ed. A. Hayward, 2nd ed. 1861.

Plomer, W., *The Listener* (8 July 1954), 57f.

Plumb, J. H., (1) *Sir Robert Walpole,* 1960; (2) *The Growth of Political Stability in England 1675–1725,* 1967.

Postgate, R. *That Devil Wilkes,* 1930.

Power, D'Arcy, in Turberville ii, 265–86.

Praz, Mario, (1) *Conversation Pieces,* 1971; (2) *The Hero in Eclipse,* 1956; (3) *Studies in 17th c. Imagery,* 1947 and 1964.

Pye, J., *Patronage of British Art,* 1845.

Quennell, P., *Hogarth's Progress,* 1955.

Radzinawicz, *Hist. of Eng. Criminal Law,* 1948 on.

Raines, R., (1) *Marcellus Laroon,* 1967; (2) *Philip Mercier,* 1969.

Ransom, H., (1) *The First Copyright Statute* (Austin), 1956; (2) *Studies in English* xviii, *Univ, of Texas* (1938), 47–66.

Read, S. E., *Huntingdon Lib. Q.* v, 361.

Réau, L., *Carle Vanloo*, 1938.

Reiter, M., *W. H. und die Lit. seiner Zeit*, Breslau, 1930.

Renard, G., with G. Weulersse, *Life and Work in Europe*, 15th to 18th c., 1926.

Rey, R., *Quelques satellites de Watteau*, Paris, 1931.

Richardson, Jonathan, (1) *The Connoisseur*, 1719; (2) *A Discourse on the Dignity, Pleasure and Advantage of the Science of a Connoisseur*, 1719; (3) *Essay on the Theory of Painting*, 1715; (4) *Works* (Strawberry Hill), 1792.

Richardson, Samuel, (1) *Novels in Shakespeare*, ed. Head; (2) *Selected Letters*, ed. J. Carroll, Oxford, 1964.

Robson, R. J., *The Oxfordshire Election of 1754*, Oxford, 1949.

Roque, John, *Plan of London*, 1746.

Rouquet, J. A., (1) *Lettres de Monsieur . . . à un de ses Amis à Paris*, 1746; (2) *State of the Arts in England*, 1755.

Roussel, J., *La Litt. de l'âge baroque en France*, Paris, 1954.

Rowe, Elizabeth, *Works*. 1750.

Rudé, G., *Hanoverian London*, Berkeley, 1972.

Sala, George, *W. H.*, 1866.

Salerno, L., *JWCI* xiv, (1951).

Saussure, C. de, *A Foreign View of England in the Reigns of George I and George II*, ed. M. van Muyden, 1902.

Savage, S., *Connoisseur* lxx (Nov. 1924), 167f (letter of H).

Schultz, W. F., *Gay's Beggar's Opera*, Yale, 1923.

Sedgwick, R., *The House of Commons 1715–54*, 1971.

Sewter, A. C., Intro. *Hogarth Print-maker*, Whitworth Art Gallery, Manchester, 1962.

Shaftesbury, Earl of (Anthony Ashley Cooper), (1) *Notion of the Historical Draught or Tablature of the Judgment of Hercules*, 1713; (2) *Second Characters, or the Language of Forms*, ed. B. Rand, 1914; (3) *Characteristicks of Men, Manners, and Opinions*, 1711.

Shirley, A. in Turberville ii, 101–71.

Singer, H. W., *Die bürgerliche Trauerspiel in England*, 1891.

Sitwell, O, in Turberville ii, 1–40.

Sitwell, Sacheverell, (1) *Conversation Pieces*, 1936; (2) *Narrative Pictures*, 1936.

Smart, A., *The Life and Art of Allan Ramsay*, 1952.

Smith, Adam, *Wealth of Nations* ed. E. Cannan, 1950.

Smith, C. J., ed., *Historical and Literary Curiosities*, 1840.

Smith, J. T., *Nollekens and his Times*, 2 vols, 1828.

Southern, R., *The Georgian Playhouse*, 1948.

Southworth, *Vauxhall Gardens* (New York), 1941.

Speck, W. A., *Tory and Whig: the Struggle in the Constituencies 1701–15*, 1970.

Steegman, J., (1) *The Rule of Taste from George I to George IV*, 1931; (2) *Connoisseur* xcvii, 309ff.

Stephens, F. G., and E. Hawkins, *Cat. of Prints and Drawings in the B.M.* Div. In vol. iii, 1877.

Sweeney, J. J., *Partisan Rev.* xx (1953), 103f.

Swift, J., *Poems,* ed. H. Williams, Oxford, 1958.
Sykes, N., *E. Gibson,* Oxford, 1926.
Symmonds, R. W., *Burl. Mag.* lxxxi (1942), 176–9, (H. and Wootton).

Taggart, R. E., *Art Q.* xix (1956), 320–3 (Tavern).
Tate: Exhibition at Tate Gallery, 2 Dec. 1971 to 6 Feb. 1972.
Testelin, H., *The Sentiments of the Most Excellent Painters Concerning the Practice of Painting,* 1688.
Treloar, W. P., *Wilkes and the City,* 1917.
Trusler, J., (1) *H. Moralised,* 1768; (2) 1841.
Turberville, A. S., ed. *Johnson's England,* OUP, 1933.
Tuve, R., (1) *Elizabethan and Metaphysical Imagery,* Chicago, 1942; (2) A *Reading of G. Herbert,* 1952.

Vertue, G., (1) *Notebooks,* 6 vols Walpole Soc. 1934–55; (2) BM Add. MSS 23069–98.
Victor, B., *Hist. of the Theatres of London and Dublin,* 1761.
Volkmann, L., *Bilderschriften der Renaissance, Hieroglyphik,* etc., Leipzig, 1923.
Vries, A. G. C. De, *De nederlandsche Emblemata,* Amsterdam, 1899.

Walpole, H., (1) *Anecdotes of Painting,* ed. Dalloway and Wornum, 1888; (2) *Aedes Walpolianae,* 1747; (3) *Corr.,* ed. W. S. Lewis.
Ward, A. W., intro. *Lillo, The London Merchant,* etc., 1906.
Ward, Eric, *Ars Quatuor Coronatorum* lxxvii (1964), 1 (H's Fraternity).
Ward, Ned, (1) *The London Spy,* 1698; (2) reprint n.d.
Wark, R. R., (1) *Burl. Mag.* xcix (1957), 344–7; (2) 1958, 26f.
Waterhouse, E., (1) *Painting in England, 1530 to 1790,* 1953; (2) *Three Decades of British Art, 1740–70,* Philadelphia, 1965.
Watson, F. J. M., *Burl. Mag.* xci, 1949, (Nazaris).
Watt, Ian, *Studies in Bibliog., Papers of Bibliog. Soc. of Univ. of Virginia* xii (1959), 3–20.
Webb, G., *Wren,* 1937.
Webb, M. I., (1) *Burl. Mag.* (c. 1938), 236–9 (Cheere); (2) *Michael Rysbrach, Sculptor,* 1954.
Welch, C., *Hist. of the Worshipful Company of Paviors,* 1909.
Wescherm P., *Art Q.* xiv (1951), 179–92 (Mercier).
Westerfield, R. B., *Middlemen in Eng. Business,* 1915.
Western, J. R., *The Eng. Militia in the 18th c.,* 1965.
Wheatley, H. B., *H's London,* 1909.
Wheatley, W. T., *Artists and their Friends in England 1700–99,* 1928.
Whitney, G., *Choice of Emblems,* ed. H. Green, 1866.
Wilding, Michael, in *Restoration Literature,* ed. H. Love (1972), 91–120.
Willey, B., *The English Moralists,* 1964.
Williamson, A., *Wilkes, A Friend to Liberty,* 1974.
Williamson, G. C., *English Conversation Pieces* 1931 (Exhib. March 1930, 25 Park Lane).
Wilson, C., *England's Apprenticeship,* 1963.
Wilson, D. D., Thomas, *Diaries,* ed. C. L. S. Linnell, 1964.

Wind, E., (1) *JWCI* ii, 1938–9; (2) *Art News* March 1947 (H., Constable, Turner); (3) *JWCI* vi (1943), 222f.

Wittkower, R., (1) *JWCI* vi (1943), 156–64 (Ps.-Palladians); *Archaeological J.* cii (1945), 154f; (3) Earl of Burlington and W. Kent, *York Georgian Soc.* Occ. Paper 5, 1948.

Wood, Sir H. T., *A History of the R. Society of Arts*, 1913.

Wornum, R., *Letters on Painting by the R. Academicians*, 1848.

Wrigley, *Past and Present* no. 37, July 1967.

Young, P. M., *The Concert Tradition*, 1965.

Zirker, M. R., *Fielding's Social Pamphlets*, Berkeley, 1966.

Note the following interesting works on Hogarth in Russian, all with the title *William Hogarth* (Moscow): E. Nekrasova, 1933; A. Sidorov, 1946; L. Voronikhina, 1963; A. E. Krol, 1965; with the introduction to the translation of *Analysis of Beauty* by M. P. Alikseev, and the essay by M. G. Sokoliansky on H. and Fielding in *Literatura i Obrazotvorche Mistetstvo* (Kiev) 1971, as both using a broad pantomime theatre.

Index

Index

Index